W9-DFL-052

COLLECTED
CORRESPONDENCE OF
J.M.W. TURNER

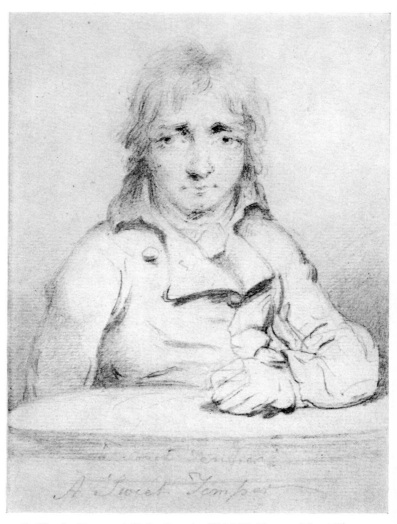

I. Charles Turner, A.R.A., *Portrait of J.M.W. Turner: A Sweet Temper.*
*c.*1807. Pencil. British Museum.

COLLECTED CORRESPONDENCE OF

J.M.W. TURNER

WITH AN EARLY DIARY
AND A MEMOIR BY GEORGE JONES

Edited by John Gage

CLARENDON PRESS · OXFORD
1980

115040

Oxford University Press, Walton Street, Oxford OX2 6DP

OXFORD LONDON GLASGOW
NEW YORK TORONTO MELBOURNE WELLINGTON
KUALA LUMPUR SINGAPORE JAKARTA HONG KONG TOKYO
DELHI BOMBAY CALCUTTA MADRAS KARACHI
NAIROBI DAR ES SALAAM CAPE TOWN

Published in the United States by
Oxford University Press, New York

© *John Gage 1980*

All rights reserved. No part of this publication may be reproduced,
stored in a retrieval system, or transmitted, in any form or by any means,
electronic, mechanical, photocopying, recording, or otherwise, without
the prior permission of Oxford University Press

British Library Cataloguing in Publication Data
Turner, Joseph Mallord William
The collected correspondence of J. M. W. Turner.
1. Turner, Joseph Mallord William
2. Painters—England—Correspondence
I. Gage, John
795.2 ND497.T8 79–40150
ISBN 0–19–817303–2

Printed in Great Britain by
Butler & Tanner Ltd, Frome and London

ACKNOWLEDGEMENTS

My chief debt is to the owners and curators of autographs, manu-
scripts, and drawings, who have generously allowed me to consult
and reproduce their holdings, and who have supplied me with photo-
copies and transcriptions. But a compilation of this sort is particularly
dependent on the patient advice and kindness of friends, and the
present book could never have been put together without considerable
help from David Bindman, Martin Butlin, David Cast, William Clen-
nell, Roy Davids, James Dearden, Trevor Fawcett, Dr. G. E. Finley,
Ian Fleming-Williams, Hardy George, Andrew Hemingway, Luke
Herrmann, Dr. A. M. Holcomb, Miss Laidman of the A.G.B.I.,
Christopher Lee, Susan Legouix, Ian Lowe, Angelina Morhange,
Chris Mullen, John Murdoch, Kathleen Nicholson, Constance Ann
Parker, Jean Pegram, Michael Pidgeley, Hinda Rose, Francis Russell,
Julian Treuherz, Selby Whittingham, Simon Wilson, and Simon
Young. I owe especial thanks to Evelyn Joll, who has answered many
tedious questions over many years, and has read and criticized my
typescript with unflagging enthusiasm.

CONTENTS

115040

ABBREVIATIONS

Agnew 1967	Thomas Agnew & Sons, *Turner*, November–December 1967.
Armstrong	Sir Walter Armstrong, *Turner*, 1902.
Bolton	A. T. Bolton, *Portrait of Sir John Soane*, 1927.
B.–J.	Martin Butlin and Evelyn Joll, *The Paintings of J. M. W. Turner*, 1977.
D.N.B.	*Dictionary of National Biography*.
Falk	B. Falk, *Turner the Painter: His Hidden Life*, 1938.
Farington	J. Farington, *Diary*, ed. K. Garlick & A. Macintyre, 1978 ff.
Finberg 1924	A. J. Finberg, *The History of Turner's Liber Studiorum*, 1924.
Finberg 1939	A. J. Finberg, *The Life of J. M. W. Turner, R.A.*, 1939.
Finberg 1953	H. Finberg, 'Turner to Mr Dobree', *Burlington Magazine*, xcv (1953).
Finberg 1961	Second edition of Finberg 1939.
Finley 1972	G. E. Finley, 'J. M. W. Turner and Sir Walter Scott: Iconography of a Tour', *Journal of the Warburg and Courtauld Institutes*, xxxv (1972).
Gage 1968	J. Gage, 'Turner's Academic Friendships: C. L. Eastlake', *Burlington Magazine*, cx (1968).
Gage 1969	J. Gage, *Colour in Turner. Poetry and Truth*, 1969.
Gage 1974	J. Gage, 'Turner and Stourhead: The Making of a Classicist?', *Art Quarterly*, xxxvii,(1974).
Hall	D. Hall, 'The Tabley House Papers', *Walpole Society*, xxxviii (1960–2).
J.W.C.I.	*Journal of the Warburg and Courtauld Institutes*.
Leslie	C. R. Leslie, *Autobiographical Recollections*, 1860.
Lindsay	J. Lindsay, *J. M. W. Turner. A Critical Biography*, 1966.
Miller	T. Miller, *Turner and Girtin's Picturesque Views Sixty Years Since*, 1854.
Monkhouse	C. Monkhouse, 'Some Unpublished Letters by J. M. W. Turner, R.A.', *Magazine of Art*, 1900.

Moore	T. Moore, *Memoirs, Journal and Correspondence*, ed. Russell, 1853–6.
Omer	M. Omer, *Turner and the Poets*, G.L.C. 1975.
Pye–Roget	J. Pye and J. L. Roget, *Notes and Memoranda respecting Turner's Liber Studiorum*, 1879.
Rawlinson (R.)	W. G. Rawlinson, *The Engraved Works of J. M. W. Turner* (2 vols), 1908–13.
Rawlinson 1878	W. G. Rawlinson, *Turner's Liber Studiorum*, 1878.
Rawlinson 1906	W. G. Rawlinson, second edition of Rawlinson, 1878.
Roget	J. L. Roget, *A History of the 'Old' Water-Colour Society*, 1891.
Ruskin, *Works*	J. Ruskin, *Works*, ed. Cook and Wedderburn, 1903–12.
T.B.	British Museum Print Room, Turner Bequest.
T.B.E.	Royal Academy, *Turner 1775–1851*, 1974–5.
T.B.M.	Andrew Wilton, *Turner in the British Museum*, 1975.
T.G.	Tate Gallery.
Thornbury 1862	W. Thornbury, *The Life of J. M. W. Turner, R.A.*, 1862.
Thornbury 1877	W. Thornbury, *The Life and Correspondence of J. M. W. Turner, R.A.*, 1877.
Whitley i	W. T. Whitley, *Art in England, 1800–1820*, 1928.
Woodbridge	K. Woodbridge, *Landscape and Antiquity*, 1970.

CHRONOLOGICAL LIST OF LETTERS

1799/1802

1. — Baron Yarborough to Turner

1800

2. — Turner to William Delamotte

1804

3. 18 April Turner to Ozias Humphry
4. 13 May Lord Auckland to Turner
5. 30 June Turner to Samuel Dobree
6. 1 July Turner to Samuel Dobree
7. 4 July Turner to John Soane

1805

8. 6 April Turner to Sir Richard Colt Hoare
9. ? May Turner to Sir John Fleming Leicester
10. ? May Gilly to William Turner Snr.
11. 23 November Turner to Sir Richard Colt Hoare
12. 14 December Turner to Sir Richard Colt Hoare
13. — Turner to James Girtin

1806

14. 4 March Turner to Sir Richard Colt Hoare
15. 29 March Turner to John Soane
16. 19 April Turner to Sir Richard Colt Hoare
17. 7 August Turner to the Earl of Elgin

1807

18. ? early 1807 Turner to F. C. Lewis
19. ? early 1807 Turner to F. C. Lewis
20. ? 9 February Turner to Sir John Fleming Leicester
21. 14 December Turner to F. C. Lewis

1808

22. 10 June The Earl of Essex to Turner

231. 25 March Turner to J. Alenson
232. 4 May Turner to John Sheepshanks
233. 18 May Turner to Sir David Wilkie
234. 31 May Turner to Thomas Griffith
235. 4 June Turner to Thomas Griffith
236. 24 August E. H. to Turner
237. 27 September Turner to W. Finden
238. 7 October Turner to George Cobb
239. 21 December Turner to Clara Wells (Wheeler)
240. ? Late Turner to George Cobb

1841

241. ? 18 March Turner to Mrs Carrick Moore
242. ? 20 March Turner to Harriet Moore
243. 24 May Turner to Dawson Turner
244. 29 May Turner to an Unknown Correspondent
245. ? Summer Turner to W. F. [?] Collard
246. 22 October Turner to William Miller
247. 3 November The Duke of Wellington to Turner
248. 9 December Turner to Mrs Carrick Moore

1842

249. 28 May Turner to Clara Wells (Wheeler)
250. 24 June Turner to William Miller
251. 9 July Turner to William Miller
252. 1 August Turner to Emma Wells
253. 5 November Turner to William Miller
254. ? 25 November Turner to Samuel Rogers
255. 29 November Turner to Dawson Turner
256. 10 December Turner to William Miller
257. — Turner to H. W. Pickersgill

1843

258. 12 February Turner to Elhanan Bicknell
259. ? March Turner to Richard Westmacott
260. 11 May Turner to Edwin Bullock
261. 23 November Turner to an Unknown Correspondent
262. 30 November Turner to William Buckland

1844

263.	? early	Turner to Clara Wells (Wheeler)
264.	1/2 February	Turner to Thomas Griffith
265.	13 February	Turner to Clara Wells (Wheeler)
266.	1 May	Turner to Henry Elliott
267.	1 June	Turner to Dawson Turner
268.	4 June	Turner to Dawson Turner
269.	? late July	Turner to Mrs Carrick Moore
270.	7 October	Turner to William Wethered
271.	? October	Turner to James Astbury Hammersley
272.	26 November	Turner to Dawson Turner
273.	29 November	Turner to Francis McCracken
274.	3 December	Turner to William Wethered
275.	28 December	Turner to F. H. Fawkes
276.	? December	Turner to William Wethered
277.	—	Turner to Harriet Moore

1845

278.	22 January	Turner to Charles Ellis
279.	31 January	Turner to Elhanan Bicknell
280.	27 February	Turner to J. J. Ruskin
281.	4 May	Turner to John Murray III
282.	15 May	Turner to J. J. Ruskin
283.	16 May	Turner to Dawson Turner
284.	22 May	Turner to Francis McCracken
285.	15 July	Turner to Sarah Rogers
286.	31 July	Turner to [?] William Wethered
287.	2 August	Turner to Richard Ford
288.	16 August	Turner to James Lenox
289.	November	Turner to J. J. Ruskin
290.	4 December	Turner to [?] Dawson Turner
291.	—	Turner to [?] J. Hogarth
292.	—	Turner to Mrs. Carrick Moore

1846

293.	5 January	Turner to J. J. Ruskin
294.	18 March	Turner to Adela Geddes
295.	24 March	Turner to Lord Robertson
296.	14 June	Turner to Francis McCracken
297.	14 June	Turner to William Wethered

298. 29 August Turner to William Wethered
299. 23 October Turner to William Wethered
300. ? October Turner to John Prescott Knight
301. 3 December Turner to John Ruskin
302. 26 December Turner to F. H. Fawkes

1847

303. 9 January Turner to Harriet Moore
304. ?early February Turner to J. J. Ruskin
305. 9 June Turner to [?] Jacob Bell
306. 16 June Turner to Harriet Moore
307. 27 December Turner to F. H. Fawkes

1848

308. 13 January Turner to John Ruskin
309. 11 February Turner to Elhanan Bicknell
310. 24 June Turner to J. J. Ruskin
311. 5 November Turner to John Ruskin
312. November Turner to John Ruskin
313. 22 December Turner to John Ruskin
314. — Turner to Ignaz Moscheles

1849

315. 24 December Turner to F. H. Fawkes

1850

316. 14 April George Jones to Turner
317. ? May Turner to Charles Stokes
318. 27 December Turner to F. H. Fawkes
319. 30 December Turner to David Roberts

1851

320. 1 January Turner to Lady Eastlake
321. 1 January Turner to George Jones
322. 30 January Turner to J. J. Ruskin
323. 31 January Turner to F. H. Fawkes
324. 7 May Turner to Thomas Griffith
325. 19 May Turner to Thomas Griffith
326. 29 May Turner to Thomas Griffith

APPENDIX I · UNDATED LETTERS

LIST OF PLATES

INTRODUCTION

English Romantic painters are among the best English letter-writers of the early nineteenth century, and in the company of Lawrence, Constable, Palmer, and John Sell Cotman, J. M. W. Turner as a correspondent does not cut an impressive figure. But there are many reasons for gathering and publishing his letters, not least that such a collection will help to dispel the impression still left by his earliest biographers, that Turner was an unsocial being, that he wrote infrequently and reluctantly, and that he showed a habitual distrust of, and incapacity with, words. 'He wrote few letters', wrote an obituarist, 'and these were, like his conversation, abrupt, and referred little to art.'[1] Thornbury quoted this assessment in the first full-length biography of Turner (1862), although he also printed a score of letters, some of them very substantial, and entitled his second (1877) edition, which added nearly as many again, *Life and Correspondence of J. M. W. Turner*. Other biographers and reminiscers referred to Turner's reluctance to lend himself to the nineteenth-century fashion for autograph collecting (reflected in the missing signatures of Letters 202, 301);[2] and although a handful of further letters appeared with successive biographical treatments—notably the series to Holworthy published by Monkhouse in 1900—they were generally introduced for their flavour rather than for their documentary value, until in 1939 Finberg printed some fifty new letters, most of which he had collected himself. But Finberg's wish to avoid an interpretation of Turner's character—he spoke of his *Life* as a 'Chronicle-biography'—made him oddly insensitive to what the letters can tell us, and the nineteenth-century view of Turner's helplessness with language has persisted.[3] G. W. Cox put this view most forcibly in the 1880s:

[1] Lovell Reeve, *Literary Gazette* (1851), p. 924.

[2] T. Miller, *Turner and Girtin's Picturesque Views* (1854), p. xliii; A. MacGeorge, *W. L. Leitch* (1884), pp. 81–2; T. S. Cooper, *My Life*, i (1890), 317. It was a fashion which has, for example, deprived us of the opportunity of including something of Turner's interesting relationship with Mary Somerville, for she simply preserved a specimen signature cut from one of his letters to her (Somerville Papers in the collection of Lady Alice Fairfax-Lucy, deposited at the Bodleian Library, Oxford).

[3] The earlier commentators who allude most forcibly to this are P. Cunningham, in J. Burnet, *Turner and His Works* (1852), p. 33; P. J. Hamerton, *Life of J. M. W. Turner* (1879), p. 144; W. J. Stillman, *The Nation* (New York), xxviii (1879), 218. A recent and more moderate restatement of this view is in Royal Academy, *Turner 1775–1851* (1974/5), p. 9.

[Turner] spoke little and wrote little even in English; in any other language he neither wrote nor spoke at all. He visited the most lovely and the most magnificent scenes in Europe; but his sketches are the only records of his thoughts. He kept no journal, he sent no letters to his friends, or none which contained anything more than references to passing incidents. He could not spell, and his strange ignorance of common things might justify the conclusion that schooling had been entirely thrown away upon him, until we see that it had given him that insight into the history of his own land and of other countries, and that sense of geography, without which he might have lacked all stimulus of curiosity, and have stagnated in contented obscurity all his days.[1]

As the letters and the diary published here abundantly show, it was not simply a geographical stimulus that Turner required and sought: and they should suggest that on occasion he could use words to considerable effect.

And yet by the standards of his century, Turner's correspondence is indeed meagre. At least three collections of it are known to have been destroyed: the letters to Henry Scott Trimmer; those to Walter Fawkes, and those to Sophia Booth, and the loss is a considerable one.[2] Although I have not managed to trace many letters which must be scattered through the autograph albums of private collectors, it seems unlikely that any extensive series remains to be uncovered. I have thought it worth while to list some of the letters recorded in sale catalogues, even if their text is not given, in the hope that they may come to light in the future, and be fitted into the sequence established here. Although I have tried to preserve most of Turner's idiosyncrasies, I have felt free to modify spelling and punctuation where the sense seemed to require it. Words in [] are interpolations of my own. Reference is made only to the earliest known place of publication, even where a letter has been reprinted more recently. For convenience of reference, I have most often cited the catalogue of the Turner Bicentenary Exhibition at the Royal Academy, 1974/5 (T.B.E.), which brought together the largest number of oils and watercolours in one place.

There are three types of communication by Turner which I have

[1] *Edinburgh Review*, cli (1880), 45 f.

[2] Thornbury 1877, p. 225, stated that Trimmer's son burned all but one (Letter 56) of Turner's letters to his father. Monkhouse (*Turner*, 1879, p. 91) denied that letters to Trimmer had been destroyed, and Armstrong (p. 92) suggested that Thornbury was confusing Trimmer with Walter Fawkes, whose letters from Turner were destroyed after his death in 1825. There seems to be no good reason to doubt Thornbury on this: he was given the benefit of much authentic information from the young Trimmer. W. Bartlett, the surgeon who attended Turner in his last hours, wrote to Ruskin in 1857: 'I was grieved after [Turner's] death to find Mrs Booth burning a clothes' basket full of letters from him received, many of them poetical effusions' (Bembridge, Ruskin MS. 54/C).

not thought it worth while to include: those with, or on, corrected proofs of engravings, which have little interest apart from the proofs themselves, the lists of picture-titles and captions which Turner sent to the Secretary of the Royal Academy to be printed in the catalogues, and a very few letters which seem to have no interest, either for their content, or for their associations. Otherwise I have cast my net very wide, and have included some letters which at first sight may seem to be too trivial to be worth printing. This is especially so with the handful of surviving letters to Turner; but I felt that in every case they provided a peg on which to hang some discussion of Turner's relationship with patrons and friends, and it is with this in mind that I have made the Biographical Index of Correspondents as full as I could. The tone of even the briefest acceptance or refusal of an invitation may tell us something of Turner's feelings for his would-be host or hostess, and this is particularly worth establishing in the case of a personality who has had the reputation of being a recluse.

In this sense the pious memoir by George Jones, which has been used by several biographers since Thornbury, but which has never been published as a whole until now, is a perfect complement to the letters, for these present that side of Turner's character which was seen at meetings of the Royal Academy and at picnics and dinner-parties: the more relaxed, conciliatory, outward-going, sometimes sentimental side which has been so consistently underestimated by Turner's biographers. In the most direct way, too, this collection establishes some new landmarks in Turner's career, notably the tour in North Wales in the summer of 1792. The diary of this tour is unique, and its authenticity has been doubted. This was Turner's first independent tour and he took not sketchbooks, but a notebook and separate sheets of drawing-paper, so he kept a far fuller diary than he was ever to do later on. Yet the handwriting and the tone of many remarks is close to those in the *Matlock* sketchbook of two years later (T.B.XIX), and there is at least one unambiguous reference (p. 14) to a drawing in the Turner Bequest in the British Museum, which includes, perhaps rather surprisingly for this seventeen-year-old artist, a substantial inscription in Latin. The letters also document three hitherto unrecorded Continental tours: 1837 (unspecified), 1839 (Belgium), and 1843 (North Italy and the Tyrol), and they give a firmer chronology for Turner's activities at Petworth. The Letter of 1846 about the duties of Acting P.R.A. which so worried Turner (No. 302), provides a rather more convincing explanation of the painter's physical decline than the simple loss of teeth to which it has been attributed.[1]

[1] Finberg 1961, p. 416.

But the correspondence is far more valuable than this. It demonstrates what Thornbury discovered, but what more recent biographers (with the exception of Lindsay) have been reluctant to concede: that Turner was at home in a wide segment of the professional and intellectual society of his day—the connection with architects and geologists is especially striking—and that he was willing and able to draw on his experiences in this society. '[The] imagination of the artist dwells *enthroned* in his own recess,' Turner told his students at the Academy in 1818, '[and] must be incomprehensible as from darkness.'[1] But we now know what a wide range of stimuli Turner's imagination was exposed to; and we know, from the 1792 diary, that his mind was alert to history and to contemporary social conditions even before his art was able to use them. There is a remarkable congruence of style between the relentless whimsicality of some of the letters, and the imagery of many paintings and watercolours. Turner appears in this collection as a thoroughly integrated personality, and it would not be too fanciful to suggest that his liberties with English, which make reading him a sometimes taxing experience, are of the same order as his liberties with the traditional structures of landscape. Turner was possessed of an astonishing singleness of mind, but it was a mind (as Constable recognized) of equally astonishing breadth. Perhaps in the end it is the written record that will stimulate a more comprehensive understanding of Turner's art.

J. G.

Mannington, 23 April 1975

[1] Gage 1969, p. 209.

RECOLLECTIONS OF J. M. W. TURNER
BY GEORGE JONES[1]

Turner, like Chantrey, was exemplary in his duties as Councillor, Visitor, or Auditor to the Royal Academy; he was always zealous and attentive, he attended all the General Meetings, and never made his excursions abroad until the business of the Academy was suspended by Vacation.

At the social meetings of the Members, unfrequent as they were, he never failed to appear; at the great dinner before the opening of the Exhibition and at the Exhibitors' Dinner at its close he invariably attended, deeming the latter a most important opportunity of getting acquainted with the artists likely to become members of the Institution.

The two artists were fond of amusement, cheerful living, and hilarity. Chantrey was hospitable to excess, Turner loved to participate, and I believe would have followed the example of his friend, if his domestic circumstances had enabled him to do so, for he often expressed to me his regret at his inability to spend a portion of his gains in receiving his friends; but certainly his early life, his ignorance of good domestic arrangements and long habit of living with his aged father, and after his parents' death his own solitary mode of life, prevented him from indulging the kindly feelings of his heart.

He was always ready to contribute his share in forming any friendly or professional party, and several times defrayed the whole expense without the company being aware of his intention;[2] he was often derided on his close and careful habits and always acquiesced in, and indulged the joke; he never appeared displeased but when he discovered an unbecoming desire to pry into his private affairs, which was often done, even by persons who would not like similar curiosity, and who did not recollect that the first duty of friends is to aid, not oppose, the inclination of each other, if that inclination be not vicious.

Probably my great intimacy with him arose from his confidence (that I had his confidence is proved by his appointing me his Executor

[1] Edited from the autograph in the Ashmolean Museum, and from the copy at Bembridge (Ruskin MS. 54/A). Jones conceived of these Recollections, composed between *c.* 1857 and 1863, as a continuation of his published *Recollections of Sir Francis Chantrey* (1849), and the present edition omits passages referring exclusively to Chantrey or to the Royal Academy, as well as some repetitions.

[2] Examples of this are given by Leslie, i. 203; Thornbury 1877, p. 289.

in 1831 without my knowledge)[1] that I had no desire to know his secrets nor control his actions to suggest improvements or alter his course of life. He never interfered with nor condemned the habits of others; if he thought them incorrect, he was silent on the subject, and if any excuse or palliation could be made, he was always ready to accept, adopt and promulgate the excuse. I never heard him speak ill of any one, and if ever he appeared morose, it was when persons were unjustly endeavouring to cajole or defraud him, which was too often the case, when his works became popular. He was rough in his manner to suppliants, yet I have known him give his half-crown, where another would have offered a penny.

He was anxious to allay anger and bitter controversy: often I have heard him in subdued tones try to persuade the excited to moderation. He would do this by going behind the speaker and by a touch or word soothe an acrimonious tone by his gentleness. He was unable to speak but would by his attempt to express himself delay a question until it received more serious and calm consideration. It should be remembered that in early life his education had been defective, his associates of a class unlikely to elevate the mind, his reading, nothing. He had no one to impress upon him that disdain of mercenary feeling which ought to accompany genius. He never in early life felt the tendered hand of generous friendship: the hands extended to him sought to profit by his talents at the smallest expense possible; he encountered the extortion of his time and work, but discovered that he was unjustly used to fill the purses of others rather than his own. He became suspicious and so sensitive that he at length dreaded the motives of all by whom he was approached on business. He desired to be wealthy and took every honourable means to be so, and was indefatigable to become independent of the world.

However great Turner's desire to accumulate money, he never betrayed the slightest envy of the wealth or success of others; he never disparaged the works of his contemporaries, nor ever sought to supersede them in obtaining employment. He seemed willing at all times to enter the lists of contest in any department of art, never with hostility, but always with jocularity.

Turner's tenderness towards his friends was almost womanly; to be ill was to secure constant attention and solicitude from him towards the sufferer. When on a visit to Lord Egremont at Petworth with Turner, I hurt my leg, his anxiety to procure for me every attendance and convenience was like the attention of a parent to a child; his application to the house-keeper, butler, and gardener for my comfort and gratification was unremitted. At a later period when Turner was

[1] Thornbury 1877, pp. 623, 624.

at Petworth,[1] Lord Egremont said to him, 'I have written to Jones to join us but he won't come'. Turner felt this remark as important to me and wrote instantly to tell me of the generous Earl's observation. Of course I did not hesitate, but went. Fortunately I did so, for in three weeks the kind and hospitable nobleman ceased to be.

When the son of Charles Turner, the late eminent engraver, was dangerously ill, J. M. W. Turner went constantly to enquire after the health of the youth and of the family; he never left his name, and this solicitude was not known to the parents until after the son's death the servant then reported that a little short gentleman of odd manners had called every evening to know the state of the sufferer.[2] Such was the character of this mis-appreciated man.

I well remember, the morning of Chantrey's death, that he came to the house of our deceased friend. He asked for me; I went to him; he wrung my hand, tears streamed from his eyes, and he rushed from the house without uttering a word.

Turner's executors discovered that the rents for houses in Harley Street had not been paid during some years; in application to the lawyer, the answer was that 'Mr Turner would not allow him to distrain'. I know that in one instance he returned a bond for £500, which was never again asked for or paid.[3]

Mr Rogers gave him a commission to illustrate his 'Pleasures of Memory' and his 'Italy'. Turner was so satisfied with the elegant way the works were published that he would only receive five guineas a piece for the loan of the drawings.[4] Campbell, the poet, desired Turner to make a set of drawings for an edition of his works, for which Campbell's circumstances did not allow him to pay, and he had the honesty to confess that it would be inconvenient for him to discharge the debt; on which Turner with kind sympathy told the poet to return the drawings and he should be satisfied. These drawings Turner afterwards gave to a friend.[5]

[1] October 1837. Egremont died on 11 Nov.
[2] See Letter 199.
[3] F. Goodall, *Reminiscences*, pp. 43 f.
[4] On Rogers's commission, cf. below, p. 278.
[5] Turner's twenty drawings (not twenty-four, as in Rawlinson i, p. lix) are on loan to the National Gallery of Scotland from the Fergusson collection. Campbell's own view of the transaction was very different: he claimed to have paid Turner 500 gns. for the drawings, which the artist bought back for 200 gns. (W. Beattie, *Life and Letters of Thomas Campbell* (1849), iii. 237 f.). See also Campbell's interview with Cyrus Redding in the early 1840s (Finberg 1961, p. 391). Redding, however agreed with Jones's interpretation. Another, completely different account of the commission was given by the son of the engraver of some of the vignettes, Edward Goodall, who claimed that it came from the publisher, Moxon, and Goodall, who agreed to give Turner £30 for each drawing. The engraver ran into difficulties, and Turner was finally pursuaded to give up the commission. But he eventually made the drawings and charged only £5

He was always willing to lend or give me any money, but always said when I complained of want of wealth 'don't wish for money, you will be none the happier'. I never needed his assistance, but I am certain no one would have given it to me more willingly. I always found him kind and much more inclined to endure than resent.

When Turner was very young he went to see Angerstein's pictures. Angerstein came into the room while the young painter was looking at the Sea Port by Claude, and spoke to him. Turner was awkward, agitated, and burst into tears. Mr Angerstein enquired the cause and pressed for an answer, when Turner said passionately, 'Because I shall never be able to paint any thing like that picture'.[1]

Persons who admired his early style of art may be pleased to know that he never would have departed from that style if he had been moderately encouraged in painting large pictures; that he preferred it is proved by his leaving two pictures painted at an early time to the National Gallery on the condition that they should be hung between two by Claude,[2] which condition has been complied with in fact, but not in the spirit. His latter pictures were too gorgeous for public approbation, yet the observer of nature will discover that at the early morn and close of day, luminous and inimitable brilliancy may be seen, brightness that even Turner could not reach, though he so zealously sought to produce it. His latter style, though possibly extravagant, was only excess in development of nature; he exaggerated what he saw, but the foundation was truth; the vivid and warm colouring of nature he painted with the most forcible colors, the lines [?] of nature and atmosphere no pigments can give, but Turner went further than any artist of the past or present age in diffusing light and air over his pictures.

I once told him that if he did not paint some cool and grey pictures the world would say that he could not do so. He said, 'I will prove to the contrary', and he sent, I think, five or seven exquisitely cool pictures to the Exhibition that year.[3]

He loved to paint the brilliant hues of the sun, and that luminary shone upon [him] as he expired.

each for the use of them (Rawlinson i, pp. lix–lx). This version is probably a confusion with the story of the vignettes for Rogers, on which Edward Goodall was also employed.

[1] Possibly N.G. 5 or 30, but probably 14: *The Embarkation of the Queen of Sheba* (see next note).

[2] Thornbury, 1877, p. 622. *Dido Building Carthage* (B.–J. No. 131) and *Sun Rising through Vapour* (B.–J. No. 69) were to hang next to Claude's *Embarkation of the Queen of Sheba* (N.G. 14) and *The Mill (Marriage of Isaac and Rebecca)* (N.G. 12).

[3] 1844 seems the most likely year: Turner showed seven oils, most of them cool, following *Walhalla* (B.–J. No. 401), *The Sun of Venice* (B.–J. No. 402), *Light and Colour* (B.–J. No. 405) and *St. Benedetto* (B.–J. No. 406), all rather hot pictures, in 1843.

Turner thought well of his own works, yet had no love of flattery, and never flattered any one, rich or poor, patron or painter. In the course of my long intimacy with him, I never knew what he thought of my works.[1] At the time that the Members of the Royal Academy touched on their pictures in the rooms before the Exhibition opened, Turner took great delight in working with and meeting his brother members. He willingly gave any hints, and in many instances behaved most generously. He, when arranger, took down one of his own pictures to give a better place to a picture by the late Mr Bird, before that artist was a member of the Academy.[2] 'The View of Venice with Canaletti painting'[3] hung at the Royal Academy next to a picture of mine[4] which had a very blue sky. He joked with me about it and threatened that if I did not alter it he would put down my bright color, which he was soon able to do by [*adding blue to his own*][5] his magical contrasts in his own picture, and laughed at his exploit, and then went to work at some other picture. I enjoyed the joke and resolved to imitate it, and introduced a great deal more white into my sky, which made his look much too blue. The ensuing day, he saw what I had done, laughed heartily, slapped my back and said I might enjoy the victory. I recommended Mr Vernon to buy the picture of Turner's for 200 guineas, which was the commencement of his large prices, for he said to me, 'Well, if they will have such scraps instead of important pictures, they must pay for them'.[6]

Another instance of Turner's friendly contests in art arose from his asking me what I intended to paint for the ensuing Exhibition. I told him that I had chosen the delivery of Shadrach, Meshech and Abednego from the Fiery Furnace. 'A good subject, I will paint it also, what size do you propose?' Kitcat. 'Well, upright or lengthway?' Upright. 'Well, I'll paint it so. Have you ordered your panel?' No, I shall order it tomorrow. 'Order two and desire one to be sent to me; and mind, I never will come into your room without inquiring what is on the easel, that I may not see it'. Both pictures were painted and exhibited; our brother Academicians thought that Turner had secretly taken an advantage of me and were surprised at our mutual

[1] Sentence deleted by Jones.

[2] Edward Bird (1772–1819) first exhibited at the Royal Academy in 1809 and became an Academician in 1815. Turner wrote some disparaging verses about his popular genre paintings in T.B.CXI p. 65a. A pencil portrait of Turner by Bird is in the British Museum Print Room.

[3] *Bridge of Sighs, Ducal Palace and Custom House, Venice: Canaletti Painting* (R.A. 1833). Bought by Robert Vernon and presented to the National Galley in 1847 (q.v. in Biographical Index). (B.J. No. 349).

[4] *Ghent* (R.A. 1833 (101)), present whereabouts unknown.

[5] Deleted by Jones.

[6] See also Letter 261.

contentment, little suspecting our previous friendly arrangement. They very justly gave his picture a much superior position to mine, but he used his utmost endeavours to get my work changed to the place his occupied and his placed where mine hung, as they were exactly the same size.[1]

Turner was sensible of, and grateful for any good service done to the Academy, and always wished such services to be acknowledged. When Sir Robert Smirke resigned the office of Treasurer, which he had filled with admirable ability and success, Turner resisted the acceptance of that resignation and delayed any proceeding until the members felt conscious that the greatest compliment that could be paid to Sir Robert was, unanimously, to request him to remain, which he did for several succeeding years.[2]

Since Turner's death the public and the Press have been fair to his talents, but his eccentricities were too delightful to the latter to pass without a sarcasm. Even his house in Queen Anne Street was a subject for sarcasm, and of comparison with the resident of the late James Barry in Castle Street, yet the door of his dwelling was the best architecture in the street, and the area and door-step were clean although the windows were neglected and the outside of the house had long been guiltless of paint.

Turner had the homage of all the best artists in Britain, particularly for his early works; and at the later period and in his more eccentric style he excited the wonder of all, if not the approbation; and such effects of light and color had never been produced in water or oil. His pictures always were placed in the best situations in the Royal Academy, and other Exhibitors yielded with content to his superior genius.

Turner had always an inclination towards classical subjects, and at an early period he attempted with the aid of his kind friend the Rev. Mr Trimmer to attain the classic languages, but the time and patience required for such study were beyond the power of the painter always assiduous and eager in his art.[3]

Turner was not a man able to develope his opinion, and probably those opinions were very incomplete, but they always tended towards good in act and art; in the latter his contemporaries always listened to him with respect, but in the former his judgement was too often

[1] Both Jones's *The Nebuchadnezzar the King was Astonied* (R.A. 1832 (256)) and Turner's *Then Nebuchadnezzar Came Near to the Mouth of the Burning Fiery Furnace* (R.A. 1832 (355)) are now in the Tate Gallery (cf. B.–J. No. 346).

[2] Sir Robert Smirke was Academy Treasurer from 1820 to 1850.

[3] For Turner's Latin, cf. below p. 14 and Letter 17. For Trimmer's attempt to teach Turner Greek in exchange for painting lessons, Thornbury 1877, p. 225, and cf. T.B. CLXIII, pp. 3a, 13.

doubted, when it might have been of infinite influence to the Institution he so much loved and served. At times it was difficult to know what Turner meant, but the indistinctness of his thoughts, like the indistinctness of his pictures, always indicated either greatness or beauty. Unfortunately there are persons by whom these opinions may be derided, but they will be felt as true by the few, who were intimate with J. M. W. Turner.

Turner's thoughts were deeper than ordinary men can penetrate and much deeper than he could at any time describe. Chantrey thought so, and sometimes detected his notion, and said that he and Wilkie often conceived that which they could not express. It is true that Turner did not give away his works, because at an early period in his life he learned that works bestowed in that manner were never appreciated, as they were considered as an equivalent for cash or as an investment.

During twenty-five years he indulged the pleasing hope that he should leave a testimony of his good will, and his compassion for unfortunate artists. To his intimate friends he constantly talked of the best mode of leaving property for the use of the unsuccessful; he wished his survivors to employ his property in building houses for the above named purpose; he did not like to call them alms houses, but had selected the denomination of 'Turner's Gift'. His benevolence was conspicuous whenever he was tried, though he often used terms of harshness in which his feelings had no part; but he hated idleness, extravagance and presumption. He thought that artists had not time for the duties and pleasures of domestic festivity, yet believed that they should often meet to strengthen fraternal feeling without much expense, therefore was zealous in support of the Academy Club,[1] tried to establish an Artists' Dinner at the Athenaeum,[2] and left £50 in his will to be expended annually on a dinner for the members on the anniversary of his birthday, the 23 April.

I have not stated that Turner was the most placable person when applied to that I ever met or became acquainted with. His distant relative Chas. Turner A.R.A. and he differed extremely about some engravings, which occasioned a long separation, but when Chas. Turner became an Associate of the Royal Academy and expressed a wish to renew his intimacy with the great painter, this latter, when I asked him to offer his hand in friendship, joyfully complied, and the two artists remained intimate the rest of their lives.[3]

A similar occurrence took place between J. M. W. Turner and

[1] Turner joined the Academy Club on his election as A.R.A. in 1799 (Finberg 1961 pp. 63, 432).

[2] Turner was an original member of the Athenaeum Club in 1824.

[3] See below, pp. 290.

Andrew Robertson, the miniature painter, both zealous in the advancement of the Artists' General Benevolent Institution, yet they disagreed about the management. The former was, or nearly so, the founder of that charity, however the instant that I expressed to Turner Robertson's regret that any estrangement had taken place, he said, 'Let us meet'. They did so, and all the past dissatisfaction was forgotten. Turner's heart was replete with charitable feeling, though his manner was not inviting to the prosperous or the poor.[1]

It has been said that Turner was unwilling to give advice and jealous of any participation in his knowledge. Such an assertion is very unjust; I have known many examples to the contrary: the following is one told me by Maclise.

When Maclise exhibited his picture 'The Sacrifice of Noah after the Deluge'[2] in 1847, Turner had a picture of the founding of the Wellington statue[3] which hung next to the above-named work. When these artists were touching their pictures preparatory to opening the Exhibition to the public, Turner, always a friend to talent, suggested to Maclise an alteration in his picture with the following colloquy:

Turner: 'I wish Maclise that you would alter that lamb in the foreground, but you won't'.

Maclise: 'Well, what shall I do?'

Turner: 'Make it darker behind to bring the lamb out, but you won't'.

Maclise: 'Yes I will'.

Turner: 'No you won't'.

Maclise: 'But I will'.

Turner: 'No you won't'.

Maclise did as Turner proposed and asked his neighbour if that would do.

Turner (stepping back to look at it): 'It is better, but not right'.

He then went up to the picture, took Maclise's brush, accomplished his wish and improved the effect. He also introduced a portion of a rainbow, or reflected rainbow, much to the satisfaction of Maclise, and his work remains untouched.

On the same occasion, one of the members came to Turner, and said, 'Why, Turner, you have but one picture here this year.' Turner replied, 'Yes, you will have less next year', doubtless alluding to his declining health.

[1] See Letter 69. On Robertson's difference with Turner, Thornbury 1877, pp. 355 f., and Finberg 1961, p. 329. For Robertson's early (1803) impression of Turner as a 'narrow-minded, nostrum sort of fellow', *Letters and Papers of Andrew Robertson*, ed. E. Robertson, 2nd edn. (1897), p. 91.

[2] *Noah's Sacrifice* (R.A. 1847 (178)), Leeds City Art Gallery (Arts Council, *D. Maclise*, 1972, No. 98 (repr.)).

[3] *The Hero of a Hundred Fights* (R.A. 1847 (180), B.–J. No. 427).

Witherington had a picture of a cornfield in the Exhibition, which he thought unsatisfactory in its effect, and on one of the Varnishing Days, he asked W. Hilton how he could improve it. Hilton said, 'I will fetch a man to tell you', and brought Turner to the picture, who after looking at it for a short time, mixed on his own palette some very bright color, which he spread on the centre of the ground. Then, taking some rich and dark tints, [he] made a long shadow in front, which completed the chiaroscuro, and only required Witherington's careful hand to finish.[1]

The last year that Turner attended on the Touching Days, he had not any picture upon the walls. He was much struck and pleased with Maclise's 'Caxton's Press';[2] he looked at, and talked of it with Maclise, then called for a seat, and sat with the painter expressing his pleasure by his odd and jocose remarks on passages of that noble and generous artist's admirable skill.

During the last year of Turner's life I had in hand a picture seven feet long of 'The Battle of Hyderabad', which I could not well move from an upper room in the house. Turner was too infirm to get up the stairs to see it, and [although] he never before appeared vexed with me, yet on this occasion he did so; but at that time it was almost impossible to move the canvas, and I hoped to see him again. My hope was fallacious and I lost his invaluable advice. He constantly gave advice to Chantrey and Thomson and others, whose good sense taught them to ask it, and it was often volunteered.

Turner was a holder of Bank Stock at the time of the reduction of interest from 5% to 4. I inquired of Mr Turner what he thought of the reduction of Bank Interest. He replied, 'I like 5% for my money and the quartern loaf at a shilling. Ask the poor man what he likes: he would say, "I like the quartern loaf at 8 pence & Interest at 4%."'

Turner seemed to have pleasure in supporting carefulness in expenditure in all instances, much more in the interest of public bodies, and his individual friends, than for his own particular profit.

Mystical and obscure were the hints that Turner often put forward respecting the right of recompense, but no one seemed to care less about it than himself. When I was working with him at our respective pictures in St James' Palace, he often joked about what we were to be paid for about a fortnight's work after the pictures were delivered,

[1] Cornfields and Harvest scenes by W. F. Witherington (1785–1865) were shown at the Academy in 1831, 1834, 1840, 1846, and 1848. T. S. Cooper (*My Life* (1890) ii. 2–3) relates this episode to about 1846. Witherington gave the story to Jones on 24 May 1863.

[2] *Caxton's Printing Office* (R.A. 1851 (67)). Knebworth House (Arts Council, *Maclise* 1972 No. 100 (repr.)).

and quoted the well-known jest on the Calendar: 'Give us back our eleven days', and so the joke ended.[1]

Turner received a great deal of money, but I never heard of his asking for any due to him. At the Royal Academy it was so difficult to get him to attend and take the sums due to him for duties performed in that Institution, that while I was Keeper the Treasurer consented to pay Turner's earnings to me, and receive my receipt for the same, that the accounts might be made up; and I kept the money until I found an opportunity of making Turner take it.

When Mrs Wells, the widow of his late friend, called to pay Turner some money that had been borrowed, he put it back into her hand, and told her never to bring him any more. The grateful debtor was overwhelmed by this act of generosity; when she looked up to express her thanks, the liberal donor was gone.

When we dined out, I always insisted on paying half the coach hire, but when we went to parties in the country, he always ordered the fly, and never would say what it cost, so I used to put a half sovereign into his waistcoat pocket, which was very rarely half the expense.

That he loved to save and accumulate for one great object is true. That [that] great object was frustrated by a nicety in law (which I feel sure Turner never knew of) seems to me the most inequitable act I ever heard of, considering that no human being doubts Turner's intentions declared in his will.[2]

[1] Turner began work on his *Battle of Trafalgar* (B.-J. No. 252) for the King's Levée Room at St. James's Palace in December 1823 (see Letter 101). The painting was on view there by 20 May 1824 (Mrs. Arbuthnot, *Journal*, ed. Bamford and Wellington (1950), i. 313), and there were government complaints about it by 27 May (B. R. Haydon, *Diary*, ii. 487). For the Duke of Clarence's objections to details while it was being finished, see the letter of 21 Dec. 1824 in *Walpole Society* XXXVIII (1960–2), 109–10. In July 1825 Turner was still uncertain of the fee he should ask (see Letter 111), but he was finally paid 500 guineas, the last instalment of £25 on 23 June 1826 (National Portrait Gallery, Stanton Album fo. 2). For Jones's pictures, *The Battle of Vittoria* and *The Battle of Waterloo*, O. Millar, *The Later Georgian Pictures in the Collection of Her Majesty the Queen* (1969), Nos. 865, 866, and p. xxxii.

[2] See Finberg 1961, ch. XXXVII.

DIARY OF A TOUR IN PART OF WALES

1792[1]

Sunday July 22. 92 Left Londn 6 in Eveg reached Oxford at 3 in the morn$_{gg}$—which was delightfully clear & the stillness of the scene gave additional solemnity to the venerable assemblage of Gothic buildings in this City. Passed thro' Woodstock to Chapel house passed the once famed Waterworks at Ens[tone] called Henrietta's—they were constructed in 1636 by [] Esq—passed thro' Chippen Norton a neat market town wth several good houses principally of stone—thence to Morton in Marsh ab. 88 Ms. from London—took Chaise from thence to Cheltenham 23 Ms.—passed at about 3 Miles distance a spacious Mansion not finished—belongg to Warren Hastings[2]—Passed Stowe in the Wold—thro' a fine fertile Country to Cheltenham—but the prospect much hurt by the perpetual range of stone walls instead of hedges—the view at Dowdeswell abt 4 Ms. before we reach Cheltenham—is truly magnificent. The Church & Village in the foreground —& the Luxuriant hills of Cheltenham & Malvern on either side— wth those of Wales in the distance—intervening—make a Complete picture.

Cheltenham is a clean small place—the avenue to the Wells from the Church—is a strait line formed between two rows of Trees & terminated by the house of Dr Walters. There is a formality in the whole scene that is not pleasant tho' the surrounding hills & Country must be allowed to be luxuriant.

Tuesday 24th Went over to Mr Capel's at Prestbury & returned by Mr Bagot's house on the hill a long & sultry Walk—went to the play in Evg—School for Scandal[3]—went on Wednesday morning to breakfast wth Mr Capel—& rode after to Sudely Castle ab. 6Ms. This charming ruin is $\frac{1}{2}$ Mile from Whinchcomb. The Chapel is particularly beautiful & overgrown wth ivy—in a very picturesque form —Within lies buried Catherine Parr. Her tomb was open'd about []ys since & the body found perfect—it was open'd again about a

1 Edited from the autograph in the Pierpont Morgan Library, New York. Turner's own spelling and punctuation have generally been retained. Nothing is known of his travelling companion, and very few of the sketches he records in the diary have been traced. For the fashion for tours in North Wales in the later eighteenth century: E. Moir, *The Discovery of Britain* (1964), pp. 129–38.

2 Daylesford House, built by S. P. Cockerell between 1790 and 1796.

3 By R. B. Sheridan, first produced in 1777.

Month since—& the body was then laid carefully in a large Stone trunk or Coffin—w^ch had contained some other bones—of the ruin— the Quadrangle seems by the date—over a door to have been cased or repaired in 1614—the Gothic windows at the end of the State room are remarkably lofty—but in danger of falling—they are much decayed & have a fine venerable appearance (vide Archeologia)[1]. The weather exceding rainy & bad prevented our Stay—being so long —as it should—to have viewed all this noble ruin—Dined with Mr Capel & returned in Ev^g to Cheltenham—set off

Thursday Morn^g & past 11 to Tewkesbury—w^th Mr Holloway—ride fine—Malvern hills full in View—in a fine range of Grey objects[2]— staid at Tewkesbury till Friday 11—set off in Coach for Worcester 16 Ms.—Dined & Slept there—& went on Saturday Morning at 6 for Shrewsbury—breakfasted at Kidderminster—Dined at Bridgenorth & arrived at Shrewsbury ab. 8 in Ev^g—

Wet on Sunday—staid there till Monday ½ past 1—fine day—the road to Kynaston Cave 9 Ms. very pleasant—the Brythin [*Breidden*] Hills &c full in view on one side & on the other the Wrekin—On the most conspicuous of the former—an Obelisk is erected to Com-memorate the victory of L^d Rodney[3]—it is therefore commonly called Rodney's hill—The view from Kynaston Cave & surrounding rocks is rich & extensive—Road from hence to Oswestry 9 Ms. not so pleasant as before—nothing worthy remark at Oswestry—trifling remains of a Castle on an Eminence—at the back of the Town hall —in the pediment of which an old figure sculptured sitting said to be King Oswald—

Tuesday 31. set off after breakfast for Chirk Castle 7 Miles pass'd thro' Chirk small Village on an emminence the Castle belongs to Mr Middleton—is of Stone & nearly a quadrangle each side has three round towers embattled. In the windows & entrance the Gothick is preserved but within every Room is modernized—one of them is very spacious—Furniture all modern, Pictures good for nothing—the views from the windows are spacious & grand particularly—towards Winstay where the House appears very conspicuous. One side of the Quadrangle is of ancient date—the other of more modern being

[1] The Revd. Treadway Nash, 'Observation on the Time of Death and Place of Buriel of Queen Katherine Parr', *Archaeologia*, ix (1789), 1–9. The tomb was first opened on 14 Oct. 1786 (ibid. 3).
[2] See T.B. XIII H: *Two Sketches near Malvern*.
[3] i.e. Admiral Rodney's defeat of the Spanish Fleet off Cape St. Vincent, 16 Jan. 1780.

rebuilt by Sir W^m Middleton in 1636 as the stone specifies. The Castle tho ancient & in a good form is yet not well situated for the Pencil[1]— Winstay is about 6 Miles—the House is not worth the notice of the Curious Traveller a Wing has been recently added by Wyat intended as a Library Room[2] it is neither spacious nor handsome—the Views from the House are rich & grand—the Bath is well situated in a Valley about a q^r of a Mile from the House & a spacious piece of water near it formed from the Bed of the old River is a fine object— Ruabon Church peeps finely over the Shrubberies & small Wooden rustic Bridge under which is small Cascade—In Ruabon Church are some monuments of the Wynne family but none yet raised to the late Sir Watkin[3] but a lofty pillar is going to be raised to his memory in the Grounds in the Way to the Bath—From Ruabon to Llangollen the ride is delightful, about 2 Ms. from Ruabon the eye is caught w^th a beautiful object on descending a hill. The winding of the Dee across which the pont Newydd [*Newbridge*] a noted stone bridge of 3 arches near w^ch the rocky & diversifyd Scenery of the romantic country— the perpetual rushing of the stream—over its rocky bed—is truly a delightful scene—about 5 Ms. farther the approach to Llangollen from the Eminence above the turnpike is charming—the village is situated in a fertile valley—w^ch appears amidst a thicket of trees—the Church & bridge[4]—river & descending road w^th the surrounding Mountains all Combine to give a complete romantic landscape. Amidst the many hills—stands on the Eminence Crow Castle or Castle Dinas Bran w^ch has anciently been of immense strength—its walls are in many places 15 ft thick—We visited the retreat of Lady El^r Butler & Miss Ponsonby—a small cottage but very neat[5]—about 2 Ms. from Llangollen is the beautiful ruin of Valley Crucis Abbey— It is situate between 2 immense hills—& within a few yards of a small gurgling stream that runs into the Dee at about ½ Mile distance—the grand window of the Chapel is a fine remain of the Gothic[6]—it stands merely a wall unsupported—the remains of the other end of the

[1] But see T.B. XXI F.

[2] James Wyatt remodelled parts of Wynnstay between 1785 and 1788.

[3] Sir Watkin Williams-Wynn, the 4th Baronet, died on 29 July 1789.

[4] See T.B. XXI G. Another young tourist, James Plumtre (1770–1832), who was in North Wales at exactly the same time as Turner, also found that 'the situation of the Town and Country about Llangollen are the most romantic I ever saw' (*A Journal of a Tour through Part of North Wales in the Year 1792*, Cambridge University Library Add. 5802, II, fo. 3).

[5] Lady Eleanor Butler (1739–1829) and Sarah Ponsonby (1755–1831), known as 'the ladies of the vale' had attempted to live there in seclusion since the 1770s, but had become the objects of pilgrimage from all over Europe (see E. Mavor, *The Ladies of Llangollen*, 1971).

[6] See T.B. XXI H 2; XXVIII, R.

Chapel are not in so fine a Style—but gives a better idea of the size of the whole Edifice—a small w[r] house has been recently built by Mr Lloyd (as a Summer house) the Lord of the Manor—but so close to the Abbey as to render it difficult to find a spot to draw from without combining this lath & plaster object—This same Gent[n] has however evinced his love for antiquity by restoring an ancient pillar about a q[r] of a Mile distance to w[ch] he has added a latin inscription (see drawing)[1]

Thursday. Quitting Llangollen—the road towards Corwen for the first 6 Ms is hilly—& the mountainous scenery on each side is noble— the Dee appears beautiful in the Valley beneath the principal part of the way—about 3 Ms before we reach Corwen pass some woody grounds said to have belonged to Owen Glendower—Nothing at Corwen worth Notice—within the Church found a fat Welch school Master teaching about 30 Child[n]—pews filled wth hay to kneel or sleep on—One old sculptured fig[r] who appears by the latin inscription to have been Vicar of the place—he is like a good priest—drawn as grasping a Cup—close to his heart—he is in his Clerical habit the fig[r] is perfect but no date—About 2 Miles beyond Corwen—at Rug —is Mr Salisbury—a very old small house—Parlor is filled wth coats of arms with innumerable quarterings & intermarriages of this family. They show here a dagger said to have been Owen Glendower's & a small silver Cup called Burguntyn—from the name of the root of the family—Near this a small river joins the Dee called the [? *Afon Alwen*] —From hence we lose sight of the Dee which rises in Bala lake—the scenery is rocky on either side & makes a wonderful appearance— within 3 Ms of Keneoga is a small village called Carig y Druidion near which is said formerly to have been a College of Druids & Bards —Approaching Keneoga the immense distant hills intersecting each other is a rich alpine scene the farther one appears only a tint greyer than the Atmosphere—Only one house at Keneoga & that indifferent —Eat a bit of tender Mutton but ill drest & set 'off at ½ past 5 for Llanwrst nothing very interesting from the Road (scene hilly & barren) till we reach the summit which overlooks the Vale of Conway

[1] T.B. XXIH 1: *Elisig's Pillar*. The original inscription is given by Thomas Pennant, *A Tour in Wales*, i (1778), 374:
Concenn filius Cateii filius Brochmail, Brochmail filius
Elisig, Elisig filius Cuollaine, Concenn itaque pronepos
Elisig edificavit hunc lapidem proavo suo Elisig.
Lloyd's inscription is recorded on Turner's drawing as follows:
Qoad hujus veteris Monumenta
 superst.
Deu ex seculus remotum Et neglectum Tandem restutit J Lloyd
de Trevati Hall ad 1779.

here the swelling hills folding as it were over each other & beautifully gradating till they blend softly into the Horizon all blue & tender grey tints irradiated in the summit in the distances by the setting sun w^ch bears the Hills in the foreground that overhang the River Conway quite in Shadow. The most conspicuous Hill is that of Moel Shabboth—Snowdon appears behind w^th one roundish & one pointed summit. This combination of Mountainous Scenery is truly sublime & surpasses any thing I have seen. At Llanwrst the Views very fine. The Bridge by Inigo Jones dated 1636 has a peculiar quality in its construction; by striking the back against one side of it you feel it shake by standing on the opposite side. In the Church is a large stone fig^r in armour seemingly not ill sculptured but from what is seen of the fig^r neither the date nor name is discoverable—The Welch have so little respect for him that he is thrust under the Gallery stairs. One large room Room or Chapel is alotted to the buriel place of the Wynnes. Many brass plates with engraved Portraits of the family are affixed to the Walls—some of them not ill engraved partarly [*sic*] one by Vaughen the Eng^r 1670. In the center of this Chapel is a large stone Coffin about 7 feet long which according to the inscription was moved from Conway Abbey at the dissolution & is s^d to have contained the remains of Prince Llewelyn see page 19[1]. The Gothic screne in this Church was brought from the same Abbey the remains of w^ch is about two Miles distant.

Saturday Aug. 4—Came to Conway—at 1.o'Clock. The Castle & fortifications w^ch form a triangle encompassing the Town truly grand. In the high street—a large old house called Plas Mawr—formerly occupied by the Governor Col. Gwyn—to whose family it is said to have been given by Eliz^th. It is much in decay—& by a date over the inner doorway was erected in 158[4]. From Conway Castle—the View is grand & Extensive S. Roger Mostyn at Llotherth [*Gloddaeth*] Hall—Treganwy [*Deganwy*] Orme's head—& opposite the Denbighshire hills &c. In Conway Church is a singular instance of fecundity recorded on a tomb stone as follows—

Here lyeth the body of Nicholas Hookes of Conway Esq^r who was the 41^st Child of his father W^m Hookes Esq^r by Alice his wife and the father of 27 Children who died the 20^th day of March 1637.[2]

Aug^t 4.—At Conway—went up to Mr Pryces at Benarth (Steward to L^d Newburgh). Commands a fine View of Marle Glodorth [*Gloddaeth*]

[1] I have been unable to trace this page reference to any of the known guidebooks to Conway.

[2] Turner's remarks about this monument are reminiscent of T. Pennant, *A Tour in Wales*, ii *The Journey to Snowdon* (1781), 316, and this may be the guidebook he chiefly used. Turner quotes Pennant (ibid. 169) in T.B. XLV, flyleaf.

& Bodyscallegh [*Bodysgallan*] and towards Conway of the Castle—the Isle of Anglesey &c—From Mr Holland's grounds called Arcadia—the View towards Conway of the Castle is fine—Went out fishing in the Ev^g about a Mile towards the Bar—caught a fine Salmon about 14 lb. returned to the Inn the Bull's head at 10—In the Morning Sunday—heard prayers in Welsh—made 2 draw^gs of the Castle[1] & set off at 1 tow^ds Aber—About 2 Ms from Conway—at Sychnant hill —the View between the hills—of the Sea—Isle of Anglesey & Penmanmawr—is truly wonderful & beautiful—from hence the road at the foot—that tremendous Mountain—running by the Sea Side w^th the Puffin or Preston's Island & the Isle of Anglesea on the opposite shore is a fine Scene—got to Aber—a beautiful situation at 3. Called on the Rev^d Mr Hugh Davies then—went into the Church, a small & wretched place—w^th a curious Welch Congregation—the Women & Men Separated—some of the latter sleeping on hay at the bottom of the pews.—About 2 Miles from Aber up the Valley—a Water fall —at some time Curious & worthy Notice but at present from want of water is of no Consequence—Rode over the sands—the tide being out to Beaumarris ferry about 3 Miles—Crossed over—to the Bull's head Inn—View'd the Castle—w^ch is now taken much care of by enclosures by L^d Bulkeley whose seat is within a ¼ Mile called Baron hill—The Views from which are very extensive & pleasing—

Monday Morn^g. 12. Set off for Mr Panton's at Plas Gwyn 5 Ms. dined there & went on to Amlwych—Tuesday View'd the Paris & Mona Mountains—Smelting houses &c a wonderful production of Nature & of equal advantage[2]—Men poorly paid—not more than 14^d p. day —ab. 1500 persons employed. Black bread & water principal diet. The most wretched & ignorant poor wretches that can be Conceived in human forms. The whole of the Mona L^d Uxbridge's—w^ch included gives him ¾ of the whole profit said to be 40,000 £ p. ann— Mr Williams his agent—very rich—as is Mr Hughes formerly a Welch Curate—Rev^d Mr Mealy dined & accompany'd us thro' the Works & all the time we were—[*blank*]

Tuesday Ev^g. went on horseback to Gwyndy [*Gwindu*] 10 Ms. & Wedy. Morn. to Holyhead—dreary Country & nothing worth seeing

[1] See T.B. CCCLXXVII, 42.

[2] Pennant (op. cit. 265–72), gives a lengthy account of the Parys Mine, and is far more favourable to it than Turner: 'At the season of the greatest work, Mr *Hughes's* men alone receive, for many weeks, two hundred pounds in one week, and a hundred and fifty in another, merely for subsistence . . .' For the picturesque fame of these mines, F. D. Klingender, *Art and the Industrial Revolution*, 2nd edn. (1968), p. 94; Moir, op. cit., pp. 95 ff.

—called on Rev^d Mr Hughes—who accompany'd us—return'd to Gwyndy to din^r & went in the Ev^g to Bangor ferry=approaching which the country improves— & the Carnarvon hills—form a fine undulating line of Mountains—in the Ev^g of a beautiful grey dissolving tint—Charge of ferrying over from the Island to Bangor—one Shill^g each person—an enormous price—for 10 minutes work—

Thursday Morn^g the 9 walk'd to Bangor—saw the Church The view of Beaumaris—fine at distance—the Bay & hills Pen Man Mawr &c. full in view. Made 2 draw^gs & return'd to ferry—dined there & took a boat in Ev^g for Caernarvon 8 Miles passed L^d Uxbridge's Plas Newydd—a Modern Castle—makes a good object from the water. Farther on tow^ds the extremity of Isle of Anglesea Mr Williams propr. of the mines has a good house commanding a fine view of Caernarvon Castle—distant ab^t 4 Miles. Had a very rough & tedious passage— up the Menai the wind blow^g hard against the tide—did not reach Caernarvon till dusk. But tho the weather was hazy on the water the view of the Caernarvon hills beautiful—seem to be from the rays of the setting sun impregnated with gold & silver.

Friday—Went on the water made 2 views saw the remains of Segontium—only an old thick wall overgrown with ivy—the town— surrounded by fortification—the appartments within the Castle[1] much in ruins the Eagle tower—said to be the part in w^ch the 1st Prince of Wales was born.[2]

Saturday 11th left Caernarvon at 9—on the road ab^t a mile near the Church a stone mark'd CVS near w^ch some years since was found a pot of copper coins of Romulus & Remus—about 4 Ms the Pont y Garnadd—a beautiful object w^th the wind^g road & distant hills &c (made a drawing)—beyond it a fine lake called Llyngwllyn [*Lyn Cwellyn*] & Snowdon on left—At Nant Mill ab^t 2 Ms farther a waterfall—fine—Snowdon near—pass the foot of it—ab^t 4 Ms further Berthgallart [*Beddgelert*] dined off bacon & eggs—the scenery about the bridge very beautiful—overgrown w^th Ivy—the small old Church behind—& close to it a Narrow stream rippling over large Craggy Stones—made 2 Views there—A Mile beyond Berthgallart a most noble & romantic scene at Pont Aberglaslin from hence the road hilly—& very craggy a rough but the views fine—dined at Tamy Cwlesh—met Mr Mander there—indifferent house—on an eminence. Mr Oakly has a house well situate over looking the river & a fine

[1] See T.B. XLIV H, Y.
[2] See T.B. XLIV I.

Valley bridge &c—made a drawing of it—Walked on Sunday 12 about 3 Ms to a waterfall among the rocks call'd Rhaider Dee—not equal to what we have seen—rode after dinner over the hills the tide not suiting to go over the sands to Harlech ab. 9 Ms—the Castle a fine old remain—standing in a bold & prominent situation—& has been of considerable strength—made 2 Views[1]—Crickieth Castle— in view on the opposite shore but small & not an object—reach'd Barmouth about 9 Ms in Ev^g but rather too late & dark—got on the sands—instead of the high road—& had much inconvenience to get to the Inn—Red Lyon—midling house—many people—here to bathe —3 machines.

Monday—Morn^g set off to Dolgelly 12 Ms road very good & ride delightful—river beneath the road & ridges of rocks on each side— pass S^r Rob^t Vaughan's ab^t 1 m^l before Dolgelly called Hengoort— at Dolgelly—met Mr & Mrs Walker & Mr Cooper—dined together & in the afternoon went up to the summit of Cader Idris the View extensive—see Wicklow—Balla Lake &c the other side totally lost in Clouds—The Clouds on the opposite hills. Dipping & forming light spots—considerably below us & the distant clouds floating in a line waving—& tinged w^th the most beautiful pearly tints—the whiter parts clear beyond expression—the way down much more craggy— & rugged—& dangerous than going up—returned after dark per- fectly fatigued & satisfied w^th the grandest scenery I ever beheld.

Tuesday—left Dolgelly ab. 10—the town appears fine w^th hills &c. —made a view of it—another house of S. Rob^t Vaughan appears on an eminence the other side of the river—An old mansion said to be the highest house of any Gentleman in England—had a very pleasant ride to Mallwyd 11 Ms—pass'd Dinas Mowdy [*Mawddwy*] within a mile of it—dined well at Mallwyd & in Ev^g had a pleasant ride to Machyntlleth the river Dovey in the Valley all the way—the country more rich in verdure—& better scenery than before—reach'd Machyntlleth at 8.—

Wed^y Morn^g. Nothing worthy remark at this place but remains (said) of Glendower's house or prison—&c
About 4 Ms on the road view at the foot of the hill—
ab^t 5 Ms farther Dovey furnace & Mill a good object
About 8 Ms from Llanidlos is the village of Caersoos [*Caersws*] near which it receives 3 rivers—Tranon & Kerrest & Caernon
then New Town

[1] See T.B. XLIV b.

Pool to Shrewsbury—Mr Lawrence—Lyon 18 Ms
[*Oak at Welsh pool—7 to Ludlow 33 Crown*
Dragon Montgomery 9]
Bear New Town ⎫13
Oak To Welshpool⎭—7
Dragon To Montgomery—7½
Castle To Bishops Castle—9
Crown To Ludlow——17
[*New Town to Ludlow 33*]
Mr Wells or Mr Long at Upton
To Llandrinnio [?*Llandysilio*] 6 MS from the at pool a bridge
there—2 Ms beyond Cut the River Vurnion [? *Vyrnwy* or *Einion*]—
joins it at Commar

THE LETTERS

1. Baron Yarborough to Turner

MS. T.B. CXX o
Publ. Finberg 1909, i. 332

[? December 1799/February 1802][1]

My dear Sir,
 I am very glad I am to have the pleasure of seeing you on Tuesday next to dinner—for fear you should forget I have sent you the enclosed cast.

<div align="right">I am truly yours
Yarborough</div>

Arlington Street
 Saturday morn

[*Addr*.] Mr W^m Turner
 N^o 64 Harley Street
[*Pen-and-ink sketch of sailing vessel*][2]

2. Turner to William Delamotte

MS. National Library of Wales

[*Postmark* [18]oo]

The point to which I would recommend your attention is the Vale of Towy and the Vale of Usk, commencing at Abergavenny, thence to Brecknock Tretowers—the Head of the Vale of Usk then commencing the Vale of Towy—Llandovery—thence to Landilo the Head Quarters in the Vale and Caerkinnon Castle, Drusslynn Castle, Dynevor Castle, thence to Carmarthen which affords only Quarters. You will find Lanstephen C and Langarn Castle on the sea there with Kidwelly Castle 9 miles from Carmarthen, to which place a coach travels th[r]o the above mentioned Valley to Gloucester. Therefore this route I trust will tho cursory amply employ you for it is by far the most luxuriantly

 [1] Turner moved to 64 Harley Street at the end of 1799; when he became a full Academician in February 1802 he abandoned the style 'William Turner' in favour of 'Joseph Mallord William Turner'.
 [2] Reproduced by G. Wilkinson, *The Sketches of Turner, R.A.* (1974), p. 121.

115040

wooded and the River Towy in particular besprinkled with Castles
or their Remains—viz.—

Vale of Usk on the Road
from Gloucester to Tretower

*Monmouth
*Ragland Castle
*Abergavenny Castle } Vale of Usk
*Brecknock Castle
 Tretower Castle

*Llandovery Castle
 Castelated Farm
 between Llandilo*
 Dinevor Castle
 Caerkinnan Castle } Vale of Towy
 Druysslynn Castle
 Green Castle
*Caermarthen Castle
 Llanstephen Castle[1]

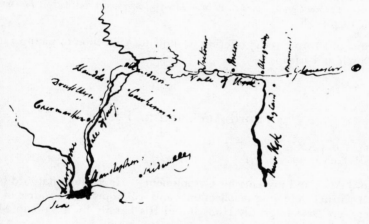

My respects to Mr Williams and family[2] and believe me to remain
 your obedient [?] Sr^t
 W. Turner

PS being yet undetermined as to my time of departure I cannot say

[1] Turner had followed this itinerary in part in 1795 (T.B. XXVI), and had advised
Farington on his South Wales tour in July 1799 (Finberg 1961, p. 61).

[2] Possibly John Williams, listed at St. Mary Hall-lane, Oxford, with 'Printsellers,
Carvers and Gilders & Picture-frame Makers' in *Pigot's Directory* (1823-4). In the
Rhine, Strassburg and Oxford Sketchbook of 1802 (T.B. LXXVII) a 'Mr Williams' is
credited with buying prints and a picture; and a 'Mrs Williams' appears next to
Delamotte as taking 25 prints of the *Shipwreck* in 1805 (T.B. LXXXVII p. 2). A
watercolour, dated 1800, of *Iffley Mill, Oxford* is described as having been given to
'Williams the Engraver, at whose house Turner was staying in Oxford' (W. E. Frost
and H. Reeve, *A Complete Catalogue of the Paintings, Water-Colour Drawings and Prints in
the Collection of the late H. A. J. Munro Esq. of Novar* (1865), No. 57).

when I shall be at Oxford but suppose about [tear] let [tear] Dr Jackson[1]
or others know well where the dot is mark there are [illeg. word] those
places without are without a Ho[tel?]

Mr Delamotte,
High Street
Oxford.

3. Turner to Ozias Humphry

MS. Untraced (? Sotheby, 22 June 1846 (382))
Publ. Reference in *Catalogue of the Autograph Room. Entirely filled with the collection
of Mr. William Upcott. Third Exhibition. Liverpool Mechanics' Institution. June and
July 1844,* p. 38

[Note of 18 Apr. 1804] offering to show his collection of pictures to
himself and friends.[2]

4. Lord Auckland to Turner

MS. T.B. CXX n
Publ. Finberg 1909, i. 331

Lord Auckland presents his Compliments—He is much flatter'd by
Mr Turner's obliging recollection;[3] and will hope in the course of a
very few Days to gratify Himself and His Family by a Visit to Mr
Turner's Gallery.

Palace Yard. May 13th [?1804]

Addr.] J. N. W. Turner Esq^re
 24 [*sic*] Harley Street

[*Verso*] *Study of a Shipwreck*

 [1] Perhaps Cyril Jackson D.D. (1746–1819), Dean of Christ Church, or his brother,
William Jackson (1751–1815), who became a Doctor of Divinity in 1799, and was a
Canon of Christ Church from 1799 to 1815. Turner painted his *Inside View of the Hall
of Christ Church* for the *Oxford Almanack* about 1803 (Oxford, Ashmolean Museum,
Herrmann No. 7).
 [2] This is probably a reference to Turner's first gallery, which was building in March
1804, and is thus the earliest-known record of the date by which that gallery was open.
 [3] Possibly a reference to Auckland's presence at the Royal Academy Dinner in 1803
(Whitley i. 56).

5. Turner to Samuel Dobree

MS. British Library Add. MS. 50118, fos. 1–2
Publ. Finberg 1953, p. 98

[*Postmark* 2°Clock 30 Ju 1804]

Sir

My Father will do himself the pleasure of waiting upon you—with the Pictures on Monday Morning—I think by 8 O Clock as the men wish to start by 5 O [C]lock to take the cool of the Morning and avoid the dust. I am afraid it will be too early for you but still hope you will excuse the inconvenience & may I ask once more 'am I to put out the cloud in the Picture of Bonneville [?]'[1] If you can drop me a line decide[d]ly yes or no this Evening or tomorrow Morning it shall be as you wish. Concerning [?conceiving] myself exceeding Obliged allow to remain

Your most truly & hum^ble Ser^t
J. M. W. Turner

64 Harley St
Saturday Morning

[*Addr.*] S. Dobree Esqr
Broad Street
City

6. Turner to Samuel Dobree

MS. British Library Add. MS. 50118, fo. 3–4
Publ. Finberg 1953, p. 99

[*Endorsed* 1 July 1804]
Harley St
Sunday Evg

Dear Sir

My not hearing from you either last night or this morning makes me fear that my note sent to Broad St. has not been received—which will make the arrival of the Pictures at Hackney unexpect[ed]ly and inconveniently early—which I hope you will excuse—for I was Oblidged to comply to the men's time.

You will find that I have sent you *all* & have added the small

[1] Châteaux de St. Michael, Bonneville, Savoy (B.–J. No. 50).

picture of Margate[1] which you appeared to like—your acceptance of
it, and to allow it always to remain in your Eye as a small remembrance
of respect will be very pleasant to me, and altho it accompanies the
'Boats going out with cables',[2] consider it not as its make-weight—as
to price, on that head I leave it entirely unto you, for you know my
feelings and opinion on that score—therefore do as you think fit—and
I shall feel much satisfaction in your allowing me to remain

<div style="text-align:center">

Dear Sir

Your most truly obliged & Ser^t

J. M. W. Turner

</div>

S. Dobree Esqr

[*Addr.*] S. Dobree Esqr
 Hackney

7. Turner to John Soane

MS. Sir John Soane's Muséum
Publ. Bolton 1927, p. 112

<div style="text-align:center">

64 Harley St

Wednesday Noon July 4th 1804

</div>

Dear Sir

With this I have sent you the Drawings; and allow me to thank
you for the loan of them.[3] With the hope of seeing you shortly I will
only ask at present if you went to the Council summoned on Monday
evening?[4]

<div style="text-align:center">

Your most truly obliged St.

J. M. W. Turner

</div>

P.S. the Print enclosed is from a Private Plate of Lord Yarborough's
of 'The Mausoleum', which Wyatt built for him in Lincolnshire,[5] if
it is any way interesting unto you, your acceptance will make me
happy.

John Soane Esq.
 12 Lincoln's Inn Fields.

[1] *A Fishing-Boat off Margate Pier, on which are numerous figures ; a vessel seen in the distance, grand effect of storm—small* (B.–J. No. 51).

[2] *Boats carrying out anchors and cables to Dutch men of war, in 1665* (B.–J. No. 52).

[3] Possibly the *Refectory of Kirkstall Abbey, Yorkshire* (R.A. 1798) and *St. Huges denouncing vengeance on the shepherd of Cormayer* (R.A. 1803), which Mrs. Soane had bought from Turner's Gallery on 3 May 1804 (Diary in Soane Museum), and which Turner would have wanted to keep for the duration of his exhibition.

[4] Soane had not been present at the R.A. Council Meeting on 2 July, which passed the Quarterly Accounts and reported on the takings of the Exhibition.

[5] Aquatint by F. C. Lewis (q.v.; R. 812).

8. Turner to Sir Richard Colt Hoare

MS. Wiltshire County Record Office 383.4
Publ. Woodbridge 1970, pp. 181–2

<div align="right">64 Harley S.

April 6th 1805</div>

The Time being past which Sir Richard Hoare mention'd
that I was to send my account of the Drawings finished I now
take the liberty of so doing—

26.5	The two outsides 25 Guineas each the Trancept 30 Guineas
26.5	and the close gate 10 making in the whole 90 Guineas.[1] The
31–10	remaining two to compleate the set of Salisbury can with
10.10	confidence be promised to be sent to Stourhead by the latter
94.10	end of this Summer.[2] I wish I could say sooner; perhaps I

may be able before I go to Devonshire, but even then I fear
the Summer will be far advanced—hoping to have the plea-
sure of hearing from you soon, allow me the honor

<div align="right">to remain

Your most truly obliged Srt

J. M. W. Turner</div>

9. Turner to Sir John Fleming Leicester

MS. (Draft, much of it illegible) T.B. CXIX Y
Publ. (fragment) Finberg 1924, p. xxvi

<div align="right">[? May 1805][3]</div>

Upside down: I hope this trespass upon your time may
excused when my] I have [?sent] this trespass upon your time
to Tabley yet trusting that you will excuse me in saying

[1] i.e. *Salisbury Cathedral from the Cloister*, Victoria and Albert Museum (Woodbridge
pl. 43); *Salisbury Cathedral, South View*, Birmingham City Art Gallery (Woodbridge
pl. 42b); *The Close Gate, Salisbury*, Fitzwilliam Museum, Cambridge (Gage 1974,
fig. 7).

[2] See letter 11, n. 2.

[3] Leicester bought Turner's *Shipwreck* (B.–J. No. 54) at his Gallery in about May
1805, and Turner issued a prospectus for the mezzotint by Charles Turner (q.v.;
R. 751) shortly afterwards (MS. in Royal Academy; Finberg 1961, pp. 118–19), so
this letter requesting permission from Leicester to retain the picture for engraving must
also have been drafted about May. Leicester paid Turner £315 for the picture on
31 Jan. 1806 (Hall, p. 93), but Charles Turner was apparently still working with it in
the summer of that year, and the print was not published until January 1807 (Rawlin-
son, ii. 362). See Letters 20, 35.

that I have to ask your then engraving of your picture
and feeling that I should be happy in seeing of will
engraved as urged me to request your indulgence in
allowing it so to be, before your proposed return to
 when it will be finished
town in the winter and *the picture* [*struck*] the
detention to me can possibly occour
 and I should be persuaded that no detention of
the Picture will occour—beyond the time of your return
to town for the winter
 proposed time of having it engraved
 during your absence from town and beyond the time you
 propose to return for the winter I shall be certain no detention
have expressed a wish to have the picture returned (viz the winter)
of the Picture
no detention shall occour—and Mr C. Turner who wishes to engrave
and in whom I can
it in mezzotinto me that will be but do not move or
 with him untill Sir John Leicst. favours me with an
and wishes on the when it will most oblige

 Yours . . .

10. Mr Gilly [?] to Turner or William Turner Snr.

MS. C. W. M. Turner
Publ. (Verso only) Thornbury 1877, p. 194

 [? May 1805]

Sir
 I have taken the liberty of giving an order upon you for the half
years rent due Lady Day last,[1] the bearer of which will convey to
you my receipt.

 I have the honor to remain
 Yr very obed.
 Mr [?] Gilly [?]

Twickenham
 Friday [*Pencil*] to Mr Will. Turner

[*Verso, in J. M. W. Turner's hand*]
 1. To receive the 31 of Septr 25 Guineas for the loan of 4 Pictures[2]

 [1] 25 Mar. This may refer to the rent of Sion Ferry House, Isleworth, which
Turner was occupying at least as early as November 1805 (see Letter 11).
 [2] Perhaps a slip for 'the picture', i.e. *The Shipwreck* (see Letter 9).

2. To pay Mr C. Turner the price of 1.6 or trade price for all I want to colour
3. The price of the print one Guinea and Half [*changed to* 2 Guineas] proofs double, size of the plate viz[1]
4. For J.M.W.T. not to part with any coloured print until 4 Months after the printing [*changed to* publishing] of the proofs
 The Plate to be finished by the end of Dec[r] 1805[2]
 £1-12—plate [ie. trade] price for £2.20
Pencil relative to the Ship Wreck

II. Turner to Sir Richard Colt Hoare

MS. Wiltshire County Record Office 383.4
Publ. Woodbridge 1970, p. 182

> Sion Ferry House Isleworth[3]
> Nov[r] 23 1805

Sir Richard
 I have as you desired sent the following account of the Salisbury set

Trancept View Cloister D° General View and the Close Gate	Charged as per letter of April last	95 Guineas
Wilton front New Market House	Drawings delivrd Nov[r] 21[4]	20 Guineas
		£120.15

I could wish you to refer to my letter of April for the first Drawings and if it is not trouble [to] you when you favour me with the draft to say if Lord Coningsby Monument is (for I think I can find the sketch)

[1] The Prospectus (Finberg 1961, p. 118) advertised the plate size as 33″ by 23½″.

[2] The prospectus stated that the prints would be *delivered* during December 1805; in the event they were not published until January 1807.

[3] This is the earliest clearly dated reference to the address Turner used until 1811. It appears in T.B. XC (cover), which also bears the date 1804.

[4] *Wilton Front* = *Wilton House* (Christie, 28 July 1927, bt. Legatt), whereabouts unknown. *New Market House* is possibly the *Council Chamber*, formerly in the collection of Ronald Addy (preparatory drawings in T.B. L O, P). Gage (1974, p. 66), following Woodbridge, read 'deliverd' as 'orderd'; but the two drawings listed here are almost certainly those referred to in Turner's letter of 6 Apr.

requisite to your History of Marden,[1] if so it shall be done by January
tho it is neither a pleasant or can it make a pleasing drawing from
its formality.

I have the honor to be
Your most truly obligd
J. M. W. Turner

Sir Richard Hoare Bar[t]

[*Endorsed*] paid p. draft on Bosanquet 7 Dec[r] 1805

12. Turner to Sir Richard Colt Hoare

MS. Wiltshire County Record Office 383.4

Isleworth D[r] 14 1805

Sir Richard

I feel sorry my being in Town when your favour (with the enclosed
check for £120 15-) arrived prevented me acknowledging the
receipt of it as you requested by return of post which delay I hope
you will excuse and allow me to be

Your most truly obliged St
J. M. W. Turner

Sir Richard Hoare Bar[t]

13. Turner to James Girtin

MS. Untraced
Publ. Notes & Queries 5th. ser. xii (1879), 228

[? 1805]

Sir—Be so good as to clear the margin lines, which are at present
very bad and double in some places, and the etching *over* (for if we
succeed I shall like to have them engraved by Mr Daniel's).[2]
Respecting the strength do not be fearful; let me see how the sky can
be made to bear out like a green [*sic*] of aqua-tinta,[3] and then the
rest in proportion, and as long as you can maintain clearness be not
timid as to depth, only regarding the gradation of shadows. You may

[1] Nothing is known either of Turner's sketch at Marden, near Hampton Court,
Herefordshire, or of Colt Hoare's *History*.
[2] Pye—Roget, p. 48, read 'like Mr Daniell's'; the reference is to Thomas and
William Daniell's *Oriental Scenery*, begun in aquatint in 1795, a copy of which was
purchased by the Royal Academy, by a unanimous vote, in August 1805 (Farington
Diary 1 Aug.). Series IV, published in 1807, was dedicated to Egremont (q.v.).
[3] The phrasing suggests that the print in question was not itself in aquatint.

be sure that I am rather anxious to see how the first answere, and therefore the sooner you can let me see a proof the more you will oblige.

Yours very ob^ly

J. M. W. Turner

Mr Girtin

14. Turner to Sir Richard Colt Hoare

MS. Wiltshire County Record Office 383.4
Publ. Woodbridge 1970, pp. 182–3

March 4 1806

J. M. W. Turner with his respects to Sir Richard Hoare has sent the Drawings of Hampton Court[1] and Sir Richard Hoare having desired that the Bill should be [advised] it is therefore subjoin'd. Yet JMWT begs leave to say that the charge for the Malmesbury expenses (e.g. five guineas) is *only* added if Sir Richard declines having the sketches finished that were made at Malmesbury.[2]

The two Drawings of Hampton Court ⎫
 S. E. and W. Views ⎬ 14.14
 7 guineas each ⎭

Expenses at Malmsbury 5.5

64 Harley St To Sir Richard Hoare Bart

[*Endorsed* paid p. draft 14.14 deducting 5.5. overcharged on last account.]

15. Turner to John Soane

MS. Sir John Soane's Museum
Publ. Bolton 1927, p. 113

Tuesday March [29] 1805[1806]

Dear Soane

You said yesterday, why not send the lines by Churchill, therefore they follow:

[1] See T.B. XXVI p. 5 (1795): Sketches for north and south fronts (drawings in Whitworth Art Gallery, Manchester), and Sabin Galleries, *A Country House Portrayed*, 1973, Nos. 9, 10 for north-west and south-east views (ill.).
[2] See T.B. XXXVIII pp. 4, 6, 9, 74, 86 (1798). It is clear from Colt Hoare's endorsement that he did not wish to have these sketches finished.

'Professors (justice so decreed)
Unpaid must constant Lectures read;
On earth it often doth befall
They're paid and never read at all'

Churchill
'Gotham'[1]

Another scrap:
'Sure of success proceeds the Man
Who from a preconcerted plan
With sticks and leaves a hut first builds
Before the Parthenon he fills
With monotriglyphs—diastyle.
Then Architecture spreads her guile
And wondering students gape the while
Twixt Attic-Salt and Roman oil'

I do most sincerely rejoice at your success last night and with much
pleasure offer my congratulations.[2]

Yours Truly
J. M. W. Turner

John Soane Esq.,
12 Lincoln's Inn Fields

16. Turner to Sir Richard Colt Hoare

MS. Wiltshire County Record Office 383.4
Publ. Woodbridge 1970, p. 183

64 Harley St.
Saturday 19 April 1806

Sir Richard Hoare
Mr Woodforde[3] call'd yesterday with your favour dated the 6 of
March for 14.14 together with copies of my letters of April and the
last one respecting the over draft of 5 Pounds and allow me to say
I feel perfully satisfy'd in the deduction you have made to agree with
my letter of April last

Your most truly obligd
J. M. W. Turner

Sir R. Hoare B[t]

[1] Turner's source is not *Gotham* by Charles Churchill (1731/2–64), but his *The Ghost*,
3rd edn. (1763), Bk. II, lines 443–6. The allusion is to George Dance, Soane's pre-
decessor as Professor of Architecture at the Academy, who had never lectured.

[2] Turner had been present at the R.A. General Assembly of 28 Mar. 1806, where
Soane had been unanimously elected Professor of Architecture.

[3] Samuel Woodforde, R.A. (1763–1817), a protégé of Colt Hoare's (Woodbridge,
pp. 98–9).

17. Turner to the Earl of Elgin

MS. The Earl of Elgin
Publ. (extract) W. St. Clair, *Lord Elgin and the Marbles*, 1967, p. 168

Many thanks my dear Lord for the perusal of your invaluable acquisitions,[1] the writer seems to do them as much justice as his enthusiasm will enable him, no one can think of them without feeling the same, your Lordships collection is perhaps the last that will be made of the most brilliant period of human nature—
 Graiis ingenium. Graiis dedit ore rotundo
Musa loqui.[2]—I shall be run away with, so must with the rest of mankind who venerate the arts, pay my homage to your Lordships exertions for this rescue from barbarism—with the hopes of being once more favored (at some future period) with the sight of the Drawings[3]

> I remain My Dear Lord
> Yours very sincerely
> J. M. W. Turner

Argyll Street[4]
7 Aug 1806

The Earl of Elgin

18. Turner to F. C. Lewis

MS. British Museum Print Room (MM.5.12)
Publ. Rawlinson 1878, p. 182

[?early 1807]
Mr Lewis
 I could wish you of course to get forward with the Etched plate as

[1] The Elgin Marbles (British Museum), which had arrived in England in 1804, but which were not unpacked until 1806. They were not exhibited publicly until June 1807, so Turner must have had special access.

[2] Horace, *Ars Poetica* 323–4: 'It was the Greeks to whom the Muse gave genius and polished speech.'

[3] Presumably the drawings of Greek buildings and sculpture made by Elgin's draughtsman Tito Lusieri. When Turner had himself declined this post in 1799, it was partly because he 'wished to retain a certain portion of his own labour for his own use' (St. Clair, p. 9).

[4] James Northcote, R.A., lived in 1806 at 39 Argyll St., but it is unlikely that Turner was on friendly terms with Northcote, who was a bitter critic of his work. W. H. Pyne, a subscriber to Turner's *Shipwreck* print (T.B. LXXXVII, pp. 2, 24) and a member of the Watercolour Society, lived at No. 38; and Caleb Whitefoord, an early supporter of Wilkie (q.v.), at No. 28.

soon as possible, only send me 12 prints [*changed to: 12 Etchings*] before you aqua tinta it.[1] I have likewise put another drawing[2] with the plate, if you can get on with it without an Etching *do so* and I will Etch it afterward, if you can not send me another *prepared plate* when you send me the 12 Etchings and the drawings back and then I will get it Etched and send it to Salisbury St—

<div align="center">
send to me at

West End Upper Mall

Hammersmith[3]
</div>

and if by the Boat from Hungerford there is more chance of care being taken of the Etched plate

<div align="right">
J. M. W. Turner
</div>

19. Turner to F. C. Lewis

MS. Untraced
Publ. Rawlinson 1878, p. 183

<div align="right">
[?early 1807]
</div>

Sir

I have sent you an Etched outline tinted as you desired—but [if] you cannot proceed without my Etching being exactly similar to my Drawing it is of little use in my Etching them first—for [I] cannot follow line by line with the Drawing[4] —therefore I wish you to Etch the one I now send and when you send it home send an Etching ground over yours with a proof print—then what etching is wanting I can then add—I think this will be the best way, for to touch up an etching is full as much trouble to me as making the drawing, so pray get this done immediately.

<div align="right">
J. M. W. Turner
</div>

West End, Upper Mall
Hammersmith

[1] This may be *Bridge and Goats* (R. 43), Lewis's only engraving published in *Liber Studiorum* and issued in 1812, although only three etchings for it appeared in the Turner sale.

[2] This may be the drawing for *The Bridge in Middle Distance* (R. 13), published in 1808 as by Charles Turner, but which has a sky in aquatint, and is of the same Claudian type as R. 43.

[3] Turner was in Hammersmith from at least January 1807.

[4] This had also happened to Charles Turner in engraving *Scene on the French Coast* (R. 4, publ. June 1807): the drawing and the etching did not tally and Turner made a tinted etching.

The new one is a view of Chepstow[1] therefore *must not be Reversed* but made like the drawing.

20. Turner to Sir John Fleming Leicester

MS. University of Manchester, Tabley House
Publ. Hall, p. 93

[?9 February 1807]

The Picture of the fall of the Rhine[2]—to be Sr John Leicesters in Exchange for the Storm[3] for 50 Guineas.

[*Endorsed by Leicester*] Pd Febr 9 [?] 1807 Mr Turner 50 Gs & Storm in exchange for ye Rhine—N.B. gave Mr T an order to receive ye Storm at his Pleasure, he to be subject to the chance of Fire &c. Memd. March 2 [?] gave Mr T. an order to receive ye Storm as he sd. he had mislaid the first.

21. Turner to F. C. Lewis

MS. British Museum Print Room (MM. 5.12)
Publ. Rawlinson 1878, p. 184

Sir

I received the Proof and Drawing[4]—the Proof I like very well but do not think the grain is so fine as those you shewed me for Mr Chamberlain[5]—the effect of the Drawing is well preserved, but as you wish to raise the Price to eight guineas I must decline having the other Drawing[6] engraved therefore send it when you send the

[1] Probably *Junction of the Severn and Wye* (R. 28), another Claudian subject with an aquatinted sky, published in 1811 as engraved by Turner himself and later described by him as 'My Chepstow' (T.B. CLIV(a) p. 26a). Pye–Roget (p. 53n), who saw the original letter with Lewis's family, state that Turner originally wrote 'Dumblane', presumably a reference to *Dumblain Abbey* (R. 56), engraved by Thomas Lupton and published in 1816. They also state that the letter is watermarked 1806.

[2] *Fall of the Rhine at Schaffhausen* (R.A. 1806, B.–J. No. 61).

[3] *The Shipwreck* (B.–J. No. 54). The explanation of the exchange given by Thornbury (1877, p. 423), that Lady Leicester did not like the picture, is unlikely, since Leicester did not marry until November 1810.

[4] Probably *Bridge and Goats* (R. 43).

[5] John Chamberlaine, who was employing Lewis to make facsimiles of drawings by Claude, Raphael, Michelangelo, and Poussin for *Original designs of the most celebrated masters of foreign schools of Art*, published in 1812.

[6] It is uncertain which this is (see Letters 18 and 19). Lewis certainly claimed that Turner sent him two other drawings to engrave, besides *Bridge and Goats* (Pye–Roget, p. 54).

plate, when they have arrived safe, the five guineas shall be left in
Salsbury St where you'll be so good as to leave a recept for same.

<div align="right">Yours,

J. M. W. Turner[1]</div>

14 Dec. 1807,
Hammersmith

22. The Earl of Essex to Turner

MS. British Museum, T.B. CXX 1
Publ. Finberg 1909, i. 331

<div align="right">Cashiobury

June 10th 1808</div>

Mr Turner,
 I have sent a Packing Case for the Picture,[2] the same as the other
Picture came in last year[3] and I will send for it to-morrow Sennight
to your House.

<div align="right">I am yours truly

Essex</div>

[*Verso: slight pencil sketch of a river scene*]

23. Turner to Charles Turner [?]

MS. University of Chicago

<div align="right">[? August 1809]

Cashiobury Tuesday</div>

Dear Sir
 Your letter has at last reached me but not think it fortunate for me
that you are so far off for belive me I do not, what I have written I
dislike and therefore cannot wish even your eye without my being
present to explain at least the writing [?] if not the meaning of it,
therefore I must ask you not to say 'send it to me', for I fear however
great my wishes may be to be of use ... that I cannot be of any in
your next Number[4]—being now upon the wing to Yorkshire for 2

[1] The letter, with the exception of the signature, is in the hand of William Turner
Snr. (q.v.) (Finberg 1961, p. 139).

[2] *Purfleet and the Essex Shore as seen from Long Reach*, shown at Turner's Gallery in
1808 (B.–J. No. 74).

[3] *Walton Bridges*, possibly shown at Turner's Gallery in 1806 and/or 1807 and now
in Melbourne (B.–J. No. 63).

[4] This may refer to the *Liber Studiorum*, and some prospectus or advertising copy for
it. Charles Turner had been responsible for engraving the first four parts, the last of

months[1] which precludes the chance of consulting you and in which before I am put in to the press I hope you will indulge

> Your most Oblig'd St
> J. M. Turner

I have received Mr Opie's Lectures[2] and have only to ask that if another Edition (which I hope will be case [*sic*] taking place) that all the *Proffessors* may be alike in the Subscribers List[3]

> direct to me
> I shall be here for a week
> Earl of Essex
> Cashiobury near Watford

24. Turner to James Wyatt

MS. British Library Add. MS. 50118, fos. 5–6
Publ. Finberg 1939, p. 161

> West End Upper Mall
> Hammersmith Nov 17 1809

Sir

I have been a few days from home or should have answered your favour earlier, but allow me, with thanks for the *compliment* you passed me, to say that probably you have made up your mind as to the expense of a drawing or Picture, therefore if you will mention—I then can tell you what size I can make it, for the subject is an excellent one. The sketch I have[4] includes the entrance & part of University Coll ... with do. of All Souls, St. Mary Church, All Saints, and looking up the High Street to Carfax Church, and of course may be

which had appeared in March 1809; he executed only one plate in the next part, which was published in January 1811. This, and the remaining two plates by him which were published in 1816 and 1819, were all of different categories of subject, and may have formed part of a new number, or part, referred to in this letter, but which was not published as such because of the rift between J. M. W. Turner and this engraver, which seems to date from early in 1810.

[1] Turner was certainly in Cumberland this year (Finberg 1961, p. 159); the *Kirkstall* Sketchbook (T.B. CVII), has notes of Otley, Bradford, and Halifax in Yorkshire, but also bears the date of July 1808.

[2] John Opie, *Lectures on Painting*, which seems to be referred to as a recent publication in August 1809 (Farington, 29 Aug.).

[3] Turner's name was the only one among the Academy Professors in the Subscriber List to Opie's *Lectures* to be without a title. The list had probably been drawn up shortly after Opie's death in April 1807, and Turner had not been elected to the Professorship until December of that year.

[4] T.B. CXX F.

considered a very full subject, and being chiefly buildings am inclined
to think that 24 inches is rather small even for an engraving.

I am, Your most oblg^d
&c &c
J. M. W. Turner

Mr Wyatt. Oxford
[*Addr.*] Mr Wyatt
 Carver & Gilder
 High St
 Oxford

25. Turner to James Wyatt

MS. British Library Add. MS. 50118, fos. 7–8
Publ. Thornbury 1877, p. 175

[*Postmark* Nov. 21 1809]
West End Upper Mall
Tuesday Afternoon

Sir

The approaching election for the Chancellorship should not pass
without a *prospectus* and therefore as far as relates [to] myself, do say
that I will do you a drawing or Painting, but must apprize you that
there is no possibility of reaching your size Frame, for my Pictures are
all 3 Feet by 4 Feet, 200 gs., half which size will be 100, but shall not
mind an inch or two. A drawing I will do you for 80gs.[1]

You will be pleased to turn in your mind what will suit your purpose
best, and if you print a *prospectus* will thank you to let me see *it* before
you print off a number for delivery.

The size of the Engraving you had better settle with your Engraver
about[2] for it is rather difficult to get a large one done, for many
engravers think the print of *Wilson's Niobe*[3] large, but it appears to me
the proportions should be about 3 to 2 or 18^{inches} by 30^{inches} [*diagram*].

Your most obed. St
J. M. W. Turner

[*Addr.*] Mr Wyatt
 Carver & Gilder
 High St
 Oxford

[1] The statement by Rawlinson (i. 37) that Turner was paid 80 guineas for each
painting, *High St. Oxford* and *Oxford from the Abingdon Road*, seems to be based on a
confusion with this remark.

[2] The Engraving, *High Street, Oxford* (R. 79) measures 47 × 63 cm.

[3] William Woollett after Richard Wilson, *Niobe*, 1761, 43·2 × 57·8 cm.

26. Turner to James Wyatt

MS. British Library Add. MS. 50118, fos. 9–10
Publ. Thornbury 1877, p. 164

West End, Upper Mall, Hammersmith
Friday, Nov. 23, 1809

Sir

I will do what I can in respect to size, time, &c, &c, considering your last letter conclusive as to choice & price, but concerning the Engraver it is a difficult thing to know who to choose, their prices are as different as their abilities, and therefore that point must remain with you. But if Mr Warren[1] will undertake a large Plate, surely his abilities may be said to equal to the task, or Middiman, Lowry, Young Byrne, or Miton [*sic*], &c.[2] The question is certainly of the first importance to me, but you must decide, and all I can do respecting *advice &c* &c, to whomsoever you may ultimately choose, shall be at his or your service.

Your most truly ob[d]
J. M. W. Turner

Britton's Antiquities[3] contains some good specimens of engraving for depth, and well-laid lines, but cannot recollect their names. [*Pencil*] Popes Villa[4]

27. Turner to James Wyatt

MS. British Library Add. MS. 50118, fos. 11–12
Publ. Thornbury 1877, pp. 164–5

Dec[r] 9, 1809
9 o'clock Saturday night

Sir

By some accident or other your letter arrived but just now, and

[1] Charles Turner Warren (*c.* 1762/7–1823).

[2] Samuel Middiman (*c.* 1750–1831), who eventually worked on the *High Street* plate; Wilson Lowry (1762–1824); John Byrne (1786–1847), who may be the 'L. Byrne' working with his father on *Donnington Castle* (R. 69) about 1805; probably James Mitan (1776–1822), who later worked for Hakewill's *Italy* (R. 161).

[3] John Britton, *The Architectural Antiquities of Great Britain*, 1806–26. Of the twenty-six engravers engaged on this work up to 1809 only four, Rawle, Storer, Tagg, and Basire, had had any association with Turner's work.

[4] *Pope's Villa* (R. 76), published in 1811 as by John Pye (q.v.), with the figures by Charles Heath (q.v.), the two remaining engravers of the *High Street* plate. The picture (B.-J. No. 72) had been painted in 1808 and the open etching by Pye is dated 1810.

therefore I shall dispatch this answer by the coach to morrow morn-
ing, for to wait for the next post would prevent your getting the
proposals printed by Tuesday, & which even now appears to be
doubtful.

I think that a *print* or an engraving should follow the words
'Proposal for Subscription' (which you think best) and that it is so
near the size of the Niobe that to mention it would perhaps induce
some to think of yours as a companion Print. Another thing, you
should by all means particularize how many *proofs* you intend to take
off, and at what price, for the public like to have more than assur-
ances: they now want particulars, and which leads me to hope that
you will be very particular about mentioning Mr Middiman's name,
for to insert it in the prospectus without being *sure* of his co-operation
would marr your endeavour in the eye of the public: for the least
deviation from a proposal renders all subscriptions void.

Be pleased to accept this hasty advice, and I am glad Mr M. is
inclined to engrave the Picture.[1] Respecting your sketches, I only
want the Houses to judge whether or not they are worth introducing,
but you have not said or hinted at a second view, and therefore it is
not of so great a consequence of taking in the corner of Queen's Coll.[2]

However, I have no objection to a trip to Oxford, but could wish
it warmer weather.

<div style="text-align: right">

Your most truly obl[d]
J. M. W. Turner

</div>

West End, Upper Mall

28. Turner to James Wyatt

MS. British Library Add. MS. 50118, fos. 13–14
Publ. Thornbury 1877, p. 165

<div style="text-align: right">

[*Postmark* Monday D[er] 25]

</div>

Sir

I cannot but think it very unhandsome of Mr Taylor,[3] and therefore
I do all that is within my power to accomodate your wishes: will leave
here some day this week for Oxford. I therefor wish you to get me a

<hr>

[1] *High Street, Oxford* (B.–J. No. 102).

[2] This feature was not included either in Turner's original sketch (T.B. CXX F) or
in the final painting.

[3] Perhaps John Taylor (q.v.), who had covered the Oxford election extensively in
The Sun from 4 Dec. until Convocation on 13 and 14 Dec., but carried no advertise-
ments for the print.

sheet of paper pasted down on a Board in readiness, about 2 Feet by 19[1].

I think [of] coming by the Shrewsbury or Birmingham Coach and therefore hope to be at Oxford by 12 at night ... could wish you if possible to secure me a bed at the *Inn*.

Yours most truly
J. M. W. Turner

[*Addr.*] Mr Wyatt
Carver & Gilder
High St
Oxford.

29. Turner to James Wyatt

MS. British Library Add. MS. 50118, fo. 15
Publ. Thornbury 1877, pp. 174–5

Sir

You may prepare a frame 2 feet 3 inches high by 3 Feet 3 long, but I think that it must be cut less, having at present too much sky,[2] so do not put the frame together until you hear again from me. By way of consolation let me tell you the picture is *very forward*, but I could wish you to send me back the annexed sketch with information how the several windows are glazed, and those *blank* in the front of the All Souls entrance, particularly those in the *large Gable part*, if they project in a bow, like the two by the gateway, as I find two marked in my second sketch more than in my first, and therefore suppose some alteration has taken place since the first was made.

Pray tell me likewise if a gentleman of the name of Trimmer[3] has written to you to be a subscriber for the print.

Your most obed St
J. M. W. Turner

West End, Upper Mall, Hammersmith
Saturday Feb[y] 4, 1810

[*Endorsed*] The sketch was sent back as requested[4]

[1] Rawlinson (i. 37) states that Turner stayed with Wyatt and made this sketch from a post-chaise parked just below the entrance to Queen's. The format demanded seems odd for a picture that was to measure 68.7×99.8 cm ($27'' \times 39\frac{1}{4}''$).
[2] See Letter 28, n. 2. [3] Revd. Henry Scott Trimmer (q.v.).
[4] This sketch has not been traced.

30. Turner to James Wyatt

MS. British Library Add. MS. 50118, fos. 16–17
Publ. Thornbury 1877, p. 166

Feb^y 28 [1810]

Sir

I did not receive yours yesterday early enough to answer by Post, but with respect to the picture, I have continued it on the same size, viz. 2^F 3¼ⁱ by 3^F 3ⁱ utmost measure. Yet the sky I do think had better be an Inch at least under the top Rabbit [*sc.* rebate], therefore I should advise you to make the Rabbit deep, so that it can be hid. Therefore the sight measures may be as follows—3 Feet 2½ by 2 Feet 2½.

The Picture you may inform Mr Middiman can be seen if he will favour me by calling, and with a line when it will so suit him, that I may be sure to be at home. I am afraid it will not be finished as early as you mention'd, but I shall not long exceed that time March 7, for it certainly would be desirable to you to have it while *Oxford* is full.

The figures introduced are as follows ... two Clericals, one in black with a master of arts gown, the other with lawn sleeves for the Bishop (being in want of a little white and purple scarf) preceded by and follow'd by a Beadle—Hence arise some questions—first ? is it right or wrong to introduce the Bishop crossing the street in conversation with his robes, whether he should wear a cap ? what kind of staff the Beadles use, and if they wear caps—in short, these are the principal figures, and if you will favour me with answers to the foregoing questions and likewise describe to me the particularities of each dress, I should be much obliged to you, for I could wish to be *right*.

I am, Your most obl^d
J. M. W. Turner

P.S. A Proctor's gown has I think you said velvet sleeves.

[*Addr.*] Mr Wyatt
Carver & Gilder
High St
Oxford.

31. Turner to James Wyatt

MS. British Library Add. MS. 50118, fos. 18–19
Publ. Thornbury 1877, p. 166

[*Embossed*] BATH
March 14, 1810

Sir

I have not heard or seen Mr Middiman, and not being so fortunate as to meet with him at home yesterday evng., I now write to ask— how to proceed, *the Picture being finished*, and in a day or two can be varnished for the last time. The packing case is likewise ready. There- fore be so good as to say what conveyance you wish me to use to send it by, and whether you positively wish Mr M. to see it first? In which case you had better write to him again, or perhaps my delivering the Picture to him, you may consider the same (sending you a receipt for it).

As to the figures introduced, I have made use of those you sent, and therefore hope you will find them right. Yet I took the hint, for the sake of color, to introduce some Ladies. The figures taking down the old Houses[1] are not only admissable but I think explains their loss and the removal of the gateway. In short, I hope that the Picture will *please* and that you will find your endeavours seconded and prove ultimately very advantageous.

Your most truly ob^d
J. M. W. Turner

P.S. The prints[2] should be returned as you direct, and allow me to thank you for sending them.

32. Turner to James Wyatt

MS. British Library Add. MS. 50118, fos. 20–1
Publ. Thornbury 1877, pp. 175–6

[? late March 1810]

Sir

I acknowledge the receipt of the draft for £105 upon Messrs Ham- mersley for the Picture, and beg to add my thanks, and am glad to

[1] The former house of Sir Robert Boyle, the chemist, which is seen under demolition beyond University College, on the left.
[2] See also Letter 30.

find that you have arranged *finally* with Mr Middiman and Pye,[1] for I greatly fear'd Mr M. would decline because the subject proved more architectural than he expected.

I shall varnish it for the last [time] this Evening, and on Saturday Morning, 9 o'clock, by Gilbert Coach, it shall [be] forwarded to Oxford. Sincerely trusting that any idea you have formed as to the Picture and to the Engraving may be realized

I am &c &c with haste, Your most truly obl[d]
J. M. W. Turner

PS. I shall be every ready to assist in advice or otherwise in your undertaking with Mr M. or Mr Pye

[*Addr.*] Mr Wyatt
Carver & Gilder
High St
Oxford.

33. Turner to James Wyatt

MS. British Library Add. MS. 50118, fos. 22–3
Publ. Thornbury 1877, pp. 167–8

[*Postmark* April 6, 1810]

Sir

I am glad to hear the picture is so approved of. Really I thought you long before you wrote and I could not have rested a day or two more without writing for uneasiness as to the safe conveyance of it, by the Coach or otherwise.

However, that is past, and respecting the spires Crosses and Window, they can be done after the 10th as you propose: you may send it to Mr Middiman direct, for I shall be in own about that time to finish my own pictures for My Gallery and therefore I can do what you wish there. I feel some concern about the Spire of St Mary. Many who look at that spire at the side opposite to it in the street think that it should look equal high at the angle, but which wholly changes its character. It becomes more dignified than piercingly lofty. However, if you can get me the height and base from the springing or setting off of the spire, or from the clock, it shall be altered to measure.

You must be the best judge how far a second print would meet the support of your friends, but as you ask my opinion, I should think you

[1] Pye was responsible for developing Middiman's open etching, and for the whole of the sky.

would feel the disposition of your present friends about it.[1] But I still think that it should be merely for names and not to confine them by a deposit (or a very small one), for in case it should be determined to try the other end of the High St it would be at least 3 years before the same engravers could furnish you with the engraving.

Your most truly
J. M. W. Turner

The book[2] will be serviceable to me to make some memoranda of respecting the dresses. Let me have it a little longer, as I am now so very busy. If you think or Mr M. wishes for it, let me know and I will deliver it safely to him.

34. Turner to James Wyatt

MS. British Library Add. MS. 50118, fos. 31–2

[2 May 1810]
Queen Ann St West
Wednesday Ev[g]

Dear Sir

I will thank you to make all *possible haste* with the *Frame* because my Gallery opens on Monday next and of course I cannot hang up the Picture[3] until the arrival of the Frame.

Your most obg
J. M. W. Turner

[*Addr.*] Mr J. Wyatt
Oxford
per favour of Mr Lesson [?]

35. Turner to Charles Turner

MS. Boston Public Library *MS. E.9.4. 64.57
Publ. (extract) Finberg 1939, pp. 169–70

July 27 1810

Mr Turner requests Mr C. Turner to explain through what cause the Print of the Shipwreck now in a shop in Fleet St late Macklin happens

[1] This seems to be the first reference to a companion to the *High Street*, an idea which produced the *View of Oxford from the Abingdon Road* (B.–J. No. 125), which was not published as an engraving until 1818 (R. 80).

[2] See Letter 30.

[3] *View of Oxford High Street*, Turner's Gallery 1810 (3). See Letters 24–34.

to be *coloured* when Mr C. Turner expressly agreed that none should be coloured but by J. M. W. Turner *only*.[1]

J.M.W.T. likewise expects 2 Proofs of the Shipwreck as his right. [*Endorsed in pencil*] now he demands 50 of each[2]

36. Turner to Sir John Fleming Leicester

MS. University of Manchester, Tabley House
Publ. (facsimile) C. Hussey, *Country Life*, LIV (1923), 117

[*Embossed*] BATH

Queen Ann St West Dec[r] 12 1810

Sir John

Perhaps the above slight mem[m] of the only four subjects[3] I have near the size may lead your recollection in regard to their fitness or class, and if I knew when you would favour me with a call I would most certainly remain at home

Your most truly obliged St
J. M. W. Turner

[1] See Letter 10.

[2] This may refer to a demand for fifty proofs of the etching or engraving of the *Liber* plate *London from Greenwich* (R. 26), published in January 1811.

[3] B.–J. Nos. 69, 87, 91, 206.

To Sir John Leicester Bart ☞ Dutch Boats, now in Sr J.L.
Gallery in Hill St Pretium *300* *G*s-----¹ ₁

37. Turner to John Taylor

MS. Untraced (with Bonfiglioli, 1963)
Publ. Whitley, i, p. 181

Jan 9 1811

Dear Sir
 Pray allow me to make my most sincere acknowledgement of *thanks*
for your kind and honourable notice of my endeavours on Monday
night in the Paper you were so good as to send me;² permit me to
add a scratch of thanks for your rememberance of Sir Francis
Bourgeois,³

And believe me to be
Your most truly obliged
J. M. W. Turner

J. Taylor Esq.

¹ *Sun Rising through Vapour* (B.–J. No. 69, R.A. 1807, B.I. 1809). See Letter 78.

² The flattering review of Turner's first lecture on perspective at the Royal Academy,
which appeared in *The Sun* on 8 Jan., is reprinted by Finberg 1961, p. 174.

³ The same number of *The Sun* carried an obituary of Taylor's close friend Sir
Francis Bourgeois (1756–1811), as an 'eminent artist and truly excellent man... His
Landscapes are characterised by lightness, elegance and spirit, and the figures which
he introduced are painted with much greater skill and fidelity than generally appear
in the works of professed Landscape painters...' Bourgeois, a pupil of Loutherbourg,
and Landscape Painter to George III, had supported Turner's candidacy as Associate
of the Royal Academy in 1799, but they had quarrelled violently in 1803 (Finberg
1961, p. 105). Taylor wrote in his obituary: 'Sir FRANCIS was animated by so
friendly a disposition, that even till within a very few hours of his death he expressed
himself in sentiments of kindness to all whom he regarded, and manifested a wish to
see those with whom he had any little differences—differences that did not arise from
narrow feelings, but opposition of sentiment respecting the affairs of the Royal
Academy.' Taylor ended with a quotation: 'Though laudably ambitious of distinction
himself, he is by no means tainted with the illiberal spirit of jealousy usually imputed
to his profession, but unites with the emulation of genius a generous zeal for the success
of contemporary merit.' For Bourgeois as a painter, L. Herrmann, *British Landscape
Painting of the Eighteenth Century* (1973), pp. 116–17.

38. Turner to John Taylor

MS. British Library Add. MS. 50118, fo. 24
Publ. (extract) Finberg 1939, p. 175

Queen Ann St. Jany 16 1811

<u>Thanks</u> gentle Sir for what you sent
with so much kindness praise—'besprente'
Upon a subject which forsooth,
Has nothing in it but its truth[1]
Where lines so round about applied
At last gives the parabolide[2]
Commixt perplexing and obscure
'Fitter to puzzle than allure'[3]
While on each point your Comet shines
It gleams to truth with truth defines
Unclothes at once the Magic shell
The Donjon Keep and Elfin yell.[4]
But let them by their parent Tweed
Still whisper on the fragile reed.
Which growing to the Public taste
Like other things may grow to waste
Its utmost strength e'en full blown pride
Could not sustain the Avon's tide![5]

[1] In his review of Turner's second perspective lecture in *The Sun* of 15 Jan., Taylor wrote: 'The Lecture, in the opinion of those best acquainted with the subject, manifested deep investigation, and the comments on the mistakes or inaccuracies of former writers were given with liberality.'

[2] Turner's manuscript for this lecture is British Library Add. MS. 46151, L, which cites the views of Smith and Emerson that light is not reflected from bodies immediately at an angle 'but makes a regular parabolic kind of curve, at a very small distance from the body', called 'the space of activity' (T. Malton, *A Compleat Treatise on Perspective*, 1779, p. 28n). Malton dissented, but Turner commented: 'If this is admissable in Cristeline bodies, may not our vision receive every impression on the like parabolide curve that may make the angle of reflection only proportionate to the ratio of that incidence which must be admitted to allow any thing that appears like rules' (fos. 21–2).

[3] Taylor had written: 'From the nature of the subject, it was not probable that the Lecture would afford much gratification to those who were unacquainted with its leading principles...' Turner is quoting Taylor's satire on Walter Scott, *The Caledonian Comet* (1810): 'Perplex'd, disjointed, and obscure/More fit to puzzle than allure...' (*Poems on Several Occasions*, 1811, p. 214).

[4] Ibid., p. 215: 'Turrets, portcullis, rusty arms,/Dwarfs, wizards, his poetic charms;/ Hostel and wassail, ruffian brawls,/And donjon keeps, and mouldering walls ...' The reference to the Donjon Keep is to *Marmion* (1808), Canto I. i, and Note VI on Norham Castle.

[5] i.e. Shakespeare.

But why promise for justice sake
Before the Lady of the Lake
The Caledonian Comet rose
Do you consign[ed] it to repose?
No!—dip the Pen, quick travel on
Proclaim the death of Marmion
Of Hostel brawls then in his cup[1]
While Common Sense gives Reason up
The Wallowing steed in dirt and mire
To prove the force of Wilton's ire;
and tho the Border Minstrelsy[2]
May have some sparks of Poesy
'With Iron claspt with Iron bound'
Sure when he took it *dead men frown'd*[3]
Or the dreadfull 'lost lost found!'[4]
Perhaps the Maid with watchet[5] Eye
The Lakes own color by the bye[6]
Possessed some beauty like the mien
'Which gently closed her bosom's screen',
But should such softness wield the oar
And in an instant reach the shore;[7]
While poor Fitz James for something sighing
'Ne'er thought his gallant steed was dying';[8]
But if opinions may be taken,
Altho I may be much mistaken
I'd chose one thought thro all the Book
'The dew drops from his flank he shook'.[9]

 This shimble shamble impromptu
 Something like the kittens mew

[1] See Note 4. The reference is to *Marmion*, Canto III, *The Hostel or Inn*, and Canto VI. vii: of the quarrel between De Wilton and Marmion: 'When in a Scottish hostel set,/ Dark looks we did exchange.'

[2] Turner intends *The Lay of the Last Minstrel* (1805).

[3] *Lay*, Canto II. xxi: 'With iron clasp'd, and with iron bound:/He thought, as he took it, the dead man frown'd.'

[4] The words of the elvish page ibid., Canto II. xxxi–xxxii, III. xiii, VI. ix: 'Lost, lost, lost', and VI. xxiv: 'Found, found, found'.

[5] Light or sky-blue.

[6] *The Lady of the Lake* (1810), Canto I. xix: You need but gaze on Ellen's eye; Not Katrine, in her mirror blue,/ Gives back the shaggy banks more true ...'

[7] Ibid. I. xx: 'The maid, alarm'd, with hasty oar,/Push'd her light shallop from the shore,/And when a space was gain'd between,/Closer she drew her bosom's screen.'

[8] Ibid. II. xxxii: 'Sleep! nor dream in yonder glen,/how thy gallant steed lay dying.' This is, however Ellen Douglas's song, not Fitz James's.

[9] Ibid. I. ii: 'The dew-drops from his flanks he shook'.

Must be considered—entres nous
Yours most sincerely
J. M. W. Turner

To J. Taylor Esq^r Author of
the Caledonian Comet

39. James Lahee to Turner

MS. C. M. W. Turner Esq.

[*Embossed Ticket*] J. Lahee, Copper Plate Printer
in all its Branches
and in Colours
No 30 Castle Street
near Titchfield St
Oxford Str.

Sir
Please to recieve herewith 7 of the E.P. Landscape[1] 13 of the
Sheep or Hind head hill[2] and the Plates

from
Your most obt
J. Lahee

Feby 2^nd 1811

40. Turner to John Taylor

MS British Museum Print Room (MM.5.12)

[?1 May 1811]
Queen Ann St. West
corner of Harly St.

Dear Sir
Allow me to thank you for your kindness in the Sun of yesterday[3]

[1] *Temple of Minerva Medica* (R. 23), published on 1 Jan. 1811 in Part V of *Liber Studiorum*. Thirteen impressions of this plate were in the Turner sale.
[2] *Hind Head Hill* (R. 25), in the same Part, thirteen impressions of which were in the Turner sale. Payments to Lahee recorded in T.B. CXI, p. 1, may be for these plates.
[3] Finberg (1961, p. 180) associates this letter with the eulogy of Turner's *Mercury and Hersé* (B–J. No. 114), which Taylor made the opening of his criticism of the Royal Academy Exhibition in *The Sun* of 30 Apr. 1811. Turner copied the whole of this review into a sketchbook (T.B. CXI, p. 68a). However, Taylor's criticisms of Turner's last four perspective lectures, on 22 Jan., 29 Jan., 5 Feb., and 15 Feb., had also

and let me add that I feel great pleasure in your thinking my endeavours deserving such attention

<div align="right">

with great respect &c
I am your truly Obl.
J. M. W. Turner

</div>

J. Taylor Esq^r

41. Turner to James Wyatt

MS. British Library Add. MS. 50118, fos. 25–6
Publ. Finberg 1939, p. 181

<div align="right">

[?May/June 1811]
Queen Ann St West
corner of 64 Harley St
Cavendish Square

</div>

Sir

In answer to the note for Mr Middiman saying you would call upon me tomorrow mrng, I must request you to let me call upon you, for really I am so surround[ed] with rubbish and paint that I have not at present a room free. Do therefore be so good as to drop me a line where I shall meet you and the time, either at Mr M. or Mr Pye¹ or wheresoever you please.

<div align="right">

Yours,
J. M. W. Turner

</div>

Thursday Evg
[*Addr*.] Mr J. Wyatt of Oxford
[*Architectural Sketch*]

42. John Britton to Turner

MS. Untraced
Publ. (Facsimile), Miller 1854, fp. lx

Dear Sir

Herewith I submit for your inspection & observations my remarks

been uniformly favourable; the last concluded 'During the whole of these Lectures, Mr TURNER proved himself a rare example of scientific knowledge and practical excellence'; and it is possible that the letter refers to one of these reviews, and should be dated accordingly.

1 The earliest publication date on proofs of *High Street Oxford* (see Letters 24–34)

on your picture of 'Pope's Villa';[1] & if you wish to make any alterations to the same, I will readily comply with your suggestions. I must beg the favor of you to return *this sheet*[2] by the <u>FIRST</u> post, as I must print the account *immediately*.[3] I am sorry I could not submit it to you previous to your leaving town. Pray inform me if you can make it convenient to oblige me with 2 or 3 drawings of Lindisfarne— they shall be engraved in the very best manner.

Yours truly,

J. Britton

November 16, 1811 Tavistock Place

43. Turner to John Britton

MS. Untraced
Publ. (Facsimile) Miller 1854, fp. lx

[Farnley Hall, November 1811]

Sir

I rather lament that the remark which you read to me when I called in Tavistock Place is suppressed for it espoused the part of Elevated Landscape against the aspersions of Map making criticism,[4] but no doubt you are better acquainted with the nature of publication, and mine is a mistaken zeal. As to remarks you will find an alteration or two in pencil. *Two* groups of sheep, *Two* fishermen, occour too close[5]—baskets to entrap eels is not technical—being called Eel pots—and making the willow tree the identical Pope's willow is

is 14 Mar. 1811; proofs lettered 'March 14 1812' carry Pye's name, but not that of the engraver of the figures, Charles Heath (q.v.).

[1] B.–J. No. 72, engraved by Pye and Heath for Britton's *Fine Arts of the English School* (R. 76).

[2] A proof of the letterpress to this plate.

[3] The published letterpress is dated December 1811.

[4] Britton stated in 1853 (Miller 1854, p. lx) that he had attacked 'certain illiberal and unfair criticisms by Fuseli', which probably refers to a passage in Fuseli's fourth Lecture on Painting at the Academy (1805): 'To portrait painting ... we subjoin, as the last branch of uninteresting subjects, that kind of landscape which is entirely occupied with the tame delineation of a given spot; an enumeration of hill and dale, clumps of trees, shrubs, water, meadows, cottages and houses, what is commonly called Views ... The landscape of Titian, of Mola, of Salvator, of the Poussins, Claude, Rubens, Elzheimer, Rembrandt and Wilson, spurns all relation with this kind of mapwork.' Britton then showed his copy to a friend, who advised him to omit the passage. Turner seems to want to extend the concept of Elevated Landscape to types not recognized as such by the Professor of Painting.

[5] In the published version of the letterpress, Britton wrote: 'Groups of sheep are reclining in their pasture; two fishermen are gently arranging their eel-pots ...'

rather strained—cannot you do it by allusion?[1] And with deference:
—'Mellifluous lyre' seems to deny energy of thought[2]—and let me
ask one question, Why say the Poet and Prophet are not often united?
—for if they are not they ought to be. Therefore the solitary instance
given of Dodsley acts as a *censure*. The fourth and fifth line require
perhaps a note as to the state of the grotto that grateful posterity
from age to age may repair what remains.[3]—If I were in town, I
would ask a little more to be added, but as it is, use your own discre-
tion, and therefore, will conclude cavilling any further with Dodsley's
lines.

Your most truly obedient
J. M. W. Turner

P.S. Respecting Lindisfarne we will have some conversation when I
return and you see the sketches which will best suit,[4] and I must of
course know what size, &c. you wish before I can positively accept of
your proposal, as one more I think of bringing into Liber Studiorum[5]—
I had not time to return this by post yesterday, but hope that no
delay has been experienced in the printing.

[*Endorsed* For Mr T's remarks]

44. Turner to James Wyatt

MS. Formerly Victor Rienaecker Esq.
Publ. Thornbury 1877, p. 169

Saturday Mch 6 1812
Sir

First let me *thank* you for the Sausages and Hare. They were very
good indeed. As to the Oxford,[6] I understood you that Mr Pye would

[1] Britton contented himself with printing: 'in strict accordance with the subject, is
the prostrate trunk of a willow tree'.

[2] This was changed to 'mellifluous and sonorous lyre'.

[3] Britton's caption ends: 'Dodsley, in the following lines, addressed to the poet, thus
anticipates the fate of this place: "On Thames' bank the stranger shall arrive/With
curious wish thy sacred *Grot* to see./Thy sacred grot shall with thy name survive.—/
Grateful posterity from age to age/With pious hands thy ruin shall repair:/Some good
old man, to each inquiring sage/Pointing the place, shall cry,—the bard lived there'./
Then some small gem, or moss or shining ore,/Departing, each shall pilfer, in fond
hope/To please their friends on every distant shore:/Boasting a relic from the Cave
of Pope".' (Robert Dodsley (1703–64), *The Cave of Pope. A Prophesy*. For the whole:
R. Anderson, *A Complete Edition of the Poets of Great Britain*, XI (1795), 103.)

[4] T.B. XXXIV, pp. 50–5 (1797). Nothing came of this proposal.

[5] Turner had published a *Holy Island Cathedral* in the *Liber* in 1808 (R. 11), but
no other Lindisfarne subjects were introduced.

[6] *View of Oxford from the Abingdon Road* (B.-J. No. 125).

have it immediately after the High St should be finish'd. Therefore
I began it at Xmas. But respecting the venerable Oak or Elm you
rather puzzle me. If you wish either say *so* and it shall be done, but
fancy to yourself how a large Tree would destroy the character! That
burst of flat country with uninterrupted horizontal lines throughout
the Picture as seen from the spot we took it from! The Hedgerow
Oaks are all pollards, but can be enlarged if you wish. As to figures,
I have not determined upon them—and even with them. If you have
any predilection for any, or *objects* it is the same to me, or if, for I
suppose the ⟨drawing⟩ have carved some out for me in idea at
least, so their opinions may be taken, reserving to myself the use or
adaptation of them as most fit or conducive to my subject as to
color, &c. &c. . . .

Mr Pye called today with a proof.[1] The Spire is much better and
it begins to look rich, clear and full. How long he will be yet I know
not, but as to intend me to send the Picture to the Exhibition you
must make haste with the Frame, for the Pictures are to be sent on
the 5th and 6th of next month. The size is the same as the other
picture, viz. 3 Feet 3 by 2 Feet $2\frac{3}{4}$ in the straining frame, and to hide
part of the sky like the High St. for it would be scarcely worth while
to make the inch in the sky—to change the size of frame.[2]

<div align="right">

Your most obliged
J. M. W. Turner

</div>

45. Turner to James Wyatt

MS. British Library Add. MS. 50118, fos. 33–4
Publ. Thornbury 1877, pp. 168–9

<div align="right">

Friday, April 10, 1812

</div>

Dear Sir

I received yours last night upon my return from the Royal
Academy where your two Pictures[3] now are, let me therefore *thank*
you for the enclosed Bill it contained. As to the Frame it is very
handsome and makes the Picture look very well but I fear that by
the time it gets back to Oxford the centre ornament will be wanting,
for it projects beyond the back, so it has no guard.

Mr Pye called to-day with proof with the alteration of the pave-

[1] i.e. *View of the High Street, Oxford* (R. 79).

[2] The present size of the *View of Oxford from the Abingdon Road* is 66×97.8 cm
($26'' \times 38\frac{1}{2}''$).

[3] *View of the High Street, Oxford* (B.–J. No. 102) and *View of Oxford from the
Abingdon Road* (B.–J. No. 125).

ment and that has improved *it*. He talks of sending you *one* down shortly for your inspection, and he hopes approval.[1]

> Your obliged,
> J. M. W. Turner

46. Turner to James Wyatt

MS. British Library Add. MS. 50118, fos. 35–6
Publ. Thornbury 1877, p. 174

Dear Sir

Your Pictures are hung at the Academy, but not to my satisfaction at least. I therefore write to you, for as I did not wish to counteract your wishes or expectation as to the benefits which you suppose might probably result from their being exhibited at the Royal Academy— consequently they were sent, and if you still think, notwithstanding their situations are as unfortunate as could possibly be allotted them (from the Pictures close to them), that their remaining there may be advantageous to you—*there they shall remain*, but if indifferent about their being exhibited *there*, *with me* or at the *British Institution next season*, I must confess I should like to have the option of withdrawing them; provided nothing can be done to make them (and another which I have sent[2]) more satisfactory in point of situation to my feelings. I must request an answer by post to Queen Ann St West, and beg that you will think of your-self *first* and afterwards for

> Your most truly obliged
> J. M. W. Turner

Monday April 13, 1812

47. Turner to W. B. Cooke

MS. British Library, Add. MS. 50118, fos. 37–8
Publ. J. Ruskin, *Dilecta*, Pt. II, 1887, §125

> [?16 or 23 November 1813]
> Wednesday morning

Dear Sir

I have taken the earliest opportunity to return the touched proof and corrected St Michael's Mount.[3] I lament that your brother could

[1] The date on the published version of the engraving after the *High Street* had been 14 Mar. 1812.

[2] Probably *Hannibal* (B.–J. No. 126). In the event all the pictures seem to have stayed for the duration of the Exhibition.

[3] R.88, published 1 Jan. 1814.

not forward the Poole,[1] or Mr Bulmer the proof sheets, for if the two
cannot be sent so as to arrive here[2] before *Tuesday next*, I shall be
upon the *wing* for London again, where I hope to be in about a
fortnight from this time, therefore you'll judge how practicable you can
make the sending the parcel in time, or waiting untill I get to Queen
Ann Street; as to your number coming out on the 10th of December
I think [it] impossible;[3] but to this I offer only an opinion? what
difference could it make if the two numbers of the Coast, Daniel's[4]
and yours, came out on the same day?—All I can say, I'll not
hinder you, if I can avoid it one moment. Therefore employ Mr Pye
if you think proper, but, as you know there should be some objection
on my part as to co-operation with him without _____ ...[5]
yet to forgo the assistance of his abilities for any feeling of mine, is by
no means proper to the majority of subscribers to the work.

<div align="right">Your most truly obliged
J. M. W. Turner</div>

PS I am not surprised at Mr Ellis writing such a note about his
signature. be so good as [to] put the inclosed—into the Twopenny
Post Box. The Book which I now send be kind enough to keep for
me untill I return as I expect it to be usefull in the description of
Cornwall.[6]

[*Addr.*] Mr W. Cooke

48. Turner to W. B. Cooke

MS. Untraced (Maggs Bros. 1931, No. 1436; Copy: Bembridge, Ruskin MS.
54/E, fo. 10)

<div align="right">Saturday Dec. 4 [1813]</div>

Dear Sir
 I agree to your wish respecting the correction of Poole by Mr Bulmer
if you'll undertake to look over it afterwards, to acquiesce to Mr

 [1] R.89, published 1 Jan. 1814.

 [2] Turner was staying at Farnley Hall, Yorkshire.

 [3] The first part of the *Southern Coast* appeared on 1 Jan. 1814, and the second on
1 Mar.

 [4] The first part of William Daniell's *A Voyage Round Great Britain Undertaken in the
Summer of 1813, and Commencing from Lands End* appeared in 1814.

 [5] The gap here is in the manuscript. Pye may already have been working on *Oxford
from the Abingdon Road* (see Letter 44).

 [6] Possibly W. G. Maton, *Observations relative chiefly to the natural history, picturesque
scenery and antiquities of the Western Counties of England*, 1797, which was indeed quoted
in the letterpress to the Cornish plates of the *Southern Coast*, notably the *St. Michael's
Mount*.

Arch's proposition—not that it is pleasant to me but to prevent the delay resting at my door, for the plea of Mr Bulmer waiting for the printing of St Michael when he had the MS of Poole at least a fortnight by him without sending or printing a proof sheet is rather futile. So that all stoppage to the publication of the *first* Number being *now* removed on my part respecting the description of Poole, I likewise send back (*by post*) to prevent any [delay] by waiting for the carrier (until Tuesday) the print of your Brother's engraving,[1] which I received only last night and as I do not recollect his direction in Gerwileth I shall in sending it to you beg you to assure him that I feel a reluctance to touch upon the sky or distance until he has done all he wishes or intends to do, and if he is confident in sending a fair translation of the drawing, that I have no wish to give him, you, or myself, the trouble of another parcel. The alterations I have made to the Poole I leave entirely to your decision and when *to print it* and St Michael with their *descriptions*,[2] for my anxiety is particularly directed to remove the impression of delay which Mr Arch may conceive doth rest with

> Yours most truly
> J. M. W. Turner

49. Turner to W. B. Cooke

MS. Untraced. (Maggs Bros. 1931, No. 1437)
Publ. J. Ruskin, *Dilecta*, Pt. II, 1887, §126

Thursday Eg. Dec. 16, 1813

Dear Sir

From your letter of this morning I expected the pleasure of seeing you, but being disappointed, I feel the necessity of requesting you will, under the peculiar case in which the MSS of St Michael and Poole are placed, desire Mr Coombe to deviate wholly from them;[3] and if he has introduced anything which seems to approximate, to be so good as to remove the same, as any likeness in the descriptions

[1] Probably George Cooke's *Land's End* (R. 90), published on 1 Mar. 1814.

[2] These descriptions were either from, or closely based on, Turner's long poem in T.B. CXXIII. His verses on *Poole*, for example (T.B. CXXIII, p. 52a; Thornbury 1877, p. 209) allude to 'the groaning waggon's ponderous load', which appears in the plate. See Letter 49.

[3] After reading Turner's caption to *St. Michael's Mount* (T.B. CXXIII, p. 132a, partly published in Thornbury 1877, p. 217), William Combe, the journalist to whom Cooke submitted the copy for editing, wrote back that it was 'the most extraordinary composition I have ever read. It is imposible for me to correct it, for in some parts I do not understand it ... In my private opinion, it is scarcely an admissible article in its present state; but as [Turner] has signed his name to it, he will be liable to the

(though highly complimentary to my endeavours) must compell me to claim them—by an immediate appeal as to their originality. Moreover, as I shall not change or will receive any remuneration whatever for them, they are consequently at my disposal, and ultimately subject only to my use—in vindication; never do I hope they will be called upon to appear, but if I ever offer'd that they will be looked upon with liberality and candour, and not considered in any way detrimental to the interests of the Proprietors of the Southern Coast work.

Have the goodness to return the corrected proof of St Michael's which I sent from Yorkshire with the MS of Poole; and desire Mr Bulmer either to send me all the proof sheets, or in your seeing them destroy'd you will much oblige

Yours most truly
J. M. W. Turner

50. Turner to John Young

MS. New York, Metropolitan Museum of Art

Jany 14 1814

Dear Sir
I have sent you one Picture subject Appulia in search of Appullus[1]
F I FI
size of Frame 6 10 by 9 3 the Price 850 Guineas and I send it as a Picture for the Premium offer'd by the Hon^bls the Directors[2]

your most truly
J. M. Turner

[*Addr.*] J. Young Esq^r

sole blame for its imperfections.' The present letter led Cooke to write to Combe requesting him 'not to insert a syllable of [Turner's] writing', in the letterpress, and in the event Combe provided prose descriptions of his own, sometimes using poems by other writers (Thornbury 1877, pp. 189–90).

[1] B.–J. No. 128. Turner did not sell it.

[2] The composition is closely modelled on Claude's *Jacob with Laban and his daughters* at Petworth, and Turner may have been thinking of the earlier conditions of the British Institution prize competition, which had stipulated that entries should be 'proper in point of subject and manner to be a companion' to one in the Old Master exhibition (B.I. Minute Book, 2 Mar. 1807; Victoria and Albert Museum, MS. R.C.V. 11, i. 189). In 1813, however, the competition rubric had stipulated simply 'the best landscape' (2 Mar.). *Jacob with Laban* may have been the Claude which Egremont had lent to the B.I. Old Master Exhibition in 1808 (ibid. 12, ii. 49). He had been Visitor to the Institution since June 1813 (ibid. iii. 108), and was appointed one of the Prize judges for 1814 (ibid. n.p.). He did not, however attend the judging on 28 Mar. 1814, when the 100 g. landscape prize went to T. C. Hofland's *Storm off the Coast of Scarborough*. Turner's entry was disqualified as it appeared 'not to have been sent to the Gallery 'till the 15th of January last, being Eleven days after the time fixed by the Directors' (ibid., n.p.).

51. Turner to W. B. Cooke

MS. Victoria and Albert Museum MS. 86. CC. 20 II

[?1814] the 9 of April Saturday Morning
8 o'clock

Dear Sir

I must request to defer my proposed visit this evening in York Place until *Tuesday* for I particularly wish to go to Twickenham *to day* being prevented yesterday

Yours in great haste
J. M. W. Turner

[*Addr.*] April 8 o Clock Morning
Mr W. Cooke
12 York Place
Pentonville Post Paid.

52. Turner to A. B. Johns

MS. Royal Academy Scrapbook 82 c
Publ. (Extracts) Falk, p. 167; Finberg 1939, p. 229

[? October 1814]
Sandycombe

Dear Johns

After an almost fruitless search for Opie Lectures[1] my finding them only added to my mortification and to you[r] disappointment for alas, being troubled with a fit of scribbling at the time I read them (and having no paper at hand the margin bears marks of *gall* in divers places—you'll say—this is but a poor excuse for breaking my promise but it is the best I can offer you to my mind as it is the truth, however I trust that Sir Jos. Reynolds works which I now send you will be of more real [service: *deleted*] assistance—yet if you are so wedded to Opie, I will endeavour to borrow them, but which will be sending Coal to Newcastle, for Sir William Elford[2] subscribed for his Lectures as per list, therefore I presume you can get them nearer home so you could Sir Joshua's, but having heard you ask Mr Tigncombe [?Fishcombe] if you might refer to them at the Library and mine being a new Edition with his Life by Malone and his Flemish

[1] John Opie, *Lectures on Painting* (1809). Turner's annotated copy is in the collection of C. W. M. Turner Esq.
[2] Sir William Elford (1749–1837), Plymouth banker, Tory politician and amateur artist, exhibiting frequently at the Academy. Turner and he had met by 1811 (Finberg 1961, p. 179).

Journey—account of Pictures &c[1] induced me to send them to you, in part a rub-off and impartially thinking them of most service—and with them a number of the Examiner to shew how the High-mightiness of Art are treated in the hot bed of scurillity *London*[2]—and to those un-acquainted with the regulations of the Academy it must have a tendency to think ill of all *artists* (as drones fattening in the Academic *hive*) this system of detraction by comparison and personality no one should countenance, those that do cannot value art or have any feeling or concern for the failings of nature or respect exertions in any department, that after a long life, 'not passed in inglorious sloth' that any man's reputation should be immolated to enhance the value of a penny sheet of paper to 8 pence ½ is no cheering prospect. and the public to relish it (even as a joke upon Joe[3]) deplorable indeed—another Editor. the Champion has broached a new doctrine 'that as Encouragement never made Genius—it is unnecessary[4] ... that to look at ancient art useless because Genius will always find its own path and that *poverty* is its best guardian

 As one in darkness long immured

 Peeps through a cranny hole and calls it day

so R.A. may hail the new light to Genius being amply possesst of the main stimulus: so like the Cornish curate and congregation we shall start (without encouragement) *fair*[5]—Sincerely hoping this will find you and Family all well

<div align="right">

I am yours sincerely

J. M. W. Turner

</div>

[1] Probably the fourth edition, of 1809.

[2] Perhaps a reference to a letter to *The Examiner* of 2 Oct. 1814, upbraiding the Academy for pretending to open its meagre library to the public: 'Now, Gentlemen, as you have got plenty of money in the Funds—as you have of late taken such especial care of yourselves, by increasing your official fees—as you have added to your hackney-coach allowances, your visiting payments, and your annual stipends—as you have, in short, provided for all your lame, your halt and your blind—(turning, according to some your Royal Academy into a Royal Hospital)—as you have done all this, pray take the melancholy condition of your *Library* into consideration, and spare a few pounds for the good of Art ...' (pp. 632–3).

[3] Possibly a reference to *The Examiner's* attack on 12 Feb. 1814 on Turner's conduct in the matter of the British Institution prize (see Letter 50): 'though the letter of the law may allow Mr TURNER to be a candidate, the spirit of it cannot. Every man must feel the painful situation in which the Royal Academy is placed by the degrading conduct of its Professor of Perspective ...' (pp. 107–8).

[4] William Hazlitt had published two articles in *The Champion* for 28 Aug. and 11 Sept. 1814, under the title of 'Fine Arts: Whether they are promoted by Academies and Public Institutions' (*The Complete Works of William Hazlitt*, ed. Howe, xviii (1933), 37–48). In the second of them he especially attacked the use of models from earlier art. On 25 September 'A Student of the Royal Academy' answered, chiefly by reference to Reynolds, and Hazlitt replied on 2 Oct. (ibid., pp. 48–51).

[5] See also Letter 90.

Give my respects to Mrs Johns. be so good as to thank her for me "say that I got rid of my cold by catching a greater one, at Dartmouth being obliged to land from the boat half drownded with the spray as the gale compeled the boatmen to give up half way down the *Dart* from Totnes. but that upon my return home by a little *care* I have got the better of both. remembrance to all *friends*

Mr Cooke having sent a Proof[1] after me to Plymouth directed to the Mail Coach office carr. paid I will thank you to get it and let me have it for him when it may be convenient for you to send either with your *Picture*[2]—the *books* or left until my next trip to Plymouth as he is anxious tht the Proof should not be lost.

Mr A. B. John's

53. Turner to W. B. Cooke

MS. Mr. Kurt Pantzer

[?1814]

D[r] Sir The second Volume of Liber Studiorum is in hand at least some Plates for it[3] the Price will be the same as the last to the original Srs, to others ... £1. 1s. 0 which is the present price for new Subscribers but probably it will be raised ... if it proceeds into the Fly Sheet do tell what the expence will be before I give the order for 250 I[mperial] and 500 Royal for I should like to know if possible first

your truly
J. M. W. Turner

5 plates in a number S[d]Vol. *10* Numbers

54. Turner to George Cooke

MS. British Library Add.MS.50118, fo.42

Tuesday 23 May 1815

Dear Sir

I have just now received your Note from Richmond—I am so much

[1] Possibly *Corfe Castle* (R. 93) or *Lyme Regis* (R. 94) for the *Southern Coast* series, published on 1 Nov. 1814.

[2] Johns seems to have exhibited no pictures at the principal exhibitions in London in 1815. In 1814 he had shown *View Near Bickham, Devon, the Seat of Sir W. Elford* at the Academy, but he showed nothing further there until 1822. His first exhibit at the British Institution was in 1817.

[3] The earliest plates in hand for the second volume of *Liber Studiorum*, published in 1816 (see Letter 60), seem to have been *Solitude* (R. 53), which bears the date

in Town now that sending there makes it longer in regard to time. If
you send therefore to Q A Street I shall be able to see the Proof[1] and
return it touched this week.

<div style="text-align: right">

Yours
J. M. W. Turner

</div>

[*Addr.*] Mr G. Cooke

55. Turner to James Holworthy

MS. Untraced
Publ. Monkhouse, p. 401

Dear Sir
 I am very sorry I cannot avail myself of your kindness to-day as I
must go to Twickenham, it being my father's birthday.

<div style="text-align: right">

Yours most truly
J. M. W. Turner

</div>

Thursday morning

56. Turner to H. S. Trimmer

MS. Untraced
Publ. Thornbury 1862, ii. 41–2; C. Monkhouse, *Turner* (1879), p. 90 (this
version is used here)

<div style="text-align: right">

Tuesday. Aug. 1 1815
Queen Anne St.

</div>

My Dear Sir
 I lament that all hope of the pleasure of seeing you or getting to
Heston—must for the present wholly vanish. My father told me on
Saturday last when I was as usual compelled to return to town the
same day, that you and Mrs Trimmer would leave Heston for Suffolk
as tomorrow Wednesday. In the first place, I am glad to hear that
her health is so far established as to be equal to the journey, and
believe me your utmost hope, for her benefitting by the sea air being
fully realized will give me great pleasure to hear, and the earlier the
better.
 After next Tuesday—if you have a moments time to spare, a line
will reach me at Farnley Hall, near Otley Yorkshire, and for some

12 May 1814; *Solway Moss* (R. 52); *Norham Castle* (R. 57) and *Ville de Thun* (R. 59),
the etchings of which are on paper watermarked 1810.
 [1] Possibly *Teignmouth* (R. 95), published 1 June 1815.

time, as Mr Fawkes talks of keeping me in the north by a trip to the
Lakes &c[1] until November therefore I suspect I am not to see
Sandycombe. Sandycombe sounds just now in my ears as an act of
folly, when I reflect how little I have been able to be there this year,
and less chance (perhaps) for the next in looking forward to a Con-
tinental excursion, & poor Daddy seems as much plagued with weeds
as I am with disapointments, that if Miss——[2] would but wave
bashfulness, or—in other words—make an offer instead of expecting
one—the same might change occupiers—but not to tease you further
allow (me) with most sincere respects to Mrs Trimmer and family,
to consider myself

Your most truly obliged
J. M. W. Turner

[*Addr.*]　Rev. Mr Trimmer
Southwold,
Suffolk.

57. Turner to Henry Woollcombe

MS. Mrs Woollcombe

Queen Ann Str West
Oct 26. 1815

My Dear Sir
I lament exceedingly that my absense from home has prevented my
assuring you how ready I shall always feel in joining any object which
my friends at Plymouth may think conducive to the promotion of
art——— John's is dated the 24 of Sept. where he says we are about
beginning an Exhibition[3] which leads me to suppose that you may
have not, tho a month has elapsed, yet begun. If not, and you will
favour me by saying which Picture you think most calculated for the
object you and my friends at Plymouth have in mind, it shall be

[1] T. B. CXLIV seems to be the sketchbook used on this trip, and Turner did not
visit the Lakes.

[2] Trimmer's son made a vague suggestion that this lady was his maternal aunt by
whom Turner was 'much smitten' (Thornbury 1877, p. 128), and the apparent oblitera-
tion of her name in the letter lends colour to this. Finberg (1961, p. 227) rejects
the idea that more than a sale of property was involved. There is a possibility that
Turner was referring to Clara Wells (q.v.), who was still alive when Thornbury wrote,
and in touch with him, and whose name would thus be protected, for Rawlinson
(1906, p. xi) mistakenly makes her Trimmer's daughter, and may have been connect-
ing her with this letter.

[3] The first Exhibition of the Plymouth Institution, which had been founded by
Woollcombe in 1812. Cf. Letters 58, 59.

forwarded as you may direct——for amongst those who feel so zealous in the cause of Art and its true welfare I shall be proud to be (or have) one.

<div style="text-align: right">

I am
my dear Sir
Your most hum^b ser
J. M. W. Turner

</div>

H. Woolcombe

58. Turner to A. B. Johns

MS. Preston, Harris Museum and Art Gallery

<div style="text-align: right">Queen Ann St Oct 26 [1815]</div>

Dear Johns

I have this day written to Mr Woolcombe[1] to state my readiness to send any Picture thought most worthy or best calculated for the intention which my friends at Plymouth may entertain for the advancement of Art—and had I order'd my Letters to be sent in chace during my rambles this summer, I could have answered *his* and yours earlier, which I lament—For if your Exhibition has commenced the case is somewhat changed—novelty then has ceased and can revive only by quantity, variety and quality, which public Exhibitions always require——

!!!!!! six notes of admiration and measure five feet by seven

<div style="text-align: right">vide John's Letter Sep^r 24</div>

or in other words the Large Picture mania—which Dear Johns I wish you well through—remembering Northcotes [saying: *deleted*] wit, !!Ah after staring for months and months at a piece of canvas an admirer determines in a moment. See [?] it is a pretty picture yes sure.[2]

C. Eastlake is painting the Ex. great man but whether on board the Bellerophon—at Malmaison or (looking at the wooden House) at St Helena—Mr Woolcombe did not mention,[3] but gives a good account of the merits of the work which indeed I am particularly glad to hear for Charles Eastlake has certainly Merit which will ultimately succeed if praise, often the bane as well as stimulus doth

[1] Letter 57.

[2] Cf. *Conversations of James Northcote with James Ward*, ed. Fletcher (1901), p. 218: 'I have frequently shut myself up in a dark room for hours, or even days, when I have been endeavouring to imagine a scene I was about to paint, and have never stirred till I had got it clear in my mind; then I have sketched it as quickly as I could, before the impression has left me.'

[3] Eastlake's portrait of *Napoleon on Board the Bellerophon* is now in the National Maritime Museum at Greenwich.

not warp him from the direct road of Art. do let me thank you and
my friends at Plymouth for their kind anxiety to see me again in
Devon, but that pleasure I must not promise myself this winter, and
next summer perhaps I may see the Louvre without the Pictures as
I saw it with them.[1] !! what a change in one twelve-months time:
past all expectancy, so you [must] come and see me at Sandycombe
[in the spring]—I pray Mr Ball if he has compleated his picture of
Jael [and] Sisera for the exposée.[2] do pray give my thanks to him
and particuary to Mrs John's who I hope and the family are well
for their kind remembrance and to all friends at Plymouth

<div align="right">

and belive me to be

Your most truly obedy

J. M. W. Turner

</div>

PS The parcel and Books arrived safe

[*Addr.*] Mr A. B. Johns
Northill Cottage
Plymouth
Devon

59. Turner to A. B. Johns

MS. Christopher Norris Esq.
Publ. Armstrong, p. 24

<div align="right">

Nov^r 4 1815

</div>

Dear Johns

I am glad to hear of your success and C. Eastlake's particularly
fortunate and I may say I believe unprecedented good luck[3]—
Appianni [the: *deleted*] a Milanese who painted the same subject viz.
Buonaparte—tho report stated the picture [had *deleted*] 15.00 yet
report only was its friend and it still remains—I fancy in the City
unsold.[4]

[1] Turner had studied the Napoleonic plunder in the Louvre in 1802; he knew that
after Napoleon's downfall it would be returned to its original owners.

[2] James Ball's *Jael and Sisera* was shown at the British Institution in 1817.

[3] Eastlake's first major success was earning some £1,000 by the exhibition of his
Napoleon in London (Lady Eastlake, 'Memoir of Sir C. L. Eastlake', in C. L. Eastlake,
Contributions to the Literature of the Fine Arts, 2nd ser. (1870), p. 56).

[4] Andrea Appiani's half-length portrait of Napoleon as King of Italy (1805) was
discussed at an Academy Club dinner at which Turner was present where it was
'reported that two merchants are competing which shall give £1500 for it'
(Farington, 7 June 1815). The portrait was exhibited at the Saloon of Fine Arts in
London in 1818, and at the Sackville Gallery in 1930.

Your letter arrived the day after the case left London containing not what you expect or perhaps will like—as you seem to have thought only of Dido[1] ... whose unweildy frame-work might e'en of itself produce a miscarriage in so long a Journey—The Frost-piece[2] I never thought of—so being generally wrong—you will find—alas, every thing contrary to your wishes, which I am believe me sorry for. But even had I been less quick in dispatching the *two* I have sent viz the picture [in the] Exhibition last year. Bligh Sands[3] and Jason[4] an old-favourite with some—still I could not have send any 30 or 40 Guineas Pictures for I have none by me for upon so short a notice— for the neglect of sending my Letters after me to Yorkshire has placed me as usual in the rear as well as prevented me getting any thing forward in that ratio of price—However you may do exactly as you please about them ... only have the goodness to consider the pictures sent *as under your care* and if they contribute one Shilling more to the Treasury of the Exhibition at Plymouth I shall feel happy and proud of being an adjunct with the intentions of my worthy friends in Plymouth towards establishing or promoting the Arts

<div align="right">

I have the pleasure to be
Your most truly obliged
J. M. W. Turner

</div>

P.S. Upon further inquiry at the White Horse Celler Russell's Waggon left Town yesterday at noon—the case is directed to you Northill Cottage North-Hill it is in future to be called by your writing it thus—(Solus viz Sandycombe)[5] Pray give my respects to Mrs Johns and to all friends. [*illeg. word*] the postman will not allow the time but to add success attend you. You may varnish the Jason with Mastic Varnish but pray don't do anything to the other but rub it with a silk Handkerchief only.

[*Addr.*] Mr A. B. Johns
North-Hill
Plymouth
Devon.

<div style="font-size:smaller">

[1] *Dido and Aeneas*, R. A. 1814 (B.–J. No. 129).

[2] *Frosty Morning* (B.–J. No. 127).

[3] *Bligh Sand, Near Sheerness* (B.–J. No. 87), shown at Turner's Gallery in 1809 and 1810, and at the R.A. in 1815.

[4] B.–J. No. 19 (R.A. 1802; B.I. 1808).

[5] The first name of Turner's Twickenham house, Sandycombe Lodge, had been Solus Lodge.

</div>

60. Turner to W. B. Cooke (?)

MS. Royal Academy Scrapbook, fo. 81
Publ. Finberg 1924, p. xxxvi

[?January 1816]

Dear Sir

I have written this[1] very hastily fearing your Boy would come before I could well begin. You may alter anything you like—but don't add anything like Puffing of the work or say that I have engraved any of the plates.[2]

What I have dashed[3] had better perhaps be printed in large letters.

Yours
J. M. W. Turner

61. Turner to John Britton

MS. Boston Public Library **G.51.5 No. 35

[*Embossed* BATH]
[? April 1816]

Dear Sir

An engagement will prevent me dining with you on Monday but you may consider me a Sub[r] to the print.[4]

[*pencil*] Posthaste
Yours Sinc [?]
J. M. W. Turner

62. Turner to Artists' General Benevolent Institution

MS. (Minute of Stewards' Meeting) Artists' General Benevolent Inst.

[4 June 1816]

[A letter was read from J. M. W. Turner Esq., Chairman of the

[1] The draft advertisement for Parts 11 and 12 of *Liber Studiorum*, to be published on 1 Feb. 1816.

[2] Turner had in fact engraved *Entrance to Calais Harbour* (R. 55), *Berry Pomeroy Castle* (R. 58), and *The Source of the Arveron* (R. 60) in these parts.

[3] *Historical, Mountainous, Pastoral, Marine,* and *Architectural*, underlined in the manuscript, were not given any special treatment in the published advertisement, inserted in a part of Cooke's *Southern Coast* (Finberg 1924, p. xxxv).

[4] Endorsed by Britton: 'Shakespere portrait'. On 23 Apr. 1816 (Shakespeare's birthday, and Turner's) Britton published an engraving by W. Ward, A.R.A. after Thomas Phillips's painting of the cast of Shakespeare's bust in Stratford-upon-Avon Church.

Directors, expressing peculiar concern in the necessity He was under of informing the Stewards that an unavoidable engagement prevented him from dining with the Subscribers; at the same time conveying to them his sincere thanks for their exertions in behalf of the charity, ... and enclosing a second donation of three guineas[1] ... with a donation of two guineas from J. J. Wheeler Esq[r2] and an annual subscription of five guineas from Mr Fawkes of Farnley Esq[re].]

63. Turner to John Buckler

MS. Oxford, Bodleian Library Dep. a 40, fo. 213

Monday Morning July 8 1816

Dear Sir

If you can conveniently favour me with a call in Queen Ann St. West tomorrow or Wednesday about 12 O'Clock I should esteem it an obligation conferred upon

Your most truly oblig'd
J. M. W. Turner

J. Buckler Esq &c &c[3]

[*Addr.*] J. Buckler Esqr.
Spa Place
Bermondsey

64. Turner to Benjamin West

MS. British Library, extra-illustrated copy of Thornbury, *Life of J. M. W. Turner, R.A.* (Tab. 438a.1), ix. 14

Queen Ann St West
July 11 1816

Dear Sir

Not being so fortunate as to meet with you at home to return you my thanks in person for the Medal sent to me on Monday in commemoration of your twenty-fifth year as President of the Royal

[1] By 1818 Turner had made four donations totalling 14 guineas (*An Account of the General Benevolent Institution*, 1818, p. 22).

[2] Possibly a member of the Wheeler family into which Clara Wells (q.v.) was to marry.

[3] This request may refer to Whitaker's *History of Richmondshire*, for which Turner had been commissioned to make drawings in May 1816 (Finberg 1961 p. 242; Rawlinson i. 89–90), and on which Buckler was also engaged.

Academy[1]—I now take the opportunity of assuring you that your kind attention to me as an artist[2] and likewise the present honourable notice of me as a Member of the Royal Academy will be ever most sincerely acknowledged and felt by—

Dear Sir, your most truly obliged
J. M. W. Turner

B. West Esq
President of the Royal Academy &c &c &c &c.

65. Turner to James Holworthy

MS. British Library Add. MS. 50118, fos. 44–5
Publ. Monkhouse, p. 401

Richmond, Yorkshire (not Sandycombe)
July 31, 1816

Dear Holworthy

I find it impossible to be [*sic*] meet you at Mr Knight's[3] by the time you wished; therefore have the goodness to make your arrangements without any consideration towards my supposed time of return, for my journey is extended rather than shortened by an excursion into Lancashire,[4] which renders it wholly out of my power at present to say when I can be at Llangold [sc. Langold]. However, I should be very happy to have the honor of hearing from you (by a letter to me at Mr Fawkes') of your movements in whatever direct they may tend, and believe me to be, Your most truly obligd

J. M. W. Turner

P.S. Weather miserably wet; I shall be web-footed like a drake, except the curled feather; but I must proceed northwards. Adieu!

[*Addr.*] J. Holworthy
39 York Buildings
New Road
London.

[1] West had become P.R.A. in 1792, but seems to have overlooked the break in his office in 1806. He was much in the habit of striking medals in self-commemoration (cf. J. T. Smith, *Nollekens and his Times* (1829), ii. 384, 396–7).

[2] West had spoken very highly of Turner's *Bridgewater Sea-Piece* (B.–J. No. 14) in 1801 (Finberg 1961, p. 71), but by 1807 he had become an outspoken critic (ibid., pp. 125. 133. 135).

[3] Henry Gally Knight (1786–1846), author, of Langold Hall, Yorkshire. Knight supplied the sketch from which Turner painted the *Temple of Jupiter Panellenius*, (R.A. 1816, B.–J. No. 134).

[4] See T.B. CXLV and CXLVIII.

66. Turner to W. B. Cooke

MS. Victoria and Albert Museum, MS. 86.CC.20.II

Farnley Hall Augt. 28 [1816]

Dear Sir

I did not recieve yours until Monday (yesterday morning) owing to my absence from here, as an unfortunate accident to the worthy family in the loss of a relative[1] which probably you saw related in the papers—made it better for me to leave for a few days—and take my Yorkshire trip for your friends the Longmans[2] &c which certainly retarded the Print of Dock[3] [*illeg. word*] returned—but as to any drawing, that was quite impossible for I had left all my sketches of Devonshire[4] in London. They however came with your parcel & I found them sent as I had desired and I really do think you must notwithstanding you have waited still give me some praise for sending you a drawing by the same parcel and so *soon*—

Poor Alexanders death has hurt me very much[5]—there is gone a truly honest man indeed—pray have the goodness to send the enclosed note directed to Queen Ann St West—and believe me to be

Your St

J. M. W. Turner

67. Turner to James Holworthy

MS. British Library Add. MS. 50118, fos. 46–7
Publ. Monkhouse, p. 401

[*Postmark* Otley]
Sepr 4th 1816

Dear Holworthy

Having just returned from part of my Yorkshire sketching trip, I am more at liberty than when I wrote to you last; mind, I say wrote

[1] Richard Hawksworth Fawkes, Walter Fawkes's youngest brother, died as the result of a shooting accident on 16 Aug. 1816 (Finberg 1961, p. 244).

[2] Cf. the sketches in T.B. CXLV and CXLVIII, used for drawings engraved in Whitaker's *History of Richmondshire*, published by Longmans from 1817.

[3] Probably *Plymouth Dock* (R. 99), engraved by W. B. Cooke and published in the *Southern Coast* on 1 Oct. 1816.

[4] The next Devon subject in the *Southern Coast* was *Ilfracombe* (R. 105), published in July 1818 (Cf. T.B. CXXIII, p. 215a, CXXVI, p. 2).

[5] William Alexander, who had made the *Southern Coast* drawing of *Carisbrooke Castle*, published on 1 Nov. 1814, had died of a fever on 23 July 1816.

to you, because I have received an accusatory message 'that you expected to hear from me'. I must admit (tho I requested you would suit yourself as to time at Mr Knights, you to let me know when) I did not say precisely that Mr Fawkes lived at Farnley Hall, near the market town of Otley, in the West Riding of the County of York, and for which omission you have thought to punish me by your silence when, how or where, you are, was or will be; so I beg leave to say that having finished nearly what I proposed doing this season in Yorkshire, think I can do myself the pleasure of waiting upon Mr Knight at Llangold within a fortnight. If I were to meet you there *it* would be much enhanced to me, and only do not say the times is too short, that I never wrote, or am not yours most truly,

J. M. W. Turner

P.S.—And I want your advice about my calling or not at Belvoir.

68. Turner to James Holworthy

MS. British Library Add. MS. 50118, fos. 48–9
Publ. Monkhouse, p. 401

[*Postmark* Sept. 11 1816]
Monday morning

Dear Holworthy—I wrote yesterday only to Mr Knight, for until then I was uncertain as to time, but your letter sets at rest all expectation of the pleasure of my being at Langold, this time at least, and as to Belvoir, I am ready to confess I did not, until the intimation of your intention and *all* you say respecting the kindness &c which requires some *attention*, that I had bent my thoughts that way, for Sir John[1] not calling, sending, or did in any degree trouble himself after he had the drawings, most assuredly helped much to keep the tenor of my road *home* direct—gone, therefore, are those intentions by your saying, 'You wish to meet me there', and as probably I shall not hear from Mr Knight, or if I do that his absence from Langold leaves me at your service (Thus, for if I understand your exquisite fluorishes of α and ∂ (not to find fault) but they put me in doubt as to the time you mean to be at Belvoir viz. Friday next ∂ Friday week α on Saturday shall be at Belvoir. Now if you really *will* be there on Saturday next (and Mr Knight is not at Langold), I *will* be at Belvoir on the Tuesday following—only do let me know of your possitive intention in that respect immediately. I must beg to

[1] The Revd. Sir John Thoroton, chaplain to the Duke of Rutland at Belvoir Castle.

say immediately, for I shall leave Farnley on Sunday morning next; therefore pray calculate as to the possibility of my receiving an answer in time, or, to the post-office at Doncaster. If I do not hear from you at either place I shall conclude you cannot be at Belvoir, and shall then continue my rout homewards when I shall the next morning call at your house. I am very sorry the Rumaticks have trespassed upon your great repose, but a little [*word smudged*] the True Briton, Lord Nelson, Highflyer may be of service. As to the weather there is nothing inviting it must be confessed. Rain, Rain, Rain, day after day. Italy deluged, Switzerland a wash-pot, Neufchatel, Bienne and Morat Lakes all in *one*. All chance of getting over the Simplon or any of the passes *now* vanished like the morning mist, and in regard to my present trip which you want to know about, I have but little to say by this post, but a most confounded fagg, tho on horseback. Still, the passage out of Teesdale leaves everything far behind for difficulty —bogged most compleatly Horse and its Rider, and nine hours making 11 miles—but more of this anon. The post calls me away, and only says tell Holworthy to write by the like return of mail.

<div style="text-align: right">Ever yours &c</div>

<div style="text-align: right">J. M. W. Turner</div>

69. Turner to R. H. Solly

MS. New York Public Library, Ford Collection

<div style="text-align: right">Queen Ann St West Dec^r 19 1816</div>

J. M. W. Turner has the honor to address Mr Solley the Chairman of the Artists Benevolent Fund and to enclose by order of the Directors of the Artists General Benevolent Institution an extract of minutes indicative of their sentiments in regard to a Union of the said Societies[1] and he is desired to request that all communications respect-

[1] A Special Meeting of the Directors of the Artists' General Benevolent Institution on 7 Dec. 1816, had resolved, 'it appears to this Meeting, that it would be highly conducive to the interests of this Institution, and the "Artists' Benevolent Fund", that the two Societies should form a union, for the purpose of consolidating the views for which they were established' (Minute Books at Artists' General Benevolent Institution). Deputations from each society, including Turner and Solly as Chairmen, met, but nothing came of the move. The Artists' Fund had been founded in 1810 as a joint stock fund whose assistance was available only to investors and their dependants. The Artists' General Benevolent Institution had been founded in 1814 for voluntary subscriptions to assist 'Decayed Artists of the United Kingdom whose works have been known and esteemed by the public' and their widows and orphans. See also Letters 153, 157, 167, 221, 222.

ing the same be sent to their Secretary address'd to the Chairman of the Artists General Benevolent Institution

T. H. Solley Esq^re Chairman to the Artists Benevolent Fund.

70. Turner to James Holworthy

MS. British Library, Add. MS. 50118, fo. 49
Publ. Monkhouse, p. 402

[*Postmark* Nov. 21 1817]

Dear Holworthy

I hope no implacability will be placed to my long silence, almost as long as yours e'er you wrote to me or to Mr Knight: but your letter with his has been sent about after my fugitive disposition from place to place, and only overtaken my aberations at Farnley, too late for anything. Mr Knight's admonition to come e'er the leaves do fall leaves me like the bare stems (late so gay[1]) to the gust of his displeasure, if he ever is displeased, for I do wish to return to town. 'No leaves', no day, no weather to enjoy, see or admire. Dame Nature's lap is covered—in fact, it would be forestalling Langold to look at the brown mantle of deep strewed paths and roads of mud to splash in and be splashed.—As you have got me in the mud, so you, I hope, will help me out again, and place me in as good a position as possible. Very likely he is in town by this time; if so, do call in my behalf, and you may say truly that I had written a letter to say I could be with him at Langold from the 23rd to the 29th October, but Lord Strathmore called at Raby[2] and took me away to the north; that the day of the season is far spent, the night of winter near at hand; and that Barry's words are always ringing in my ears: '*Get home and light your lamp*'.[3] So Allason has found the art of construction practically arranged, its members defined and beautifully proportioned.[4] When

[1] Cf. Shakespeare, *Sonnet* lxxiii: 'When yellow leaves, or none, or few, do hang/Upon those boughs which shake against the cold,/Bare ruin'd choirs, where late the sweet birds sang ...'

[2] Cf. T.B. CLVI.

[3] 'Go home from the Academy, light your lamps, and excercise yourselves in the creative power of your art, with Homer, with Livy, and all the great characters, ancient and modern, for your companions and counsellors' (*The Works of James Barry* (1809), i. 555). It is likely that Turner was present when Barry, as part of his lecture VI (*On Colouring*), 18 Feb. 1793, delivered the eulogy on Reynolds from which this passage is taken.

[4] Turner seems to be referring to *The Antiquities of Pola* by Thomas Allason (1790–1852), for which he had provided a frontispiece (R. 162, publ. date. 1818). Of the Amphitheatre at Pola, Allason wrote (p. 12) 'The height is divided into three

every one seems so happy, why do you delay? for the world is said to be getting worthless, and need the regenerating power of the allworthy parts of the community.

<div align="right">Yours most truly
J. M. W. Turner</div>

Farnley Hall
near Otley

71. Turner to Thomas Phillips

MS. British Library, Add. MS. 50119, fo. 78

<div align="right">[?25 January 1818]</div>

Dear Phillips
 Do have the goodness to lend me your Prints of Titian's *St Peter Martyr* and its companion *with the columns* in the background[1]— except [?] in the soft ground and &c

<div align="right">yours most truly
J. M. W. Turner</div>

PS You shall have them back to morrow[2]

72. Turner to the Earl of Darlington

MS. (Draft) T.B. CLXIV, p. 15

<div align="right">[April 1818]</div>

My Lord
 My having the picture[3] in commission forwarded led to to inquiry in Y shire
what time your Lordship might be in town this month, but feeling that possibly this [*illeg. word*] be April induces me to require your Lordship's commands as to my keeping the picture if so as she must be sent to the R.A. by the 1 of next month may I call on your Lordship that it may be ready by the time I send the Pictures to next months Exhibition.

stories, and by its particular construction, displays an uncommon lightness and elegance of effect ...' See also Letters 82, 90, 112, 122, 127.
 [1] The Pesaro Altarpiece in the Frari Church, Venice.
 [2] Turner probably wanted these prints to illustrate his fifth perspective lecture of the 1818 series, which was given on 25 Jan. (see the report in the *Morning Herald* of 26 Jan.), and in which he discussed both these compositions (Gage 1969, p. 203).
 [3] *Raby Castle, the seat of the Earl of Darlington* (R.A. 1818, B.-J. No. 136).

73. Turner to Dawson Turner

MS. Royal Academy, Anderson Catalogues, 1815, facing p. 6
Publ. Finberg 1939, p. 252

Thursday Morning. May 1818

J. M. W. Turner in presenting his respects to Mr Dawson Turner begs to say he shall feel very great pleasure in showing his works to Mr and Mrs Turner and friends and in enclosing the price of Crossing the Brook[1] & Frosty Morning[2] hopes he may have the opportunity of according with any arrangement most agreeable to Mr D. Turner and to offer in return to Mr D. Turner's kind and friendly invitation to Yarmouth his most sincere *thanks* and *esteem*.

 Crossing the Brook 6 Feet by 5F½—550 gns
 Frosty morning 4F½ by 5F½—350 gns

74. Turner to W. B. Cooke

MS. Untraced (Sotheby, 20 May 1975 (326) bt. Bennett)

Queen Anne Street West
21 July 1818

[Telling Cooke that the drawing of Hastings[3] is nearing completion, and asking when he will be paid for it and some previous work.[4]]

75. W. B. Cooke to Turner

MS. Untraced (Draft on *verso* of Letter 74)

[? 21 July 1818]

[Cooke will not alter his established method of making payments.]

[1] B.–J. No. 130. See Letter 283.
[2] B.–J. No. 127.
[3] *Hastings: Deep Sea Fishing* (T.B.M. No. 54).
[4] Cooke paid Turner £42 for 'Hastings from the Sea, for Mr Fuller's Work', which is probably identical with this *Hastings*, although it was not engraved in Fuller's *Views in Sussex*, on 31 Aug. 1818 (Thornbury 1877, p. 633).

76. Turner to W. B. Cooke

MS. Untraced (Maggs Bros. 1911, No. 509)

[22 October 1818]

You most certainly declined extending the subjects of the Rhine beyond twelve,[1] but an application has been renew'd, and therefore I do particularly wish you to give me your ultimate decision relative to it!! Take a month to consider of it. My only object in writing is that if you eventually decline that, you cannot but hereafter say that every opportunity was offered (you) before any other.

77. Turner to Francis Legatt Chantrey

MS. Untraced (Maggs Bros. 1911 No. 992)
Publ. (Facsimile) Maggs Bros. *Catalogue of Autographs*, facing p. 183; Whitley, i p. 291

Queen Ann St West London
Thursday Oct 22 1818

Dear Chantrey
 From what I heard last night viz that Mr Rhodes had left London to meet you on your way from Edinburgh I begin to fear I shall not arrive before your leave it tho I hope to be in Edinburgh by this day week ... I therefore write to beg of you to send West's Bust[2] for your diploma that we may be in the Council together.[3] I think there are
 I heard
many reasons for your sending it now, that you had once intended so to do and therefore *pray do* order the Bust to be sent directly to the Academy and leave me a note at Macgregor's or the Post Office

[1] An autograph note of the original agreement for Turner to make twelve Rhine drawings for Cooke at 17 guineas each is in British Library, Add. MS. 50118, fo. 50. In the same collection is the final contract of 9 Feb. 1819 by which Turner agreed to make thirty-six drawings (published in J. Ruskin, *Dilecta*, ch. III). But the whole scheme foundered because of a rival publication by Ackermann, and only two or three drawings seem to have been made for it (cf. Finberg 1961, pp. 256–7; T.B. CLXIX, pp. 7 ff.).

[2] *Bust of B. West Esq. P.R.A.* (R.A. 1818, Burlington House).

[3] Chantrey had been elected R.A. in February 1818, but was not eligible to serve with Turner on the 1819 Academy Council until he had submitted his Diploma work. The bust was sent in time and Chantrey served on the Council.

that you have or will do so or I shall try if a letter will find you at Sheffield.[1]

yours most truly
J. M. W. Turner

78. Turner to Sir John Fleming Leicester

MS. University of Manchester, Tabley House
Publ. Finberg 1939, p. 255

Wednesday Decr. 16 1818

Sir John

Allow me to return you my thanks and to acknowledge the receipt of the 100£ in part of the 350 Gs. Mr Bigg[2] very likely I shall see tonight at the Academy when I will appoint Saturday to call upon him in Gt. Russel [St.] to settle more particularly about the cleaning of the Picture, if you will have the goodness to send it to Mr Bigg's, either tomorrow or Friday. The description of the Picture was as follows: Dutch Boats and Fish Market—Sun rising thro' Vapour; but if you think 'dispelling the morning Haze' or 'Mist' better, pray so name it,[3] and believe me to be with great respect

Your most truly oblig'd
J. M. W. Turner

To Sir John Leicester, Bart.

79. Walter Fawkes to Turner

MS. T.B. CLIV, Y
Publ. Finberg 1909, i. 438

[? Autumn 1818]

By to-morrow's coach I shall send you a box containing two Pheasants, a brace of partridges, and a hare—which I trust you will

[1] Chantrey's home town.

[2] William Redmore Bigg R.A., genre-painter and restorer. Farington reports that he had completed the cleaning of Leicester's *Dutch Seaport*, by Turner, by 16 Jan. 1819.

[3] See also Letter 36. Leicester had acquired the painting during 1818. Turner's title at the R.A. in 1807 had been *Sun rising through vapour: fishermen cleaning and selling fish*; at the British Institution in 1809 it was *Sun rising through vapour, with fishermen landing and cleaning their fish*, and at his own Gallery in 1810: *Dutch Boats (Sun rising through vapour, etc.)*. In 1819 Leicester had the picture catalogued as *Dutch Fishing Boats: the sun rising through Vapour*.

receive safe and good. We have tormented the poor animals very much lately and now we must give them a holiday.

Remember the Wharfdales[1]—everybody is delighted with your Mill.[2] I sit for a long time before it every day.

Ever very truly yrs.,
W. Fawkes.

[*Verso: pencil sketch of a church, not by Turner*]

80 Turner to George Cooke

MS. National Library of Scotland, MS. 3219, fo. 206

[*On envelope addressed to Turner*]

I will touch the proof by the time you come tomorrow Morng 9 O Clock. I will thank you bring the *size* of the plate of Pye's of Mr Lambton House Glover's picture for Surtees *Durham*[3]

J.M.W.T.

[*Addr.*] Mr G. Cooke

81. Turner to W. B. Cooke

MS. Cambridge, Fitzwilliam Museum Library, MS. 212–1949

[*Postmark* 10 Feb. 1819]
Wednesday Evening

Dear Sir

Just send me the vignette Helmet for an Hour or so I think I can further improve it at least Allen will be released from a little more of the coat of mail.[4] I have got a most confounded cold and swelled throat by *paddling . . . last night*; send *it* if possible before the Evening

[1] Fawkes may refer to the landscape itself; but two Turner drawings of *Wharfdale from the Chiven* [*sic*] were shown at Fawkes's exhibition in 1819 (9, 11). The group is now given to *c*. 1818 (cf. T.B.E. Nos. 189 ff.).

[2] Possibly *View of Otley Mills, with the River Wharfe and Mill Weir* (Christie, 27 June 1890, bt. Sedelmeyer).

[3] John Pye after J. Glover, *Lambton Hall*, 1 Jan. 1816, published in R. Surtees, *History and Antiquities of Durham*, ii (1820), facing p. 162. The size is 19·3 × 28 cm, the same as Turner's own contributions to Surtees's *Durham*, the first of which was published in December 1819 (R. 141). Two of Cooke's engravings for Turner, R. 106 and R. 148, are dated 1818, and one of them may be the proof referred to in the note.

[4] The cover design for *Views in Sussex* (R. 128), the etching of which has hitherto been attributed entirely to Turner.

because there will be a General Assembly tonight which I mean to attend.

<div align="right">J. M. W. Turner</div>

[*Endorsed* J. C. Allen etched the vignette of the helmet for me W. B. Cooke]

82. W. B. Cooke to Turner

MS. Untraced (formerly C. M. W. Turner Esq.)
Publ. A. J. Finberg, *An Introduction to Turner's 'Southern Coast'* (1929), p. 70

<div align="right">June 3. 1819</div>

My Dear Sir

Will you have the goodness to touch on Allen's Proof of Ivy Bridge[1] and tell the bearer when he shall call again for it. I wish (as well as Allen) the Ivy Bridge *done*, particularly as it is so near it—do not the Ducks want to come out more conspicuously by light and dark touches?

I met Mr Fuller[2] the other morning and he expressed himself surprised at not seeing the Sussex advertised in the Quarterly Review. You see how these things operate—every one who knows Murray to be my publisher must attribute it to neglectful conduct or to Hostility[3]—the more I think of it (for I am determined to think cooly of it) the more I am convinced of its being one of the most unjust things ever done by a Publisher—a Publisher by tying you first to himself by stipulating that none of the *Trade* shall be supplied but through his hands, under a Promise that he will do everything for the Work and also promises to introduce it in all his lists on acct. of his extra Commission of 10 per Cent and then to behave in this manner is acting either the part of a madman or with a downright deviation from all Principles of honesty or justice—no failure of Promises (which are in themselves physically impossible to perform, and which are dictated by an enthusiasm or too great confidence in one's own powers as to time) on my part can be any excuse for such malignity and littleness. I am not sure whether by Action by law I could not recover for the probable loss sustained by me on this acct. at this season of the year. Can I hereafter confide in a man like this who

[1] Allen's *Ivy Bridge* (R. 139), for *Rivers of Devon* was begun in 1816, but not finally published until 1821.

[2] Jack Fuller of Rose Hill, Sussex, was the sponsor of Turner's *Views in Sussex*, and had been an important patron of the artist since 1810 (Cf. T.B.E. Nos. 127, 130, and B.–J. No. 211).

[3] John Murray was the publisher of the *Quarterly Review*.

has struck a blow without a threat? who has made a cut at my property without declaring war? You say *dont be hasty but think well before you act.* In my opinion it beats Longman's conduct though that was as bad as could be.[1]

I am slaving away at Allason's Plates[2] which I shall be very happy to have done with; when they are finished something must be done with Murray

<div style="text-align:right">

I remain Dear Sir
Yours respectfully
W. B. Cooke

</div>

[*Addr.*] J. M. W. Turner Esq.
Queen Ann St West

83. Walter Fawkes to Turner

Publ. Catalogue of the Fawkes Collection at 45 Grosvenor Square, 1819

TO J. M. W. TURNER, ESQ., R.A., P.P.

My Dear Sir

The unbought and spontaneous expression of the public opinion respecting my collection of water-colour drawings,[3] decidedly points out to whom this little catalogue should be inscribed.

To you, therefore, I dedicate it, first, as an act of duty; and, secondly, as an offering of Friendship; for, be assured, I can never look at it without intensely feeling the delight I have experienced, during the greater part of my life, from the exercise of your talent and the pleasure of your society.

That you may year after year reap an accession of fame and fortune is the anxious wish of

<div style="text-align:right">

Your sincere friend,
W. Fawkes

</div>

London, *June,* 1819

[1] Possibly an allusion to Longman's publication of Whitaker's *History of Richmondshire*, with which Cooke may at one time have been associated (see Letter 121). The earliest plate, Pye's *Hardraw Fall* (R. 182) is dated 1815, but most were engraved in 1819 or later, and none of Cooke's engravers were involved, except W. Radclyffe in 1822.

[2] Murray had a share in Allason's *Antiquities of Pola*, for which Turner supplied the frontispiece (R. 162).

[3] Fawkes collected together a number of the reviews of his exhibition, which had been open since April (cf. Finberg 1961, p. 258, M. Hardie, *Water-Colour Painting in Britain*, ii (1967), 36–7).

84. Turner to Robert Stevenson

MS. National Library of Scotland, MS. 785, fos. 9–10v.

My dear Sir

The Drawing of the Bell Light House[1] was sent to the Wharf on Saturday last, but the Porter forgot to ask when the Smack (the Swift, according to the paper he brought back) would sail, but I trust by the time you will receive this that she will be near if not at Leith, of which and your approval of my Endeavour I shall be very anxious to hear of, the subject being rather a difficult one, and should you wish or if it requires any alteration do not hesitate to send it up for it, only write the word of the extent, that I may judge how far the same may be beneficial or practicable in a pictorial sense. As to prices, mine are regulated by size, it being somewhat above the thirty Guineas size but not so large as the next one, 35 Gns, the drawing will be therefore 30 Gs, and respecting the Engraving the plate, Mr Cooke is so much engaged that he has begged he says all further engagements until he can clear off some of his may premiums,[2] indeed, if you wish to have the plate the full size of the drawing,[3] the Expense will be heavy in the line manner. ? how would the Mezzotinto style suit the object you have in view, and if you wish I can somewhat ascertain the difference before I leave Town and send you word.

If you think of Framing my Drawing, do pray not leave so much margin as to the two Drawing[s] sent to me, and let a small flat of

matted gold be next the same, thus May I request if you are passing any time by F Camerons in Bank St you will favour me by telling him that I received the money and paid the Balance to Mr Palmer and I have his receipt for it.

<div style="text-align: right">

I am tho in great haste
Yours most respectfully
J. M. W. Turner

</div>

[1] *The Bell Rock Light House,* still in the collection of the Stevenson family.
[2] The frontispiece to Stevenson's *Account of the Bell Rock Light House* (1824), was engraved in the event by J. Horsburgh (R. 201).
[3] The drawing measures 44·5 × 29·3 cm, the line-engraving 21·8 × 15 cm.

Mr Stevenson Baxter's place Edin

[*Endorsed* J. W. Turner
 London
 8 July 1819.]

85. Turner to Robert Stevenson

MS. Stevenson Family

Monday July 26. 1819

Dear Sir
 My being from home on Saturday when your favour arrived pre-
vented me then returning you my *thanks* which I beg leave now so
to do for the check upon Messrs Barclay and Sutton and remit the
receipt according to the request of Mr Kennedy signed as received by
 Dear Sir
 Yours most truly
 J. M. W. Turner

PS. I should very much like to know how you like the drawing. My
very short stay in London for I think of leaving for Italy on Saturday,
makes it now certain even were you to favour me by return of post,
but which I still could wish the chance if convenient to your care [?].[1]

[*Addr*.] Robert Stevenson Esq[r]
 Baxters Place
 Edinburgh
 or Baxters Square

86. Turner to Antonio Canova

MS. Bassano, Museo Civico, MS. Canoviani, IX, 1040 5 201

Palazzo Poli[2] Saturday Morn
Nov 27 1819

My Dear Sir
 I have sent the letter addressed to the President of the Academy of
St Luke's as you directed me and I beg leave that you will allow me

[1] Stevenson must have suggested modifications to the watercolour, since he claims
(*An Account of the Bell Rock Light House*, 1824, p. 529) that Turner used outline sketches
by an interior decorator, Macdonald, made in 1820.

[2] Enrico Keller lists a history painter, Pasinati Romano, and a cameo carver, Villa
Tomati, in the Palazzo Poli in 1824 (*Elenco di tutti gli Pittori … Esistenti in Roma …*,
1824).

the opportunity of offering you my most sincere thanks for the distinguished honour of your Nature in recommending me.[1] Your approbation of my Indeavours in the Art will be very long felt believe me, My Dear Sir by Your most truly obliged Ser[t]

<div style="text-align: right">J. W. M. Turner</div>

87. Turner to Clara Wells (Wheeler)

MS. University of Manchester John Rylands Library, Ryl. Eng. MS. 345/115

<div style="text-align: right">[Postmark 4 May 1820]
Wednesday</div>

Dear Madam

I but yesterday received a card from Mr Fawkes who is very unwell and the view of the works at Grosvenor place is but a private one this year of course[2] therefore extr [emely limited? *tear*] however I have the pleasure of sending *one* for Mr W and yourself. be pleased to accept my *respects* and forward the same to the Country Squire and Family at Mitcham[3] and you will oblige

<div style="text-align: right">Yours most truly
J. M. W. Turner</div>

[*Addr.*] Mrs T. Wheeler
 Gracechurch Street
 City
 near the corner
 of Fenchurch Street

88. Turner to William Collins

MS. C. W. M. Turner Esq.

<div style="text-align: right">Sunday May 14 1820</div>

Dear Collins,

Having heard from Mr Hills[4] yesterday that your card for Mr Fawkes (sent to the Academy) *had not come to your hand* I now leave

[1] 'Furono acclamati in accad. di onore i signori Giusep. Rebell Paesista di Vienna; ed il Sig. Touner [*sic*] Paesista di Londra ...' (Rome, Academy of S. Luke, MS. *Congregazioni*, Vol. 59, fos. 87[v]-88; 24 Nov. 1819).

[2] The first exhibition of watercolours at Fawkes's house, 45 Grosvenor Square, in 1819 had been public. See p. 78.

[3] i.e. Clara's father, W. F. Wells (q.v.).

[4] Robert Hills (1769–1844), many years secretary of the Old Water-Colour Society. In 1818 he had been the guest of Walter Fawkes at Farnley, and Fawkes bought and exhibited several of his works (Roget, i. 311).

you another and I am sorry that [*tear*] did not hear of the mishap of the first earlier

<div align="right">

Yours truly

J. M. W. Turner
</div>

W. Collins Esq^r R.A.

89. Turner to W. F. Wells

MS. British Library Add. MS. 50118, fo. 56
Publ. Finberg 1939, p. 266

Queen Ann St West. Monday Nov 13 1820
Dear Wells
—Many thanks to you for your kind offer of refuge to the House-less, which in the present instance is humane[1] as to cutting, you are the cutter. Alladins palace[2] soon fell to pieces, and a lad like me can't get in again unsheltered and like a lamb. I am turning up my eye to the sky through the chinks of the Old Room and mine; shall I keep you a bit of the old wood for your remembrance of the young twigs which in such twinging strains taught you the art of wiping your eye of a tear[3] purer far than the one which in revenge has just dropt into mine, for it rains and the Roof is not finish'd. Day after day have I threatened you not with a letter, but your Mutton, but some demon eclypt Mason, Bricklayer, Carpenter &c. &c. &c. . . . has kept me in constant osillation from Twickenham to London, from London to Twit, that I have found the art of going about doing nothing—'so out of nothing, nothing can come'.[4]

However, joking apart, if I can find a day or two I'll have a peep at the North Side of Mitcham Common, but when, it is impossible to say. Whenever I have been absent either something has been done wrong or my wayward feelings have made me think so, or that had I been present it would not have occurred, that I am fidgetty whenever away. When this feeling has worn *itself* away, at least I shall become a better guest. But in whatever situation I may be . . . believe me to be

<div align="right">

With sincere regard

Yours most truly

J. M. W. Turner
</div>

[1] i.e. because of the disruption during the building of Turner's second gallery.
[2] Turner's first gallery, opened in 1804.
[3] Wells had been at school with a Mr. Harper in a building on Turner's Queen Ann St. site (Roget i. 132).
[4] *King Lear*, I. i.

P.S. I am glad to find that yourself and Family are all well.

[*Addr.*] W. F. Wells Esq^r
 North Side of Mitcham Common, Surrey

90. Turner to James Holworthy

MS. British Library Add. MS. 50118, fos. 61–2
Publ. Monkhouse, p. 402

 [*Postmark* Dec. 23 1820]
 Saturday night
Dear Holworthy
 Alas, poor Sir John Thoroton is no more. Stegler, the frame-maker,
called yesterday evening to tell you Sir John died last Friday, and
would be buried as yesterday or today, so adieu to all my prospects
again at Belvoir. Can anything be done for Allason,[1] but I am sure
you will do all you can that he may start fair, as the Cornish Curate
said to his parishioners upon the occasion of a *Shipwreck* upon the
coast,[2] so are perhaps Sir John's!! designs, but do let us hope for the
best. Again, in the catalogue of Death is Naldi, the primo buffa of
the opera. Visiting his friend Garica, and inspecting the cooking by
steam, he stopt the valve, when the boiler burst, and the fragments
carried away the upper part of his skull; instant he became a corpse[3]—
but a truce to misery. The garrison is well in the New Road[4] only
besiged Morning and Night (the Noon is sometimes given to 2 A S)
by General Miss Croker who has not forgotten the sweets of that
delicious wine you gave at Nine at night, which appear the favourite
hours of attack ... hasten home Dear General or your weak Aid de
Camp may be forced to capitulate
 Yours truly
 J. M. W. Turner

[*Addr.*] J. Holworthy Esq^r
 Henry Drummond Esq^r
 Aldbury Park
 near Guildford
 Surrey.

[1] Thomas Allason, the architect (1790–1852). See Letters 70, 82, 112, 122, 127.
[2] See also Letter 52.
[3] Giuseppe Naldi (1770–15 Dec. 1820), baritone, pianist, violoncellist. Singing
regularly in London 1806–19. Killed in Paris.
[4] Holworthy's London address (see Letter 65).

91. Turner to an Unknown Female Correspondent

MS. Untraced (Maggs Bros., Autumn 1932 (1296))
Publ. Maggs Bros., *Catalogue of Autographs*, 1920 (2649)

[? December 1820[1]]
Queen Anne Street

I will with great pleasure accept your invitation to meet him on New
Years Day, if the sad lassy *Nemesis* does not again say *No* in the follow-
ing manner *viz*: It is usual for the Old and New Members of the
Council to dine together at the Royal Academy on the last day of the
Year and hand the New in with the Office of the New Council. I
am one who will go out of the list this year, and the last day of the
Year being on Sunday, should it so happen that the Dinner takes
place on Monday instead of Saturday[2] (for we always keep the Sabbath
holy) the consequences will be against me ...

92. Turner to W. B. Cooke

MS. British Library Add. MS 50118, fo. 60
Publ. Finberg 1939, p. 266

Thursday Evening
[?late 1819 to late 1820]

Dear Sir
 I shall not be in town again before next Thursday. if you can send
the proof[3] to Sandycombe—I can touch it: but otherwise it can be
left at Queen Ann St on Wednesday next and you may have it again
on Friday morning.

Yours truly,
J. M. W. Turner

PS. I only come to Town once a week owing to my accident and
 rebuilding.[4]

[1] Turner was an outgoing member of the Academy Council this year, when 31
Dec. fell on a Sunday.

[2] The Dinner was held on Saturday 30 Dec. (Farington).

[3] Probably a *Southern Coast* subject. The only plates issued between 1818 and 1824
were R. 107–9, published on 1 Apr. 1820, and R. 110–12, published on 1 Jan. 1821.

[4] The building of Turner's second Gallery at Queen Ann St. took place between
1819 and early 1822 (Gage 1969, p. 162). Nothing has come to light about Turner's
'accident'.

93. Turner to Emma Wells

MS. British Library, Extra-illustrated copy of W. Thornbury, *Life of Turner* (Tab. 438a 1) ix. 134
Publ. Lindsay 1966, p. 243 n. 6

[?1820]

Dear Emma

I am sorry to say that at present I am hard at work in the Gallery but shall be happy to have a peep at you in the Parlour whenever you please

Yours truly
J. M. W. Turner

94. Turner to James Holworthy

MS. British Library Add. MS. 50118, fos. 65–6
Publ. (Extract) Finberg 1939 p. 270

Sunday Evening [?early 1821]

Dear Holworthy

I[f] you are in Town on *Tuesday* do pray hold yourself disengaged in the Morning and honor me with your company to Hick's Hall[1] to help me over the wall for I am afraid they the Gents of the Robe may require something more than hearsay of the delivery of the notice upon Mr Young[2] so do not forget your pocket-book noticing the time, for they have made me trouble Allason for an Afidavit of the first Notice so probably they may ask for yours. I call'd at Haddon Hall [?] but I suppos'd you (if report be true) at Pinner so I may be thrown over the bridge instead of the wall on Tuesday

yours truly
J. M. W. Turner

[*Addr.*] J. Holworthy Esq[r]

[1] Clerkenwell Session House.
[2] Benjamin Young, dentist, part tenant of Turner's premises in Harley St. (See Finberg 1961, pp. 267–9).

95. Turner to W. B. Cooke

MS. Royal Academy, Anderdon Catalogues, xvii (1820), after p. 48

[*Postmark* 13 June 1821]
Sir Today is the 12 of June making four months since the 12 of
February 1821.

J. M. W. Turner

[*Addr.*] To Mr Cooke
 9 Soho Square.

96. Turner to Abraham Cooper

MS. British Library, Add. MS. 50118, fo. 64
Publ. Finberg 1939, p. 271

[*Postmark* 7 Aug. 1821]
Queen Anne St.

Dear Sir
 The *second* Meeting of the Pic-nic-Academical Club will take place
at Sandycombe Lodge, Twickenham, on Sunday next, at about three
o'clock. Pray let me know in a day or two that the *Sec^y* may get
something to eat.

Yours truly,
Jos. Mallord Wm. Turner

For map, turn over to the other side [shown opposite]

[*Addr.*] A. Cooper Esq^r R.A. ..., New Milman St.,

97. Turner to J. Robinson

MS. Untraced
Publ. Thornbury 1862, ii. 250–1

June 28 1822, Friday morning.

My dear Sir
 In the conversation of yesterday respecting prints, you said that if
I would have engraved a plate worthy of any of my pictures, that
you would take 500 impressions, provided none were sold to any
other person for two years. If you really meant the said offer for me
to think of, it appears to me that my scheme, which I mentioned to

[*Verso*]

you in confidence, would hold—viz. four subjects to bear up with the 'Niobe', 'Ceyx', 'Cyledon', and 'Phaeton'[1] (in engraving as specimens of the British school). Whether we can in the present day contend with such powerful antagonists as Wilson and Woollett would be at least tried by size, security against risk, and some remuneration for the time of painting. The pictures of ultimate sale I shall be content with; to succeed would perhaps form another epoch in the English school; and, if we fall, we fall by contending with giant strength.

If the 'Hannibal'[2] or the 'Morning of the Chase'[3] be taken, the first plate would stand thus:—

 1. Plate, in two years.

[1] Woollett had engraved Wilson's *Niobe* (1761), *Ceyx and Alcyone* (1769), *Celadon and Amelia* (1766), and *Phaeton* (1763), for Hurst & Robinson's predecessor, Boydell. After the success of the *Niobe*, it seems likely that the other subjects were painted specifically for engraving (cf. Tate Gallery, *Landscape in Britain c. 1750–1850* (1973–4), No. 31).

[2] B.–J. No. 126.

[3] *Dido and Aeneas leaving Carthage on the Morning of the Chase*, R.A. 1814 (B.–J. No. 129). The picture was engraved by Smith for Griffith in 1842 (R. 652).

2. Picture to be painted, three years.
3. Ditto and two years longer, fourth.
4. Ditto and ditto—five years the four plates.

Or if all the pictures are painted, if thought more desirable, then take the pictures now done, 'Carthage' picture[1] excepted; one year more must be added, making six years, which allows one year for painting each picture, and two to engrave it, and put into the hands of different engravers immediately. Mr Pye to engrave one or more if your arrangement with him would not be interrupted thereby,[2] or the general arrangements of time broken in upon, for six years added to forty-five is not a trifle.[3]

<div style="text-align: right">

Yours most truly
J. M. W. Turner

</div>

P.S.—This is *private*; if not to be thought of, burn it immediately, and only mention on July 1 the receipt of the said note.[4]

[*Addr.*] J. Robinson Esq.,
 90 Cheapside,
 Corner of Ironmonger Lane.

98. Turner to W. B. Cooke

MS. Alan Cole Esq.

<div style="text-align: right">

[*Watermark* 1822]
Thursday Morn
9 O Clock

</div>

Dr Sir

Mr Calcott objects to have his name in the Prospectus[5] for he cannot do one for the first No. (and wishes to see the work proceeding with, or a chance of its continuing) all I could obtain towards the work

[1] Probably *Dido Building Carthage* (R.A. 1815, B.–J. No. 131), which Hurst & Robinson later (1825) tried unsuccessfully to purchase from Turner (Finberg 1961, pp. 290–1).

[2] Hurst & Robinson may already have bought Turner's *Temple of Jupiter Restored* (R.A. 1816) to be engraved by Pye (cf. Finberg 1961, p. 277), but the earliest proofs (R. 208), are of 1824.

[3] Turner was forty-seven in 1822.

[4] No agreement seems to have been reached.

[5] Possibly *River Scenery*, the first number of which appeared in 1823, and which included plates after Girtin and Collins (q.v.) as well as Turner. Callcott (q.v.) did not contribute.

therefore stands thus. "that if I do not hear from him in the course of a few days he declines it all together.

<div align="right">J.M.W.T.</div>

PS? had you not better see Mr Calcott yourself.

99. Turner to W. F. Wells

MS. British Library, Add. MS. 50118, fo. 68
Publ. Finberg 1939, pp. 281–2

<div align="right">[Postmark Sept. 6, 1823]
Saturday</div>

Dear Wells

My Daddy cannot find the recipe, but I have puzzled his recollection out of two things ... Poppies and Camomole ... $\frac{1}{2}$ a cup of poppy seeds to a good handfull of Camomile flowers simmer'd from a Quart of water to a pint in a glazed vessel ... and used by new-flannel as hot as can be ... alternately one piece soaking, while the other is applied ... to keep up equal warmth.

<div align="right">Yours most truly
J. M. W. Turner</div>

[*Addr.*] W. F. Wells Esq^r
Mitcham Common, Surrey

100. Turner to W. B. Cooke

MS. Liverpool, Hornby Library

<div align="right">[Postmark 5 NO 182[?3]]</div>

Dear Sir

I am sorry I was out of the way last night when you called for I could have told you that the Drawing would be ready whenever you would send for it. I shall leave it out should you send tonight.

<div align="right">yours Obt.
J. M. W. Turner</div>

[*Addr.*] Mr W. B. Cooke
Soho Square

101. Turner to J. C. Schetky

MS. Untraced
Publ. Miss Schetky, *Ninety Years of Work and Play* (1877), pp. 129f

[3 December 1823]

Dear Sir

I thank you for your kind offer of the Téméraire;[1] but I can bring in very little, if any, of her hull, because of the Redoutable. If you will make me a sketch of the Victory (she is in Hayle Lake or Portsmouth harbour) three-quarter bow on starboard side, or opposite the bow port, you will much oblige; and if you have a sketch of the Neptune, Captain Freemantle's ship, or know any particulars of Santissima Trinidada, or Redoubtable, any communication I will thank you much for. As to the former offer of yours, the Royal Barge, I beg to say that I requested your brother[2] to give you my thanks, and that whatever you sent to him the same would be in time; but there is an end to that commission owing to the difficulty attending engraving the subjects[3]—

Your most truly obliged
J. M. W. Turner

P.S.—The Victory, I understand, has undergone considerable alterations since the action, so that a slight sketch will do, having my own when she entered the Medway (with the body of Lord Nelson),[4] and the Admiralty or Navy office drawing.

[1] A sketch of the second ship in Lord Nelson's division at Trafalgar, and the subject of a later painting by Turner (B.–J. No. 377). Turner needed the following sketches for his *Battle of Trafalgar* for St. James's Palace (see p. 9f. and Letter 111), although he himself had a sketchbook of studies of the ships in the Trafalgar engagement, which he had made in 1805 (T.B. LXXXIX) and used in his *Death of Nelson* (B.–J. No. 58), exhibited in 1808.

[2] Alexander Schetky, doctor and amateur marine-painter, whom Turner had met in Edinburgh in 1818, and who was working in Rochester in the summer of 1823.

[3] This may refer to an unrealized project for a series of engravings after Turner recording George IV's visit to Edinburgh in August 1822 (G. E. Finley, 'J. M. W. Turner's Proposal for a "Royal Progress"', *Burlington Magazine*, cxvii (1975), 27–35). Schetky had accompanied the King and painted at least one picture including the Royal Barge (cf. Scottish National Portrait Gallery, *Visit of George IV to Edinburgh, 1822* (1961), No. 3). Turner had sketched the same event in T.B. CC, pp. 58–9.

[4] Probably T.B. LXXXVII, pp. 41 ff.

102. Turner to W. B. Cooke

MS. Untraced (Maggs Bros. 1922, No. 808)
Publ. Thornbury 1862, i. 404

Saturday Morning

My dear Sir
 I rather expected you would have called yesterday, as your
messenger said there required no answer when he left your letter.
However, I have seen Mr Fawkes this morning, and there appears a
great misconception respecting the extent of the drawings offered to
you, *for the Swiss drawings are either bound together, or cannot be lent.*[1] I
shall be at home all tomorrow, if you can give me a call.

Yours most respectfully
J. M. W. Turner

[Attached to this letter was a pencil note, now British Museum Print
Room MM.5.12]

I told your brother George on Thursday or Saturday last that I
expected to have heard or seen you before then, particularly when I
had heard you did not go to Brighton, and to tell you so, you having
left a message that things must remain until you returned—that the
list you sent me had an inaccuracy or two which required me to see
you &cc
 "call tomorrow before 12 or after 2 o clock yours

J. M. W. Turner.

103. Turner to John Soane

MS. Sir John Soane's Museum

[? December 1823 or early 1824]

Dear Soane
 You are to be *first Horse* tomorrow Evening

I salute Mon[r] Auditor[2]
J. M. W. Turner

Friday Evening

[1] This may refer to a request by Cooke to borrow drawings from Fawkes for his
own watercolour exhibitions held in 1822, 1823, and 1824. No Fawkes drawings were
included in any of them.

[2] Turner and Soane were elected, with Chantrey, auditors of the Academy accounts
on 10 Dec. 1823 (see also T.B. CCX(a) p. 2).

104. Turner to James Holworthy

MS. British Library, Add. MS. 50118, fos. 70–1
Publ. Art Journal, vii (1868) 129

April 30 1824

Dear Holworthy

I shall feel uncomfortable if anything should in this note give you any pain, but when I look back upon the length of time you took to acknowledge the receipt of the drawings,[1] and with-held the pleasure I expected of at least hearing if Mrs Holworthy (to whom in your mutual happiness I certainly presented *one*) approved; but your letter treats them both so like a commission that I feel my pride wounded and my independence rouzed. I shall be happy to receive any presents of recollection you may with Mrs H think of to send me, and will keep alive my high considerations, but money is out of the question in the present case. It gives me great pleasure to hear from Mr Phillips[2] of your comforts at Green-hill, and I may perhaps, if you have as great a regard for 'Auld lang sine' as myself, witness *all*, and tho I may not ever be blest with (a) Half, yet you may believe me that it gave me the greatest pleasure to hear, and will continue to give to the end of this sublunary turmoil, for I do not mean my comforts or miseries to be my measure of the like in others. When you come to town I have a great many interrogations to make, not in doubt but for want of experience in these matters, and I do not hesitate to acknowledge it in offering my respects to Mrs Holworthy.

Believe me to be
Dear Holworthy
Yours most truly
J. M. W. Turner

[*Addr.*] J. Holworthy Esq.
Green-hill
Derby

[1] Two Turner drawings from the estate of Holworthy's wife, Anne: *Coast Scene, Sunrise*, and *Mountainous Landscape*, together with a snuff-box (6·8 cm diameter), made from lava from Vesuvius, and used as a palette on his Italian tour, have not been traced (*Art Journal*, vii (1868), 129).

[2] Thomas Phillips, R.A. (q.v.)

105. Turner to William Mulready

MS. Victoria and Albert Museum, Mulready MS. 86 NN. 1

[*Postmark* 18 JU[?] 1824]
Friday Morning

My Dear Sir

I have received another letter expressing a great concern that you cannot spare the subjects of the Pictures but yet hoping you may be induced to part with some sketch or study for about ten or fifteen guineas—and to this hope allow me to add my own for it is the first act (I do sincerely hope) of a good disposition towards modern art, to collect works of merit. Your favourable consideration of the intention will much assist that feeling and oblige

yours most truly
J. M. W. Turner

PS. pray let me know as early as possible [*deleted*] you can and the size of the Picture of the Wolf and the Lamb[1] and the Price you wish for it.

[*Addr.*] W. Mulready Esq[r] R.A.
Moscow Cottages,
Bayswater

106. Turner to J. C. Schetky

MS. Untraced
Publ. Miss Schetky, *Ninety Years of Work and Play* (1877), p. 130

September 21 1824

Dear Sir—

Your sketches[2] will be with you, I trust, by (the Rocket coach) to-morrow evening. They shall be sent to the coach-office this evening. *Many* thanks for the loan of them, and believe me to be your most truly obliged

J. M. W. Turner

To J. C. Schetky, Esq.

[1] Mulready's *The Wolf and the Lamb* had been shown at the Academy in 1820 and acquired by George IV (O. Millar, *Later Georgian Pictures in the Royal Collection*, 1969, No. 970). Mulready had taken back the picture between October 1823 and December 1825, while it was being engraved by J. H. Robinson, and Turner may have thought it was for sale.
[2] See Letter 101.

107. Turner to T. J. Pettigrew

MS. Alan Cole Esq.

[*Watermark* 1824]
47 Queen Anne St West

J. M. W. Turner begs to present his respects to Mr Pettigrew and he feels particular[l]y that he is prevented the pleasure of being at the Conversazione on Friday Evening next.

Wednesday Evg

[*Addr.*] Pettigrew Esq^re
8 Saville Street,
Burlington Gardens.

108. Turner to Arch

MS. Miss Hazel Carey

[?1824]

Mr Arch, Have the goodness to say to the Bearer (my Papa) if you have the means of sending to Edinboro, with Miller's print[1] a set of Liber Studiorum or not. They are about 12 Inches Broad and 18 long but must go flat, if you can, and ask Mr Miller to cause them to be delivered as directed. You will much oblige Dr Sr yours truly J.M.W.T.

Goodall has got his proof[2]—Miller's[3] is ready.

PS There is so much good work about Miller and it would [be] but justice to tell him so from me if you like.

109. Turner to Charles Stokes

MS. Untraced (Maggs Bros. 1921, No. 2392)

[?1824]

I think I shall have a drawing for the Coast Work to place before you, with the Horse and Paniers.[4]

[1] Possibly *Clovelly Bay*, Miller's first contribution to the *Southern Coast*, published in March 1824 (R. 115).

[2] Possibly *Boscastle*, published in the *Southern Coast*, 10 Mar. 1825 (R. 121).

[3] Perhaps *Comb Martin* (R. 119) or *Portsmouth* (R. 120), published in the *Southern Coast* in January and February 1825.

[4] Possibly *Clovelly Bay* (National Gallery of Ireland), published in the *Southern Coast*

110. Turner to Sir Thomas Lawrence

MS. Royal Academy of Arts, Lawrence Correspondence, iv. 100
Publ. (Facsimile) Miller 1854, facing p. lx

Thursday Eve [3 May 1825]

J. M. W. Turner presents his respects to Sir Thos Lawrence and he feels sorry an Ingagement will prevent him the pleasure of waiting upon Sir Thos tomorrow morning he called in Russel Square to request he might be excused giving any opinion of the Picture[1] in consequence of his having positively determined so doing to Mr Wright a particular friend of Sir Wm Pilkington on the part of Mr Gray.[2]

To Sir Thos Lawrence

111. Turner to Sir Thomas Lawrence

MS. Royal Academy of Arts, Lawrence Correspondence, iv. 105
Publ. (Facsimile) Miller 1854, facing p. lx

July 1 1825 Queen Anne St West

Dear Sir Thomas

I have just now received a letter from the Lord Chaimberlains Office stating that the amount for my Picture[3] will be paid upon demand I therefore feel the necessity of again asking you if you do authorize me in demanding the 600 Gs you mentioned, or if in your warmth for the service of the Arts you did exceed (in your wishes) the terms proposed. Do pray have the goodness to tell me?

In regard to the fees I beg to renew my Objections ... but do believe me to be

with true regard
yours most faithfully
J. M. W. Turner

To Sir Thos Lawrence

in March 1824 (R. 115), or *Comb Martin* (Oxford, Ashmolean Museum), published in January 1825 (R. 119), both of which have several laden donkeys among the *staffage*. *East and West Looe* (Manchester City Art Gallery) has laden horses, but this had been published in 1818 (R. 104), and shown at Cooke's loan exhibition in 1822. Stokes is not known to have owned any *Coast* watercolours except the six he lent to Cooke's exhibition in 1822 and 1824.

[1] Probably an Old Master whose authenticity was in dispute.

[2] Perhaps Gray of Leadenhall Street, for whom Turner, together with Callcott, West (qq.v.), Glover, and the two Reinagles, had authenticated a Claude in 1816. The case had been dealt with by Lawrence (Farington, 24 Nov. to 9 Dec. 1816).

[3] *The Battle of Trafalgar.* See p. 9f.

112. Turner to James Holworthy

MS. British Library, Add. MS. 50118, fos. 72–3
Publ. Monkhouse, pp. 402–3

[*Endorsed* Jan 7 1826]

Dear Holworthy

Your turkey was excellent; many thanks to you and Mrs H for it. Daddy being now released from farming[1] thinks of feeding, and said its richness proved good land and good attention to domestic concerns, so be it in continuity say I, tho you talk of mountains as high as the moon, and the creaking timber wain labouring up the steep, and your riding post by the cardinal points for materials, but consider the pleasure of being your own architect day by day, its growing honors hour by hour, increasing strata by strata, but not the clang of the trowel I fear, minute by minute, according to your account. However, I am glad to find you all covered in, tho I suppose I must not use the masonic term 'tiled in' before the frost, which has been most severe here—I ought to say 'is', for the Thames is impeded below bridge; St James' and Serpentine both frozen in spight of every attempt to keep them open by folly and rashness; so the advantage is by the side of the trout stream in more ways than one. Look at the crash in the commercial world of mercantile speculation, and the check which must follow, but the trouts will be found in the pool and the gudgen in the shallow, but everyone seems to have had a nibble, and experience so bought will last longer than a day or its day, who to use Allason's phrase, 'never contemplate what has already taken place'; by-the-bye, he is getting a fortune rapidly, so I am told; his connection with the great men in the east prevents his looking westward now,[2] while everything jogs on as usual, every one for himself, but at a more rapid trot notwithstanding steam boat liability, banks and stoppages. Alas! my good Auld lang sine is gone ... and I must follow; indeed, I feel as you say, near a million times the brink of eternity, with me daddy only steps in between as it were, while you have yet *more* and long be it say I. Whether I ever see her or not in London, don't think that that promise of bringing drudgery [?] or your tremendous mountains will prevent my trudging up some Summer's day I hope, tho they are all winter days now, to see how your farm goes on. Let me join you in concern

[1] A reference to William Turner Sn's gardening at Sandycombe Lodge, which was sold up later this year.

[2] Possibly a reference to Allason's employment as Surveyor to the Stock Exchange in the City of London.

for your loss at Belvoir has now faded away from me, and I think Geddes feels much in the same way,[1] tho I hope not for his picture of the family. Phillips, upon his election to the Chair of Professor of Painting, started for the Eternal [*changed to* immortal] city, as Eustace calls it, *Rome*,[2] and I expect he will come home as plump as your Turkey with stuffing!! Hilton, Wilkie, and Dawson Turner formed the *quartetto amico*;[3] they were when I last heard of them feeding away upon M. Angelo, Raffilo [*sic*], Domenicino, Gurcenio [sc. Guercino], Corregio, not Stuffarcio, Pranzatutto, Gurgeco, Phillippo mezzo, Guini, Notto Thomaso; and if they have not ere this time passed the Alps, we shall not have any fruits of their gathering in the Exhibition this year I fear, for Mont Cenis has been closed up some time, tho the papers say some hot-headed Englishman did venture to cross a pied a month ago, and what they considered *there* next to madness to attempt, which honor was conferred once on me and my companion de voiture. We were capsized on the top. Very lucky it was so; and the carriage door so completely frozen that we were obliged to get out at the window—the guide and Cantonier began to fight, and the driver was by a process verbal put into prison, so doing while we had to march or rather flounder up to our knees nothing less in snow all the way down to Lancesbyburgh [sc. Lanslebourg] by the King of Roadmakers' Road, not the Colossus of Roads, Mr MacAdam, but Bonaparte, filled up by snow and only known by the precipitous zig-zag[4] ... *Well* I don't know what you will say to my letter, so I will say it myself that I think it is a very long one, and if it is not so good or so long as yours, it beats yours in one respect—it is more uninteligable and non-leguble out and out. Yours took me twice to read; mine will but require at least three times, but there is one comfort that I draw from your small writing, tho you did not say so, that your eyes are better. You will call me thrifty having begun this on an old canvass, but I did not know so until this moment, and its picture

[1] Andrew Geddes (1783–1844), who was painting a family portrait for the 5th Duke of Rutland, who died on 29 Nov. 1825.

[2] J. C. Eustace, *A Classical Tour Through Italy*, 3rd edn. (1817), i. 341: 'that ETERNAL CITY', and, in general, ch. X. For Turner's use of Eustace's guide, Gage 1974.

[3] Phillips and Hilton set out from England together; they were joined for about a month in North Italy by Dawson Turner, and saw Wilkie regularly in Rome (M. R. Pointon, 'The Italian Tour of William Hilton, R.A. in 1825', *J.W.C.I.* xxxv (1972), 339–58). It was, however, not entirely a friendly quartet: Hilton wrote to De Wint in December: 'Turner's object in visiting Italy and ours did not agree and I rather feel he has been a good deal mortified in consequence of our time when he was with us being exclusively taken up with pictures' (ibid. 345).

[4] This incident took place on 15 Jan. 1820; see Turner's watercolour: *Snowstorm Mont Cenis* (T.B.E. No. B.90).

like in relief was not to be put into the fire to begin de novo. So to
conclude, all happiness and comforts attend your fireside etc. etc. etc.

Yours truly
J.M.W.T.

My respects to Mrs H.

[*Addr.*] J. Holworthy Esq
Hathersage
near Sheffield
Yorkshire.

113. Turner to Henry Howard[?]

MS. British Library, Add. MS. 50118, fo. 74
Publ. Armstrong, p. 177

[?April 1826]

Dear Sir,
I cannot but feel anxious for the invitation of Mr Fawkes—in the
place of his late father;[1] first because he has uniformly expressed
himself in the favour of the Arts and in the incouragement which
Farnley Hall *proves* at least to me,—but that any mark of attention
to the present Mr Fawkes might induce him to give his thoughts
likewise to the patronage of the Arts . . . in short, it would be a favour
conferred on

Your most obliged
J. M. W. Turner

114. Turner to John Soane

MS. Sir John Soane's Museum

Tuesday Night [1 May 1826]

My Dear Sir
I have altered the inscription upon the Arch of Titus[2] and it is
said to be now quite right, and as I must say something about the
price of the Picture I will say 500 Gs if you like what I have done,
for without your intire approval I, or rather let me say *we*, shall not
be happy. I have a Tickit in reserve for the private view on Friday—

[1] Finberg (1961, p. 294) suggests that this letter is to the Secretary of the Academy,
proposing Francis Hawksworth Fawkes as a guest at the Annual Dinner, in succession
to his father, who had often been present in the 1810s.

[2] *Forum Romanum, for Mr. Soane's Museum* (B.–J. No. 233).

so have the goodness to let me know in the course of tomorrow if you can conveniently—if you would like to have it, and believe me my dear Sir

> Yours most truly
> J. M. W. Turner

115. Turner to Robert Balmanno

MS. New York Public Library, Ford Collection
Publ. (Facsimile) Falk 1938, facing p. 138

To
 R. Balmanno Esq[r]
 Free-Mason's Tavern[1]
 With J. M. W. Turner's thanks

[*Newspaper Cutting:*
It is impossible there can be a greater contrast of colour than is found between Mr Constable and Mr Turner who exhibits three pictures— *Cologne*, No. 72;[2] *The Forum Romanum* (for Mr Soane's Museum),[3] No. 132; and another.[4] In all, we find the same intolerable yellow hue pervading every thing; whether boats or buildings, water or watermen, houses or horses, all is yellow, yellow, nothing but yellow, violently contrasted with blue.[5] With greater *invention* in his works than any master of the present day—invention which amounts almost to poetry in landscape, Mr Turner has degenerated into such a detestable manner, that we cannot view his works without pain. He is old enough to remember Loutherbourg, whose red-hot burning skies were as repulsive as these saffron hues of his own. We mention this not unkindly, and would wish Mr Turner to turn back to Nature, and worship her as the goddess of his idolatry, instead of this 'yellow bonze' which haunts him.

 Mr Callcott has two pictures of large size and high rank, the *Quay at Antwerp, during the fair-time*, No. 102, and *Dutch Fishing-boats running foul, in the endeavour to board, and missing the painter-rope*, No 165.[6] It is

[1] The traditional meeting-place of the Artists' Annuity Fund, of which Balmanno was Secretary.

[2] *Cologne, the arrival of a packet boat. Evening*, R.A. 1826, (B.–J. No. 232).

[3] B.–J. No. 233. See Letter 114.

[4] Probably *The Seat of William Moffatt, Esq., at Mortlake Early (Summer's) Morning*. (B.–J. No. 235).

[5] See Letters 116, 119, 161.

[6] According to Thornbury (1877, p. 293), this was a jocular response to Stanfield's *Throwing the Painter* which had just missed the Exhibition of 1826. Turner continued the joke in 1827 with *Now for the Painter (Rope). Passengers going on Board* (B.–J. No. 236).

astonishing to see under what various aspects different artists view nature. Here we have, in Mr Callcott, the cool fresh breeze of European scenery, while in Mr Turner's pictures we are in a region which exists in no quarter of the universe.]

[*Endorsed, ? by Balmanno* R.B. British Press 30 Apr. 1826]

116. Turner to James Holworthy

MS. Reg Gadney Esq.
Publ. Monkhouse, p. 403

[*Postmark* May 5 1826]

Dear Holworthy

Many thanks for your letter and the trout fishing invitation to Hatheread [*sic*] but that is quite impossible now at least, so I shall expect to see you first in Town, and then we may talk *how* and when—I am glad to hear you have got so far with your architectural [*illeg. word*] as to be talking of moving <u>in</u> at Midsummer; but mind you get the plaister'd walls tolerably dry before you domicile a camera. These things are not minded so much as formerly, and particularly in London, but when the *walls* weep there is some hazard. Thirty men, and not in Buckram,[1] have made your Ducats move, but you have something for their departure—While the crash among the Publishers have changed things to a stand still, and in some cases to loss—I have not escaped;[2] but more when I see you. Professor Phillips returned quite a carnation to what he went jumbling about did him good, at least in complection. Tho the executive, alias hanging committee at the Royal Academy this year has brought him back to his original tone of colour—but I must not say yellow, for I have taken it <u>all</u> to my keeping this year, so they say, and so I meant it should be;[3] but come and see for yourself, and therefore I shall only say that Portraiture has not forgotten her usual rank or quantity. History rather less than last year and Landscape more if Marine is to be classed with it—Geddes[4] has just called I told him of hearing from you and your Exploits; and beg me me [*sic*] to give his best regards

[1] Cf. Falstaff's battle in *Henry IV Pt. I*, II, iv: where the number of his imaginary assailants increases with the telling of the story. Prince Hal concludes: 'O monstrous! eleven buckram men grown out of two!'

[2] Possibly a reference to the demise of the printsellers Hurst and Robinson, who were publishing the *Temple of Jupiter Restored* (R.208), begun in 1824, but not issued until 1828 by their successors, Moon, Boys & Graves.

[3] For the criticisms of yellowness in Turner's work this year, Gage 1969, p. 20, and Letter 115.

[4] Andrew Geddes (1783–1844).

and Congratulations upon your Building acts, and this being no restriction, you may throw out any front, Geddes says, you please. this I suspect, contains some Enquiry as to the next generation, for it is us poor Londoners who must not trust such things. However, I do trust that Mrs Holworthy is well, and hope that your Eyes are better. Bricks and mortar are said to be very beneficial in some cases, but in no case but of happiness may you ever be placed is the wish of your well wisher, and most truly yours

J. M. W. Turner

[*Addr.*] J. Holworthy Esq^r
Hathereage [*sic*]
near Sheffield
Yorkshire.

117. Turner to John Soane

MS. Sir John Soane's Museum

Saturday July 8 1826

My Dear Soane

As there appears by your note of this morning[1] some kind of dis-approbation of my Picture it is needless to me to say how I intended to make its oversize[2] accommodate to the place.

I like candour and my having said that if you did not like it when done I would put it down in my book of Time!! My Endeavour to please you, and which I beg leave now to do—in regard to the smaller pictures they are not mine, one belongs to W. Moffatt Esq^r of Mortlake[3] and the other to Lady Gordon.[4] Believe me to remain

Yours most truly
J. M. W. Turner

[1] Soane attached the following note to Turner's letter: 'In the beginning of last week before the rec^t of this letter—I wrote to Mr Turner saying that if he was of the same opinion respect^g the picture as when he wrote me on the subject (namely that if I was not perfectly satisfied with it he did not wish me to have it) I would candidly say—the picture did not suit the place or the place the picture but that if the small picture in the present exhibition came within my grasp, I should like to posess it.'

[2] *Forum Romanum* measures $1\cdot27 \times 2\cdot36$ m.

[3] *The Seat of William Moffatt, Esq., at Mortlake. Early (Summer's) Morning* R.A. 324 (B.–J. No. 235).

[4] *View from the Terrace of a Villa at Niton, Isle of Wight, from sketches by a lady* (R.A. 297, B.–J. No. 234).

118. John Soane to Turner

MS. (draft) Sir John Soane's Museum

9 July

My Dear Turner

In answer to the letter you left with me yesterday evening, I enclose a draft for 500 gns[1] as the price named in your first letter— I have only to request you will have the goodness to take charge of the picture until I can find a suitable place for it or a purchaser.

I am my dear T. Yrs *truly* [*deleted*] always

John Soane

119. Turner to James Holworthy

MS. British Library, Add. MS. 50118, fo. 75
Publ. Monkhouse, p. 404

Dec 4 1826

Dear Holworthy

Many thanks for your second letter, which has relieved me some-what from doubts and fears about the first, the same being in the French post-office for me a cachet, it was sent after me, and having said I should be in Paris at a certain time; and my daddy thought it a good opportunity to calm his own fears of my being in the neighbourhood of Ostend, about the time of the blow-up there;[2] so by some means or other he contriv'd to stir up others in the alarm, and in a short month out comes a report in the 'Hull Advertiser' that J.M.W.T. not having written home since the affair at Ostend, at which place it is known he intend to be; therefore great fears are entertained for his safety. However, it does not appear by your letter that the report reached your quiet valley. The lake babbled not lost or the wind murmured not, nor the little fishes leaped for joy that their tormentor was not; they have a respite and liberty to grow bigger by being fed by their master's hand at morn, high noon, or falling eve. By-the-bye, how did you manage to make a lake while all the country was parched with the long drought[?] I thought your situation was high, not low in the valley of Brookfield's pastoral

[1] Soane's cheque is preserved with the correspondence, and Turner's picture returned to his own collection.

[2] An explosion on 20 Sept. at a powder-magazine outside Ostend, killing and wounding several soldiers. For the probable source of the rumour, Lindsay 1966, p. 251.

shades. You talked of moors, but ocular demonstration will rectify all my fanciful notions, ? *when*, that can't be at present, in the spring when the trout begin to move, I am fixt by Exhibition's log [?]; in the summer I have to oil my wings for a flight, but generally flit too late for the trout, and so my round of time. I am a kind of slave who puts on his own fetters from habit, or more like what my Derbyshire friends would say an Old Batchelor who puts his coat on always one way. The knot of celibacy (alias maguilpe) grows beautifully less. Callcott is going to be married to an acquaintance of mine when in Italy, a very agreeable Blue Stocking;[1] so I must wear the yellow stockings.[2] Phillips has been presented by Mrs P with a young Angelica, so when you travel South again contrive to stay longer away. I had nearly forgotten to say that Monro[3] desires me to tell you of his return to town from the East and South, but last from the north—Scotland, of his pleasure of hearing that you are so delightfully employed on the moors, and that others situated farther North ever ready whenever you will turn your attention towards them, and happy to hear from you ever and often. He has lost a great deal of that hesitation in manner and speech, and has I think been spoken to not to blush as heretofore; so French manners does some good with good subjects. But with myself I am as thin as a hurdle or the direction post, tho not so tall that will show me the way to Hathersage. Many thanks for your kind wishes, etc. and compts to Mrs Holworthy. Who the intended visitor from Ld de Tabley can possibly be I know not without I were to say *Ward*.[4] But Adieu and believe me

<div align="right">Most truly yours
J. M. W. Turner</div>

J. Holworthy, Esq.,
Brookfield,
Hathersage,
Derbyshire
near Sheffield.

[1] Maria Graham, Whose Roman address, 12 Piazza Mignanelli, appears on one of Turner's 1819 sketchbooks (T.B. CLXXX, p. 81a). She was an authoress and art historian (see R. B. Gotch, *Maria, Lady Callcott*, 1937).

[2] Cf. Malvolio in *Twelfth Night*, II. v: 'every reason excites to this, that my lady loves me. She did commend my yellow stockings of late, she did praise my leg being cross-gartered; and in this she manifests herself to my love, and, with a kind of injunction, drives me to these habits of her liking. I thank my stars I am happy. I will be strange, stout in yellow stockings ...' Also a reference to Turner's reputation as a colourist: see Letter 116.

[3] H. A. J. Munro of Novar (q.v.).

[4] James Ward, R.A. (1769–1859), an especial friend of Sir John Fleming Leicester (q.v.), who had been created Baron de Tabley this year.

120. Turner to W. B. Cooke

MS. British Library, Extra-illustrated copy of W. Thornbury, *Life of Turner* (Tab. 438 a.1), viii, facing p. 402

[? late 1826]

There is something in the manner of your note received yesterday Evening so extraordinary and differing so materially from the conversation of Wednesday last that I must request you to reconsider the following [*end of fragment*]

[*Verso*] I am
 Dear Sir
 Yours
 J. M. W. Turner

121. W. B. Cooke to Turner

MS. Untraced
Publ. Thornbury 1862, i. 400–3

January 1, 1827

Dear Sir,

I cannot help regretting that you persist in demanding twentyfive sets of India proofs before the letters of the continuation of the work of the 'Coast',[1] besides being paid for the drawings. It is like a film before your eyes, to prevent your obtaining upwards of two thousand pounds in a commission for drawings for that work.

Upon mature reflection, you must see I have done all in my power to satisfy you of the total impossibility of acquiescing in such a demand. It would be unjust both to my subscribers and to myself.

The 'coast' being my own original plan, which cost me some anxiety before I could bring it to maturity, and an immense expense before I applied to you, when I gave a commission for drawings to upwards of 400*l*. *at my own entire risk*,[2] in which the shareholders were not willing to take any part, I did all I could to persuade you to have

[1] A note of four vignettes for an *East Coast* series is on T.B. CCLXXX, 110, and eight engravings have been associated with it (R. 305–12). None was published.

[2] If this refers to Cooke's initial commission to Turner, which, as he states later in this letter, and as a receipt for three drawings in June 1814 confirms (British Library, Add. MS. 50118, fo. 39), he must have ordered more than fifty drawings, whereas only forty were eventually engraved; but he may be including the contributions of other artists to the *Southern Coast*.

one share; and which I did from a firm conviction that it would afford some remuneration for your exertions on the drawings in addition to the amount of the contract. The share was, as it were, forced upon you by myself, with the best feeling in the world; and was, as you well know, repeatedly refused, under the idea that there was a possibility of losing money by it. You cannot deny the result: a constant dividend of profit has been made to you at various times, and will be so for some time to come.

On Saturday last, to my utter astonishment, you declared in my print-rooms, before three persons who distinctly heard it, as follows:— 'I will have my terms! or I will oppose the work by doing another "Coast"!' These were the words you used; and everyone must allow them to be a *threat*.

And this morning (Monday) you show me a note of my own handwriting, with these words (or words to this immediate effect): 'The drawings for the future "Coast" shall be paid twelve guineas and a half each'.

Now, in the name of common honesty, how can you apply the above note to any drawings for the first division of the work, called the 'Southern Coast', and tell me I owe you two guineas on each of those drawings? Did you not agree to make the whole of the 'South Coast' drawings at 7*l*.10s. each? and did I not continue to pay you that sum for the first four numbers?[1] When a meeting of the partners took place, to take into consideration the great exertions that myself and my brother had made on the plates, to testify their entire satisfaction, and considering the difficulties I had placed myself in by such an agreement as I had made (dictated by my enthusiasm for the welfare of a work which had been planned and executed with so much zeal, and of my being paid the small sum only of twenty-five guineas for each plate, including the loan of the drawings, for which I received no return or consideration whatever on the part of the shareholders), they unanimously (excepting on your part) and very liberally increased the price of each plate to 40*l*.; and I agreed, on my part, to pay you ten guineas for each drawing after the fourth number. And have I not kept this agreement? Yes; you have received from me, and from Messrs. Arch on my account, the whole sum so agreed upon, and for which you have given them and me receipts. The work has now been finished upwards of six months, when you show me a note of my own handwriting, and which was written to you in reply to a part of your letter, where you say, 'Do you imagine I shall go to John o'Groat's House for the same sum I receive for the Southern part?' Is this *fair* conduct between man and man, to apply the note

[1] The first four numbers appeared between June 1814 and May 1817.

(so explicit in itself) to the former work, and to endeavour to make me believe I still owe you two guineas and a half on each drawing? Why, let me ask you, should I promise you such a sum? What possible motive could I have in heaping gold into your pockets when you have always taken such especial care of your interests, even in the case of 'Neptune's Trident',[1] which I can declare you *presented* to me; and in the spirit of *this* understanding I presented it again to Mrs Cooke. You may recollect afterwards charging me two guineas for the loan of it, and requesting me, at the same time, to return it to you; which has been done.

The ungracious remarks I experienced this morning at your house, when I pointed out to you the meaning of my former note—'that it referred to the future part of the work, and not to the "Southern Coast"'—were such as to convince me that you maintain a mistaken and most unaccountable idea of profit and advantage in the new work of the 'Coast'; and that no estimate or calculation will convince you to the contrary. Ask yourself if Hakewill's 'Italy', 'Scottish Scenery' or 'Yorkshire'[2] have either of them succeeded in the return of the capital laid out on them.

These works have had in them as much of your individual talent as the 'Southern Coast', being modelled on the principle of it; and although they have answered your purpose by the commissions for drawings, yet there is considerable doubt remaining whether they will ever return their expenses, and whether the shareholders and proprietors will ever be reinstated in the money laid out on them. So much for the profit of works.

I assure you I must turn over an entirely new leaf to make them ever return their expenses.

To conclude, I regret exceedingly the time I have bestowed in endeavouring to convince you in a calm and patient manner of a number of calculations made for *your* satisfaction; and I have met in return such hostile treatment that I am positively disgusted at the mere thought of the trouble I have given myself on such a useless occasion.

I remain, your obedient Servant,
W. B. Cooke

[1] T.B., CLXVIII, C: the drawing for the vignette on the wrapper of *Marine Views*, 1825 (R. 770).
[2] James Hakewill's *Picturesque Tour in Italy* (1820); Scott's *Provincial Antiquities of Scotland* (1826); and probably Whitaker's *History of Richmondshire* (1823).

122. Turner to James Holworthy

MS. Untraced
Publ. Monkhouse, p. 404

April 21, 1827

Dear Holworthy

... Now for news. Glover[1] it is said has discovered an infallible recipe, for what [?] the Tick dolorous, but I cannot tell the fee or account for all that is said. Professor Phillips acquitted himself capitaly, and he knows it.[2] Wheeler[3] has been robbed of his small articles because he was petulant, and altho he bears it very well it is not expected to be cured by ringing bells violently. Monro has made his election and shows some attention to first impressions on India paper before and after the letters. Allason is building poligonals for silk worms, and Grand Alliances Tower [?],[4] how came you to ask for him, *perhaps* he has been with you [?] *I hope so*, or what's the use of adding acre to acre and moor to moor or more to more? What may become of me I know not what, particularly if a lady keeps my bed warm, and last winter was quite enough to make singles think of doubles. Poor daddy never felt cold so much. I began to think of being truly alone in the world, but I believe the bitterness is past. But he is very much shaken and I am not the better for wear; but come and see all the shows of the great town for your kend [sc. kind?] o! The water colour opens next Monday, the British artists last Monday, the roundabout Monday week,[5] the shop Monday fortnight.[6] The lions are fed every night at eight O'clock and Bones make [sc. made] use of every Thursday and Monday evenings at Somerset House during the winter season.[7]

Yours most truly
J. M. W. Turner

[*Addr.*] J. Holworthy Esq.
 Brookfield
 Hathersage.

[1] John Glover (1767–1849), Holworthy's former teacher.
[2] Thomas Phillips gave his first series of lectures as Professor of Painting in 1827.
[3] Possibly Thomas Wheeler, a surgeon, and husband to Clara Wells (q.v.).
[4] Possibly a reference to Allason's work as Surveyor to the Alliance Fire Office.
[5] Probably the Royal Academy Summer Exhibition, which opened at the beginning of May.
[6] Probably Turner's Gallery in Queen Ann St.
[7] A reference to the bone or ivory tickets for admission to Royal Academy lectures (see Letter 263).

123. Turner to William Turner Snr

MS. Untraced
Publ. Finberg 1939, p. 303

[? August 1827]

Mr Broadhurst is to have the Picture of Cologne, but you must not by any means wet it, for all the Colour will come off.[1] It must go as it is—and tell Mr Pearse, who is to call for it, and I suppose the Frame, that it must not be touched with Water or Varnish (only wiped with a silk handkerchief) until I return, and so he must tell Mr Broadhurst. I wrote a day or two ago to say that I shall want more light Trouzers—and so I do of White Waistcoats. I ought to have 4, but I have but 2, and only 1 Kerseymere [*margin* 2 washing or color'd]. Do therefore manage to send some down, if I do not write to desire you to send them to Newman's, which I think I must do, for I must I believe send for some more canvass. However do get them ready and when they are so send them down either by the Southampton or Portsmouth coach,—the direction you will find again written [?within].

J.M.W.T.

124. Turner to William Turner Snr.

MS. C. W. M. Turner Esq.
Publ. National Gallery of British Art, Catalogue, 14th edn. (1906) p. 286

[? August 1827]
Sunday

I wrote yesterday to Mr Newman[2] to get a canvass ready—size 6 feet by 4 feet.[3] I wish you to call and ask if he has it by him and if he get it done by Middleton[4] in St Martins Lane or at home, if by Middleton, then let two be sent; if he does it at home, then he will be some

[1] For the story of Turner's toning down of the *Cologne* with a watercolour wash to avoid hurting a neighbouring canvas by Lawrence, *The Frick Collection*, i (1968), 128, and B.–J. No. 232.

[2] James Newman of Soho Square (cf. W. T. Whitley, *Artists and their Friends in England* (1928), i. 330; *Art in England 1800–1820* pp. 26 f.)

[3] Possibly the canvas on which Turner painted nine sketches of yacht racing at Cowes (B.–J. Nos. 260–8).

[4] John Middleton (cf. Whitley, *Artists and their Friends*, i. 333–4; ii. 360 f.; *Art in England*, pp. 155 f.).

time about it—and then tell him a whole length Canvass to send it instead of preparing the 6 feet 4 canvass … if he has not then go to Middleton and if he has one a whole Length Canvass let him send it me immediately—I want the canvass only. I dont want the stretching frame made in town if Middleton or Newman has the canvass ready done even if a whole length let either send it down to me

<div align="center">

at J. Nash Esq^{re}

East Cowes Castle

Isle of Wight

</div>

if they are both ready send them together rolled up on a small roller and put the linen things I wrote for on the outside …

I want some scarlet Lake and dark Lake and Burnt Umber in powder from Newman one ounce each

<div align="right">

J.M.W.T

</div>

1 ounce of Mastic

[*Addr.*] Mr Turner

 Queen Ann St

47 Cavendish Square

<div align="center">

125. Turner to William Turner Snr.

</div>

MS. Formerly C. M. W. Turner Esq.
Publ. (Facsimile) C. Holmes (ed.), *The Genius of Turner* (1903), between pp. o ii and o iii.

<div align="right">

[*Postmark* Cowes 8 Sp 1827]

</div>

Daddy

It is of no use to talk to Smith.[1] I have long ago desired you and Marsh[2] to get him out but that seems to be of no use or to give him any more time or Jobs & so again I say get him out at any rate … tell him therefore if he does not get out of the House by next Saturday week, that is tomorrow week that you or [*crossed out*] Mr Marsh will seize and will not take away the man—but sell the things at once.

You have not said one word about whether Mr Marsh has sent or not, or Mr Quilly[3] for the Picture or Mr Broadhurst[4] or any thing

[1] Unidentified.
[2] Turner's stockbroker. See Letter 328 and B.–J. No. 104.
[3] J. B. Quilley, the engraver of Turner's *Deluge* (B.–J. No. 55), which was published as a mezzotint in 1828 (R. 794).
[4] See Letter 123.

which I care about why teaze me about Smiths affair!! take the
Paper about *Wapping*[1] and get it stampt at the Office.

Somerset House

 J.M.W.T.

126. Turner to George Cobb

MS. Maggs Bros. 1975

 Petworth Sunday
 [*Endorsed* 28 Oct. 27]

Sir

Mr W Millar of No 7 of New Gravel Lane Wapping wishes to have
a Lease of no 7 and 8[2]—but before he moves—begs to know how much
will be the expense. if therfore you will see him viz send him word and
if he agrees to your terms I will then by your informing me thereof
by a line to me at Lord Egremonts Petworth Sussex ... or *then* you
may proceed—to draw up the Copy—as follow[s] thus 14 Years Lease
at 6oL per year clear of all and every thing—Church R [ate] & & &
to pay the insurance 6oo each in joint names .. to repair substan[ti]aly
and a given Sum to be Paid out for each House now and a further sum
in future to prevent the Houses being left at the termination of the 14
Years End and to paint at a given time—and clear the Lawn [?] which
belong to them.

 Now I beg you to lose no time for he is to begin the Rent of No 8
as soon as the Lease is signed .. but you must get his consent to your
charge before Nov[ember] begins and I expect to be in Town about
Tuesday Week for a day or two when I hope all will be ready.

 yours most Obed^y
 J. M. W. Turner

[*Addr.*] G. Cobb Esq^re
 Solicitor
 13 or 14 Clements Inn
 London

[1] For Turner's Wapping property, see Letters 126–7.
[2] For Turner's Wapping property, inherited in 1821, Falk, pp. 116–17; Finberg
1961, p. 275.

127. Turner to George Cobb

MS. Royal Academy Scrapbook, 82 d

[*Postmark* 31 Oc 1827]
Tuesday

Sir

I received your letter this morning and beg to say that Mr Mitchell's Brother of Rotherhithe is to be guarantee [*pencil* or be Bound [?]] for the Rent[1] this I forgot in my last but trust that he mentioned it unto you when you were at Wapping. In regard to the Sum to be laid out I mean to be guided by the Architect who looked over the Houses, Mr Allason 64 Lincoln's Inn Fields;[2] he will say if you care to call on him with my compliments. In fact should Mitchell particularly want to know, but otherwise I should like to see Mr Allason myself because what I want secured is for substantial doings absolutely necessary to make the House good to the end of the Leases.

I think I ought to see the draft as well as Mitchell before you go to Parchment

J. M. W. Turner

[*Addr.*] G. Cobb Esq[re]
Solicitor
13 or 14 Clement's Inn
London

128. Turner to Charles Heath

MS. Cambridge, Fitzwilliam Museum MS. 214–1949

Petworth Sunday [? Oct. 1827]

Dear Sir

Mr Griffiths might with concern [?] (even with his consent obtained) conceive the notion that the best drawings for the England are selected to be used for another purpose, and thereby disturb your arrangement with him.[3] I do not advise you so to do but the contrary

[1] For T. Mitchell as tenant of 7 and 8 Gravel Lane, Wapping, which Turner subsequently converted into the *Ship and Bladebone* Public House, Falk, pp. 116–17.

[2] Thomas Allason (See Letters 70, 82, 112, 122).

[3] This may be understood to mean that Thomas Griffith (q.v.) was the agent entrusted with the disposal of the *England and Wales* drawings made by Turner for Heath. In 1833 Griffith lent twenty-eight *England and Wales* drawings to the Moon, Boys & Graves (q.v.) Exhibition, some thirteen of which had been in Heath's 1829 Exhibition at the Egyptian Hall (See Appendix II). Heath himself lent only eleven, all

[?] all you can gain *is time* (the next drawing can be for the Keepsake[1])
and the good which may be lost by creating any feeling of uneasiness
in him cannot (well be in reality) calculated upon.

Believe me, dear Sir
Yours most truly
J. M. W. Turner

129. Turner to Charles Stokes

MS. Trewin Copplestone Esq.

[*Postmark* 17 NO 182[?]7]
Isle of Wight

Dear Stokes

Many thanks for the information of the Nice Wine; have the good-
ness to let me have the whole 5 Doz if you can

Yours most truly
J. M. W. Turner

To C. Stokes Esqre

[*Addr.*] C. Stokes Esq^re
Verulam Buildings
Grays Inn

130. S. Lovegrove to Turner

MS. T.B. CCLXIII(a), 7
Publ. Finberg 1909, ii. 846

Dear Sir,

I received the 10^th Instant your very kind Letter and I am very
much Oblig'd for your Information. I also Rec^d at the same Time,
One from Mr Harpur,[2] with the Leagacy Stamp Enclosed in it for
me to sign the Receipt; and to return it to him and likewise to
Inform him in what way I would have the Money sent, which was

of which were in the process of being engraved. The drawings referred to may be the
two *Virginia Water* watercolours, of the same size and type as the *England and Wales*
series, and shown with them in 1829, but subsequently engraved for the *Keepsake* in
1830 (R. 322–3).

[1] See p. iii n. 3. No other English subjects after Turner were engraved for the
Keepsake, Turner's first contribution for which (*Florence*, R. 319) is dated October 1827.

[2] Henry Harpur, a distant relative of Turner's, who became his solicitor. His name
is mentioned on the document referred to in p. 113 n. 1, and he may have lived at
Sunningwell, near Oxford.

the same way that he sent Mrs Marshalls,[1] for that always came very safe and without much Trouble, and I returned him the Receipt on Last Munday and I have not heard from since which I thinks that odd that he has not sent to me before now. D[r] Sir I must beg you to Excuse my riteing for my eyes are so very bad that it is almost done by feeling. If you please to give my kind Respects to M[r] Turner,[2]

> So I Remains Sir,
> Your obedient Servant,
> S. Lovegrove

Sunningwell, ye 19th of Nov[r]., 1827
 I shall send you a Turkey and Chine very soon.

[*Verso: Pencil study for a classical subject*]
[*Addr.*] J. M. W. Turner, Esq[r]
 Queen Ann Street West
 Harley Street Cavendish Square
 London.

131. Turner to James Pickering Ord

MS. Untraced
Publ. Finberg 1939, p. 305

> [*Postmark:* December 15 1827]
> 47 Queen Ann St West
> Saturday

Dear Sir
 I beg to lose no time in the hope that I may request my most sincere and respectful remembrances to Mrs Fawkes before you leave Farnley, and if a stranger might ask more, to say that I directed two letters to Spa, as Mr Hawkesworth Fawkes requested me in June last, but have received no answer to them.
 To this liberty allow me to offer my thanks for your kind regard to my late dear *friend's*[3] value and his appreciation of my endeavours— that to any friend of his ... I am ready to answer—yes—but I fear

[1] Lovegrove may have been the third beneficiary of the will of Joseph Mallord William Marshall, who died at Sunningwell in June 1820. Turner, another beneficiary, seems to have been in the habit of collecting the rents of the Marshall property in Wapping, and transmitting the money by friends or associates to Sunningwell. In 1822 the carrier was W. B. Cooke (q.v.), and Turner's instructions to him (British Library, Add. MS. 50118, fo. 67) bracket Lovegrove's name with that of Mrs. Marshall (see Finberg 1961, pp. 275–6).

[2] Turner's father.

[3] Probably Walter Ramsden Fawkes (q.v.).

that time and circumstances have made it necessary to make some restrictions upon the drawings, viz. that they are not to be lent for Engraving without an additional sum being paid for the same whenever engraved. In regard to my not wishing to make short of four, without they are Large drawings—that is remov'd (tho' you have not mentioned price or size) by your words 'in continuation if you like'. As to the Rhine or Switzerland—certainly if you please, only let me request your not leaving the choice wholly to me.[1]

Permit me [to] add my thanks for your kind invitation to Edge Hill, and as I contemplate a visit to Derbyshire and perhaps Northward next year I will avail myself of your kindness.

<div align="right">

Yours very sincerely
J. M. W. Turner

</div>

P.S. Pray excuse the haste of this—to be in time for the post.

132. Turner to George Cobb[?]

MS. Private Collection, New York

Sir

I have just received your proposition from Mrs Byrne[2] viz to allow the Quarter's Rent for her fixtures in *Harly St*—which I beg leave to decline altogether for I cannot tell (even from you) what they are .. which are said to be equal to the above value

<div align="right">

yours &c
J. M. W. Turner

</div>

Petworth Dec 18

133. Turner to James Holworthy

MS. British Library Add. MS. 50118, fos. 78-9

<div align="right">

[*Endorsed* 1827]

</div>

Dear Holworthy

Have the goodness to make an apology for me *for the inclosed* and

[1] Ord seems to have hoped for a 'continuation' of the Swiss and Rhineland watercolours at Farnley. It is not known whether Turner executed this commission.

[2] Charlotte Byrne was the occupier of 66 Harley Street (renumbered 74 in 1826), of which Turner had held the lease since 1823 (Finberg 1961, p. 268), between 1826 and 1830 (Rate Books in Marylebone Public Library). The present letter may thus belong to 1827 or 1829.

I am very sorry that an Engagement will prevent [?] me the pleasure of accepting the invitation and of meeting you there

<div align="right">

Yours most truly
J. M. W. Turner

</div>

[*Addr.*] J. Holworthy Esq^re

134. Turner to Moon, Boys & Graves

MS. Untraced (Sotheby, 3 July 1908 (109), bt. Shepherd)

<div align="right">[20 February 1828]</div>

If my assistance in bringing the plate[1] to a completion under all circumstances [be] thereby rewarded, I must submit, for I made no stipulations whatever.

135. Turner to Robert Finch

MS. Oxford, Bodleian Library, MS. Finch c.2 d.15, fo. 437

<div align="right">[*Endorsed* Rec^d March 16 1828]</div>

J. M. W. Turner presents his respects to Mr and Mrs Finch and he is very sorry he has an engagement on Thursday next the 20^th

<div align="right">

47 Queen Ann ^st West
Sunday

</div>

J. Finch Esq^re

136. Turner to George Jones

MS. Alan Cole Esq.

[On 1 Apr. 1826 the Royal Academy Council received a request from the Treasurer that £500 worth of stock should be sold to cover a deficit in the accounts. The sale was authorized. On 23 Mar. 1827 Shee proposed a law tightening the rules governing expenditure by the Academy; and on 16 July at the General Assembly, 'Mr Turner gave notice that at the next General Assembly he would bring forward a motion relating to the sale of stock belonging to the Academy'. Nothing seems to have been done until the General

[1] Possibly one of the four *England and Wales* subjects published on 1 Mar. 1828 (R. 221–4).

Assembly of 9 Feb. 1828, when 'Mr Turner moved in pursuance of the notice he had given in July last "that the Council be requested to take into consideration the expediency of proposing a law to provide against the sale of any stock belonging to the Royal Academy without the consent of the General Assembly and the sanction of His Majesty"'. He was seconded by Jones and the motion passed. The Council, of which Turner was a member this year, considered the proposal on February 21, but it was not referred back to the General Assembly at their next meeting on 5 Apr., nor does anything further seem to have been heard of it.]

[*Watermark:* 1827]
[5 April 1828]

Dear Jones

I cannot very well avoid the G A to night but I beg you will not think of going,[1] indeed I shall be much mortified if you do, for with me the bitterness of the thing is past and therefore wish you not to CARE about it. I shall follow your advice and be silent: all I care about is that a fair statement be made by the Council to the Gen Assembly

Yours most truly

Saturday Mor^g for Tuesday

G. Jones Esq^r RA

137. Turner to John Thomson of Duddingston

MS. National Library of Scotland MS. 786, 104–105^v

June 2^d 1828

Dear Sir

I herewith send you the inclosed Bank Post Bill for eighty Pounds being the sum for your Share of the Provincial antiquities of Scotland sold to Mr R. Jennings of the Poultry[2] and I have given him an order upon Messrs Arch to deliver this No to him.

[1] Both Jones and Turner were present at the Assembly on 5 Apr.

[2] Thomson had contributed eleven plates to Scott's *Provincial Antiquities and Picturesque Scenery of Scotland*, published by Arch in 1826. Turner supplied twelve plates, and others were provided by Callcott, Geddes and Schetky (qq.v.), Blore, H. W. Williams and A. Naysmyth.

Pray have the goodness to send me word *instanter* that I may be happy in knowing you have received the said £80 Bill safe &c&c&c&c. hoping you will approve of this my said act

<div align="right">

Believe me most truly
Yours faithfully
J. M. W. Turner

</div>

[*Addr.*] To the Rev^d John Thomson
Duddingstone
near Edinburgh N.B.

138. John Pye to Turner

MS. (Copy) Victoria and Albert Museum, Pye MS. 86 FF. 73, fo. 4

Dear Sir

You request me to give you [*hole*] Engraving a plate from your picture of [*hole*] the Carthaginian Empire now Exhibiting [*hole*] House,[1] the size of the plate which I have recently engraved of the Temple of Jupiter.[2]

financially [?] I beg to state that the price will be nine [?] Hundred Guineas payable as follows (viz) two [?] hundred on the delivery [?] of a proof of the etching—fifty on the 25 of each of the months of Dec^r March June & Sept in the two subsequent years and the remainder on the completion of the plate which I engage to do in 4 years from the receipt of the picture for the purpose of being engraved.

<div align="right">

Yrs
John Pye

</div>

[*Endorsed by E. Pye*] I believe the plate was etched by my brother but it was not engraved by him. Oct. 1888.]

[*Verso*] Terms on which I engaged to engrave W. Turner's picture of Dido and also W. Turner's acquiescence in those terms expressed in a note which is enclosed.

<div align="right">

June 3 1828.

</div>

[1] *Dido directing the Equipment of the Fleet, or the Morning of the Carthaginian Empire* was No. 70 in the Royal Academy Exhibition at Somerset House (B.–J. No. 241). Pye's plate was advertised in 1828 (Finberg 1961, p. 306), but not published.
[2] *The Temple of Jupiter Panellenius Restored* (R. 208), on which Pye had been working since February 1823 (cf. *European Magazine* February 1823, p. 163), and which was published in March 1828. See Letter 139.

139. Turner to John Pye

MS. Victoria and Albert Museum, Pye MS. 86 FF. 73, fo. 5

Mr Pye

In answer to your note of to day June 3rd 1828 I agree to the terms proposed for engraving the Dido

J. M. W. Turner

140. Turner to C. L. Eastlake

MS. British Library Add. MS. 50119, fo. 74
Publ. (Extract) Finberg 1939, p. 307

[*Postmark* 23 Aout 1828]
Paris August 1828

Dear Signor Carlo

Being at last off from the loadstone London, I venture to apologize for not being with you by the time I expected to be in Rome and likewise with you no 12 Piazza Mignanelli which our friend Maria Callcott[1] has given such a remarkable account of that I am delighted to have an entrance from the Clouds [?] in practice, but how far I can keep pace with her remembrance of past days by my remembring of her love of art and Endeavours to be in nubibus—by reflections [I cannot say].

However it may be I must trouble you with farther requests viz . . . that the best of all possible grounds and canvass size 8 feet 2½ by 4 feet 11¼ Inches to be if possible ready for me, 2 canvasses if possible, for it would give me the greatest pleasure independant of other feelings which which [*sic*] modern art and of course artists and I among their number owe to Lord Egremont that the my [*sic*] first brush in Rome on my part should be to begin for him con amore a companion picture to his beautiful *Claude*[2]—Tho I cannot say when I can arrive in Rome owing either to my passing by way of Turin to Genoa or by Antibes yet our agreement from the 1st of Sept holds good and I hope then you have een now seen Roma for I have been delay'd longer than I ought—but do pardon me in saying order me what ever may be [*tear*] to have got ready that you think right and plenty of the

[1] Maria Graham, who had stayed at the same address with Eastlake in 1819 (Cf. T.B. CLXXX, p. 81a). She had married A. W. Callcott (q.v.) in 1827 (see Letter 119).

[2] *Jacob and Laban* (see Letter 50). Turner's companion was probably *Palestrina* (B.–J. No. 295) although this was never acquired by Egremont.

useful—never mind Gim Cracks of any kind even for the very Easel I
care not

So wishing you are in good health
&&& Believe me truly J. M. W. Turner

Signor Carlo Eastlake
Piazza Mignanelli
Rome

141. Turner to George Jones

MS. Untraced
Publ. Thornbury 1862, i. 225–6

Rome: Oct. 13 1828.

Dear Jones

Two months nearly in getting to this Terra Pictura, *and at work*;
but the length of time is my own fault. I must see the South of
France, which almost knocked me up, the heat was so intense, par-
ticularly at Nismes and Avignon; and until I got a plunge into the
sea at Marseilles, I felt so weak that nothing but the change of scene
kept me onwards to my distant point.

Genoa, and all the sea-coast from Nice to Spezzia is remarkably
rugged and fine; so is Massa. Tell that fat fellow Chantrey that I
did think of him, *then* (but not the first or the last time) of the
thousands he had made out of those marble craigs which only afforded
me a sour bottle of wine and a sketch; but he deserves everything
which is good, though he did give me a fit of the spleen at Carrara.

Sorry to hear your friend Sir Henry Bunbury has lost his lady. How
did you know this? You will answer, of captain Napier, at *Siena*.[1] The
letter announcing the sad event arrived the next day after I got there.
They were on the wing—Mrs W. Light to Leghorn, to meet Colonel
Light, and Captain and Mrs Napier for Naples; so, all things con-
sidered, I determined to quit instanter, instead of adding to the
trouble.

Hope that you have been better than usual, and that the pictures
go on well. If you should be passing Queen Anne Street, just say I
am well and in Rome, for I fear young Hakewell[2] has written to his

[1] Sir Henry Bunbury, of the Sicilian Command, and Lady Bunbury's family, the
Napiers, were close friends of Dr. and Mrs. Somerville, with whom Turner was in
touch in these years (cf. Letters 151, 175; M. Somerville, *Personal Recollections of Mary
Somerville* (1873), pp. 154–5). A George Thomas Napier, half-pay Colonel in the
Sicilian Regiment, is recorded in the *Army List* for 1828.

[2] Probably, F. C. Hakewill, a son of James Hakewill, whose *Picturesque Tour in Italy*
Turner had illustrated. Hakewill exhibited a *Madonna and Infant Christ* at the Academy
in 1829, and his address appears in T.B. CCCXLIV, 196.

father of my being unwell; and may I trouble you to drop a line into the twopenny post to Mr C. Heath, 6 Seymour Place, New Pancras Church, or send my people to tell him that, if he has anything to send me, to put it up in a letter (it is the most sure way of its reaching me) directed for me, No. 12 Piazza Mignanelli, Rome, and to which place I hope you will send me a line? Excuse my troubling you with my requests of business. Remember me to all friends. So God bless you. Adieu.

<div style="text-align: right">J. M. W. Turner.</div>

142. Turner to Francis Legatt Chantrey

MS. Untraced
Publ. Thornbury 1862, i. 224–5

<div style="text-align: right">No. 12 Piazza Mignanelli, Rome
Nov. 6. 1828.</div>

My Dear Chantrey

I intended long before this (but you will say Fudge) to have written; but even now very little information have I to give you in matters of Art, for I have confined myself to the painting department at Corso;[1] and having finished *one*, am about the second,[2] and getting on with Lord E's,[3] which I began the very first touch at Rome; but as the folk here talked that I would show them *not*, I finished a small three feet four to stop their gabbling:[4] so now to business.

Sculpture, of course, first, for it carries away all the patronage, so it is said, in Rome; but all seem to share in the goodwill of the patrons of the day. Gott's Studio is full.[5] Wyatt[6] and Rennie,[7] Ewing,[8] Buxton,[9] all employed. Gibson has two groups in hand, 'Venus and

[1] Many history-painters are listed with addresses in the Corso by Enrico Keller, *Elenco di tutti gli Pittori ... in Roma ...* (1824).

[2] Probably *Medea* (B.–J. No. 294) and *Regulus* (B.–J. No. 293).

[3] *Palestrina* (B.–J. No. 295), painted for Lord Egremont (see Letter 140).

[4] *View of Orvieto* (B.–J. No. 292).

[5] Joseph Gott (1786–1860), settled in Rome since 1822, close to Eastlake (q.v.) and Joseph Severn and patronized by Lawrence (q.v.) (cf. Leeds/Liverpool, *Joseph Gott*, 1972).

[6] Richard James Wyatt (1795–1850), settled in Rome from 1821; patronized by Lawrence and Canova (q.v.).

[7] George Rennie (1802–60), whose first R.A. exhibit was presented in 1828, when he returned from Rome.

[8] William Ewing or Ewins (fl. 1820–8), influenced by Chantrey. Exhibited ivory busts of Canova and Pius VII at R.A. in 1822. A marble bust of Robert Finch (q.v.) in the Ashmolean Museum is dated 1826.

[9] Untraced.

Cupid', and 'The Rape of Hylas,'[1] three figures, very forward, though I doubt much if it will be in time (taking the long voyage into the scale) for the Exhibition, though it is for England. Its style is something like 'The Psyche',[2] being two standing figures of nymphs leaning, enamoured, over the youthful Hylas, with his pitcher. The Venus is a sitting figure, with the Cupid in attendance; if it had wings like a dove, to flee away and be at rest, the rest would not be the worse for the change. Thorwaldsten is closely engaged on the late Pope's (Pius VII) monument.[3] Portraits of the superior animal, man, is to be found in all. In some the inferior—viz. greyhounds and poodles, cats and monkeys, &c. &c. . . .

Pray give my remembrances to Jones and Stokes, and tell *him* I have not seen a bit of coal stratum for months.[4] My love to Mrs Chantrey, and take the same and good wishes of

<div style="text-align:right">

Yours most truly
J. M. W. Turner

</div>

143. Turner to Charles Turner

MS. Alan Cole Esq.

<div style="text-align:right">

[*Postmark* De 15 1828]
No 12 Piazza Mignanelli Nov [20]
Rome

</div>

Dear Charles

I have just recived a letter from Mr Jones and I sit down to congratulate you or rather myself, for without Sir Tho[s] casting vote your losing the election by my absence would have made me miserable[5]— I do not mean by saying so to take any credit to myself but on the contrary do beg that you regard with truly worthy and not an obseqqious respect the Members who so nobly supported you and particularly to the President who may have had some cause of yore of displeasure, for the flattering manner which he bestow'd it, your never to be *forgotten* esteem and regard, and now do think what a shame [?] the clamour of the love of money caused, dismiss it now

[1] John Gibson (1790–1866) had begun a *Hylas and the Naiads* for Robert Vernon (q.v.) in 1826 (Tate Gallery). *Venus and Cupid* has not been traced.

[2] *Psyche Carried off by the Zephyrs* had been carved for Sir George Beaumont in 1822.

[3] The monument to Pius VII in the Capella Clementina of St. Peter's had been commissioned from Bertel Thorvaldsen (1768/70–1844) in 1823, and was unveiled in 1831.

[4] Charles Stokes (q.v.) was an enthusiastic amateur geologist.

[5] Charles Turner was elected Associate Engraver at the Royal Academy on 3 Nov. 1828. See also Letter 144.

unworthy of yourself, your family need it not and will readily accord [?] for your honor and for your *name*.[1]

> Belive me most truly
> yours
> J. M. W. Turner

P.S. You see I am acting again the Papa with you but it is the last time of asking

> Yours truly
> J.M.W.T.

[Addr.] C. Turner Esq^re
 50 Warren Street
 Fitzroy Square
 London

144. Turner to Sir Thomas Lawrence

MS. C. W. M. Turner Esq.
Publ. Notes & Queries, ser. VI, xi (1885), 25

[*English Postmark* Dec 15 1828]

Dear Sir Thomas

Allow me to thank you for your casting vote in favour of Charles Turner and the kind and flattering notice of his talents with which you bestowed it.[2]

I have but little to tell you in the way of Art and that little but ill calculated to give you pleasure. The Sistine Chapel Sybils and Prophets of the ceiling are as grand magnificent and overwhelming to contemplating as ever, but the Last Judgement has suffer'd much by scraping and cleaning particularly the sky on the lowermost part of the subject so that the whole of the front figures are in consequence one shadde. And it will distress you to hear that a Canopy (for the Host, the Chapel being now fitted up for divine service) is fixed by 4 hoops in the Picture,[3] and altho' nothing of the picture is obliterated by the points falling in the sky part, yet the key note of the whole—sentiment is lost, for Charon is behind the said canopy, and the rising from the dead and the Inferno are no longer divided

 [1] In 1852 Charles Turner claimed that his need to raise his prices from 8 to 10 (or 12) guineas per *Liber* plate led to a 'nineteen-year' rift with the painter (Pye–Roget, pp. 59 ff.).
 [2] See Letter 143.
 [3] The canopy was already there on Turner's first visit in 1819 (H. Sass, *A Journey to Rome and Naples* (1818), p. 120).

by his iron mace driving out the trembling crew from his fragile bark.

Before quitting the subject it is but justice to a departed spirit, whose words and works will long dwell in your remembrance—and I hope so in mine—to acknowledge my error in shirking his remark, viz. 'To my eye it doth possess some good Colour of Flesh,—that a second look at the Last Judgement I must admit of for there are some figures in the Inferno side worthy of our friend Fuseli's words.[1]

Orvieto I have seen[2] and Signorelli there shining preeminent, father of the rising of the Dead and Inferno, and Michael Angelo has condescended to borrow largely, and not in the case [*tear*] demon flying away with the finial [*tear*] improved it. Mr Ottley will call me to account for so daring an opinion[3] but I must defend myself with all due humility—in person, I hope about the beginning of February— when I shall feel truly happy to pay my respects to you in Russel Square. In the mean time

<div align="right">Believe me most truly yours
J. M. W. Turner</div>

Excuse haste

[*Endorsed* Nov 27 12 Piazza Mignanelli]

145. Turner to Charles Heath

MS. New York, Pierpont Morgan Library

<div align="right">[*Postmark* 15 De 1828]
No 12 Piazza Mignanelli
ROME Nov^r 28</div>

My Dear Sir

I think of leaving here about the first of January and therefore supposing that early in February I shall have the pleasure of seeing you again in Queen Ann St it will be not worth while to send any print after you receive this[4] without very urgent cause or so that it can

[1] Fuseli and Turner's view on Michelangelo's colour was not uncommon in the 1820s: see Etty to Lawrence in 1822 (D. Farr, *William Etty* (1958), p. 117) and Wilkie to William Collins, December 1825 (A. Cunningham, *Life of Wilkie* (1843), ii. 198).

[2] Cf. T.B. CCXXXIV, p. 35a.

[3] W. Y. Ottley, *A Series of Plates engraved after the Paintings and Sculptures of the Most Eminent Masters of the Early Florentine School* (1826), caption to plates LI–LIV, had pointed to Michelangelo's borrowing from Signorelli's *Demons of the Air* (pl. LIII) at Orvieto, but without discussing the value of the borrowing. He was simply quoting Vasari.

[4] Presumably prints for *England and Wales*, eight of which were published during 1829. See also Letter 128.

be in Rome by Xmas day or the end of Dec^r—wishing you the
Compliments of the season Keepsake[1] &c

> Believe me yours most truly
> J. M. W. Turner

C. Heath Esq^r

[*Addr.*] C. Heath Esq^{re}
No 5 Seymour Place
Euston Square

146. Lord Egremont to Turner

MS. T. L. and E. C. Griffith

Dear Sir
 If my letter does not come too late I shall be glad to have the
Torso,[2] and I hope soon to have the pleasure of seeing you again in
England

> ever truly yours &c
> Egremont

Petworth Dec^r 2 1828

[*Addr.*] To Mr J. W. Turner
No. 12 Piazza Mignanilli
Rome

147. Turner to C. L. Eastlake

MS. Untraced (Maggs Bros. 1914 (2065))

[16 February 1829]

First list: Constable 12; Danby 6; Clint 5; Briggs 2; Eastlake 2;
Landseer 1.[3] Draw your own conclusion from this petty treason, and

[1] Turner's first contribution to Heath's *Keepsake* (*Florence*, R. 319) was published in
1828. It was an annual intended for the Christmas market (see S. C. Hall,
Reminiscences (1883), i. 306–10).
[2] See Letters 147, 154. The torso is perhaps the *Torso restored as Dionysos* (M.
Wyndham, *Catalogue of the Collection of Greek and Roman Antiquities in the Possession of Lord
Leconfield* (1925), No. 14 (ill.)). The restoration is probably by J. E. Carew (1785?–
1868), who was employed almost exclusively by Egremont between 1822 and 1837.
[3] The list of votes for new Academicians, 10 Feb. 1829.

I trust close to your work, for I have said, a picture is in hand and will arrive in time for the Exhibition.[1]

Now for my affairs. How walk they in Rome? I hope Peter[2] has got the stove up in lieu of the Fire place, and found some body to take the Studio and Rooms left.

! ! ! Hope that the Torso[3] is safely off.

! ! ! Hope that my Pictures are half way home and insured for 500 and you have the invoice; pray tell me how they are directed, who consigned to in London, they and the Torso, for I begin to be figgitty about them. I know you will have directed right, but I should like to know How, for my last two or three days in Rome were all in a whirl; and you at last packed me up... Mr B[4] desired me to say 'when he saw Mr E's mother last, she was well' & tell him from me that I have asked Chantrey to *lend me a bust* which shall be expressed to Rome for his use. Say if you wish any thing sent in the Case—some stone shall be put in for those who want yellow in Rome.[5]

Now for my journey *home*. Do not think any poor devil had such another, but quite satisfactory for one thing at least, viz. not to be so late in the season of winter again, for the snow began to fall at Foligno, tho' more of ice than snow, that the coach from its weight slide about in all directions, that walking was much preferable, but my innumerable tails would not do that service so I soon got wet through and through, till at Sarre-valli the diligence zizd into a ditch and required 6 oxen, sent three miles back for, to drag it out; this cost 4 Hours, that we were 10 Hours beyond our time at Macerata, consequently half starved and frozen we at last got to Bologna, where I wrote to you. But there our troubles began instead of diminishing—the Milan diligence was unable to pass Placentia. We therefore hired a voitura, the horses were knocked up the first post, sigr turned us over to another lighter carriage which put my coat in full requisition night and day, for we never could keep warm or make our day's distance good, the places we put up at proved all bad till Firenzola being even the worst for the down diligence people had devoured everything eatable (Beds none) ... crossed Mont Cenis on a sledge—bivouaced in the snow with fires lighted for 3 Hours on Mont Tarate while the diligence was righted and dug out, for a Bank of Snow saved it from upsetting[6]

[1] Probably *Lord Byron's Dream*, 1827 (Tate Gall.). See Letter 149.
[2] Possibly the German painter Wenzel Peter, who died in Rome in 1829.
[3] See Letter 146.
[4] Possibly William Brockendon: See Letter 154.
[5] i.e. gallstone. See Letter 156.
[6] See Turner's *Messieurs les voyageurs on their return from Italy (par la diligence) in a snow drift upon mount Tarrar, 22nd of January, 1829,* shown at the Royal Academy in 1829 (T.B.M. No. 147 (ill.)).

—and in the same night we were again turned out to walk up to our knees in new fallen drift to get assistance to dig a channel thro' it for the coach, so that from Foligno to within 20 miles of Paris I never saw the road but snow!

148. Turner to Clara Wells (Wheeler)

MS. British Library, Add. MS. 50119, fo. 3
Publ. Finberg 1939, p. 313; (Facsimile) *British Museum Quarterly*, XXII (1960), pl. xxii.

[*Postmark* March 19 1829]
Thursday

Dear Clara
 I must not allow myself the pleasure of being with you on Saturday to dinner
 Time Time Time
 so more haste the worse speed

[*Addr.*] Mrs J. Wheeler
 60 Grace Church St
 City
 near Fenchurch

149. Turner to C. L. Eastlake

MS. Cambridge, Fitzwilliam Museum MS. 213–1949
Publ. Gage 1968, p. 680

[*Postmark* May 2 [?] 1829]
Winchester Tower, Windsor[1]

Dear Eastlake, I received yours from Rome the second letter just at

[1] The letter was written on a visit to Sir Jeffry Wyatville (1766–1840) at Windsor Castle, which Jones claimed was an annual event for Turner (Thornbury 1877, p. 281). Wyatville had a residence in Winchester Tower, while working on the fabric of the Castle, from 1824 to 1840 (D. Linstrum, *Sir Jeffry Wyatville* (1972), pp. 42 f.).

starting for this place and sit down to say all I can before I may be called away.

Thanks therefore for full admission to grumble with your permission for no tidings of my pictures up to the present time from Smith or his agents at Florence or London have crossed my path. Bad news flies apace it is said 'How long will good news be'? Maldaza Torio [?] I have heard of by a letter dated Florence the 7 of March ... by Invoice [?] of the good ship (Brig) Won [?] No young master this must have left Rome long after my Pictures—particularly after the great trouble you had with him Maldaza for which do allow me to offer my thanks for you did quite right in all and everything but taking the Raphael plates into your own safe care!!! (do pray do so by power of the receipt he gave you) for he may charge their full worth for their package and until Ld. Egremont comes to Town, which will be about Easter week, I can say nothing conclusive about them excepting I would prefer your keeping far better.

It is lucky that time prevented me taking up the Pen until after your Byron's dream made its appearance at Somerset House[1] not because you accused me of witholding [?] a secret even to me of a Picture being necessary to be thought of next time, perhaps your friendly informant can tell what would be [*blot*] beneficial to the *Body* than myself as he seems to know more about it, and it would be well to know what secret spring can make an idle Academician work —however a bad excuse is better than none—and the next I hope will be to the proof that no stone has been left unturned—for you have got me into a pretty scrape with Mr Soane, who had some doubt when I told him of its being on hand, for he asked me the size and I told him about 2 feet and a half.[2]

Do pray make Smith see about the Pictures and write me word what agent he consigned them to; surely they are one among the Fishes, the trouble of getting things home is abominable and if lost of whom am I to demand the insurance of the 500?

Hammersly shall have another £10; you will hand the first at Torlonia's or if you like it better to draw upon me for the second £10 do so, only let me know the date—June will be too early for my return; August [or Sept *deleted*] will overtake me I fear and I rather tremble at the heat of July in Rome and what is the use of painting Pictures if I cannot get them safe; it is a sad drawback.

Tell Wyatt[3] his brother called to ask after him; his Family are

[1] *Lord Byron's Dream* (R.A. 1829, Tate Gallery) Reproduced Gage 1968, 683, Fig. 51.
[2] *Una delivering the Red Cross Knight from the Cave of Despair* (Sir John Soane's Museum). The commission dated from 1824 (Gage 1968, pp. 680–1 and fig. 47).
[3] The sculptor R. J. Wyatt (1795–1850).

anxious to hear from him. Give my remembrance to all *friends* in Rome

 and believe me most truly J. M. W. Turner

Good Friday—Get the *Room* let if you can safely [?] Should Peter[1] not want to.

Charles Eastlake Esq^re
12 Piazza Mignanelli Rome.

150. Turner to Henry Rogers

MS. British Library, Add. MS. 50119, fo. 5

 Friday May 29 1829
My Dear Sir
 I am very sorry to say that I have an engagement to dine at Black-heath on Sunday next therefore cannot have the pleasure of seeing the Italian Sun set bespoke at Highbury Terrace that Evening
 with great respect
 yours most truly
 J. M. W. Turner

H. Rogers Esq^re

151. Francis Legatt Chantrey to Turner

MS. British Library, Add. MS. 50119, fo. 7
Publ. Finberg 1939, p. 316

 Wednesday 24 June 1829

Dear Turner
 Mr & Mrs Whitbread[2] will cook a Turtle at Purfleet[3] for Sunday next & will be most happy to see you. I prevented their calling upon you & undertook to engage you without ceremony.
 The Steam boat leaves the Tower at 8 o'clock and you will meet

 [1] Probably Wenzel Peter. See Letter 147.
 [2] W. H. Whitbread (1795–1867) and his wife. See Letters 156, 200, 216.
 [3] Two pencil drawings from the Whitbread collection, inscribed 'From Purfleet' and 'Purfleet, by J. M. W. Turner R.A. July 1829' were deposited at the West Sussex Record Office in 1958 by Mrs. S. M. Prior-Palmer, but withdrawn in 1959. Their present whereabouts is unknown.

Penn¹ & Somervill:² any of the steam boats will put you on shore at
Purfleet. You may return Monday or Tuesday as you please—F.C.

[*Addr.*] J. M. W. Turner by Mrs C

152. Turner to W. F. Wells

MS. British Library, Add. MS. 50119, fo. 6
Publ. Finberg 1939, p. 316

[*Postmark* 27 June 1829]
Friday

Dear Wells

The Old Story. I am stopt again on Sunday next the inclosed note³
will prove without my consent or knowledge. I called yesterday even-
ing to try and get off this engagement of Chantrey's but could not
succeed. However I trust you will forgive me if I show my brazen
face on Tuesday next or Sunday week. So no Molly Poll in the
Hayfield or 3s/6 per day this year⁴ for I suppose it will be all over.
But believe me

Most truly yours
J. M. W. Turner

[*Addr.*] W. F. Wells Esqʳ
Mitcham Common
Surry.

153. Turner to W. L. Roper

MS. (Copy) Artists' General Benevolent Institution

Wednesday July 15 1829

Dear Sir,

Have the goodness to give my best thanks to the Directors of the

¹ Richard Penn (1784–1863), whose *Maxims and Hints for an Angler, and Miseries of
Fishing* (1833) was illustrated by Chantrey. See Letter 200.
² Dr. William Somerville (1771–1860), husband of Mary Somerville. A letter from
Chantrey to Mary Somerville, 7 Jan. 1828, also mentions the Whitbreads
(Somerville Papers, Lady Alice Fairfax-Lucy, deposited at the Bodleian Library).
³ Letter 151.
⁴ Turner missed an invitation to haymaking at Mitcham in June 1828, although
he was expected for the harvest home (Emma Wells to R. Finch, 16 June 1828:
Oxford, Bodleian Library, MS. Finch d. 17, fo. 21).

Artists' General Benevolent Institution and that I beg leave to resign
the Office of Chairman.[1]

<div style="text-align: right">

Yours most truly

[signed] J. M. W. Turner

</div>

To Mr W. J. Roper Assis^t Sec^{ty}

P.S. Let the cases of Applicants be confirmed & Miss Atkinson's case
be considered previously to the above communication—

154. Turner to C. L. Eastlake

MS. British Library, Add. MS. 50119, fo. 84
Publ. Finberg 1939, pp. 316–7

<div style="text-align: right">

Tuesday Augst 11 1829

</div>

Dear Eastlake,

It is a long time since the receipt of your last but do not conclude
that your complaining of ill health and your sitting in a dark corner
for your eyes could be indifferent to me; entre nous your other com-
plaints you deserve whipping for; incorrigibility is a fundamental
evil.

Richard Westmacott[2] has particularly desired me when ever I wrote
to say to his friends in Rome that he had not put down his name
for the Associateship. Mr Soane, who I think would be glad to have
or to hear from you *yourself* as to the Picture[3] there is a little shyness
or coyness which said at last 'do you think' it is done? I should like
to have bought West['s] Cave of Despair[4] and lament I did not.

I told your friend Mr Harman that I left it in a very forward
state and should advise him, the aforesaid Jeremiah, to become the
happy medium. 'Now you must act for yourself in this matter, only
recollect I am ready to say "what you will" tho I do not think it the
best way.?' Johns[5] has been in Town with your brother William,

[1] Turner had been elected a Director of the Artists' General Benevolent Institution
at the First General Meeting of Subscribers on 13 June 1815, and Chairman at a
Directors' Meeting on 25 July. He was Treasurer by 1818, and a 'Trustee' on 21
May 1819. He remained Treasurer until succeeded by Chantrey (q.v.) on 1 June
1830 (see Letter 157), and Trustee until 1839 (see Letter 222). In July 1845 he was
again approached to be Chairman of the Council, but declined. In his first will of
30 Sept. 1829 Turner left £500 to the A.G.B.I., but revoked this bequest on 7 June
1830 (Finberg 1961, p. 329).

[2] Richard Westmacott the younger (1799–1872), the sculptor (q.v.).

[3] Eastlake's *Cave of Despair*, which did not reach Soane until 1830.

[4] R.A. 1773: sold for 40 guineas at the West Sale, Robins, 23 May 1829 (77) and
now in the Mellon Collection (repr. Gage 1968, fig. 49).

[5] A. B. Johns (q.v.).

Norton and his Sons. He is to become a Painter under the advice of Johns. Some anxiety was shown by J and N about your return; perhaps there might be more than meets the Ear, but I could give no opinion about what I know not of. Had I been within when your brother called his ingress would have given me more difficulty to answer [?]. I mention this to show that my opinions, whatever they are, are yet my own on this head at least. I lament to hear that your friend Wyatt has broken his thigh but hope he is doing well. Were you of the party? All my friends the sculptors if they will become equestrians [should know] that Marcus Aurelius[1] is a much better model in regard to safety, he being half in the body of the Horse while Elgin's[2] ride outside. But the Greeks must be followed vide Gibson[3] in Roma.

Alas now for my affairs. I shall not be able to be with you in *Roma* this year, therefore I must beg of you to do the best for me to lessen the [*tear*] of my rooms. Tell Peter[4] I would say to be [*tear*]. I'll leave it to him to say which is best to lett [*tear*] whole or part, lamenting as I do I cannot see you all the next year in Rome

Believe me most truly

Yours Truly J. M. W. Turner

£10 you will find at Torlonias and draw upon me for the remainder at Hammersleys or write me word when you have arranged. I could wish to keep the closet in the studio close or suppose the packing *case another three* it would relieve the Chevalier Ugo[5] from a great nuisance. Make the best bargain you can about the Closet for another year after January 1 1830. Tell Ewings[6] Chantrey has given me a bust of Sir Jos[h] Banks which I will endeavour to get off some time. Brockendon[7] has not sent your port folio. De Santis has this month sent the invoice of the Torso.[8] I think there is a chance of your seeing Jones R.A. and Miss E. Jones in Rome; they start about Saturday next. Any kindness shewn to them will be mine to thank you for whenever we may meet again.

[1] The bronze equestrian statue of Marcus Aurelius (*c*. A.D. 176) on the Capitol.
[2] The riders in the Parthenon frieze among the Elgin Marbles, now in the British Museum.
[3] John Gibson R.A. (1790–1866), whose friendship with Turner is recorded in Lady Eastlake's *Life of John Gibson R.A.* (1870), p. 107.
[4] Probably Wenzel Peter. See Letter 147.
[5] The landlord at 12 Piazza Mignanelli (cf. R. B. Gotch, *Maria, Lady Calcott* (1937), p. 279.).
[6] W. Ewing. See Letter 142.
[7] William Brockendon (1787–1854), geologist and amateur painter, with whom Turner crossed the Alps in 1844 (T.B. CCCXLVIII, p. 17a).
[8] See Letters 146, 147

Linton[1] has got his picture but complains latterly of Smith's charges and the rolling up of the Pictures, which Lord Egremont has had upwards of 2 months; this is the way Smith and de Santis does business. Your Picture[2] got some trifling damage at the Ex. but can be Easy repaired. My Pictures arrived tho perfectly safe as to condition only on the 20 of last month, too late for any thing and disturbed all my plans. Tell Gibson Ld Egremont likes the Marble.[3] Remember me to all friends not forgetting the ladies.

Williams[4] Geddes[5] Wilson[6] Theed,[7] Mr & Mrs Severn[8]

Charles Eastlake Esq^re
1 2 Piazza Mignanelli,
Rome.

155. Turner to Clara Wells (Wheeler)

MS. British Library Add. MS. 50119, fo. 8

[*Postmark* Aug[?] 1829]
Friday [? August 1829]

Dear Madam
 I forgot when Papa and Emma call'd yesterday to say that I should write to Rome by tomorrow's post.[9] If you or
 I hope he is there
him have any thing to say have the goodness to let me know and
 believe me most sincerely
 Yours &c
 J. M. W. Turner

[1] William Linton (1791–1876), whose *Grecian Seaport—Morning*, was painted for Egremont in 1828–9.

[2] *Lord Byron's Dream.* See Letter 149.

[3] Gibson's *Cupid* (R.A. 1829).

[4] Penry Williams (?1800–1885), to whom Lawrence (q.v.) wrote on 9 Mar. 1829 that he had heard 'a very favourable opinion from Mr Turner' about one of his landscapes (D. E. Williams, *Life and Correspondence of Sir Thomas Lawrence* (1831), ii. 241).

[5] Andrew Geddes (1783–1844). See Letter 112.

[6] Andrew Wilson (1780–1848), a friend of Wilkie (q.v.).

[7] William Theed (1804–91) a student of Gibson and Wyatt.

[8] Joseph Severn (c. 1793–1879).

[9] Cf. Clara Wells to Robert Finch, 10 Aug. 1829: 'The second chance you mention, viz. Turner, by whom to send the books, is a broken reed, he coming overland, will not increase his luggage, and if he would, I should be quite sorry to trust him, for he would be quite sure to lose your books, as he invariably does, more than half his own baggage in every tour he makes, being the most careless personnage of my acquaintance' (Oxford, Bodleian Library, MS. Finch c. 2 d. 17, fo. 205).

P.S. Bravo Ro^t Finch he has behaved nobly in a certain connection
[?] of the trip to Whitby [?]

Truly glad &c.

[*Addr.*] Mrs Wheeler
60 Grace Church St
City
near Fen Church

156. Turner to Francis Legatt Chantrey

MS. Philadelphia, Temple University, Rare Book Department, MS. 479
(Gift of Leon Benoit)

Wednesday Sep^t 9 1829

Dear Chantrey

I have at last returned from France half drowned 'tho much better
in health but alas I fear I shall not be able to join you at Southill
for I must go to Petworth for a day or two, if not longer and so I
think I must trouble you to give my *best respects* to Mr and Mrs
Whitbread and say how sorry I am in fearing thus [?] I shall not
have it in my power this time to avail myself of their kind invitation
to meet you but that I hope for another more fortunate (to me)
opportunity as I reckon by the time of my return you will be upon
the move homewards yet do give me line by Friday's post if you can

My best regards to Mrs Chantrey
and Return me yours
J. M. W. Turner

P.S. Hope you have had good Sport—tho the Rain has been much
against you!! Hi ho for a field of beans in a wet morning. Sorry
that most accounts of L E[1] health are not so well as I could wish but
I shall however [*deleted*] on Saturday (I hope at least) be able to
judge for myself adieu

[*Addr.*] F. Chantrey Esq^re R.A.
(at W. Whitbreads Esq^re M.P.) Southill
Bedfordshire

[1] Lord Egremont (q.v.).

157. [W. L. Roper] to Turner

MS. (Draft copy) Artists' General Benevolent Institution

[24 December 1829]

The Directors of the Artists' General Benevolent Institution beg to present their respects to Mr Turner and regret exceedingly to find from a letter addressed by him to Mr Phillips, the Deputy Chairman of the Institution, that he decidedly withdraws from any further share in the management of its concerns either as Chairman or as Treasurer.

The Directors had flattered themselves that Mr Turner might from the Letter they had the pleasure to address to him on the 15th July last,[1] expressive of their consciousness of his long continued usefulness to their Institution, their extreme regret at his retirement and consequently their sincere desire to meet his wishes as far as possible in transacting the business of the Society, that he might have been induced to re-assume the Chair which he had resigned.

But it is not for them further to press the cares of the Society upon Mr Turner by whose paternal superintendance & beneficial anxieties in its behalf, it has so long profitted & become so firmly & usefully established.

They feel themselves therefore compelled though with regret to accept his resignation of Offices as Chairman and as Treasurer, but will rejoice if at some future time it may be agreeable to him to be reinstated in both.

158. Turner to F. C. Lewis

MS. Yale University Library, Osborn Collection

[*Watermark* 1812]
[? late 1824 or 1829][2]

Dr Sir
 The Picture wants Varnish therefore say *Saturday* instead of tomorrow

yours &c
J. M. W. Turner

47 Queen Ann St Tuesday Eg.
[*Addr.*] Mr F. C. Lewis
 12 Charlotte St

[1] A draft copy of this letter is in Minute Book of the Directors' Meeting.
[2] No pictures by Turner appeared in the Lewis sales (Christie, 27–8 June 1855;

159. Turner to Clara Wells (Wheeler)

MS. British Library Add. MS. 50119, fo. 12
Publ. Finberg 1939, p. 319

Sunday Evng. Jan^y 3, 1830

Dear Clara

Your foreboding letter has been too soon realized. Poor Harriet,[1] dear Harriet, gentle patient amiability. Earthly assurances of heaven's bliss possesst, must pour their comforts and mingle in your distress a balm peculiarly its own—not known, not felt, not merited by all.

I should like to hear how they are at Mitcham, if it is not putting you to a painful task too much for your own misery to think of, before I go on Friday morning. Alas I have some woes of my own[2] which this sad occasion will not improve, but believe me most anxious in wishing ye may be all more successful in the severe struggle than I have been with mine.

Yours faithfully
J. M. W. Turner

P.S. The Indian [?] order which give so much discontent is I hear recinded or [*illeg. word*] whenever been done by some mistake in the East.

[*Addr*.] Mrs Thos Wheeler
62 Grace Church St
City

160. Turner to C. L. Eastlake

MS. Oxford, Bodleian Library, MS. Autog. d. 24, fos. 21–2
Publ. Gage 1968, pp. 682–5

Thursday Feb 11 1830

Dear Eastlake, Sig^r Carlo in Rome, R.A. in England now Charles

Southgate 10–16 June 1857); this letter probably refers to a painting sent to Lewis for engraving, perhaps the *Colebrook Dale* (*c.* 1797, B.–J. No. 22), a mezzotint of which was published in 1825 (R. 775), or more probably, the *Field of Waterloo* (B.–J. No. 138) of 1818, engraved by Lewis and published in 1830 (R. 795).

[1] Harriet Anne Wells, Clara's sister.

[2] Turner's father had died on 21 Sept. 1829. Clara wrote to Finch in Rome on 4 Nov. 1828: 'Will you have the kindness to give my kindest regards to Turner, and tell him I sent to his father's house to enquire after his father's health, that I might send him the latest intelligence, and that the old gentleman was very well, but was out of town' (Oxford, Bodleian Library, MS. Finch, c. 2. d. 17, fo. 201).

Eastlake Esq^r Royal Academician[1]—greeting and to myself greeting for now surely all the Endeavours mistakes and misconceptions of stimulating what would be called infirmity in dispite of its own powers has been esteemed by many like myself as possessing qualities which I now call upon you to admit and ask for some kinder terms for my desurnment & zeal than the suppositious ones, taunts and ridicule—which never interred my head nor could I have dreamt of but by one of your letters, but away *it* also in thought word and deed for Ever—Active abilities and Institutions like ours requires constant support mutal exertions and strenuous endeavers and my dear Charles you are now a complete brother labourer in the same Vineyard and England expects every Man to do his duty—

Do but think what a loss we and the arts have in the death of Sir Tho^s Lawrence; he would have been pleased by your success—but in justice to his successor your friend Mr Shee[2] felt great pleasure in it being the first announcement and commencement of his Presidency. He desired me to remember his Plymouth friends when I wrote to Rome. A line or two by way of thanks to him, or congratulary would be pleasing and to Chantrey, who deserves much. Jones broke ground, for tho' in Rome I saw his letter. Tell him he is a good boy but not for sweeping with one fell swoop like a whirlwind the face of the country or talking of coming back by April & not going on to Naples. To [tell?] Miss Eliza[3] with my remembrance that I walked immediately from Golden Square to Poland St to find the likeness to drawn [*sic*] for I could not [*tear*] My Roman recollections and I must go to [*tear*]

I'll not bother you with my Roman affairs; I know they are in good hands[4] so adieu, Dear Eastlakee [*sic*]

Yours most truly
J. M. W. Turner

P.S. just tell Jones I forgot to add a Glossary to my letter so I meet the error. Mr Phillip had one vote for President not mentioned—Mr Howard will send you an official letter of your Election, I gave him y^r directive last night.

[*Addr.*] Charles Eastlake Esq^re R.A.
No 12 Plazza Mignanelli
Rome

[1] Eastlake was elected Royal Academician on 10 Feb. 1830.

[2] Sir Martin Archer Shee (1769–1850), who was elected P.R.A. on 25 Jan. with eighteen votes. Phillips (q.v.) secured one vote.

[3] Probably Jones's sister. See Letter 154.

[4] Eastlake wrote to Robert Finch (q.v.) on 28 Feb.: 'I received a letter of congratulation also from Mr Turner, he does not say who my competitors were nor if any other

161. Turner to George Jones

MS. Untraced
Publ. Thornbury 1862, ii. 233–4

London [22] February 1830

Dear Jones

I delayed answering yours until the chance of this finding you in Rome, to give you some account of the dismal prospect of Academic affairs, and of the last sad ceremonies paid yesterday to departed talent gone to that bourne from whence no traveller returns.[1] Alas! only two short months Sir Thomas followed the coffin of Dawe[2] to the same place. We then were his pall-bearers. Who will do the like for me, or when, God only knows how soon. My poor father's death proved a heavy blow upon me, and has been followed by others of the same dark kind.[3] However, it is something to feel that gifted talent can be acknowledged by the many who yesterday waded up to their knees in snow and muck to see the funeral pomp swelled up by carriages of the great, without the persons themselves.[4] *Entre nous,* much could be written on this subject; much has been in the papers daily of anecdotes, sayings, and doings, contradictory and complex, and nothing certain, excepting that a great mass of property in the unfinished pictures will cover more than demands. The portraits of the potentates[5] are to be exhibited, which will of course produce a large sum. The drawings of the old masters are to be offered to his Majesty in mass, then to the British Museum.[6] Thomas Campbell is to write Sir Thomas's life at the request of the family,[7] and a portrait of himself, painted lately and engraved, for which great biddings

person is chosen—Mr Turner, altho he alludes to his property in Rome, & is content it should remain in statu quo, does not say a word about the time of his returning here' (Oxford, Bodleian Library, MS. Finch c. 2 d. 5, fos. 220 f.).

[1] *Hamlet* III. 1: 'The undiscover'd country, from whose bourn/No traveller returns.'

[2] George Dawe, painter and engraver, died 15 Oct. 1829.

[3] Cf. Letters 159, 160.

[4] Turner's watercolour of Lawrence's funeral was exhibited at the Academy in 1830 (T.B.E. No. 436) (G. Wilkinson, *Turner's Colour Sketches, 1820–1834* (1975), p. 47).

[5] The Waterloo Portraits. Cf. K. Garlick, *Sir Thomas Lawrence* (1954), pp. 12–14.

[6] For the fate of the Lawrence collection of drawings, W. T. Whitley, *Art in England 1821–1837* (1930), pp. 200, 276–80; K. T. Parker, *Catalogue of the Collection of Drawings in the Ashmolean Museum*, ii (Italian Schools), 1972[2], pp. x–xvii. Cf. Letter 164.

[7] Campbell's biography of Lawrence was abandoned after a few months to D. E. Williams, whose work was published in 1831 (W. Beattie, *Life and Letters of Thomas Campbell* (1849), iii. 61–7.).

have been already made.[1] I wish I had you by the button-hole, not-
withstanding all your grumbling about Italy and yellow. I could then
tell more freely what has occurred since your departure of combina-
tions and concatenations somewhat of the old kind, only more highly
coloured, and to my jaundiced eye not a whit more pure.[2] ...
Chantrey is as gay and as good as ever, ready to serve; he requests,
for my benefit, that you bottle up all the yellows which may be found
straying out of the right way; but what you may have told him about
the old masters which you did not tell me, I can't tell, but we
expected to hear a great deal from each other, but the stormy brush of
Tintoretto was only to make "the Notte" more visible.[3] May you be
better in health and spirits.

<div style="text-align:right">

Adieu, adieu; faithfully yours,
J. M. W. Turner

</div>

162. Turner to Edward Goodall [?]

MS. Untraced
Publ. Finberg 1939, p. 322

<div style="text-align:right">

Thursday June 17 [1830]

</div>

My dear Sir,
 I find that the drawing you sent me is intended for an Annual.
This has not added much to my comfort. So I must be in three
beauties *nolens-volens*.[4] If it will be any accomodation to you I will
touch the Print for 50 Impressions, but you must excuse my making
the drawing again saleable by repairing and alterations of figures &c
under 10 Guineas.[5]

<div style="text-align:right">

Yours truly
J. M. W. Turner

</div>

47 Queen Ann St.

[1] An engraving by S. Cousins after Lawrence's unfinished self-portrait, now in the
Royal Academy, was published in 1830.

[2] Finberg 1961, pp. 320–1, interprets this as a reference to Wilkie's manoeuvres
to become P.R.A.

[3] For Chantrey's and Turner's admiration for Tintoretto, T. Moore, *Memoirs,
Journal and Correspondence*, ed. Russell, vii (1856), 149.

[4] In 1831 Turner's work appeared in the *Keepsake* (R. 324–5), *The Amulet* (R. 337),
and *The Talisman* (R. 341).

[5] Goodall's engraving of *Florence* (R. 337) is a reduced replica of G. Cooke's
engraving for Hakewill's *Italy* (R. 158). The drawing is untraced.

163. Turner to J. C. F. Rossi

MS. Sir John Soane's Museum

[*Watermark* 1827]
[20 June 1830[1]]

Dear Rossi

Mr Soane has written me a letter from Lowestoft to remind *us* of our promise to meet at Hampton Court on Thursday next Midsummer-day [*deleted*] and that he will be at home on Sunday (today). Unfortunately for me in dining out today and tomorrow I cannot be with him before Tuesday Evening. I wish you would call on him and say as much and that I shall be most happy to be with him and you at Hampton Court on Thursday next.

Let me know Mr Soane's wishes and believe me

Yours most truly
J. M. W. Turner

Sig Carlo Rosso Antico Armigio Regio Academio

164. Turner to James Holworthy

MS. British Library Add. MS. 50119, fos. 14–15
Publ. Monkhouse, p. 404

Monday Nov 7 1830

Dear Holworthy

I am and have been a sad truant & delinquent with your invitations I admit, and therefore to save myself from a charge of vagrancy beg leave to say I am at home again. I could not get so far North as your worship's residence, for I know full well that your kindness with Mr Read would have kept me like brother Jackson[2] beyond our meeting at the Academy. It turned out however that the part which I felt most anxious about stands adjourned to next Monday.[3]

[1] 1830 is the first year after 1827 when Midsummer Day fell on a Thursday.

[2] John Jackson, R.A., who was staying with Holworthy; Read may be Joseph Read of Wincobank in the West Riding of Yorkshire, a friend of Sir Francis Chantrey (q.v.) and with him in Rome in 1819 (G. Jones, *Recollections of Chantrey* (1849), p. 23).

[3] At the Academy General Assembly on 15 Nov., Turner 'gave notice that at the next meeting he should move that the resolution which passed on the 30th of July last, on the motion of Mr Phillips, seconded by Mr Westmacott, be rescinded'. This was a resolution that if the executors of Sir Thomas Lawrence permitted it, his collection of Old Master drawings should be examined by Phillips, Hilton, George Jones,

If you should come athwart his hose in the sailors phrase tell him, and that Witherington was elected the last meeting an Associate. To Mr Read may I trouble you to give my thanks for his kind intentions towards me, and beg you to accept the like yourself and Mrs Holworthy. Your account of Mr G.[1] puzzles me—what it may be. I understand he is off but not to the Swan River but to New South Wales and has taken a van load of pictures. (The ship had sailed, and he was obliged to hire another horse and take the kit down to Gravesend). So with a little vamping up which the cobblers call translating we may (if we live long enough) see some of our old friends (under new names) of the Van Family.

<div align="right">Yrs most truly &c &c
J. M. W. Turner</div>

Nov. 9th—The postponement of the visit to the Lord Mayor's feast has caused great dissatisfaction to most folks in and out of the City.[2]

[*Addr.*] J^s Holworthy Esq^{re}
Brookfield
near Hathersage
Derbyshire.

Howard and R. Cook, and if their report was favourable, the Academy should subscribe £1,000 for the purchase of the collection for public use. The committee reported to the General Assembly on 1 Nov., at which Turner was present that, 'with a great number of inferior works, [the collection] probably contains a larger portion of choice specimens in the art than any museum in Europe, & such as in the present state of the public taste it would be highly advantageous to the country to possess'. Reinagle and Westmacott moved that the report should be received, and Callcott and Pickersgill (qq.v.) that discussion should be adjourned until the 15th. On 1 Dec. Turner's motion, seconded by Callcott, was passed; but Turner was absent on 10 and 17 Dec., when there was further discussion, and Phillips carried a resolution that this ruling should be rescinded, by 13 votes to 8. See also Letters 161, 168.

 [1] John Glover, who arrived at the Swan River Settlement, Van Diemen's Land (Tasmania), in March 1831.

 [2] Wellington's Cabinet had prevented William IV and his Queen from attending the Lord Mayor's Banquet.

165. Turner to Henry Rogers

MS. Peter Rhodes Esq.

[*Postmark* 25 NO 1830]
Tuesday Evng

My dear Sir
 I will have the pleasure of being with you at Highbury Terrace
on Sunday next at ¼ before Six

Yours most truly
J. M. W. Turner

[*Addr.*] H. Rogers Esq^re
 No 10 Highbury Terrace
 Islington

166. Turner to H. A. J. Munro of Novar

MS. With Colnaghi, 1965

[*Watermark* 1830]
Saturday Afternoon

My Dear M
 Holworthy having said you are engaged on Sunday, tomorrow, but
not on Monday, may I ask you[r] kind assistance to make him go
with us *any where* to a kind of Olden Time—you shall be commodare
toute [?] or myself—to meet at Spring Garden Coffee House at
3 o clock—my choice is Greenwich if you approve.[1]

Believe me I shall be most truly obliged
J. M. W. Turner

P.S. Will you call on me or shall I be with you? pray say what time
ever &c J.M.W.T.

[*Addr.*] H. J. Monro Esq^re
 113 Park Street

[1] This may be the occasion of an anecdote told by Munro: 'Turner always said
the admiralty made him spoil this picture [*The Battle of Trafalgar*] & the only sensible
observations were from the Duke of Clarence, afterwards William 4th. Turner once
invited Holworthy & myself to dine with him at Greenwich. We, after dinner, visited
the Hall and were looking at this painting; a pensioner came up and told us it was
like a carpet. "That is the one to look at", pointing to the Loutherbourg. I turned
to look on Turner, who was gone' (manuscript note by Munro in a copy of
Thornbury 1862, i. 292, in the collection of Professor Francis Haskell).

167. W. L. Roper to Turner

MS. (Copy) Artists' General Benevolent Institution

Dear Sir—

I am requested by the Directors of the Artists' General Benevolent Institution again to express their undiminished regret that they are still deprived of your invaluable services & support. Understanding however that you are desirous of being relieved from any responsibility that attaches to you as Trustee & Treasurer, the Directors, anxious to conform to any wishes on your part, would feel much obliged if you would have the goodness to communicate to them in what manner they may best give effect to your desires.

<div align="right">

I have the honor to remain
Dear Sir, Your most Ob Ser^t
W. L. Roper
Assis Sec^{ty}

</div>

14 Duke Street
Feby. 5 1831
To J. M. W. Turner Esq. R.A.

168. John Soane to Turner

MS. Untraced
Publ. Bolton 1927, pp. 473–4

<div align="right">Lincoln's Inn Fields, 17 Feb^y 1831</div>

My Dear Sir

I was prevented by indisposition from attending the General Meeting of Academicians at Somerset House, when the proposition was made for applying one thousand pounds from the funds of the Royal Academy towards purchasing Drawings by the Old Masters, collected by Sir Tho^s Lawrence, to be deposit'd in the British Museum.

I am most anxious that this collection should remain entire, and that the sole property be invested in the President and the members of the Royal Academy for the improvement of the National Taste: with this in view I repeat my offer of giving one thousand Pounds for that purpose, providing the said collection becomes the sole property of the Royal Academy and be deposited in the present, or in any future structure appropriate o the members of that Institution.

Allow me to add a few words. Success, my dear Sir, has caused me many enemies, always anxious to ascribe improper motives to my conduct; I shall therefore, that I may not be misunderstood, take

this opportunity to state briefly the principles on which I have acted:—

Under the auspices of His Majesty, King George the third, and the kindness of Sir William Chambers, I was enabled to pursue my Studies in Italy; this most gracious condescension on the part of His Majesty, to which I owe all the advantages I enjoy, created in my mind a debt of gratitude never to be forgotten. I was most happy in the opportunity of subscribing my mite, for the raising, not a cenotaph, but a colossal statue in honor of his late Royal Highness the Duke of York. In the same feelings—to a sincere regard for the Fine Arts, and the grateful recollection of what I owe to the Royal Academy for favours conferred in early youth, and subsequent honors, I have been induced to make the offer contained in this letter.[1] I have only to add that with sentiments of regard,

> I remain, My dear Sir, Most truly yours
> John Soane

This is a sad scrawl, but it's as bad with my impaired sight!

169. Turner to Sir Walter Scott

MS. National Library of Scotland MS. 3917, fo. 270
Publ. W. Partington, *The Private Letters-Books of Sir Walter Scott* (1930), p. 252

> 47 Queen Ann St West
> April 20 1831

Dear Sir Walter

It is no small compliment to me your invitation to Abbotsford in manner or purpose and therefore do allow me to offer you my thanks and be pleased to include in that word whatever feeling may be most pleasing to yourself for compliments to you can be of no value.

Mr Cadell has said he would most cheerfully pay the expenses if a Journey should prove necessary and my having 15 of the subjects[2] induced a thought that it might without he particularly wished me so to do be managed by another means. By your letter I read it is desired and in my furtherance of your wish I will try what can be done (Oh for a feather out of Times wing) I have a trip to make

[1] At the General Assembly of the Academy of 25 Feb. 1831, 'Mr Turner stated that he had received a letter from Mr Soane, which he read . . .' Thanks were moved by Thomas Phillips and seconded by George Jones (cf. Letter 161); but it was later decided to press for the drawings to go to the British Museum or the National Gallery, rather than to the Academy, and in the end nothing came of Soane's offer.

[2] Twenty-four subjects were proposed in February 1831 for the illustration of Scott's *Poetical Works*, for which Turner asked 25 guineas each (Finley 1972, p. 359).

across the Channel if circumstances permit and the days of last July
[*sic*] do not make the next too hot and impracticable. Therefore do
pray say how long do you think it will take me to collect the material
in your neighbourhood. Many are near but my bad horsemanship
puts your kind offer of Poney I fear out of the account of shortening
the time and when I get as far as Loch Kathrine shall not like to turn
back without Staffa Mull and all. A steam boat is now established
to the Western Isles so I have heard lately and therefore much of the
difficulty becomes removed but being wholly unacquainted with
distances &c will thank you to say what time will be absolutely
wanting.[1] Mr Cadell has most probably another list or I would inclose
the one he sent me. Skiddaw from Penrith round is the most southern
subject[2] and could be taken in my way homewards or out or whatever
way you think best or most convenient.

> I am most respectfully
> Yours most truly
> J. M. W. Turner

To Sir Walter Scott Bart
Abbotsford

P.S. The Scottish Antiquities being now finally disposed of and
divided 31 Copies (your share) are at Arch's Cornhill? Can I do
anything for you.

170. Turner to John Soane

MS. Sir John Soane's Museum

> 47 Queen Ann St
> May 5 1831

My Dear Sir
 With my most sincere thanks I beg to acknowledge the receipt of
the draft upon Prescotts and C⁰ for £262.10

> Believe me most truly
> Yours faithfully
> J. M. W. Turner

John Soane Esq^re

[*Endorsed by Soane* 5 May 1831 Paid J. M. W. Turner for a Picture[3]
£262.10.0]

[1] Turner seems to have been in Scotland gathering this material from about 4 Aug.
to 18 Aug. 1831 (Finley 1972, pp. 363–5).

[2] *Skiddaw* (R. 513) was sketched by Turner on his way to Scotland about 27 July
(Finley 1972, p. 363 n. 36).

[3] *Admiral Van Tromp's barge at the entrance to the Texel, 1645* R.A. 1831 288 (Sir John
Soane's Museum, B.–J. No. 339).

171. Turner to George Cobb

MS. British Library Add. MS. 50119, fo. 16
Publ. Finberg, 1939, p. 331

[*Postmark* June 21 1831]
[*Endorsed* With Mr Cobb's compliments
to Mr Turner 20 June 1831]

I suppose that no objection on my part should be made—but is not the written notice and repairs to be done in the 3 months after any survey, something too like the compulsory clause of Parring [?] Lease, so that I am to repair whenever call'd upon at their will and pleasure.

Get it finished, for I want to be off to Scotland, and wish to order what is to be done at *Epping* before I start. N.B. The Clarendon St. is far too much. NO, NO, NO.

J.M.W.T.

Pray is the present proposed draft[1] like the former to Mr Marshall?[2] Look at the other remarks.

172. Turner to Edward Francis Finden

MS. Boston Public Library MS. E.9.1.107

Oban Sep^tr 2 1831

My dear Sir
 It appears very probable that I shall be not
a very great distance from the Lin of Don (Lord Byron)[3]
if there is any other subject you may want in the
neighbourhood pray write to me to W. H. A. Monro Esquire
NOVAR H
Novar House near Evanton North Britain[4]—*immediately*
by return of Post and altho some expense will occour

[1] Turner's note is written in pencil on a fragment of letter addressed to him by Cobb and sent with a draft lease.

[2] Possibly Joseph Mallord William Marshall, from whom Turner inherited his Wapping property in 1820. See Letters 126, 127.

[3] Turner seems to be confusing the waterfall of Linn of Dee and the Brig of Don, two childhood haunts of Byron recorded in the first chapter of Moore's *Life and Letters of Lord Byron.*

[4] i.e. H. J. A. Munro of Novar (q.v.), whose address also appears in T.B. CCLXX, inside cover.

I write this to say of the opportunity what now offers
of getting any subject you may be in want of for Byron.[1]

> Believe me most truly
> Yours &c &c
> J. M. W. Turner

P.S. Send one likewise to the Post Office Aberdeen by way of
chance [?]

[*Addr.*] Ed Finden Esq[re]
 Southampton Terrace
 betwixt Euston Square New Road
 and Tottenham Court Road London

173. Turner to Robert Cadell

MS. National Library of Scotland MS. Acc. 5188, Box 10
Publ. G. E. Finley, *Burlington Magazine*, cxv (1973), 741

> 47 Queen Ann St West
> Thursday 22 Dec[r] 1831

My dear Sir

I am glad to find (by the Times paper of today) that Sir Walter
has arrived at Malta and by his own words "for myself I am *quite
well* and heart-hole like a Biscuit".[2]

For myself I wish I could say the same, but I purpose to give you
the first touch[3] in the new year so think about the size of the draw-
ings[4] & if they are to be the same as the Eg Waverley Novels or not;[5]
now I beg you to determine once for all; because of the reducing
by the Engraver which of course adds to his time and your Expense
thereby—instead of tracing—have the goodness to let me know at your

[1] No Scottish subjects appeared among the seventeen vignettes which Turner pro-
vided for *The Works of Lord Byron: with his Letters and Journals, and his Life, by Thomas
Moore* (1832–4).

[2] Scott, on a voyage to Malta for his health, had written: 'We have been nearly
three weeks at sea, the first four or five days being as cross as possible, and unfavour-
able—ship-rolling, passengers cruelly sick, and all the inconveniences which a float-
ing life can bring with it. But after that time the wind was favourable, the weather
moderate—we have been heart-whole as a biscuit, and not the slightest complaint of
any kind. I am myself quite well' (*The Times*, 22 Dec. 1831).

[3] i.e. to an engraver's proof for Scott's *Poetical Works*.

[4] For Scott's *Poetical Works* (see p. 147 n. 1).

[5] The edition of the *Poetical Works* was to be uniform with the *Waverley Novels* issued
by Cadell from 1829 with engravings after other artists than Turner.

earliest convenience[1] and if it matter doing or sending them to you, in succession according to your list?[2]—with the Compliments of the Season to you and Family

> Believe me most truly
> Yours &c
> J. M. W. Turner

P.S. Sorry in your last but you gave so very indifferent an account of your own health.

174. Turner to Robert Cadell

MS. National Library of Scotland MS. Acc. 5188, Box 10
Publ. G. E. Finley, *Burlington Magazine*, cxv (1973) 741–2

> Saturday Feb[r] 25th 1832
> Queen Ann S[t] West

My dear Sir

By the time you receive this I hope to have done six drawings and six Vignettes—for Minstrelsy 1 2 3 4 Sir Tristan and Rokeby.[3]

Supposing that you do not come to London (for we are visited like you at Edinburgh with the Cholera)[4] & say if you *wish* me to send them to Edinburgh by the next Mail? for I fear I cannot hold out the prospect of doing the remaining six *Books*[5] until my Pictures for the Exhibition are sent in to Somerset House (April 10th) tho I do hope you will not call me very idle since January.

In regard to the Cholera I will thank you to send me the paper which your medical-men printed as to the treatment &c. or if any thing

[1] Finley (loc. cit., n. 6) assumes that Cadell's answer was that the drawings should be larger than the engravings, but in the first batch that Turner completed (see Letter 174) at least one, *Caerlaverock Castle*, is the same size as the plate, and among the later drawings, this is true of *Fingal's Cave*, *Staffa* (see Omer Nos. XVII and 91, XIX and 104). Most of the drawings are, however, larger than the engravings.

[2] Of subjects and the sequence of volumes.

[3] These twelve drawings were half the number of the whole commission. They were: *Carlisle* (Private Collection) R. 493; *Johnny Armstrong Tower* (Cincinnati, Taft Collection) R. 496; *Jedburgh Abbey* (Cincinnati, Taft Collection) R. 495; *Smailholm Tower* Private Collection; Omer No. XVI) R. 494; *Kelso* (Duke of Roxburghe) R. 497; *Lochmaben Castle* (Murray Collection) R. 498; *Caerlaverock Castle* (Private Collection; Omer No. XVII) R. 499; *Hermitage Castle* (Sir Richard Proby, Bt.) R. 500; *Dryburgh Abbey* (Tate Gallery; T.B.E. No. 290) R. 501; *Bemerside Tower* (Private Collection) R. 502; *Junction of the Greta and Tees* (Private Collection) R. 509; *Bowes Castle* (With Leicester Gallery, 1940) R. 511.

[4] Cadell had probably written to Turner late in January, when he recorded the first cases of cholera in Edinburgh (Finley, loc. cit., n. 10).

[5] Volumes vi to xii of Scott's *Poetical Works*.

has been discovered during the progress of the disease in Scotland and [in] your opinion is shown (contagious or Epidemic) from known cases.[1]

Here the dispute runs high and no treatment made known or Cholera Hospitals Established—some will have it is typhus owing to the state of the Winter which has been very damp and partic[ularly] foggy.

> Yours most truly
> J. M. W. Turner

P.S. Hope you and family *are well*.

175. Turner to Robert Cadell

MS. (Copy) National Library of Scotland MS. 1555, fos. 75–76v
Publ. G. E. Finley, *J.W.C.I.* xxxvi (1973), 393–4

Tuesday Oct 24 [1832][2]

Dear Sir

I returned yesterday evening to London and found among my Letters one proposing to place my name on a committee to perpetuate the memory and talent of Sir Walter Scott, answer to be addressed to W. F. Scott M.P. John St Berkley Square, which I have done with the word *yes*, now do tell me something about it immediately if you please by post.[3]

I have been to Briene the Ecole Militaire is but [?not] in existance it was demolished nearly at the first Revolution yet it will do with the Chateau being some distance from Paris on the road toward Nancy,[4] But not [being] direct caused some trouble but the lodging of Bonaparte in Paris[5] seemed at one time hopeless; all thought it easy by every one thinking it in a different place—after making several sketches & Bourrienes among the number No. 19 Rue Maris[6] —however I have it beyond doubt tho' placing you & myself somewhat in

[1] Cadell answered Turner's queries on 3 Mar. (Finley, loc. cit., n. 13).

[2] In 1832 24 Oct. fell on a Monday.

[3] Finley, (loc. cit., p. 393, n. 19) gives the text of the printed circular Turner probably received. The reply was to be sent to H. T. Scott, M.P. On Turner's interest in the Scott Memorial see also G. E. Finley, *Connoisseur* 183 (1973).

[4] Turner had been gathering material to illustrate Scott's *Life of Napoleon.* Napoleon had studied at the Brienne Military Academy. See T.B. CCLVII, p. 109a and R. 527 (Finley, figs. 66 a, b).

[5] *Quai Conti* (R. 526)

[6] Bourrienne was Napoleon's secretary and had lived at 19 Rue de Marais, Paris. The subject was not used.

debt to Baron Le Roy[1] and Dr Sommerville.[2] I have ordered ... [?] arch Etoile[3] Paris, Vincennes, Malmaison, St Cloud, Versailles, Rambouillet, St Germains, Fontainebleau. Compaigne [?Compiègne] struck me might be wanted—but it lay so far out of the way that I have been promised a sketch if it is indispensible.[4] As to the Battles I have made sketches from the pictures painted by order of Bonaparte of Marengo and Eylau[5] Lodi I can get in London—Waterloo I have[6]—but I desired a German Bookseller in Paris to obtain any print of the above places with Austerlitz, Wagram & Friedland, & he is to write me word on what terms sketches can be had. In regard to Bonaparte's portrait, I have endeavoured to make some arrangement with a French artist who will write me word of the expense.[7] Baron Le Roy has one but nothing can induce him to let it be copied nor will he sell the Picture. It would do well, is very like & [of] the time when Bony was first consul.[8] I believe I have go[t] thro' all the business at least I hope so—adieu & Believe me with many thanks most truly

<div style="text-align:right">yours J. M. W. Turner</div>

[1] Probably Baron Dominique-Jean Larrey (1766/8–1842), who had been Napoleon's surgeon-in-chief, and whom Scott consulted in 1826 (P. Triaire, *Dominique Larrey et les campagnes de la Révolution et de l'Empire 1768–1842* (1902), pp. 688 f.).

[2] Probably William Somerville (1771–1860), the husband of the scientist Mary Somerville (see Letter 151). Both were especial friends of Scott and had met Larrey in Paris in 1816 (M. Somerville, *Personal Recollections of Mary Somerville* (1873), pp. 98, 113). The Somervilles were spending the winter of 1832–3 in Paris (S. Smiles, *A Publisher and His Friends* (1892), ii. 408).

[3] Cf.. T.B. CCLVII, p. 126a, not used in the publication.

[4] The only subjects from this list to be used were: *Paris from Père-la-Chaise* (R. 536); *Vincennes* (R. 531); *Malmaison* (R. 537); *St. Cloud* (R. 532); *Fontainebleau* (R. 538). *St. Germains* was used in *Turner's Annual Tour—the Seine*, 1835 (R. 480).

[5] From the large paintings by Carle Vernet and Gros, which Turner probably saw at Versailles. No battle-pictures were used in the publication.

[6] This may refer to the large canvas exhibited in 1818 (B.–J. No. 138) or the notebook from which Turner drew his knowledge of the subject (T.B. CLX, see G. Wilkinson, *The Sketches of Turner, R.A.* (1974), pp. 159–60).

[7] Finley (loc. cit., p. 393, n. 31) suggests that the artist is J. B. Isabey (1767–1855), whose portrait of Napoleon appeared in the first volume of Scott's *Life of Napoleon*.

[8] This is probably the unfinished portrait of Napoleon as First Consul by Girodet, which was one of the finest items in Larrey's private Napoleonic Museum (A. Soubiran, *Le Baron Larrey, chirurgien de Napoléon* (1966), pp. 404 f.)

176. Turner to Edward Francis Finden

MS. National Library of Scotland MS. 3418, fo. 84

Feb^y 28 1833

Dear Sir

Three drawings done—Nineveh[1] Sidon[2] and the Convent of St Antonio M^t Lebanon.[3] Have the goodness to make your call before 12 O Clock.

Yours most truly
J. M. W. Turner

177. Turner to F. G. Moon

MS. Untraced (Maggs Bros. Autumn 1932 (1297))
Publ. Finberg 1939, p. 341

[20 May 1833]

I beg to say No 169 Ducal Palace Venice[4] will be 60 guineas, and not to be engraved.[5]

178. Turner to J. H. Maw

MS. British Library Add. MS 50119, fo. 17
Publ. Finberg 1939, p. 344

Sunday Evening
Oct. 20 1833

Dear Sir

The Drawings and your Copies being sent late last Evng. (Saturday) I like the first *Post* of Monday *to thank* you for so doing, for you have placed them to your uttermost endeavours in their original purchased position from Messrs. Christie.

The circumstance and cause you shall if you please write upon your

[1] Engraved for Finden's *Landscape Illustrations of the Bible* and published in 1835 (R. 585) (watercolour: formerly R. B. Preston).

[2] Engraved by William Finden for the same publication and published in 1834 (R. 596) (watercolour: Fine Art Society, 1948).

[3] Engraved by W. Finden and published in 1834. The watercolour is in the Ashmolean Museum, Oxford.

[4] R.A. 1833 No. 169, bought by B. G. Windus (B.–J. No. 352).

[5] The picture was engraved by William Miller (q.v.) in 1854 as *Venice–The Piazetta* (R. 674).

second copy to explain—what you have written on one (or shall I do so) for they will keep company in the same wrappers

Believe me most truly
your much obliged
J. M. W. Turner

[*Addr.*] J. H. Mawe Esq^re
Aldermanbury
City.

179. Turner to George Cobb

MS. Sotheby, 24 July 1891 (109)

Dec. 31 1833

[Other, undated, letters to Cobb were lots 107, 110, 111 in this sale.]

180. Turner to Thomas Phillips

MS. Untraced (Sotheby, 13 June 1911 (227), bt. Gregi)

April 11 1834

[declining to become a Vice-President of the Artists' General Benevolent Institution].[1]

181. Turner to Abraham John Valpy

MS. Royal Academy, Anderdon Academy Catalogues, XXII, fo. 102
Publ. Finberg, 1939, p. 347

8 of May 1834

Sir

In answer to your note allow me to say my terms are as follows. 25 Guineas each drawing vignette 50 proof impressions of each plate, with a presentation copy of the work (and the drawings and plates not to be used for any other work).

Yours most obed.
J. M. W. Turner

Valpy Esq^re
[*Addr.*] Valpy Esq^re
Red Lion Court

[1] See Letter 167.

182. Turner to Robert Wallis

MS. Untraced (Sotheby, 22 Apr. 1912 (197), bt. Stevens)

Q Anne St
[8 May 1834]

I am in want of my Picture.[1] Therefore I beg you to send it to me in the course of next week.

183. Turner to George Cobb

MS. Maggs Bros. 1922 (809)

22 June 1834

[On a proposal for leasing a house.]

184. Turner to William Finden

MS. Paris, Institut Néerlandais MS. I.7358
Publ. Thornbury 1862, i. 396–7

[? July 1834]
47 Queen Ann St West

Dear Sir

I shall want some Money before I leave London for my Summer Tour which will take place in about a fortnight.

Yours truly
J. M. W. Turner

W. Finden Esq.

Mr Mac Queen Called (to look about printing my plates, I did not see him but sent down word that I would thank him to send me the remaining proofs belonging to you, he answered that he did not know he had any of Mr Finden's ... if he had he would send them'. This somewhat says that you have not sent anything to him for my remaining proofs or Book.[2]

J.M.W.T.

[1] No oil painting is known to have been engraved by Wallis, and Turner may be referring to the *England and Wales* subject of *Dudley* (T.B.E. No. 426), which Heath had shown at Moon, Boys & Graves in 1833, and the engraving of which was published in 1835.

[2] The last book Turner had published by the Findens was *Landscape Illustrations to the Bible*, which appeared in 1836.

185. Turner to Sarah Rogers

MS. British Library Add. MS. 39809, fo. 22

> Atheneum Sunday
> 12 o Clock

My Dear Miss Rogers

I have just now left St James' Place and am glad [to] say Mr Rogers is much better and will be down stairs *to day*.

Fearing I may be so unfortunate as not to find you at home (after Church time) I write this to ask if Wednesday or Sunday next will suit your convenience or any other day after Sunday ... have the goodness to let me hear from you tomorrow for if you do not say *Wednesday* next I shall start for Oxford[1] in the Morning instead of Thursday.

> Yours most sincerely
> J. M. W. Turner

To Miss Rogers
Hanover Terrace

186. Turner to Robert Wallis [?]

MS. Mr. Kurt Pantzer

> Thursday Augt
> 7^2 1834

Dear Sir

You calld but I certainly did expect you would have repeated your call (for what I do not conjecture) but I do trust you will send home the Picture[3] forthwith for I am about leaving Town for some time.

> yours truly
> J. M. W. Turner

[*Addr.*] R. Wallis [?] Esq.
Pinton St.

[*Endorsed* Not known in Laston Street W.H.H.]

[1] Turner seems to have been in Oxford in July 1834 (T.B. CCLXXXVI, p. 18a), and the Hanover Terrace address of this letter makes it later than 1832.
[2] The figure may be '1', but 1 Aug. fell on a Friday in 1834.
[3] See Letter 182.

187. Turner to Henry McConnell

MS. R. C. Naylor Esq.

47 Queen Ann St West
Cavendish Square

Dear Sir
 Your Picture of Venice[1] will leave Town today, Saturday Aug^t 9th,
by Pickford Fly Boat.
 May I request the favour of hearing from you when it arrives (safely
I hope) at Manchester.

yours most truly
J. M. W. Turner

To
 H/y Ma^cConnel Esq^r
Manchester

188. Turner to J. H. Maw

MS. Royal Academy Scrapbook 82 b

J. M. W. Turner begs to present his respects to Mr Maw and his
sincere *thanks* for the Clotted-Devonshire Cream he received yester-
day Evening in Queen Ann St.

Nov. 26 1834

189. Turner to J. H. Maw

MS. Untraced (formerly Robert Amey)
Publ. Listener, 2 Sept. 1965, p. 347

[*Watermark* 1834]

Dear Mr Maw,
 I beg to enclose a note containing my thanks for the clotid cream
which note I hope you will take for my humble apology for my
servant not sending it on the morning I left you desiring him so to
do.

Yours most true
J. M. W. Turner

[*Addr*.] Mr J. Maw

[1] *Venice* (R.A. 1834; B.–J. No. 356). McConnell wrote of this purchase in 1861:
' "Venice" was exhibited in May 1834; and before it had hung one week on the walls
of the Academy, I paid [Turner], without the slightest objection or hesitation, 350*l*,

190. Turner to J. Henshall

MS. British Library Add. MS. 50119, fo. 24
Publ. Finberg 1939, p. 347

Saturday March 29 1835[1]

Dear Sir—In answer to your note (for not doing so earlier I beg to apologize to you)—the work mentioned I am not acquainted with; and not being in the habit of making single drawings, makes me feel a difficulty about it, without you would have the goodness to say what sum you think the work will bear for two Drawings.

Yours most truly
J. M. W. Turner

J. Henshall Esq^re

[*Addr.*] J. Henshall Esq^re
1 Cloudesley Terrace,
Islington Midd^x

191. Hodgson, Boys & Graves to Turner

MS. British Library Add. MS. 50119, fo. 21
Publ. Finberg 1939, p. 357

Messrs Hodgson Boys and Graves present their Compts. to Mr J. M. W. Turner and would feel greatly obliged by his putting the names of the places on the enclosed cards,[2] as he kindly intimated he would some time since.

May 5.

the price which he had fixed for the picture; and 300*l*, a larger sum than Turner had asked, was a year or more afterwards paid for that beautiful creation of "Lightermen heaving in Coals by Night at South Shields"' (*Athenaeum*, 1861, p. 808) See Letter 193.

[1] The last digit is unclear, and Finberg reads the date as 1834, but the postmark has 1835.

[2] Probably Turner's *Ten Views and ruins* (*in colours, on cards*) which Moon, Boys & Graves had purchased at the Monro Sale, Christie, 26 June 1833 (lot 80). See Letter 192.

192. Turner to Hodgson, Boys & Graves

MS. Verso of Letter 191
Publ. Finberg 1939, p. 357

Gentlemen—I have found the original sketches by Dayes,[1] being [*deleted*] but they are not named of the places. I can only mark two by recollection. N.B. I want to know what number and subjects you may have sent me of Mr Cadell's 50 proofs.[2]

<div style="text-align: right">

Yours most truly
J. M. W. Turner

</div>

May 6.

193. Turner to Henry McConnell

MS. R. C. Naylor Esq.
Publ. The Times, 29 Jan. 1887, p. 15

<div style="text-align: right">

July 23 1835

</div>

Dear Sir
 I have received the Picture of the Moonlight[3] from the Academy Exhibition. Have the goodness to say what you wish me to do with it before I leave Town for the summer months

<div style="text-align: right">

I have the honor to be
Yours most faithfully
J. M. W. Turner

</div>

H. M^cConnel Esq^r
Manchester

 [1] T. B. CCCLXXXVII, purchased by Turner at the Monro sale, Christie, 26 June 1833, lots 81, 82.
 [2] For Scott's *Prose Works.* Moon, Boys & Graves were the London publishers of this work.
 [3] *Keelmen heaving in Coals by Night* (B.–J. No. 360). This picture, and *Venice* (see Letter 187) were sold to John Naylor in 1849, but in 1861 McConnell wrote to Naylor: 'I cannot overcome my hankering after one of the Turners. I know, at least I am pretty certain, nothing would tempt you to part with the Venice; but are you irresistably determined not to part with the Moonlight? I believe I can get other Turners, but yours, being painted at my especial suggestion, produce a yearning of the spirit which others do not' (*The Times,* 29 Jan. 1887, p. 15).

194. John Pye to Turner

MS. (Copy) Victoria and Albert Museum, Pye MS. 86 FF. 73, fo. 7

42 Cirencester Place Fitzroy Sq^{re}
August 19 1835

Dear Sir,

I beg to subjoin a brief memorandum of the terms on which you were led to paint the picture of Ehrenbreitstein;[1] and to assure you that I am fully prepared to carry my part of it into effect.

I have carefully looked at the different propositions made since the picture has been painted, for engraving the plate on a large scale, for you to pay half the price of engraving it &c. But they all appear objectionable, and throw me back to the original one in which we started and which led you to offer to paint the picture instead of making a drawing.

I am dear Sir
Yours respectfully
John Pye

turn over

Memo: The picture of Ehrenbreitstein was painted to be lent to Mr Pye for the purpose of a plate being engraved from it about the size of a work box i.e. the size of Mr G. Cooke's plate of the Rotterdam,[2] on the following conditions—The plate to be engraved free of all cost to Mr Turner. Mr Turner to aid Mr Pye in its progress by his suggestions and by touching proofs.

Mr Pye to be paid out of the publication of the plate the price of engraving it; after which the plate and stock of prints (Mr Turner paying half the price of printing) to become the joint property of Mr Turner and Mr Pye—Mr Pye further agrees that Mr Turner shall be entitled to 100 print impressions of the plate beyond an equal division.

The price of engraving the plate the size of the plate of Rotterdam Mr Pye estimates at £400.

The division of the property not to exceed two years from the completion of the plate or earlier if possible—Mr Turner to have twelve unlettered proofs, Mr Pye to have six.

[1] B.–J. No. 361. Pye's plate (R. 662) was eventually published in 1845, after the picture had been sold to Elhanan Bicknell (q.v.). In his manuscript memoir (Victoria and Albert Museum, Pye MS. 86 FF. 73, fo. 89) Pye states that it was intended that Turner should paint a picture for Pye to engrave while he was abroad educating his daughter, but that *Ehrenbreitstein* proved too large to take, so it was not engraved until he returned.

[2] Cooke's plate, after A. W. Callcott's *Rotterdam*, was published in 1825 (25 × 34 cm).

Mr Pye engages to deliver up the picture so soon as the plate is completed; or, in the event of the death of Mr Pye the picture to be delivered up so soon as demanded—the picture to be returned to Mr Turner within the space of five years from its delivery to Mr Pye and as much earlier as can be effected consistently with Mr Pye's other professional engagements.

195. Turner to J. Henshall

MS. Untraced (with Maggs Bros. 1972)

[*Postmark* 16 October 1835]

Your *proof*[1] is ready, whenever you send to Queen Ann St. for it.

196. Turner to John Macrone

MS. British Museum Print Room, Anderdon Academy Catalogues, xi. 5365

Atheneum D[ecember] 15
1835

My dear Sir

Please to send me all the Proofs of the Milton 50 each—and accept my joy of your having received the price for the 6 [*changed from or to 5*][2] Drawings, on your behaff and because it makes the proportion we talked about 5 to 3 in the first outlay—and say *when* the draft to your concurrence [?] may be paid away.

Yours truly
J. M. W. Turner

[*Addr.*] J. Macrone Esq^re
St James Square

197. Turner to H. A. Monro

MS. Untraced
Publ. (Extract) Finberg 1939, p. 357

Monday [?1835]

[Hoping Monro would call on Thursday rather than Tuesday, as

[1] The only recorded prints by Henshall after Turner are of 1830 (R.245; 340).
[2] Six of the seven drawings for Macrone's edition of *Milton's Poetical Works* (R. 598–604) were in the collection of Munro of Novar (q.v.) in 1865, and may well have been purchased from Macrone (Omer Nos. XXIV–XXVI, 149–55).

Lord Egremont has] sent word that he wishes me to dine in Grosvenor place tomorrow, Tuesday.

[*Addr.*] H. A. Monro, Esq.

198. Turner to Henry McConnell

MS. British Library Add. MS. 50119, fo. 26

[?early January 1836]
47 Queen An[n St.] West

My Dear Sir
 Happy New-Year to you and many of them. I write merely to say I received your letter *asking me for my account* which I left to you to decide upon for me *as to the amount.*[1]

Believe me most truly
J. M. W. Turner

H. McConnel Esq^re
Manchester

199. Turner to Charles Turner

MS. Untraced (Maggs Bros. 1927 (1918))
Publ. A. Whitman, *Charles Turner* (1907), p. 18

[26 February 1836]

My Dear Charles
 I must break through the rules of propriety to ask you, you, 'to throw myself upon your kindness'—only—think what I suffered at Sir Thomas Lawrence's [death] and for so long an illness—that I beg of you to yield to my fears against my will—which believe me Charles is with you in your present misery[2] and do not think a particle of respectful regret is wanting to your (?amiable) loss or in any want of attention to your request by a note yet now arrived from Mr Chittendon[3] 43 Greek St. Soho—that I do again beg of you to let me feel at home all that true concern!! without any alloy of apprehension.

[1] This almost certainly refers to *Keelmen Heaving in Coals by Night* (See Letters 187 and 193).
[2] Charles Turner's wife had died. [3] The undertaker.

200. Turner (and others) to William Henry Whitbread

MS. Untraced (deposited by Mrs. S. M. Prior-Palmer at the West Sussex Record Office, 1958–9)

July 4 1836

[Letter signed by Chantrey (q.v.), H. Maconochie, Stokes (q.v.), Turner, Jones (q.v.), Edwin Landseer (1802–73), and Wilkie (q.v.) to W. H. Whitbread, thanking him for a fish, and referring to Richard Penn (See Letter 151).]

201. Turner to J. T. Willmore

MS. Birmingham City Art Gallery, 410'40

Tuesday July 26
36

Dear Sir
 I cannot answer your note of this morning (respecting the Plate)[1] with any certainty; you had better not hinder yourself in any way *whatever* or in any *respect* &c &c

Yours truly
J. M. W. Turner

[*Addr.*] J. Willmore Esq
 Polygon[2]

202. Turner to John Ruskin

MS. British Library Add. MS. 50119, fo. 27
Publ. J. Ruskin, *Praeterita*, i (1885), ch. XII, §243

47 Queen Ann St West
Oct 6 1836

My Dear Sir
 I beg to thank you for your zeal, kindness, and the trouble you have taken in my behalf in regard of the criticism of Blackwoods Mag for Oc respecting my works,[3] but I never move in these matters. They

[1] Probably one of the *England and Wales* plates published in 1836; *Powis Castle* (R. 285) or *Llanthony* (R. 287).

[2] i.e. Willmore's address at 23 Polygon, Somer's Town.

[3] [The Revd. John Eagles], *Blackwood's Edinburgh Magazine*, xl (1836), 550–1.

are of no import save mischief and the meal tub which Maga fears for by my having invaded the flour tub.[1]

[*signature cut away*]

P.S. If you wish to have the Mans back have the goodness to let me know. If not with your sanctions I will send it to the Possessor of the Picture of Juliet.[2]

[*Addr.*] J. R. Esq^re
　　　　 Messrs Smith, Elder and Co
　　　　 Cornhill
　　　　 City

[*Endorsed* The first letter I ever received from Turner, thanking me for a letter in defence of his picture of 'Juliet and her nurse', the first I ever wrote about his work.
　　　　　　　　　　　　 John Ruskin
　　　　　　　　　　　　 Brantwood 19^th May 1880]

[1] Eagles had said of *Juliet and her Nurse* (B.–J. No. 365): 'The scene is a composition as from models of different parts of Venice, thrown higgledy-piggledy together, streaked blue and pink, and thrown into a flour tub. Poor Juliet has been steeped in treacle to make her look sweet, and we feel apprehensive lest the mealy architecture should stick to her petticoat and flour it.'

Ruskin used this passage in one of the purpler passages of his *Reply* of 1 Oct.: 'Many-coloured mists are floating above the distant city, but such mists as you might imagine to be aetherial spirits, souls of the mighty dead breathed out of the tombs of Italy into the blue of her bright heaven, and wandering in vague and infinite glory around the earth they have loved. Instinct with the beauty of uncertain light, they move and mingle among the pale stars, and rise up into the brightness of the illimitable heaven, whose soft, sad blue eye gazes down into the deep waters of the sea for ever,—that sea whose motionless and silent transparency is beaming with phosphor light, that emanates out of its sapphire serenity like bright dreams breathed into the spirit of a deep sleep. And the spires of the glorious city rise indistinctly bright into those living mists like pyramids of pale fire from some vast altar; and amidst the glory of the dream, there is as it were the voice of a multitude entering by the eye—arising from the stillness of the city like the summer wind passing over the leaves of the forest, when a murmur is heard amidst their multitude.

This, oh Maga, is the picture which your critic has pronounced to be like 'models of different parts of Venice, streaked blue and white, and thrown into a flour-tub!' (J. Ruskin, *Works*, iii. 638 f.).

[2] H. A. J. Munro of Novar (q.v.). Ruskin's manuscript survives only in a copy in the Ruskin Collection (*Works*, iii. 635–40), so it was probably sent to Munro.

203. Turner to William Miller

MS. Cambridge, Fitzwilliam Museum Library

Petworth
21 Oct 1836

Dear Sir

Mr Edward Swinburne in the course of last Summer told me you said to him that you wished to Engrave Sir John's Picture of mine viz. Mercury and Herse[1] upon your own Speculation. My answer was, I thought your doing so, being employed on the Venice,[2] it would not answer [?] but it was left to me intirely and I told more than one Publisher about it without any result.

Since which I have painted an upright Picture—Mercury and Argus[3] which will answer very well as a companion print and an Engraver has fallen in love with it[4] and he has offered me the following terms which I now offer to you viz. I am to have eleven of my 50 Proofs before letters and in liew[?] of having money for the Picture loan—one third of the printing, say 800 clear of all expenses and 10 a year during the stay of the Picture with you, the *Coppers* after printing to be mine.

Whether you accept or refuse this let it be considered Private for I do not wish to be bound in future cases to these terms or should not have mentioned them but to show that if one person thinks well so to do, that it is or may be more safe for two—for one Print will help the other, being Companion Plates—the only think against [?] is—your being engaged about the Venice might [?] make it £10 more against you—2 years is the time for the last Picture—waiting your earliest answer to Queen Ann St West 47

I am yours truly
J. M. W. Turner

[*Addr.*] Mr William Miller
Braed,
Edinburgh [*redirected to* 4 Hope Pk.]

[1] R.A. 1811, B.–J. No. 114. The picture was not engraved by Miller, but by J. Cousen, and published in 1842 (R. 655).

[2] *The Grand Canal, Venice* (R.A. 1835 as *Venice, from the Porch of the Madonna della Salute,* B.–J. No. 362). Miller's engraving was published in 1838 (R. 648).

[3] R.A. 1836, B.–J. No. 367.

[4] Either J. T. Willmore or F. G. Moon (qq.v.) who engraved and published the plate in 1839 (R. 650).

204. Turner to Clara Wells (Wheeler)

MS. British Library Add. MS. 50119, fo. 29

[?11 November 1836]

Dear Clara

I am much bothered and much agrieved by your injury[1] and Mr Wheeler calling yesterday Evening hope you have written to Mitcham with my best regards

Believe me most truly
tho in great haste
J. M. W. Turner

[*Addr.*] Mrs Wheeler
[*Pencil*] by hand

205. Turner to Robert Hollond

MS. Untraced (Maggs Bros. 1920, No. 1774)
Publ. Lindsay 1966, p. 183

Your Excursion[2] so occupied my mind that I dreamt of it, and I do hope you will hold to your intention of making the drawing, with all the forms and colours of your recollection.

[1] The letter is on black-edged paper, and probably refers to the death of Clara's father, W. F. Wells (q.v.), on 10 Nov. 1836. Clara told Thornbury that Turner 'came immediately to my house in an agony of grief. Sobbing like a child, he said, "Oh, Clara, Clara! these are iron tears. I have lost the best friend I ever had in my life"' (Thornbury 1877, p. 236). If this letter does relate to this incident, then it seems Clara's memory was somewhat at fault.

[2] Hollond was the sponsor of a balloon trip from London to Weilburg in November 1836. One of his companions, Monck Mason, described some of the views which Turner may have had in mind. Crossing the Channel from Dover to Calais at sunset, 'It would be impossible not to have been struck with the grandeur of the prospect at this particular moment of our voyage ... Behind us, the whole line of the English coast, its white cliffs melting into obscurity, appeared sparkling with the scattered lights, which every moment augmented, amongst which the light-house at Dover formed a conspicuous feature, and for a long time served as a beacon whereby to calculate the direction of our course. On either side below us the interminable ocean spread its complicated tissue of waves without interruption or curtailment, except what arose from the impending darkness, and the limited extent of our own perceptions; on the opposite side a dense barrier of clouds rising from the ocean like a solid wall fantastically surmounted, throughout its whole length, with a gigantic representation of parapets and turrets, batteries and bastions, and other features of mural fortifications, appeared as if designed to bar our further progress...' [T. M. Monck Mason], *Account of the late*

206. Turner to R. Griffin & Co. [?]

MS. Untraced (Sotheby, 8 Dec. 1911 (207), bt. Sabin)

[? 1836]
47 Queen Anne St

I beg in answer to your note of the 8th to say the cost price of the
Liber Studiorum viz 14 Nos. at one Guinea each will be 14 Guineas
—without any deduction whatever—therefore no selling price [Mentions his tour in France and Switzerland.]

207. Turner to Clara Wells (Wheeler)

MS. British Library Add. MS. 50119, fos. 30 f.
Publ. Finberg 1939, p. 365

[12 March 1837]

Dear Clara
Many thanks for your inquiry about my health—and I am sorry to

Aeronautical Expedition from London to Weilburg accomplished by Robert Hollond Esq. Monck Mason Esq. and Charles Green, Aeronaut (1836), pp. 21 f.

During the moonless night over France, 'The whole plane of the earth's surface, for many and many a league around, as far and farther than the eye distinctly could embrace, seemed absolutely teeming with the scattered fires of a watchful population, and exhibited a starry spectacle below that almost rivalled in brilliancy the remoter lustre of the concave firmament above. Incessantly during the earlier portion of the night, ere the vigilant inhabitants had finally retired to rest, large sources of light, betokening the presence of some more extensive community, would appear just looming above the distant horizon in the direction in which we were advancing, bearing at first no faint resemblance to the effect produced by some vast conflagration, when seen from such a distance as to preclude the minute investigation of its details. By degrees, as we drew nigh, this confused mass of illumination would appear to increase in intensity, extending itself over a larger portion of the earth, and assuming a distincter form and a more imposing appearance, until at length, having attained a position from whence we could more immediately direct our view it would gradually resolve itself into its parts, and shooting out into streets, or spreading into squares, present us with the most perfect model of a town...' (pp. 26 f.).

'The sky, at all times darker when viewed from an elevation than it appears to those inhabiting the lower regions of the earth, seemed almost black with the intensity of night; while by contrast no doubt, and the remotion of the intervening vapours, the stars, redoubled in their lustre, shone like sparks of the whitest silver scattered upon the jetty dome around us. Occasionally faint flashes of lightening, proceeding chiefly from the northern hemisphere, would for an instant illuminate the horizon and after disclosing a transient prospect of the adjacent country, suddenly subside, leaving us involved in more than our original obscurity...' (pp. 30 f.).

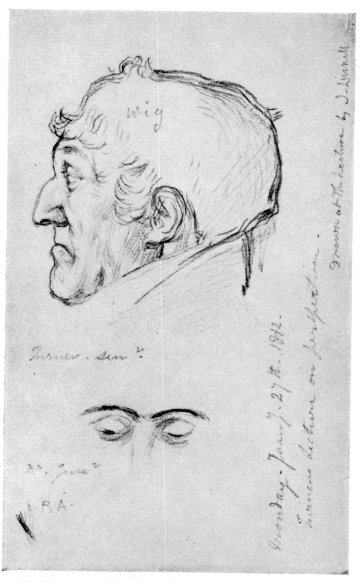

wig

Turner. Senʳ

Dᵒ. Junʳ
R.A.

Monday. Janʸ. 27ᵗʰ. 1812.
Turners Lecture on perspective.

Drawn at the Lecture by J. Linnell

II. John Linnell, *Portrait of William Turner Snr. at a Lecture by
J.M.W. Turner.* 1812. Pencil. A. Buckland Kent Esq.

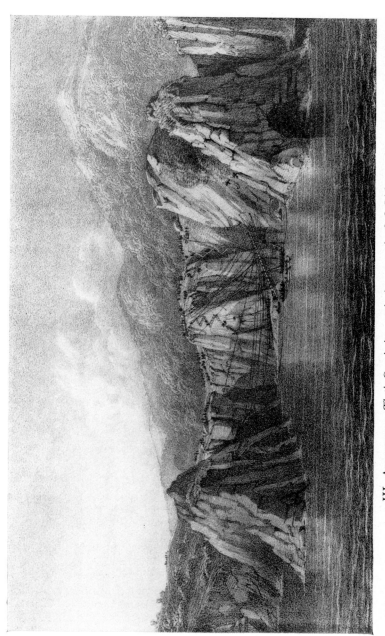

III. Anonymous, *Thetis Cove in its most 'quiescent state'*. 1836. Lithograph.

hear of Mr Wheeler being so *ill* for I know your fears (I hope so) are magnified, if I were to judge by own feelings, having yet the baneful effects of the *Influenza* hanging upon me yet daily (for it alternates) and hourly . . . that the lassitude the sinking down and yet compelled to work the same is not to be expressed but must be borne by me if possible 3 weeks longer without any help . . . so do not make yourself more uneasy than the suffering which this confounded malady has visited almost every one. give *him* my best regards—your *sister* and take the same yourself

<div align="right">Yours truly,
J. M. W. Turner</div>

[*Addr.*] Mrs Wheeler
 Grace Church St.,
 City.
 Sunday Evg.

208. Turner to Emma Wells

MS. British Library Add. MS. 50119, fo. 32

<div align="right">Sunday Night
4.16.37</div>

Dear Emma

I am sorry to say that I did not receive your note in sufficient time to answer it before the evening (Saturday Post) to thank Mrs Stephenson by your kindness in saying it for me, and the impossibility of availment owing to an engagement

<div align="right">Yours most truly
J. M. W. Turner</div>

209. Turner to Emma Wells

MS. British Library Add. MS. 50119, fo. 33
Publ. Finberg 1939, p. 366

<div align="right">Sunday April 24 [sc. 23] [1837]</div>

Dear Emma

I must beg pardon for [not] sending the enclosed by Post of Monday last,[1] to thank Mrs Stephenson for her kind invitation for the Sunday previous but the fact is, I thought I had put it into the Box on my way

[1] Letter 208.

home, and only found it to-day in my Holiday-coat for any thing will do to hang Pictures.[1]

Thank God (pardon) we have so nearly done, that you may tell Briggs[2] (if he has not [received] amended notice of the *Painting Days*[3] that *we* have by Whip and Spur made Monday also—let him know immediately if he is at Hampstead

<div align="right">Yours truly
J. M. W. Turner</div>

[*Addr.*] Miss Wells
 Mrs Stephenson
 Branch Hill
 Hampstead
 Middx.

210. Dawson Turner to J. M. W. Turner

MS. C. W. M. Turner Esq.

My Dear Sir

Could I have persuaded the binder to move a little more quickly, you would not have found me thus tardy in availing myself of the permission you gave me to put a set of my wife's etchings into your hands.[4] Very few of them, as you will see, have yet been printed; few more ever will be so. She most kindly employed herself upon them, so long as her health and her eyesight allowed her, with a view to gratify and by enabling me to gratify my friends; and I, as the only relation in any power, have been desirous to place them in the great public libraries of Europe, & in the hands of those most capable of appreciating them. I am most happy to place them in yours. I should be insensible indeed, did I not feel how much honor the name I bear derives from my bearing it in common with you; & I should have a very low estimate of my own feeling for art, were I not morally certain that the time must come, will soon come, when your works will be ranked above those of any other painter in your line, who have ever yet appeared upon the face of the earth. With this feeling, you will not wonder I shd say, 'do pray come & see and stay here as long as you can'. You will no where find a house that will open its doors more

[1] Turner was on the Academy Hanging Committee this year.
[2] Henry Perronet Briggs, R.A.
[3] i.e. Varnishing Days, of which there was one extra this year.
[4] *One Hundred Etchings by Mrs. Dawson Turner*, one of forty-nine copies, privately printed, 1837.

proudly to receive you; no where a family that will more appreciate your standards [?]

My dear Sir
Yours most truly
Dawson Turner

Yarmouth 28 August 1837

211. Turner to Dawson Turner

MS. Cambridge, Trinity College, Dawson Turner Letters

Wednesday Sept 6
1837

My Dear Sir

With the full I trust feeling of recipricly both being fellow labourers in the furtherance of art and of the same name I hope Mrs Turner will accept of my thanks and you likewise my thanks for the kindness in sending it to me viz a Book containing 100 Etchings by Mrs Turner —and honoured by being made one of the few, which 49 copies only must make me.

Your invitation to Yarmouth I shall not forget tho it may never be my lot to know its happiness tho I live in hope.

I must beg to apologise for the delay of acknowledging[?] the receipt of the *present sent in the end of July,* but I only knew of it yesterday on returning home after my Summer's trip on the Continent.

Yours most truly
J. M. W. Turner

To Dawson Turner Esq^r
Yarmouth

212. Turner to George Cobb

MS. Untraced (Maggs Bros. 1920 (877))

26 October 1837

We have got into the yellow leaf again and they will not shew their colours long and no fishing weather, but with an East wind, so get yourself strong and merry, and fly me a kite [*sketch*] with a long (tale) tail, whenever you have a wind...

213. Turner to George Cobb

MS. Untraced (Maggs Bros. 1920 (876))

8 November 1837
Atheneum

Many thanks for your kind and warm invitation to Wilton and Sketch of Mansion, not forgetting the large gateway to the No Garden, and tho' the Chimnies are wanting I am quite sure the good cheer is within the Batchelor Box and the four post bed . . .

214. Turner to J. H. Maw

MS. British Library Add. MS. 50119, fo. 35
Publ. Finberg 1939, pp. 368–9

Thursday Decr 7 1837

My Dear Sir
 Many thanks for your kindness in thinking of my loss at Petworth[1] and offer to fill up in part, by a few days at Guildford toward [?] the Xmas. I must confess I do feel disposed but fear much it would be to you and Mrs Maw a great trouble, for I am now more than an invalid and Sufferer either from having taken cold at the Funeral of Lord Egremont or at the Life Academy,[2] but I hope the *worst is now past*, but Sir Anthony Carlisle, who I consult in misfortune[3] says I must not stir out of door until it is dry weather (frost) I hope he includes, or I may become a prisoner all the Winter.
 In regard to the purchase ground pray think twice. I had a look at it again going down, but if it must be so, any opinion of mine is at your service. Glad you like the *Campbell illustrations*.[4]
 Believe me with best respects to Mrs Maw and Self
 Your most truly obliged
 J. M. W. Turner

J. Maw Esqr
Guildford

[1] Lord Egremont (q.v.) had died at Petworth on 11 Nov.
[2] Turner was Visitor to the Life Academy in November.
[3] Sir Anthony Carlisle (1768–1840) Professor of Anatomy at the R.A. 1808–24.
[4] Turner's engravings for *Campbell's Poetical Works* (1837). See above, p. 3, and Omer Nos. XXVII–XXVIII, and 156–75.

215. Turner to Dawson Turner

MS. Cambridge, Trinity College, Dawson Turner Letters

47 Queen Ann St West
Tuesday Dec 20 1837

My dear Sir

Your letter of the 16th arrived to day and I have to thank your kidness for sending me the Barrel of Herrings. I thought whence they came being the true Yarmouth *ones*.

Phillips and myself have to thank you for your *good wishes* but he says Lord Egremont has left but few or scarcely any legacies, his Lordship having been his own Almonor [?] during life doing good to all around him. I have not been able to taste your present for I am sorry to say I have been too unwell ever since I saw you at the Atheneum when [?] I caught cold at Lord Egremont's funeral or attending the Life Academy (got damp) thus [?] I [sc. a] very sharp touch of fever followed which has confined me at home for 3 weeks (to the use of Pallit and Brushes) but I do hope to get my breakfast Tea-kettle burnished up by the next time you come to Town. with best respects to Mrs Turner

Believe me to be
Yours most truly
J. M. W. Turner

Dawson Turner Esq^r
Yarmouth

216. Turner to C. L. Eastlake

MS. The Editor

Friday Evening
Dec^r 23 1837

Dear Eastlake

I beg to apologize for sending for your acceptance a small Barrel of *Red Herrings*, but a friend of mine living at Yarmouth having sent them, I venture [?] to warrant veritable *Yarmouth's*.[1]

yours truly
J. M. W. Turner

[1] See Letter 215.

217. Turner to Mrs W. H. Whitbread

MS. Untraced (Deposited by Mrs. S. M. Prior-Palmer at the West Sussex Record Office, 1958–9)

[2 January 1838]

[Thanking her for a New Year's Gift.]

218. Turner to Clara Wells (Wheeler)

MS. Untraced (Sotheby, 1 Dec. 1906 (144), bt. Stoddart)

[26 February 1838]

219. Turner to J. Hammersley

MS. (Copy by Ruskin) British Library Add. MS. 50119, fo. 37
Publ. Thornbury 1862, ii. 115–16

47 Queen Ann St West. London
Dec. 4th, 1838

Dear Sir

I have truly I must say written three times and now hesitate, for did I know your son's works or as you say his *gifted merit*, yet even then I would rather advise you to think well and not be carried away by the admiration which any friendly hopes (which ardent friends to early talent) may assume. They know not the difficulties or the necessities of the culture of the *Fine Arts* generally speaking: in regard to yourself it is you alone can judge how far you are inclined to support him during perhaps a long period of expense, and particularly if you look towards tuition the more so—for it cannot ensure success, (however it may facilitate the practice) and therefore it behoves you to weigh well the means in your power before you embark him in a profession which requires more care, assiduity and perseverance than any person can guarantee.

I have the honour to be
Your humble servant
J. M. W. Turner

[*Addr.*] John Hammersley Esq.
Liverpool-road,
Stoke-upon-Trent
Staffordshire Potteries.

220. Samuel Rogers to Turner

MS. Tate Gallery

Dear Mr Turner
 Pray dine with me tomorrow, if you can, at 6 o clock
 Yours very truly
 S. Rogers

St James's Place
 Sunday, 30 dec^r [?1838]

221. Charles Fowler to Turner

MS. (Copy) Artists' General Benevolent Institution

 Gordon Square April 5 1839
Sir,
 By the desire of the President and Directors of the Artists' General
Benevolent Institution, I beg to communicate the annexed Resolu-
tion[1] and I shall be much obliged by the favor of your reply by the
same at your earliest convenience.
 I am &c
 Charles Fowler Hon^y Sec^y
To J. M. W. Turner Esq.

222. Charles Fowler to Turner

MS. (Copy) Artists' General Benevolent Institution

 Gordon Square Apr. 15 1839
Sir—
 I had the honor of addressing you about a fortnight since & of
forwarding a resolution of the Directors of the Artists' General
Benevolent Institution relative to the funds for which you are a
Trustee, and as another meeting must shortly be held when that

[1] A resolution of 3 Apr. that Turner, together with Chantrey (q.v.) Phillips (q.v.),
and C. R. Cockerell should be approached to act as the four Trustees in whose names
the Funded Property of the Institution should be vested. See Letter 222.

subject will be brought under consideration, and I have earnestly to request the favor of your answer as early as possible.[1]

I am, Sir, your most Ob^t & humble Sert.
Chas Fowler

To J. M. W. Turner Esq.

223. Turner to William Miller

MS. National Library of Scotland MS. 590, fo. 165

Mr Turner will thank Mr Miller to keep the Picture of Modon [*sic*] Italy[2] always in the *Packing case* that the back of the Picture may be protected from injury.

47 Queen Ann St May 9 1839

224. Turner to James Wheeler [?]

MS. C. W. M. Turner Esq.

Monday Morning
May 27 1839

My Dear Sir
The chances are so much against my being in Town on Wednesday that I fear I must feel myself engaged and be sorry in not having the pleasure of waiting upon you at Maida Hill—on the occasion of Mr Wheeler's[3] Birth–day—wishing you and family—with him and all present—*Health and happiness*

Believe me most truly
J. M. W. Turner

225. Turner to [?William] Marshall

MS. Cambridge, Trinity College Add. MS. c. 66[63]

[12 June 1839]

J. M. W. Turner presents his comp^ts to Mr Marshall and begs to

[1] By the Directors' Meeting of 1 May there was still no reply from Turner, and J. H. Mann's name was substituted for his as Trustee.

[2] R.A. 1838, B.–J. No. 374. Miller was about to engrave the painting. See Letters 246, 250, 251, 253, 256.

[3] Possibly Clara's husband, Thomas Wheeler.

apologise for not sending an earlier answer to the note of the 7th owing to his being from Town for a few days last week.

The only picture in the east Room[1] unsold is the Marine subject[2]/ Price 250 Guineas.

The Fountain of Fallacy[3] 400 Guineas—Exclusive of Frames and the copyright of Engraving.

J.M.W.T. has many Pictures of the same size with the Marine viz. 3 feet by 4 feet and will feel honored by Mr Marshall looking at them in Queen Ann st whenever most convenient—but the larger Picture—Fountain of Fallacy he has not one of the same size.

226. Turner to C. R. Leslie

MS. Untraced (Sotheby, 13 June 1966 (261))

[Watermark 1838]
47 Queen Ann St
Tuesday Night

Dear Leslie

I thank you very much for your note respecting the Price of the Temeraire[4] Picture which until I have the yea or nay of two Gentlemen who cannot make up their minds and how long I am (or ought)

[1] At the Royal Academy Summer Exhibition.

[2] *The Fighting Temeraire* (B.–J. No. 377). See Letter 226.

[3] B.I. 1839. The picture may be that referred to by G. Waagen (*Treasures of Art in Great Britain*, iii (1857), 183 ff.) as in the collection of William Marshall of 85 Eaton Place, London: 'A large picture, belonging to those examples of his later time which ... I have denominated as souls of pictures without bodies. In order to admire such as these, the spectator must have been led by the magician step by step to this extreme.' The *Fountain of Fallacy* was described in 1839 as: 'A wide, far-reaching horizon of uplands, towers, temples and streams losing their light among tufted groves, offers to the eye an ample and delicious repose from the dreamy splendours of the foreground, where the magic fountain, like an enormous bubble of painted air, is throwing gleams of rainbow light on every side, in the midst of which a thousand winged spirits are floating, like a shower of flower leaves—gay, light, and indistinct. In harmony with the brilliancy of this enchantment, the sun of noon mingles its unbroken light with the glory of the fountain. Critics may shake their heads at this picture, but poets will go home from it—to dream' (*Athenaeum*, 1839, p. 117). It may be identical with the *Fountain of Indolence*, first shown in 1834 and now in the Beaverbrook Gallery, Fredericton, New Brunswick, Canada. (See B.–J. No. 376.)

[4] The word is unclear, but the *Temeraire* seems likely, which would date this letter in the summer of 1839 (see Letter 225 and Thornbury 1877, pp. 462–3). Leslie, who was the agent for James Lenox (q.v.), may have been trying to secure the picture for his New York client as early as this; Lenox's later extravagant offers for it are recorded both by Leslie (*Autobiographical Recollections*, i. 207) and by Stillman (see under GRIFFITH).

to wait is my present difficulty but I think of going out of Town for a few days—and will let you know more about it (one way or other) on my return

Yours mos[t] truly
J. M. W. Turner

To C. R. Leslie Esq R.A.
 Maida Hill

227. Turner to H. W. Pickersgill

MS. Mr. Kurt Pantzer

47 Queen Ann St
Saturday Augt
2 1839

My dear Pickersgill
 Pray forgive me but excuse my being with you on Wednesday next for I am on the Wing for the continent (Belge)[1] this morning
yours truly
J. M. W. Turner

[*Addr.*] W. Pickersgill Esqr R.A.
 Soho Square

228. Turner to J. H. Maw

MS. Untraced
Publ. (Extract) Finberg 1939, p. 377

[11 December 1839]

[Declining an invitation to Hastings for Christmas because] I have been so idle all the summer.[2]

[1] Turner perhaps used sketchbooks Nos. T.B. CCXCVI, CCLXXXVII, and CCCIII on this trip.
 [2] See also the letter of 10 Jan. 1840, quoted by Thornbury 1877, p. 245.

229. Turner to John Sheepshanks

MS. Private Collection

47 Queen Ann St West
Cavendish Square
Jan^y 29 1840

My dear Sir

Have the goodness to let me know the size you wish me to paint the Picture of Venice.[1] 'Pray suit your own convenience in every way and

Believe me
Dear Sir
Yours most truly,
J. M. W. Turner

J. Sheepshanks Esq^re
Blackheath Park

P.S. ?Shall the Venice be lengthways or not[2]

230. Turner to Harriet Moore

MS. Untraced
Publ. Thornbury 1862, ii. 229–30

J. M. W. Turner presents his compliments to Miss Moore, and requests her to make his thanks to Mrs Moore for the very kind offer of forgiveness to him, which he will avail himself of with very great pleasure on Sunday next, at a quarter past six o'clock.

February 3 1840: 47 Queen Ann Street
To Miss H. Moore.

[1] *Venice, from the Canale della Giudecca, chiesa di S. Maria della Salute, etc.* (R.A. 1840), now in the Sheepshanks Collection at the Victoria and Albert Museum (B.–J. No. 384).
[2] The *Venice* is a horizontal composition; Turner's only upright Venetian subjects had been *Venice*, R.A. 1833 (B.–J. No. 352) and *The Grand Canal, Venice* (R.A. 1837, B.–J. No. 368).

231. Turner to J. Alenson

MS. New York Public Library (Seligman Coll. of Irvingiana)

47 Queen Ann St
March 25, 40

Sir

I must request your indulgence until after the 10th of April respecting my Pictures being seen because I am at present working in my Gallery.

Yours truly
J. M. W. Turner

[*Addr.*] J. Alenson Esq^{re}
7 Claremont Road
Barnsbury Road
Islington

232. Turner to John Sheepshanks

MS. Private Collection

47 Queen Ann St West
May 4 1840

My dear Sir

I beg you will not trouble yourself about leaving the Cheque for the 250 G^{s1} but I must say I should like to have the pleasure of seeing you and to know which of the two Pictures (you will find at the Royal Academy on the North side of the East Room) you like the best to consider as yours[2]—when you desired me to tell Mr Foord to make for you the Frame I told him to make exactly the like for me. hence arose the Two Pictures—

yours most truly
J. M. W. Turner

J. Sheepshanks Esq^{re}

[1] Presumably payment for the *Venice* (see Letter 228).
[2] The only other painting (by Turner) shown in the East Room this year was *Venice, the Bridge of Sighs*, which remained unsold (B.–J. No. 383).

233. Turner to Sir David Wilkie

MS. British Library, Add. MS. 50119, fo. 38

47 Queen Ann St West
Cavendish Sq^r May 18 1840

Dear Sir David

I beg to offer you my *thanks* for the Postscript of Mr Burke's[1] Letter and if it is not troubling you too much to say that I shall be most happy to Paint him a picture upon his favouring me with his wishes respecting the size—price and Subject, and I hope my endeavours will meet his approval and you will much oblige me

I am Dear Sir David
Yours most obliged
J. M. W. Turner

234. Turner to Thomas Griffith

MS. E. C. and T. Griffith
Publ. Finberg 1939, p. 379

Sunday May 31 –40

My dear Sir

I have just left Jony[2] who has kindly consented to another change of time for I have placed my self in a dilemma from which your indulgence only will relieve [?] me 'Can you make our visit to Norwood for the Monday following viz June 16 and make my pardon with Mrs Griffiths for my almost unpardonable fault in forgetting that the 9th would be Whitmonday[3] and reminded but only last night on my return to Town of being long engaged for Whitmonday and Tuesday so that I have to apologize for not finding out my Error sooner in regard to the time and not writing earlier of my double misfortune.

I am my dear Sir
Yours most truly
J. M. W. Turner

T. Griffith Esq^re
Norwood

[1] Probably Glendy Burke of New Orleans, who had bought Wilkie's *Grace Before Meat* (Birmingham City Art Gallery) in 1839. Turner is not known to have executed any work for him.
[2] George Jones, R.A. (q.v.).
[3] Whitmonday 1840 was on 8 June, and the Monday following 15 June.

235. Turner to Thomas Griffith

MS. E. C. and T. Griffith

Athenaeum Thursday
June 4th 1840

My dear Sir
 Our worthy Keeper G. Jones[1] and self will have the great pleasure
of being at Norwood on the 22nd of June.
 Many thanks for your kind indulgence for the change of time[2]
which I asked with best respects to Mrs Griffith

Believe me most truly
J. M. W. Turner

T. Griffith Esq[r]

236. E. H.[3] to Turner

MS. Untraced (formerly C. M. W. Turner Esq.)
Publ. A. J. Finberg, *In Venice with Turner* (1930), pp. 119–21

Rome. 24 August 1840.

My Dear Turner,
 My better half would have written to you herself, but since she
has been here, unfortunately her health has not been very good and I
have therefore taken up the Pen for her. We both hope this letter will
find you well at Venice, after you left us at Bregentz[4] we soon found
ourselves among the Mountains, and from the fineness of the sky
anticipated a clear day for the Splugen, but in the Morning it rained
and continued to do so until the day when we passed the celebrated
Via Mala and slept at Splugen, the next day was beautiful, and
taking all the passes I have yet seen, this is by far the best, the Via
Mala is a gorge so close that the Rhine is chased between the Rocks
so close that a piece of wood of the size of a foot cannot descend and
in consequence when the Rains fall, the Water rises 400 feet. We
afterwards descended the Lake of Como from the Head of the Town
in the Steam Boat, and after staying at Milan—on the fête of the
assumption reached Genoa and passed the day. This City reminded

[1] Jones was Keeper of the Antique Academy at the Royal Academy Schools.
[2] See Letter 234.
[3] Possibly Edward Hakewill (1812–72), nephew of James Hakewill, Turner's col-
laborator in 1819, and pupil of Turner's friend Phillip Hardwick in 1831.
[4] The conjunction of sketches of Bregentz and Venice in T.B. CCCXX makes it
likely that this book was in use on this trip. But see also Letter 257.

us of Venice. The Road from this place to Lucca by the Sea Coast all the way skirting the Bay is very beautiful, many of the Towers, probably original Watch Towers, require your pencil to describe them accurately. When at Lucca we visited the springs at the Baths 14 miles distant, it is a sort of Matlock upon a large scale. We then took Pisa with its Cathedral falling Tower &c. the next day and the Steam Boat took us to Civita Vechia.

This place is very hot and the Mal Aria so bad from it that we decided upon going back to Chivita Vechia and thence by sea to Naples. During the 4 days we have been here by means of a Carriage we have visited the principal places, perhaps after all, the Colliseum strikes us both, as the most wonderful, last night upon our second visit, we were fortunate, in seeing the Monks and Nuns assembled in the Arena with an immense audience.

It is not our intention to go by way of Paris Home, and consequently we may have the pleasure of seeing you on our way back, as you said you would return in 2 months which is our time. Will you write us two Lines at Basle, if you write soon; or at Liege. This is the 24th, and taking it that we reach Naples on the 27th, about the 2nd we shall be on our Return over Mount Cenis to Geneva, Fribourg, Berne, Basle, and down the Rhine. I am rather improving but the heat is so intense it is sickening. How sincerely I hope you have been quite well and pleased with your route and with our united regards believe me

<div align="right">Affectionately yours
E.H.</div>

P.S. If you should have altered your Route and come near Genoa, we shall probably be there about the 5th, at any rate if you will write to us at Basle stating where and at what time you probably will reach the Rhine we shall most probably meet.

[*Addr.*] J. M. W. Turner Esq^{re}
 Post Office
 Venice.

237. Turner to William Finden

MS. British Library Add. MS. 50119, fo. 40

<div align="right">[*Postmark* Dover SP. 27 1840]</div>

Dear Sir

(By a gentleman travelling faster who promised me to put a wafer and drop this into the Post Box at *Dover*) May I ask you to stop the

payment of the Draft which I left for payment at Hammersleys ...
which you gave me upon Barclays and Co and you will oblige

J. M. W. Turner

Mem. it will make my life the easier in the lodging of accounts

[*Addr.*] W. Finden Esq^{re}
 Southampton Terrace
 New Road Pancras
 London

238. Turner to George Cobb

MS. British Library Add. MS. 50119, fo. 42
Publ. Finberg 1939, p. 381

47 Queen Ann St
Oct 7 1840

Dear Cobb

Why! you are like a Jack of Trumps—turning up at cribbage = so
two thanks for your letter from Brighton or anywhere—though I am
sorry to hear you complaining yet of illness.

Wally Strong[1] shall be paid but confound him he will not move
about the piece of ground, so things remain (as they were). What
Young[2] has built and paid his rent for *Heaven only knows*, for I do not.

Having left the great Gates and no garden,[3] and having locomotive
Engines in Progress towards you, we may meet again ere long—by
rail-road, either at Brighton or London, but I suppose you are not
so located by the hills[?] Mr Jack of Trumps, but do come to town
occasionally by the Rapid Dart or Quicksilver; that I do hope to see
you before the Chemin de Fer is completed.[4]—I should have answered
your letter sooner, but have only arrived from Venice a few hours
—but

Believe me to be Dear Cobb
Yours truly
J. M. W. Turner

G. Cobb Esq^{re}
Brighton

[1] See Letter 238.
[2] Finberg assumes that this is the Harley St. dentist, Benjamin Young, although he
seems to have left No. 65 by 1826.
[3] See Letter 212.
[4] The London and Brighton Railway was under construction between 1837 and
September 1841 (H. Ellis, *British Railway History*, i (1954), 123–4).

239. Turner to Clara Wells (Wheeler)

MS. British Library Add. MS. 50119, fo. 44

[*Postmark* Dec 21 1840]
Thursday Night

Dear Clara
 The chances are so much against my *appearing* in Grace Church Street tomorrow that I pop this into the Letter Post to night with my little hope of being of the party but with the best regards to all so do not wast one moment after the time but concluding the colours are moving yet are more than could be wished

Believe me truly
Yours
J. M. W. Turner

[*Addr.*] Mrs T. Wheeler
 60 Grace Church Street, City

240. Turner to George Cobb

MS. Mr. Nelson C. White
Publ. (Facsimile) Armstrong, facing p. 236

Dear Sir
 Mr Strong[1] seems to wish for a job—to [*deleted*] draw up a Lease?!! What for a *Frontage* No No No. The whole is bad enough for that expense with rent to boot (watch him) but mind I will be at [*deleted*] not be charged for his ifs and ands, send him your plan it is quite sufficient because the boundaries are marked by other allotments; whereas he wants to charge for drawings (for surveyor the same), and all he can to swell the cost of the Lease for him some how or other is this charge for Lease before he begins it. But I will not ask of one Inch less of ground than the *whole* upon any terms whatever

Yours most truly
J. M. W. Turner

[*Verso*] G. Cobb Esq.

[1] Probably the Wally Strong of Letter 238. Finberg (1961, p. 350) dates this letter 1834, but it may well refer to the transaction of 1840.

241. Turner to Mrs Carrick Moore

MS. Anthony Heath Esq.
Publ. Thornbury 1862, ii. 228

47 Queen Ann St
Thursday 18 Mar[ch 1841][1]

Dear Madam
 Mr Jenkins[2] will take the Benefit of the Act himself and will (without asking Counsel's opinion therein) appear before the Court of Brook Street on Wednesday the 24 instant ¼ before 7 O clock, and abide by the same

I have the honor to be
for Mr Jenkins's case
J. M. W. Turner

242. Turner to Harriet Moore

MS. Untraced
Publ. Thornbury 1862, ii. 229

Wednesday 20th [? March] 1841

Dear Miss Moore—
 I am very sorry to be engaged on the 29 th, Friday, and therefore excluded from the happiness of being in Brook Street on that day. Very many thanks for the name of the church, Redentori.[3]

Yours truly,
J. M. W. Turner

243. Turner to Dawson Turner

MS. Cambridge, Trinity College, Dawson Turner Letters

47 Queen Ann S^t West May 24 1841

My dear Sir
 May I (M. W. Turner) take the liberty to ask Mr Dawson Turner

 [1] During the period when Turner was close to the Carrick Moores', only 18 Mar. 1841 and 18 May 1843 were on a Thursday, and the month in this letter seems to read 'Mar'.
 [2] Turner's *alter ego* in the Carrick Moore circle (see p. 199).
 [3] Harriet Moore told Thornbury (ibid.) that Turner 'asked me to find the name of the church in Venice which contained three pictures by G. Bellini.' This was in connection with Turner's painting, *Depositing of John Bellini's Three Pictures in La Chiesa Redentore, Venice* (R.A. 1841). For the identification of the Bellinesque pictures alluded to by Turner, B.–J. No. 393.

to say to Sir Francis Palgrave;[1] a good word on behalf of Mr H. Green—occasionally imployed in or by the Office of the Duchy of Lancaster in making out records. He having now completed or some change being thought of (so he tells me) his fears have passed his hopes—but not his anxieties to be employ'd somehow or other—your assistance in this matter will much oblige

<div align="right">yours most truly
J. M. W. Turner</div>

Pray have the goodness to offer
my best respects to Mrs Turner

244. Turner to an Unknown Correspondent

MS. Cambridge, Fitzwilliam Museum

<div align="right">29 May [1841]</div>

Dear Sir

I feel much obliged by your think[ing] of me and sending the enclosed letters from Daniel[2]—and he seems quite well and spirited. I wish he had met with Sir David for Miss Wilkie[3] was rather in tribulation when I last saw her.

However I heard last Eving that he is now painting the Pasha's Portrait alias Mahogany face[4] vide *Daniel's Letters*

<div align="right">Yours truly
J. M. W. Turner</div>

245. Turner to W. F. [?] Collard

MS. Christopher Norris Esq.
Publ. Finberg 1939, p. 383

<div align="right">[Athenaeum Stamp]
Tuesday 1841</div>

Dear Sir

I beg to your pardon in not sending an earlier answer to your

[1] Sir F. T. Palgrave (1788–1861) was Dawson Turner's son-in-law, and had been made Deputy Keeper of the Records in 1838.

[2] E. T. Daniell (1804–43), amateur artist and close friend of Turner's, who was, like Wilkie, travelling in Asia Minor, where he died (cf. F. R. Beecheno, *E. T. Daniell: A Memoir* (1889), pp. 13 ff.).

[3] Wilkie's sister had taken a dislike to Turner in 1821. Wilkie wrote to Mrs. Nursey in December: 'my sister has upon the occasion conceived the most rooted aversion to that Artist whom so many admire, from his habit of tasting everything and leaving a great deal of everything upon his plate...' (*The Academy* (1878), pp. 232 f., 345 f.).

[4] *Muhemet Ali* (1769–1849) (Tate Gallery). This oil sketch, dated Alexandria, 11 May 1841, was probably Wilkie's last work.

note respecting the Picture N⁰ 277 John Bellini[1] and now beg to say the price is 350 Guineas. N⁰ 72—250 Guineas 53 sold (both of Venice).[2] These prices are exclusive of the Copy rights & that—the power of Engraving resting with Mr Turner—the Frames if liked at their cost price—or lent until others are made—or to any fixed time, to be returned before the next Exhibition.

<div align="right">

Yours most truly
J. M. W. Turner

</div>

Collard Esq^{re} (Bank)

246. Turner to William Miller

MS. Cambridge, Fitzwilliam Museum
Publ. Thornbury 1877, pp. 170–1

<div align="right">22 Oct 1841</div>

My Dear Sir,

So much time—for I only return'd from Switzerland last night—since your letter and the arrival of the proof,[3] for Mr Moon has sent only *one*, that I hope you have proceeded with the plate, in which case it is evident you must take off *three* and mark the two for me—if you adopt the same medium of transfer—but I would say send them direct—my remarks would be wholly yours—and some inconvenience to both avoided—if you have not done anything take off one for me ... so now to business.

It appears to me that you have advanced so far that I do think I could now recollect sufficiently—without the Picture before me[4] but will now point out *turn over* and answer your questions viz. if the sky you feel [is] right you could advance more confidently therefore do not touch the sky at present but work the rest up to it. The distance may be too dark, tho it wants more fine work, more character of

[1] *Depositing of John Bellini's Three Pictures in La Chiesa Redentore, Venice* (R.A. 1841). See Letter 242.

[2] Turner mistakes No. 72 at the Exhibition for No. 66: *Giudecca, la Donna della Salute and San Georgio* (B.–J. No. 391). No. 53, *Ducal Palace, Dogano with part of San Georgio, Venice* (B.–J. No. 390) had been sold to Chantrey (q.v.). Collard bought neither of the other two.

[3] For *Modern Italy* (R. 658), published by F. G. Moon in 1844. Rawlinson lists an exceptionally full series of touched and annotated proofs. See also Letters 223, 250, 251, 253, 256.

[4] The painting (R.A. 1838, B.–J. No. 374) was still in Miller's hand; it is not clear whether it had been lent from the Munro of Novar collection, or whether Munro (q.v.) acquired it later.

woods down to the very campagna of Rome a bare sterile flat ...
much lighter in tone.

The question of a perpendicular line to the water ... pray do not
think of it until after the very last touched proof, for it has a beautiful
quality of silvery softness, what is only checked by the rock which is
the most unfortunate in the whole plate—how to advise you here I
know not, but think fine work would blend the same with the reflec-
tions of it with the water—this is the worst part and I fear will give
us some trouble to conquer and if you can make it like the water in
the middle of the plate, I should like it better. The Houses above and
particularly [?] from the Figures, and the parts from and with the
Boys looking down are what I most fear about, which range all along
the rock and the broken entrance and the shrine want more vigours
to detach from the Town all the corner—figures &c. The foreground
will be required to be more spirited and bold; open work, dashing
Wollett like toutches and bright lights; so do all you can in the middle
part and lower [?] part of the Town and leave *it* all for the present
in front. The *Figure* in front would be better with the white cloth
over the face done by one line only [*diagram*] and perhaps a child
wrapped up in swaddling clothes before him would increase the senti-
ment [?] of the whole.[1] The ground on which she kneels *and* [seal]
to the front wall [*deleted*] break with small pebbles on broken pavement—
Now for the good parts—the greatest part of the sky, all the *left side*,
the upper castle and Palace and partly round to the Sybil Temple—
Town and procession on the right side, and the water in the middle
particularly good and I hope to keep it untouched if possible.

I am glad to hear you say I can have the picture after the first
touched proof and *that* [*deleted*] this long letter of directions will be
equal to *one* and you will be able to proceed with confidence—write
if you feel any difficulty and believe me truly yours

<div style="text-align: right">J. M. W. Turner</div>

P.S. Very sorry to hear of the loss you have sustained.

247. The Duke of Wellington to Turner

MS. E. C. and T. Griffith

<div style="text-align: right">London 3 Nov 1841</div>

V M The Duke of Wellington presents his compliments to Mr Turner.

[1] This feature was added to the plate by Miller.

The Comg. officer in the Tower has given orders that no person shall be admitted except on business.[1]

It cannot be expected that the Duke should interfere with an order so given without being responsible for the consequences—

The Duke declines to take upon himself such responsibility.

J. M. W. Turner Esq R.A.
Royal Academy

248. Turner to Mrs Carrick Moore

MS. Anthony Heath Esq.
Publ. Thornbury 1862, ii. 230

47 Queen Ann St
Thursday Eg
Dec 9 41

Dear Madam

I am truly sorry in being ingaged Tuesday and Wednesday next (out of town) particularly sorry on the present occasion of your kind invitation

most sincerely
J. M. W. Turner

P.S. very low indeed for our loss in *Dear* Chantry.[2]

249. Turner to Clara Wells (Wheeler)

MS. British Library Add. MS. 50119, fo. 46
Publ. (Extract) Finberg 1939, p. 391

47 Queen Ann St West
Friday May 28 42

Dear Clara

I am glad to hear Mister Tom[3] has passed his examinations at the

[1] Nothing is known of the circumstances of Turner's proposed visit to the Tower, which may, however have been to see the results of the great fire of 30 Oct. 1841 'which exceeded in grandeur even the great fire at the House of Commons ...' (*The Times*, 1 Nov.). Other artists, including George Cruikshank, were allowed to visit and sketch the ruins on 6 Nov., and they were not finally closed to the public until 10 Nov. But the fire was still raging until 5 Nov. (ibid.). John Britton had also had a similarly brisk refusal from Wellington a few years earlier when he wished to visit Dover Castle for archaeological purposes (*Auto-Biography*, 1849, ii. 53n).

[2] Francis Legatt Chantrey (q.v.) had died on 25 Nov. 1841.

[3] Probably Thomas Wheeler Jun., who appears to have been born in February 1823 (Oxford, Bodleian Library, MS. Finch c. 2 d. 5, fo. 321).

Hall with such *Eclat*. I hoped to have congratulated you and Mr W in person—however let me say I trust it will be the harbinger to his success happiness and renown.

I expected to have intercepted you at the Ex[1] but another mishap occurred in the morning to see in the Gazette Messrs Finden's Bankruptcy.[2] *Woe is me*—one failure after another is quite enough to make me sick of the whole concern.

Glad to hear your sister arrived safe in Belge[3]

Pray tell Dr Roupill whenever it suits his convenience and the ladies

<div align="right">

Yours truly
J. M. W. Turner

</div>

250. Turner to William Miller

MS. Alan Cole Esq.
Publ. Thornbury 1877, p. 172

<div align="right">

47 Queen Ann St West
June 24 1842

</div>

Dear Sir

I have now nearly done all I have to do before I quit for *My Trip*, so make all *haste* possible to get your plate finished *first* and foremost.[4]

<div align="center">you can</div>

Let me know as soon as possible and ask your *Printer* what he will Print. 500 Grand Eagle—Eagle—or Columbia—India and Plain *for* <u>(paper included)</u>. Not every proof to be *N⁰ and marked* by

<div align="center">printing or</div>

him when taken off and all failures in so doing—to be rendered unsaleable—by

marking & *given up—but not charged*—what time the 500 will take printing and all sent to me or in London—and if the number is increased, what reduction per *100* and if ready money—what discount?

[1] The Royal Academy Summer Exhibition.

[2] Finden had still to publish the large engraving of *Nemi* (R. 659), in hand since 1840 and issued with the dateline of June 1842. It was the second plate in *Finden's Royal Gallery of British Art* (the first, *Oberwesel* (R. 660) had appeared in April) and no more were published.

[3] Emma Wells. See Letter 252.

[4] Miller's plate of *Modern Italy* (R. 658).

Your answer as soon as possible—viz. at your earliest convenience will oblige

<div align="right">Yours truly
J. M. W. Turner</div>

W. Miller Esq^r
Hope Park
Edinbro.

251. Turner to William Miller

MS. Cambridge, Fitzwilliam Museum Library
Publ. Thornbury 1877, pp. 172–3

<div align="right">Saturday, July 9, 1842
47 Queen Anne St West</div>

My Dear Sir

I beg to thank you for the terms of the Printer,[1] and will thank you for your kindness in offering to look after the Printing during progress[2]—but your plate is Mr Moon's, and I was asked for a plate of my own *only*. May I now trouble you further by asking him, the Printer, if he allows *discount* for ready Money and how many printing presses he has ... and if *two* or more plates were worked at the same time—what deductions he could make in proportions.

<div align="right">Yours most truly
J. M. W. Turner</div>

P.S. Your box[3] has not arrived—but have the goodness to get me an answer about the Printing at your earliest convenience. Your proof shall be touched immediately it arrives in Q. Anne St. Excuse haste & Margin[4] and all to be in time for the Post to night.

[*Addr.*] W. Miller Esq^r
4 Hope Park,
Edinburgh.

252. Turner to Emma Wells

MS. British Library Add. MS. 50119, fo. 47
Publ. (Extract) Finberg 1939, p. 391

<div align="right">[Postmark Liège 1 Aug 1842]</div>

Dear Emma

Finding the letter which Mr T. Wheeler in destination $3\frac{1}{2}$ Leagues

[1] R. Lloyd (see Letter 253). [2] Miller's engraving of *Modern Italy*.
[3] Presumably the case with Turner's picture (see Letter 223).
[4] Where the postscript ended.

from Liege and with friends wishing to get onward to the Rhine with all possible speed, I have put it in to the post, which I promised so to do (had it been within distance I would have had the pleasure of being Poste—moi meme). And now drop this notice into the Box (and I shall be happy to hear of your receipt of 1 or twain at Lucerne Poste Restante so to feel certain you have Mr Wheeler safe

<div style="text-align:right">Yours truly
J. M. W. Turner</div>

Liege Monday
 Aug 1 1/4 o'Clock

[*Addr.*] Miss Wells
 Captain Chaplins
 Chateau de Cleokear
 Pres de Liege
 Belgique

253. Turner to William Miller

MS. Untraced
Publ. Thornbury 1877, p. 173

<div style="text-align:right">Saturday, November 5, 1842</div>

Dear Sir,

I have received a case left by Mr Lloyd, the printer, directed to Mr Moon. It appears to me, by the direction and handwriting, to be from you.

I therefore, having no message with it, write to you to know what it contains,[1] and what you wish or want me to do.

<div style="text-align:right">Yours most truly,
J. M. W. Turner</div>

254. Turner to Samuel Rogers

MS. Tate Gallery

<div style="text-align:right">47 Queen Ann St West
Friday Night
[? 25 November 1842][2]</div>

Dear Sir

I will with great pleasure be with you on Sunday next.

<div style="text-align:right">Yours truly,
J. M. W. Turner</div>

S. Rogers Esq^{re}
St James's Place

[1] Probably some proofs of *Modern Italy*. [2] See Letter 255.

255. Turner to Dawson Turner

M.S. Cambridge, Trinity College, Dawson Turner Letters

Atheneum—Pall Mall
[*Endorsed* 29 November 1842]

My dear Sir

Many thanks for your kind present of Yarmouth manufactory—truly and so good mild and relishing—and to have the pleasure of acknowledging your gift at the appearance of the like manufactory of Yarmouth at Mr Roger's table today—Sunday 27 N 1842

You ask me what 'are you doing' 'answer endeavouring to please myself in my own way if I can for after all my determination to be quiet some fresh follerey comes across me and I begin what most probably never to be finish'd' alas too true—but belive me most truly yours

J. M. W. Turner

256. Turner to William Miller

MS. Cambridge, Fitzwilliam Museum Library
Publ. Thornbury 1877, p. 173

47 Queen Ann Street West
Saturday December 10 1842

Mr Miller, I beg to know when (as to time) and how you received the last touched proof[1] which I touched upon more especially to meet your wishes expressed in your last letter. The Box was delivered to the porter who left and called twice for it, you will write if you afterwards sent the amended proofs and touched proof back to me—and how, for none having reached me—and Mr Lloyd is now printing the plate.

Therefore I declare that not having seen your amended proof or my touched proof since that, I consider the Plate of Modern Italy unfinished.[2]

Yours truly
J. M. W. Turner

[*Addr.*] Mr W. Miller
Hope Park
Edinburgh.

[1] Of *Modern Italy*.
[2] The first published date of impressions from this plate (or from an electrotype of it) is 2 Jan. 1843 (R. 658).

257. Turner to H. W. Pickersgill

MS. Boston Public Library, I, 3.56

[? 1842]
Thursday

Dear Pickersgill
 Your servant did not wait or ask for an answer, so I was told.
But I will attend your month at the Royal Academy[1]
 Yours truly,
 J. M. W. Turner

258. Turner to Elhanan Bicknell

MS. Paris, Institut Néerlandais, I.7586

[Athenaeum Stamp]

J. M. W. Turner presents his respects to Mr and Mrs Bicknell and
will with very great pleasure wait upon them Feb 25 Tuesday (at
Herne Hill) 6 o Clock.

 47 Queen Ann St
 Wednesday Feby 12 1843

259. Turner to Richard Westmacott

MS. Untraced (Abstract in British Museum Print Room, MS. of Finberg's
Life of Turner, ii. 510)

March 1843[2]

[Westmacott had advised Mr. Trelawny rightly in sending Mr.
Leader's pictures to Christie's,[3] though Turner was sorry Mr. Leader
feels disposed to part with them.]

[1] Turner and Pickersgill were both Visitors to the Royal Academy Painting School
in 1842.

[2] Finberg dates this letter March 1846, but it clearly refers to the sale at Christie's
on 18 Mar. 1843.

[3] The sale was of paintings by Morland, Smirke, Neefs, Zorg, Loutherbourg,
Wilson, Wouwermans, Reinagle, Van der Neer, G. Poussin, Zuccarelli, and water-
colours by Hamilton, Wheatley, Havell, Westall, Hills, Girtin (eight), as well as seven
by Turner. J. Temple Leader of Putney Hill was a son of William Leader, an early
patron of Turner's, who owned at least two oils (cf. *Liber Studiorum* No. 20 and T.B.
XXXVIII, p. 50a; LXXXIV, p. 67a, B.–J. Nos. 141, 205), and was a subscriber to

260. Turner to Edwin Bullock

MS. Tate Gallery

[*Endorsed* May 11 1843]

J. M. W. Turner presents his respects to Mr Bullock and being obliged to dine at 21 Coburg place Vauxhall Road Kennington new Cross—Mr Harpur's,[1] but any messenger sent there in the course of the Evening—Mr T. will do himself the honor of waiting upon Mr Bullock immediately.

Craven Hotel[2] 11 of May
5 o Clock

261. Turner to an Unknown Correspondent

MS. Mrs. G. A. Palmer

November 23 rd 1843
Queen Ann St Cavendish Sq.

Sir

On my return from my summer trip to the Tyrol and parts of Northern Italy[3] I found your letter of October 18th and I beg to apologise for the long delay in answering it.

I have no small picture in hand and indeed I have no wish to

The Shipwreck (T.B. LXXXVII, pp. 2, 24). The watercolours by Turner at this sale presumably came from his collection, since all of them seem to be early. They were:

 35. *Vessels on shore near Caernarvon Castle—small.*
 43. *Hereford Cathedral from the River.*
 49. *Warkworth Castle, with vessels—sunset* [? Buckley Coll. 1901; Armstrong, p. 283].
 50. *Conway Castle, with vessels and boats; beautiful effect of evening sun.*
 53. *An extensive view in Wales, with a bridge, and cows watering in front—fine effect of evening sun.*
 57. *Conway Castle, from the bridge, coloured with grand and fine effect—capital* [? Roberts or Ashton Coll., Armstrong, p. 248].
 59. *View of London from Wandsworth, with cows in the foreground, a grand drawing* [? Lady Brocklebank and R.A. 1801 as *London: Autumnal Morning*].

'Mr Trelawny' is probably Edward John Trelawny (1792–1881), the associate of the Byron–Shelley circle, who was also close to J. Temple Leader in the 1830s (see W. St. Clair, *Trelawny: The Incurable Romancer* (1977)).

 [1] Probably Henry Harpur, a relative of Turner's and his solicitor.

 [2] Probably the Craven Hotel, Craven St., The Strand.

 [3] Sketchbooks Nos. T.B. CCCIX, CCCXII, CCCXIII, CCCXX may have been used on this trip.

paint any smaller than Mr Bullocks[1] and those all of Venice 200 gns
if painted by commission—250 gns afterwards.

This is the offer made to Mr B who thought of a companion
picture to his bought last year out of the exhibition[2] —but I will paint
a picture double the size 3 feet by 4 feet—Pastoral landscape or
Marine subjects (Venice size being best 2 feet 3 feet) for the same
terms.

> Your most truly obed
> J. M. W. Turner

262. Turner to William Buckland

MS. The Editor

> 47 Queen Ann S[t] West
> Nov[r] 30 1843

My dear D[r] Buckland

I beg to thank you for the perusal of the Book[3] which I now return
at the G S—your kindness and intention of finding me a Subject I
truly appreciate but alas ... the Thetis is at the bottom of the Sea
and the Spanish[4] is not to be seen—the fishing by torch Light is fine
and well told[5] but some pictorial misfortunes hold good and the cords

[1] *Dogana, and Madonna della Salute* (R.A. 1843, B.–J. No. 403). See also a note from
Turner to Edward Carey in 1837 'that he cannot undertake a picture of less size than
three feet by four and that his price will be 200 guineas for that size' (C. R. Leslie,
Autobiographical Recollections (1860), ii. 237).

[2] Nothing is known of a companion to Bullock's picture, which was, of course,
purchased not 'last year' but not earlier than the spring of 1843.

[3] T. Dickinson, *A Narrative of the Operations for the Recovery of the Public Stores and
Treasure sunk in H.M.S. Thetis at Cape Rio, on the Coast of Brazil on the 5th December
1830* (1836). Buckland was a subscriber to this book.

[4] Turner was probably thinking of the treasure (which was not Spanish), but he
may have been referring to the Indian divers provided by the Spaniard Guasque
(p. 37).

[5] To depict the scene now presented, is a task beyond my powers of description.
Thetis Cove on this occasion would have supplied a fine subject for the artist. The
strong glare cast from the torches on every projection of the stupendous cliffs,
rendered the deep shade of their indentations and fissures more conspicuous—their
darkness more visible, and notwithstanding there was a flickering brightness thrown
upon some parts, a solemn gloom pervaded the whole, which was much heightened
by contrast with the brilliant whiteness of the foam on the rocks beneath. The rush-
ing of the roaring sea into the deep chasms, produced a succession of reports like
those of cannon, which were multiplied by echoes from the surrounding cliffs; and
the assembled boats, containing groups of persons employed in their various occupa-
tions, kept in constant motion by the influence of the swell, completed a scene
which, when viewed from the heights above, might suggest the idea of looking into
Pandemonium. This experiment succeeded to admiration, and we continued taking
up treasure until two-o'clock in the morning of the 1st of April, when we were glad

from the cliffs-derriks[1] up all chance of grandeur.

So I will think of your admonition (I hope in time)
conflagration
of the Last Day.

Believe me most truly
Your obliged
J. M. W. Turner

Dr Buckland
Oxford

[*Addr.*] Dr Buckland
Geological Society
Somerset House
with a Book from J.M.W.T.

263. Turner to Clara Wells (Wheeler)

MS. British Library Add. MS. 50119, fo. 51
Publ. (Extract) Finberg 1939, p. 398

[On Athenaeum paper]

Dear Clara

I send you a card of the lectures in Anatomy and an Ivory Ticket which will admit Mr James Wheeler's[2] friend to the whole course for the season.

His name to be put in the hollow part—but you let me know when I see you, for I have lost one of my three tickets and mean to try and stop it if presented this year, for the person I lent it has used it two seasons without asking me—

Yours truly
J. M. W. Turner

[*Addr.*] Mrs Cᵃ Wheeler
60 Grace Church Street,
City

to retire; having obtained in the whole by this attempt 6326 dollars, 36 pounds 10 ounces of Plata pina, 5 pounds 4 ounces of old silver, 243 pounds 8 ounces of silver in bars, and 4 pounds 8 ounces of gold' (pp. 61 f.)

[1] See pls. III and IV. [2] Clara's brother-in-law.

264. Turner to Thomas Griffith

MS. British Library Add. MS. 50119, fo. 49
Publ. Finberg 1939, p. 397

47 Queen Ann St Feb 1 1844

My Dear Sir

The Picture[1] was Exhibitd at the British Insitution about 8 years ago—30 years between the two makes Lord Egerton Pict[2] the first about 1806—Lord Gower bought it and thereby launched my Boat at once with the Vandevelde[3]—I should wish much the Duke of Sutherland to see it—but in regard to the price that is the greatest difficulty with me the price was not sent with it to the Institution— so I escape condemnation on that head—and any who likes may offer what they please.

This is not answering your views I know—and may be troublesome —but the Picture has to work up against the reputation of Lord E Pictures, and I wish they could be seen together or belong to the same family[4]—

The 3 feet 4s are fixed by your kindness—and now at work. The large Pictures I am rather fond of tho it is a pity they are subject to neglect and Dirt—the Palestrina I shall open my mouth widely ere I part with it[5]—the Pay de Calais[6]—is now in the Gallery (suffering) —the Orange Merchant[7] I could not get at[8]—if I could find a young man acquainted with Picture cleaning and would help *me* to clean

[1] *Fishing Boats, with Hucksters bargaining for Fish* (B.-J. No. 372) had been shown at the British Institution in 1838.

[2] *Dutch Boats in a Gale* (R.A. 1801, B.-J. No. 14), in the collection of Lord Francis Egerton in 1844.

[3] Turner is confusing Lord Gower, who transmitted the commission, with the Duke of Bridgewater, who gave it to Turner, for a companion-piece to *A Rising Gale* by Willem van de Velde the Younger. Lord Francis Egerton had exhibited both pictures at the Old Master exhibition of the British Institution in 1837 (cf. Finberg 1961, pp. 69–70).

[4] The Duke of Sutherland, who had apparently asked to see *Fishing Boats*, was the elder brother of Lord Francis Egerton.

[5] *Palestrina* (B.-J. No. 295) had been painted for Lord Egremont (see Letter 140), but for some reason had remained with Turner after its exhibition at the Academy in 1830. Elhanan Bicknell (q.v.) seems to have acquired it with a number of other pictures in 1844 (see notes 12, 14).

[6] '*Now for the painter*' (*rope*) *Passengers going on board* (B.-J. No. 236), shown at the Academy in 1827.

[7] *Entrance of the Meuse: Orange-merchant on the Bar, going to pieces; Brill Church bearing S.E. by S. Masensluys E. by S.* (R.A. 1819, B.-J. No. 139).

[8] From this point in the letter the ink changes, and it was probably continued on the date given at the end. The postmark is 2 Feb.

accidental stains away, would be a happiness to drag them from their dark abode[1]—to get any lined is made almost an obligation confer'd—and subject to all remarks. The stormy Picture[2] you said in the Parlour for Mr Foords *Hero*[3] to advise with about both cleaning and lining but cannot find out who was employ'd for the Ivy Bridge[4] so well done.

Pray tell Mr Tomkinson[5] you have another batch of (3 feet by 4) —and Pray tell me if the new Port Rysdael[6] shall be with fish only and if the new *marine* Pictures are to have Dutch Boats only?[7]

<div align="right">

Yours most truly

J. M. W. Turner

Feb 2nd
</div>

T. Griffiths Esq[re]
Norwood

NB ?Have you seen the advertizement in the Times Paper.[8] I have not—if you have just say how it look'd.

[1] In 1848 Turner employed Francis Sherrell as an assistant (Gage 1969, p. 171).

[2] Probably *Hero and Leander* (R.A. 1837, B.–J. No. 370).

[3] Presumably a punning reference to an employee of Foord of Wardour St., Ruskin's framemaker, who was attending to Ruskin's Turners in 1844 (J. Ruskin, *Works*, xxxvi. 39).

[4] R.A. 1812 (B.–J. No. 122). The picture was acquired by Bicknell (q.v.) together with others, including *Ehrenbreitstein* (B.–J. No. 361), about the time of this letter.

[5] Probably Thomas Tomkisson, or Tomkinson, a pianoforte maker and connoisseur, a collector of Wilson (W. Jerdan, *An Autobiography* (1853), iii. 320) and of Turner watercolours at least since 1822. Tomkisson seems to have been born in 1764 and died in 1853 (*Athenaeum*, 1861, p. 691). He was a well-known eccentric (Jerdan, loc. cit.; J. R. Planché, *Recollections and Reflections* (1872), ii. 126–8), who has sometimes been confused with his father, a silversmith and jeweller, one of the first to recognize the promise of Turner as a boy (*Notes and Queries*, 2nd ser. v. 475; 5th ser. viii. 65, 114).

[6] *Fishing Boats bringing a Disabled Ship into Port Ruysdael* (R.A. 1844, B.–J. No. 408), as opposed to *Port Ruysdael* (R.A. 1827, B.–J. No. 237), which was sold to Bicknell (q.v.) in 1844.

[7] Turner showed two other Marines at the Academy in 1844: *Ostend* (B.–J. No. 407) and *Van Tromp, going about to please his masters, ships a sea, getting a good wetting* (B.–J. No. 410).

[8] The advertisement does not seem to have appeared in *The Times* until 10 Feb.: 'J. M. W. TURNER, R.A., begs to acquaint the subscribers to his PLATES of Caligulas Bridge, Dido and Aeneas, Juliet after the Masquerade, Crossing the Brook, and Mercury and Hersé, that they will be READY for DELIVERY at the end of April. Any further information may be obtained by application to T. Griffith, Esq., Norwood.'

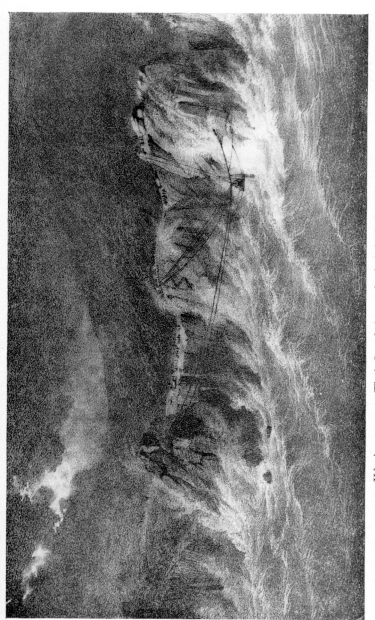

IV. Anonymous, *Thetis Cove during a gale of wind*. 1836. Lithograph.

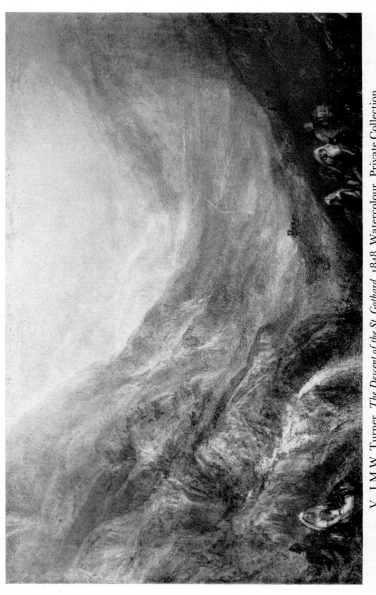

V . J.M.W. Turner, *The Descent of the St. Gothard.* 1848. Watercolour. Private Collection.

265. Turner to Clara Wells (Wheeler)

MS. British Library Add. MS. 50119, fo. 53
Publ. Finberg 1939, p. 398

[*Postmark* Pall Mall, Feb 13 1844.]

Dear Clara

I intended to have called in G Church St yesterday but the Enemy beat me. Time always hangs hard upon me, but his auxiliary, Dark weather, has put me quite into the background, altho before Xmas I conceived myself in advance of Mr Time.

In regard to Mr Gales I will endeavour to keep it in my mind, yet I will thank you for a remembrance per Post, and pray accept my concern for the delay of your seeing such kind friends through my engagements at the R.A., which I really do dread. However I have got a Macintosh and with some fur round the shoulders I hope to fare better betwixt the heat and the cold. If not I will give in for everyone feels the variety of the temperature of the Life Academy to be very bad.[1]

With best regards to all inquiring friends

Believe me Your obliged
J. M. W. Turner

Monday night
I have been to the R.A. study. It is equal cold and hot like Death.

[*Addr.*] Mrs Wheeler
60 Gracechurch Street.

266. Turner to H. Elliott

MS. Untraced (? Sotheby, 25 July 1891 (108))
Publ. Sotheby Catalogue, 5 Mar. 1879 (175)

May 1st 1844

[Short note to [Mr. Elliott] at Fitzroy Square ... *with drawing of Cupids*, endorsed 'Drawn by Mr Turner for Miss Elliott, at Mr Wells'. (bt. Waller)[2]]

[1] Turner had not been Visitor to the Life School since 1838, so he may himself have been studying on this occasion.

[2] Lot 174 at this sale was 'Two Autograph Notes [by Turner] to Mr Elliott to meet some old friends at his house in Devonshire Street'.

267. Turner to Dawson Turner

MS. Royal Academy, Jupp Catalogues, v (1787–92), 24

June 1 1844

Dear Sir

Enclosed you find 2 cards ... one for Mr Vernon[1] and one for Mr Munro[2] thinking that when you are in Park Street to see the Wilsons at Lady Jones' [?][3] you might like to look at a collection of a friend of mine at 113 in the same Street.[4]

Yours truly ...
J. M. W. Turner

Dawson Turner Esq ...

268. Turner to Dawson Turner

MS. Cambridge, Trinity College, Dawson Turner Letters

47 Queen Ann St West
Friday June 4 1844

My dear Sir

Allow me to return you my most sincere thanks for your kind letter and present of yours. The Book in which you have been pleased to write of my endeavours in the Art and so flatteringly of posthumous hopes[5] that I scarcely know how to attempt or express my individual thanks for myself and for my brethern [?] in the Vineyard of the Fine Arts, of our own soil, our own ground, our Father-land—for the true zeal you have evinced in our behalf in combating Waagen's

[1] Robert Vernon (q.v.).

[2] H. A. J. Munro of Novar (q.v.).

[3] No Lady Jones is recorded at Park Street, Grosvenor Square, in 1844. Turner probably intends Lady Ford, the mother of Richard Ford (q.v.), who lived there, and who had inherited a large and important collection of Wilsons from her ancestor, Benjamin Booth.

[4] Munro, who had collected some nineteen Wilsons.

[5] Dawson Turner, *Outlines in Lithography* (1840), p. 25: 'The beauties of Turner are peculiarly his own; and his transcendant excellencies are neither discernable at first sight nor to an unpractised eye: they are "caviar to the multitude"; but they will not fail to be acknowledged; though, possibly, not till after the hand that gave them birth shall be cold. Sure I am; and although I speak strongly, I do not speak hesitatingly, that the time will come, when not only the high character of this artist will be admitted, but when his pictures will be allowed a pre-eminence over those of Claude, and Gaspar, and a pre-eminence no less decided than is already conceded to the *Liber Studiorum* over the *Liber Veritatis*.'

opinions respecting us and our Works[1] and your record of it merits our warmest acknowledgements and thanks.

May I add that we are much indebted to M.A.T.[2] for the style of each master in the able Etchings and that I may be permitted to offer my best respects and be pleased to accept the same yourself. will much oblige

<div style="text-align:right">

My dear Sir
yours most truly
J. M. W. Turner
</div>

D Turner Esq[r]
G[t] Yarmouth

269. Turner to Mrs Carrick Moore

MS. Untraced
Publ. Thornbury 1862, ii. 231 f.

[? late July 1844]

Mr Avalanche Jenkinson presents his thanks to Mrs Moore for the kind invitation to Wonhams,[3] which by some mischance he did not find till this morning, because ''twas not in sight', and he feels his mishap the greater because the chance becomes the lesser, for the Exhibition closes to-day, the anniversary dinner on Monday, and the Spanish Fleet (*alias* pictures) will be removed from their present moorings to be scattered W $\overset{N}{+}$ E like the Armada.

$$\overset{S}{}$$

Therefore Mr Jenkinson fears he may be driven before the wind with his passport before the end of next week, but he begs to offer his sincere thanks, though with slender hope of being able to have the pleasure of being at Wonhams until his return from Switzerland. Mr Jenkinson, with great respect, becoming to all enquiring friends,

<div style="text-align:right">

Most sincerely,
J. M. W. Turner
</div>

[1] Dawson Turner continues this passage (p. 26) by attacking G. Waagen, *Works of Art and Artists in England* (1838), i, where, on p. 232, Waagen had complained of the 'flimsiness and negligence' of English painting since Reynolds.

[2] One of Dawson Turner's daughters, who had lithographed Crome's *Scene on the River at Norwich*, whose caption included these remarks on the English School.

[3] Probably Wonham House, Buckland, Surrey.

270. Turner to William Wethered

MS. Mr and Mrs Cyril Fry

47 Queen Anne St West
Oct 7 1844

My Dear Sir
 On my return from Switzerland I found your note containing a
commission to paint for you another approach to Venice.[1] I beg to
thank you for allowing me to make some change—tho I suppose you
wish me to keep somewhat to the like effect. In regard to sending me
any part of the 200 Gs on account, 'Pray do as you please'.—the
Pictures to be ready for the next Exhibition if possible

Believe me most truly
your obliged St
J. M. W. Turner

To W. Wethered Esq^re Jn^r
Kings Lynne—Norfolk

271. Turner to James Astbury Hammersley

MS. Untraced
Publ. Thornbury 1862, ii. 118

[? October 1844]

Dear Sir,—Mr L. Ritchie[2] intimates to me that you desire to see my
pictures. The weather is fine, and if you will call here either on
Thursday or Friday this week, not earlier than eleven o'clock, I shall
be glad to see you.

Your obedient Servant,
J. M. W. Turner

[1] *Approach to Venice* (R.A. 1844, B.–J. No. 412). The picture Turner probably had in
mind is *Venice, evening, going to the ball* (R.A. 1845, B.–J. No. 416).
[2] Leitch Ritchie, the author of the letterpress to *Turner's Annual Tours* from 1833.
For his slight acquaintance with Turner, see his letter to Alaric Watts of December
1852 (A. A. Watts, *Alaric Watts* (1884), ii. 312–13).

272. Turner to Dawson Turner

MS. British Library Add. MS. 28860, fo. 15

Tuesday Nov. 26 1844

My Dear Sir

I beg to offer you my best thanks for your kind present of a Barrel of Fine Yarmouth Bloaters which I found upon my return home and which you so kindly sent me in the course of the last week.

I have great pleasure to tell you that Mr Phillips is recovering from his severe attack of something like Bilious Jaundice.

Sorry to see by the paper of this morning that Callcott is no more /alas/ and that a great Robbery has been committed upon friend

S. Rogers and C⁰s Bank, 40,710 in Bank notes—

Yours most truly
J. M. W. Turner

273. Turner to Francis McCracken

MS. Paris, Institut Néerlandais, I.7712
Publ. (Extract) Finberg 1939, p. 405

47 Queen Anne St West
Cavendish Square
Novʳ 29 1844

My Dear Sir,

Many thanks to you for your kind accordance with my notions of Copy right &c &c. but I must reqest your conclusion respecting the subjects to be painted, for the more I read your words 'I will wait readily another year' which implies the top of the said Riggi only[1]— if therefore it is to be done this season I think I can do it by the means of the Swiss Panoramic Prints and knowing tolerably well the geography all round the neighbourhood.

If it is to be left for the next season summer trip to Switzerland I must request you give up the Venice commission—but pray bear in mind I do not wish to drag you into two commissions—altho I have commenced one of Venice[2] and one the lake of Lucerne sun-rise[3]—

[1] No subject of this description has been traced, but it is more likely to have been a watercolour than an oil.

[2] This is probably *Morning, returning from the ball, St. Martino* (B.–J. No. 417), shown at the Academy in 1845.

[3] Untraced, but almost certainly a watercolour.

but as I wish to meet your wishes soley pray tell me conclusively
how I am to direct my steps towards it this year.

<div align="right">

Yours most truly
J. M. W. Turner

</div>

P.S. I am very happy in your predilection for the Fine Arts &c &c
&c.

274. Turner to William Wethered

MS. National Museum of Wales (Pyke Thompson Bequest)

<div align="right">

47 Queen Dec 3 1844
Anne St

</div>

My Dear Sir
 I think I succeeded yesterday with Mr Mulready—but not quite
sure—he has he said some [much *substituted*] illness at home and felt
unable to talk about particulars of time or subject 'tho there appear'd
an acquiescence. When any more occours I will let you know

<div align="right">

Yours truly
J. M. W. Turner

</div>

W. Wethered Esq^re
Mr L[1] was not at the meeting

275. Turner to F. H. Fawkes

MS. Untraced
Publ. Armstrong, pp. 174–5

<div align="right">

47 Queen Anne Street
Dec. 28, 1844

</div>

Dear Hawkesworth,
 First let me say I am very glad Mrs Fawkes has recovered in
health so as to make Torquay air no longer absolute, and that the
Isle of Wight will, I do trust, completely establish her health and
yours (confound the gout which you work under), tho' thanks to your
perseverence in penning what you did and likewise for the praises of
a gossipping letter, thanks to Charlotte Fawkes who said you thought
of Shanklin, but you left me to conjecture solely by the post mark
Shanklin—Ryde—so now I scribble this to the first place in the hope

[1] Probably Edwin Landseer (see Letters 200, 299).

of *thanking* your kindness in the remembrance of me by the Yorkshire Pie equal good to the olden time of Hannah's[1] culinary exploits.

Now for myself, the rigours of winter begin to tell upon me, rough and cold and more acted upon by changes of weather than when we used to trot about at Farnley, but it must be borne with all the thanks due for such a lengthened period.

I went however to Lucerne and Switzerland, little thinking or supposing such a cauldron of squabbling, political or religious, I was walking over. The rains came on early so I could not cross the Alps, twice I tried, was set back with a wet jacket and worn-out boots and after getting them heel-tapped I marched up some of the small valleys of the Rhine and found them more interesting than I expected.[2]

Now do you keep your promise and so recollect that London is not such much out of nearest route to Farnley now *** Shanklin and [I] do feel confoundedly mortified in not knowing your location when I was once so near you, for I saw Louis Philippe land at Portsmouth.[3]

> Believe me, Dear Hawkesworth,
> Yours most sincerely,
> J. M. W. Turner

F. H. Hawkes Esq.

P.S.—Best respects to Mrs Fawkes and all at Farnley and compliments of the season happy new year.

276. Turner to William Wethered

MS. Harvard University, Houghton Library, Lowell Autographs

> 47 Queen Ann St West
> [? December 1844]

My Dear Sir

Allow me to thank you for very fine Norfolk *Turkey and Chine* [?], quite equal if not superior to the olden renown of the county for sausage rolls and Turkey-pie and much better (my Damsel[4] said) in being ready for the cooking.

[1] Hannah Danby, Turner's housekeeper.
[2] Cf. T.B. CCCXLV–CCCLII.
[3] Louis Philippe landed at Portsmouth on 8 Oct. 1844 for his visit to Queen Victoria.
[4] Hannah Danby.

I will let you know whenever Mr M or L[1] favours me with a note.
Believe me most truly
J. M. W. Turner

P.S. Comp[ts] of the Season happy new year

J.W.

[*Addr.*] W. Wethered Esq.
Lynn. Norfolk

277. Turner to Harriet Moore

MS. Anthony Heath Esq.
Publ. Thornbury 1862, ii. 231

Tuesday night
[? 1844]

Dear Miss Moore
Jones must have pulled a feather from the Wing of Time, so with
your permission and Mr and Mrs Moore &c—I will try to borrow it
on Saturday—but if I should be beyond ¼ past 6—Pray ask him for
the loan (for me) fearing others are like

yours obedly
J. M. W. Turner

278. Turner to Charles Ellis

MS. Untraced (Transcription in A. J. Finberg, *MS. Life of Turner*, ii. 489 f.;
British Museum Print Room)

[22 January 1845]

Dear Sir
I have been a great truant to your Letter respecting a Picture of
Richmond Hill[2]—but really and truly I know not Mr Baxter's mode
you mentioned in your note,[3] nor do I ever part with the Copyright

[1] Probably Mulready and Landseer (see Letters 274, 299).

[2] Ellis had probably approached Turner for a drawing for the frontispiece to his
Richmond, and other Poems (1845). The published version: *View from Richmond Hill,
Morning*, shows a similar composition to Turner's designs for *The Literary Souvenir*,
1826 (T.B.E. No. 257) and *England and Wales*, 1838 (T.B.E. No. 434), but was
engraved by George Baxter after a design by H. Warren.

[3] Baxter's was a method of colour printing in oil colours, much in vogue in the mid-
nineteenth century (see C. T. Courtney Lewis, *The Picture Printer of the Nineteenth
Century: George Baxter, 1804–1867*, 1911).

(for Engraving) without stipulations and considerations of some
moment.

<div align="right">

Yours most truly
J. M. W. Turner

</div>

[*Addr.*] Mr C. Ellis
Richmond,
Surrey

279. Turner to Elhanan Bicknell

MS. Untraced (Formerly Fairfax Murray)
Publ. Armstrong, p. 175

<div align="right">

47 Queen Anne Street,
Jan 31 1845[1]

</div>

My Dear Sir
I will thank you for a call in Queen Anne Street at your earliest
convenience for I have a whale or two on the canvas.[2]

<div align="right">

Yours truly
J. M. W. Turner

</div>

E. Bicknell Esq., Herne Hill.

280. Turner to John James Ruskin

MS. British Library Add. MS. 50119, fo. 59
Publ. J. Ruskin, *Praeterita*, ii (1887), ch. VIII, §163

<div align="right">

[*Athenaeum Stamp*]
47 Queen Ann West
Thursday 27 Feb

</div>

My dear Sir
Have the goodness to offer my *respectful thanks* to Mrs Ruskin for
the kind present of a part of the little fat friend's ribs—Portugal onions
for stuffing them included &c &c. Hoping you are all well.

<div align="right">

Believe me Most truly obliged
J. M. W. Turner

</div>

J. Ruskin Esq[r]
In the Times!! sad news from Switzerland[3]

[1] Armstrong gives the date as June, which has thirty days. Evelyn Joll has convincingly argued that Turner would be unlikely to have been finishing a new batch of pictures only two months after the opening of the Exhibition.

[2] Bicknell was engaged in the sperm-whale fishery. None of the four whaling pictures exhibited by Turner in 1845 and 1846 was acquired by him.

[3] In *The Times* of 26 Feb. 1845 was half a column on 'The Affairs of Switzerland'. '... The *National* publishes a letter from Berne of the 19th inst.

281. Turner to John Murray III

MS. John Murray Esq.

Sunday morning
May 4th 1845

My Dear Sir
I feel the sad necessity of leaving Town to morrow morning and therefore to part with the great pleasure I promised myself of Tuesday grieves me much, be pleased to pardon

yours truly
J. M. W. Turner

J Murray Esq^{re}
Albemarle St

282. Turner to John James Ruskin

MS. British Library Add. MS. 50119, fo. 60

May 15 1845

Dear Sir
I am very glad to hear of your son's arrival in Italy and his good health and safety.

In regard to the Liber Studiorum it will be ready in a week[1] but really I have been so unwell that I was obliged to go away from Town to revival by a little change of fresh air.

I have taken the liberty of giving a card to Mr Fawkes of Farnley, Yorkshire the son of an Early patron and friend to me! and now possessing the whole—Drawings and Pictures made for his Father— it is the Slave-Ship[2] which he so wishes to see during his stay in Town—that induced me so to do and I now request you will have the goodness to look at it (the Picture) when he may happen to call

announcing that the Government of Valais ... had decreed a levy *en masse* of all the able bodied men of the Canton, from 16 to 60 years of age, to repel invasion on the side of Vaud ...' John Ruskin was preparing to visit Switzerland at this time.

[1] Turner was having new impressions of the *Liber* printed by McQueen this year (dated June), although he still had many of the original printing in his own hands (Gage 1969, p. 43).

[2] B.–J. No. 385.

he being rather out of health and only in Town for about a fortnight
could not fix any precise day

<div align="right">

Yours most truly
J. M. W. Turner

</div>

J. J. Ruskin Esq^r

283. Turner to Dawson Turner

MS. Cambridge, Trinity College, Dawson Turner Letters

<div align="right">

47 Queen Ann S^t West
May 16 1845

</div>

My Dear Sir
 I have great pleasure of acknowledging your kind note—indeed
from a friend and name the same and to thank you respecting the
Crossing the Brook Picture[1] (Thank Heaven which in its kindness has
enabled me to wade through the Brook)—it I hope may continue to
be mine—it is one of my children—

<div align="right">

Many thanks for your regard and
Believe me truly
J. M. W. Turner

</div>

Dawson Turner E^r
Yarmouth

284. Turner to Francis McCracken

MS. Mr Kenneth A. Lohf.

<div align="right">

[*Postmark* May 22 1845]

</div>

My dear Sir
 I am sorry to find you are not coming to Town during the
Exhibition—it will close about the middle of July—Pray have the
goodness to point out how you wish it to be sent to you and by what
conveyance, if you wish me to order a Frame or not.
 The Subject is returning from the Ball—the dawn of day when the
Moon withdraws her light and rosy Morn begins—the company
Pause.[2] Going to the Ball—sun setting and the moon rising—over
Venice [is] painted for a gentleman of King's Lyne: the Campo Santo

[1] B.–J. No. 130. See also Letter 73. For the poor condition of the painting about
this date, and for an expression of Turner's indifference about it, Gage 1969, p. 171.
 [2] *Morning, returning from the ball, St. Martino* (R.A. 1845, B.–J. No. 417).

with Boats and masqueraders proceeding towards the City[1]—Yours returning to St Martino, an Island in the Adriatic.

> Your truly obliged
> J. M. W. Turner

Mac Cracken Esq[r]
Belfast

285. Turner to Sarah Rogers

MS. Cambridge, Fitzwilliam Museum, MS. 3–1966, No. 69

> Q.A. Street July 15 [? 1845]

Dear Miss Rogers

I will with very great pleasure be at Hanover Terrace on Saturday next the 19th ½ past 6.

> Yours sincerely
> J. M. W. Turner

286. Turner to William Wethered [?]

MS. British Library Add. MS. 50119, fo. 62

> July 31 1845

Dear Sir

I must beg to say that I do not understand by your last (In regard to the Pictures) and would like to do what you wish but should like to return you the £160 paid ... your answer will oblige—I meant to have 300 Gs for all the Venice Pictures return'd from the Ex.[2]

> Yours truly
> J. M. W. Turner

P.S. the Frame and packing Case ready by tomorrow or Saturday.

I shall not until I hear from you draw the £115 at Prescotts and Co.

I requested your Sheffield Friend Mr P[3] to let his choice of two Venice Pictures to stand over until you had decided.

> Yours most truly
> J.M.W.T.

[1] *Venice, Evening, going to the ball* (R.A. 1845, B.–J. No. 416), apparently painted for W. Wethered (q.v.), but, like its companion, returning to Turner's own collection (see Letter 296).

[2] All the Venetian subjects shown at the Academy in 1845 are now in the Turner Bequest (B.–J. Nos. 416–19).

[3] Not identified.

287. Turner to Richard Ford

MS. Brinsley Ford Esq.

Aug 2 1845

My Dear Sir

With very great pleasure any day next week—most convenient to you and Friends—permit me to say the Room is in a very desorderd state owing to the pictures just returned from the Exhibition being scattered about.

Yours most truly
J. M. W. Turner

R^d Ford Esq 123 Park St

[*Endorsed*] From the mighty *Turner* his autographs are very rare as he was fonder of the pencil than of the pen. my uncle R. S. Booth was his early patron.[1]

Rich^d Ford.

288. Turner to James Lenox

MS. Untraced
Publ. Lenox Library: A Guide to the Paintings and Sculptures (1877), p. 8

[16 August 1845]

We left the Sound of Mull, in the Maid of Morven, to visit Staffa, and reach Iona in due time;[2] but a strong wind and head sea prevented us making Staffa until too late to go on to Iona. After scrambling over the rocks on the lee side of the island, some got into Fingal's Cave,[3] others would not. It is not very pleasant or safe when the wave rolls right in. One hour was given to meet on the rock we landed on. When on board, the Captain declared it doubtful about Iona. Such a rainy and bad-looking night coming on, a vote was proposed to the passengers: 'Iona at all hazards, or back to Tobermoray'. Majority against proceeding. To allay the displeased, the Captain promised to steam thrice round the island in the last trip. The sun getting towards the horizon, burst through the rain-cloud, angry, and

[1] Nothing is known of this relationship.
[2] Turner's visit had been in August 1831 (G. E. Finley, *J.W.C.I.* xxxv (1972), 364).
[3] Turner was one of them: see T.B. CCLXXIII and G. Wilkinson, *Turner's Colour Sketches 1820–1834* (1975), p. 69.

for wind;[1] and so it proved, for we were driven for shelter into Loch Ulver, and did not get back to Tober Moray before midnight.

289. Turner to John James Ruskin

MS. British Library Add. MS. 50119, fo. 63

47 Queen Ann St
Sunday Evng

Dear Sir
 Very glad to hear of your Son's arrival in England again[2] and I hope he is well &c.
 Truly unfortunate in my being out of Town when your kind invitation to meet him and Mr Boxall[3] in Denmark Hill *arrived*.

Yours most truly
J. M. W. Turner

Best respects to Mrs Ruskin & Mr John

290. Turner to Dawson Turner [?]

MS. Untraced (formerly P. O'Callaghan or G. Manners)
Publ. (Facsimile) L. B. Phillips, *The Autographic Album* (1866), p. 217

Many thanks for a fine Barrel of Herring from Yarmouth and hope you and family are all well

Yours most truly
J. M. W. Turner

Dec. 4
45[4]

 [1] This was the moment chosen by Turner for *Staffa, Fingal's Cave* (B.–J. No. 347) which Lenox had bought.
 [2] John Ruskin returned from his visit to France and Italy on 4 Nov. 1845 (*Works* iv, p. xxxix).
 [3] Sir William Boxall (1800–79), chiefly a portrait painter. He and Ruskin probably met in Venice in September 1845 (M. J. H. Liversidge, 'John Ruskin and William Boxall. Unpublished Correspondence', *Apollo*, 85 (1967), 39 ff,). Turner and Boxall did meet at the Ruskins' on 19 Mar. 1846 (J. J. Ruskin, *Diary*, Bembridge, Ruskin MS. 33).
 [4] Falk, p. 207, notes a similar gift of Yarmouth Bloaters from Dawson Turner on 26 Nov. 1847. Cf. Letters 215, 255, 272.

291. Turner to J. Hogarth [?]

MS. (Draft) Untraced
Publ. Finberg 1939, p. 417

[? 1845]

Dear Sir I have received your note via Margate and am so ill that
[? I am not] disposed to write

I differ most materially with you—and no considerations of money
or favour can induce me to lend my Darling[1] again

Untill I have my 50 Proof India before the Letters, we are two—

292. Turner to Mrs Carrick Moore

MS. Untraced (Maggs Bros., 1931 (303))
Publ. Thornbury 1862, ii. 229

[1845 or 1846]

Dear Madam

It is very, very unlucky for me that although dear Miss Rogers
had induced me to hope for your kind invitation, it should be
thwarted in any manner, and particularly by me, against my own
inclination; but I have received a summons to attend the Council of
the Royal Academy at $\frac{1}{2}$ past 8 on Saturday Evng, to consider upon
a case which friend Jones will tell you more about if you feel inclined
to know why I am constrained to defer (I hope only in the present
case) your kind and friendly feelings towards me.

<div style="text-align:center">

I have the honour to be, dear Madam,
Yours most truly obliged,
J. M. W. Turner

</div>

[*Addr.*] To Mrs Carrick Moore,
1 Saville Row.

[1] Finberg suggests that this is a reference to *The Fighting Temeraire* (1839, B.–J.
No. 377), which had been exhibited by Hogarth in Great Portland St. in 1844, while it
was being engraved by Willmore (q.v.). The plate was published by Hogarth in 1845,
and he may well have wished to promote the print by a further exhibition. See also
Letters 224, 225.

293. Turner to John James Ruskin

MS. British Library Add. MS. 50119, fo. 64

Monday Jan^y 5 1846

Dear Sir

Many thanks for your promptness for the fishing card [?] and sending us all home.[1]

I have not been yet able to see Mr Harpur[2] but trust to do so soon. Hopeing you and Mrs Ruskin and Mr John Ruskin are well.

Believe me truly
J. M. W. Turner

J. J. Ruskin Esq^re

294. Turner to Adela Geddes

MS. Untraced (Sotheby, 21 February 1972 (607), bt. Maggs; Transcription, British Museum Print Room, A. J. Finberg, MS. *Life of Turner*, ii. 509).

[18 March 1846]

Dear Mrs Geddes—I shall be happy for Lord Napier[3] to see the Gallery after the 10^th of April, any day he likes, but at present I am hard at work for the Exhibition. The Pictures go in on the 7^th of April and it will take two or three days for my traps to be clear'd away out of the *Room*. Many thanks for the invitation to the *Meade* of England's *Early Liberty*.

[*Addr.*] Mrs Geddes
Runnymeade
Old Windsor.

[1] Presumably from the New Year celebrations, which Turner attended.

[2] Turner's solicitor Henry Harpur, who was also a guest at John Ruskin's birthday dinner in February this year.

[3] Presumably Francis Napier, Lord Napier of Merchistoun (1819–98), who may be related to the Napier of Letter 141. He was made Secretary to the British Legation at Naples in 1846.

295. Turner to Lord Robertson

MS. Liverpool Public Library, Hornby Library

March 24th [? 1846]
47 Queen Ann St
Cavendish Square

Mr Turner begs to return his thanks to Lord Robertson for the Poetic Lines which his Lordship kindly sent this day and written to illustrate the Picture of Mercury and Argus.[1]

Mr T hopes his Lordship will honour him with a call in Queen Ann St.

296. Turner to Francis McCracken

MS. Untraced
Publ. Extract in unidentified sale-catalogue, British Museum Print Room, *Whitley Papers*, xii. 1545

[14 June 1846]

I wrote asking if you wished me to get a frame ready by the End of the Exhibition, like last year,[2] but it appears unseasonable at the present time ...

297. Turner to William Wethered

MS. Mr. Kurt Pantzer

June 14 1846

My Dear Sir
The inclosed returnd from Ireland proves that the [my *substituted*] sad error [was] occasiond by the two Letters being popped into wrong envelopes—the subject of your Picture being (St Martino) returning

[1] *Mercury and Argus* (B.–J. No. 367) was first exhibited at the Academy in 1836, then at the British Institution in 1840 and finally at the Royal Scottish Academy in 1846. It is likely that this last occasion is when Robertson saw it, since Turner addresses him in his post-1843 style. Robertson's poetic illustration does not appear among his published poems.

[2] See Letter 284. For a discussion of the problems presented by this and the following letter, see B.–J. Nos. 421–2.

from the Ball—and not (St Martha) going to the Ball which is for Mr F. Macraken of Belfast.[1]

Have the goodness to send me back the letter intended for him which asks if I am to get a frame ready by the end of the Exhibition[2] like to the one of last year.

<div align="right">J.M.W.T.</div>

298. Turner to William Wethered

MS. Untraced (Sotheby, 2 June 1932 (489), bt. Hudson)

<div align="right">[29 August 1846]
Queen Ann Street</div>

[He had sent off a picture to Kings Lynn by the Eastern Counties Railway. He has done up the frame and it now looks very well etc.]

299. Turner to William Wethered

MS. Wisbech and Fenland Museum, Townshend Collection IV, 66

<div align="right">Queen Ann St
Oct. 23 1846</div>

My dear Sir—

On my return yesterday Evening I found your Letter wishing me to Paint you a Landscape—(English scenery) size 3 feet by 4 feet—

The Subject must be fixed (for I have faild twice in my choice in the Venice commission[3] therefore I tremble about it and the price will be five Hundred Guineas—in regard to Landseer and Muready the copyright of Peace and War[4] a Thousand Guineas each withou

[1] Joll points out (B.–J. Nos. 421–2) that Turner has also confused the titles, which in 1846 were: *Going to the Ball (San Martino)* and *Returning from the Ball (St. Martha)*. This letter suggests that Turner intended the 1846 pictures to be companions to the 1845 pair (see Letter 284): Wethered was to have a *St. Martha* pair and McCracken a *San Martino* pair, each pair consisting of a *Going* and a *Returning*.

[2] See Letter 296. The references to making a *new* frame like that of the previous year suggests that Wethered and McCracken were still holding the earlier pictures.

[3] i.e. *Venice, going to the Ball*, 1845 (B.–J. No. 416), which Wethered must have sent back to Turner by now, and *Returning from the Ball* (B.–J. No. 422), which must also have been returned, and sold to Windus (q.v.). See Letter 297.

[4] Edwin Landseer's *Time of Peace* and *Time of War* were Nos. 53 and 83 in the 1846 Royal Academy Exhibition. They were at one time in the Tate Gallery.

the Pictures and the Choice of the Wedding Gown[1] having placed
him, M^r M, *so* that I have no hope of them now for you

I am yours
most truly
J. M. W. Turner

W. Wethered Esq^r
Kings Lynne
Norfolk

300. Turner to John Prescott Knight

MS. Pierpont Morgan Library

[? October 1846]

Dear Knight
Have the goodness to do all in your power for Eliza Jones[2] and
Miss O'Grady.

J.M.W.T.

301. Turner to John Ruskin

MS. British Library Add. MS. 50119, fos. 66–7
Publ. Finberg 1939, pp. 415–16

[*Athenaeum Stamp*]
Decr. 3 1846
Queen Ann St West

My dear Sir
Sorry to say I have engaged myself for the 1st of January. Have
the goodness to give my respects to Mr and Mrs Ruskin in not being
able to begin the New Year with them—including yourself.

Much concerned to hear that foggy Novr. troubled and kept you to
your room by illness.

In regard to myself I think I am better and looking forward to-
wards the end of this month to be relieved from the unpleasant duty
of acting (Pro Pre) at the Royal Academy.[3]

[*signature cut away*]

[1] Mulready's *Choosing the Wedding Gown*, R.A. 1846 (140) is now in the Victoria and
Albert Museum (Sheepshanks Collection).
[2] On 23 Oct. 1846, when Turner was acting President of the Academy and Knight
was Deputy Secretary, the Council received a petition for a pension from the daughter
of an Associate, Eliza Joseph, who may be the person referred to in this note (see
Letter 267 for another confusion of names).
[3] See Letters 300, 302.

302. Turner to F. H. Fawkes

MS. Mr. Kurt Pantzer

Queen Ann St West
Dec.^r 26 1846

My Dear Hawkesworth

Many returns of the Season compl^{ts} but versus Gout the con-
founded and painful visitor to Farnley Hall [which] is very unseason-
able just now—but I hope you will be soon on your Pedestal again.

Trust all are well; no news of Mrs Fawkes health must be con-
sidered on the well being side.

Thank you for the excellent Pie for Xmas day—

Happy New-Year when it comes—in regard to my health sorry to
say the tiresome and unpleasant duties of [presiding] during the con-
tinued illness of our President[1] for two years—viz my rotation of
Council—and being senior of the lot made me Pro Pre[2]—it distroyd
my happiness and appetite [so] that what with the business and
weak[ness] I was oblidged to give [up] my Summer's usual trip
abroad—but thank Heaven I shall be out of office on Thursday the
31 of this month.[3]

Pray remember my best respects to Mrs Fawkes and all inquiring
friends at Farnley and

Believe me most truly
Your obliged
J. M. W. Turner

F. H. Fawkes Esq^{re}
Farnley Hall

303. Turner to Harriet Moore

MS. Anthony Heath Esq.
Publ. Thornbury 1862, ii. 231

Saturday the 9th of
January 1847

Dear Miss Moore

Charming weather for the Arts—they must be fine this weather of
uniformity.

[1] Sir Martin Archer Shee (1769–1850).
[2] See Letter 301.
[3] Turner was succeeded in 1847 by Abraham Cooper (q.v.), having completed his
two years on the Academy Council.

Sorry to be likewise engaged on Sunday next the 10th best regards to Mr and Mrs Moore yourself and all the Family.

<div style="text-align: right">

yours truly

J. M. W. Turner

</div>

304. Turner to John James Ruskin

MS. British Library Add. MS. 50119, fo. 68

Dear Sir

I will with very great pleasure be with you and Family at Denmark Hill on Monday the 8th of February[1] at six O'Clock.

<div style="text-align: right">

Yours truly

J. M. W. Turner

</div>

J. Ruskin Esqre

305. Turner to Jacob Bell [?]

MS. Sotheby, 12 Dec. 1922 (478), bt. Atkinson

<div style="text-align: right">

June 16—47

</div>

[Cannot lend a picture, owing to its being] so great a pet of mine.[2]

306. Turner to Harriet Moore

MS. Anthony Heath Esq.
Publ. Thornbury 1862, ii. 230

<div style="text-align: right">

47 Queen Ann St
June 16—47

</div>

My dear Miss Moore

Very glad to hear Mr Moore is quite well again—and hope Mrs Moore will now be better being relieved from the anxiety attendant to the illness of Mr Moore.

Many thanks for the news of the whereabouts of the Jones's—and

[1] 8 Feb. fell on a Monday in 1847, when Turner is recorded by J. J. Ruskin as a guest at John's birthday dinner.
[2] See also the wording of Letter 291.

his piece of your Letter sent me inclosed!!! How we all grumble in
search of happiness or benefits for others yet find Home at Home.

<div align="right">

yours truly

J. M. W. Turner

</div>

307. Turner to F. H. Fawkes

MS. Untraced
Publ. Armstrong, p. 176

<div align="right">

Queen Ann St West
Decr. 27 1847

</div>

Dear Hawksworth

!!*Many thanks* for three PPP viz. Pie Phea[sant] and Pud—the
Xmas cheer in Queen Ann St.

It was very unfortunate for the Under Graduate of Oxford[1] you
were on the wing—but he must take to himself the Bramah Locks.[2]

I will scold Griffith, which you desire me to do—but if I feel right
from him, Mr G—Mr G was much pleased and his appetite to see
more at Farnley Hall much increased: so I do yet hope you may see
him at Farnley—and before the Dort.[3]

Now for Aberiswith—I think you have well chosen—it is well
sheltered, from the East—the Town close to the sea, no doubt must be
much improved, in regard to comfort and good quartering since my
seeing it, and the scenery of natural valley, the Estwith, the Ridol
and the Devil's Bridge are beautiful and Grand features. The view
from the Inn near the Devil's Bridge commands the falls of the Ridol—
the Devil's Bridge torrent rushes down a deep chasam, under two
Bridges one over the other—viz the new one built upon the old one—
You are in the neighbourhood of Havord or Hawvaford, know[n]
I dare say yet known by being the Seat of Esquire Johns a fine place
well wooded and he employ'd Stothard to paint the same[4] so think
you will find some Pictures by him there. I do not think that you

[1] John Ruskin, whose *Modern Painters* (Vol. i, 1843, Vol. ii, 1846) had been pub-
lished anonymously as by 'A Graduate of Oxford'.

[2] 'Bramah-locks for writing desks and coach-seats' are among *Requisites for
Travellers* listed my Mariana Starke, *Information and Directions for Travellers on the
Continent*, new edn. (1829), p. 324. Turner owned this guide. The construction of these
locks was also a 'favourite subject' with Charles Babbage, whom Turner had met in
the circle of Rogers, the Eastlakes, and Mrs. Carrick Moore (qq.v.) (*Personal
Remembrances of Sir F. Pollock*, ii (1887), 4). Turner probably means simply that Ruskin
must be on his travels, perhaps to Yorkshire again.

[3] Dort or Dordrecht: *The Dort packet-boat from Rotterdam becalmed*, 1818. Formerly at
Farnley, now Mellon Collection (B.–J. No. 137).

[4] See Tate Gallery, *Landscape in Britain c. 1750–1850* (1973–4), Nos. 139–40.

could have hit upon a more desirable spot for your pencil and hope you may feel—just what I felt in the days of my youth when I was in search of Richard Wilson's birthplace[1]

> I am Dear Hawkesworth
> Your truly obliged
> J. M. W. Turner

P.S.—Compliments of the Season and my respects to all friends at Farnley.

308. Turner to John Ruskin

MS. British Library Add. MS. 50119, fo. 70
Publ. Finberg 1939, p. 420

Jany 13 1848

My Dear Sir

Have the goodness to give my best thanks to Mrs Ruskin[2] for the kind present of Eggs—and the honor of her Card.

I will (I hope) have the pleasure of drinking your health on the 8th of Feby to wish you many happy returns of the day.

In regard to the mounts the the Drawings[3] I will carry them in on their own paper until you have finally fixed.

> I am Yours most truly
> J. M. W. Turner

J. Ruskin Esqr Jn
Denmark Hill

309. Turner to Elhanan Bicknell

MS. Untraced[4]
Publ. Finberg 1939, p. 421

11 Feb. '48

Dear Sir

Have the goodness to favour me with your permission to James

[1] Wilson was born at Penegoes, near Machynlleth, Montgomeryshire, about 1713 (cf. T.B. XXXIX, p. 1).

[2] In his endorsement on the reverse of this letter, Ruskin conjectured that this was the last call made by his mother at Queen Anne St.

[3] Ruskin identified this as a reference to *Brunig* (Untraced) and *The Descent from St. Gothard to Airolo* (see Letter 310).

[4] I have been unable to trace the grangerized copy of Frith's *Autobiography*, recorded by Finberg as in the British Museum.

Lenox, Esqre of New York to view the works of art at Herne Hill.
You will oblige,

Yours truly,
J. M. W. Turner

E. Bicknell, Esqre.

310. Turner to John James Ruskin

MS. National Library of Scotland MS. 590, fo. 163¹

Midsummer-day
1848

Dear Sir

I have received a Letter from Mr J. Ruskin—Dover for a few days
and stating that you intended being in Town on the 26ᵗʰ or 27ᵗʰ for
Switzerland on Paper¹ and I would be most happy to meet your
expecting them—*the first two Drawings* but having been laid up with a
broken Knee-pan I must require your indulgence a few days more—
say on or before the 1ˢᵗ of July.

Believe me most truly
Yours Obligᵈ
J. M. W. Turner

J. J. Ruskin Esqʳ
Denmark Hill
P.S. Best respects to Mrs Ruskin

311. Turner to John Ruskin

MS. British Library Add. MS. 50119, fo. 71

[5 November 1848]

Dear Ruskin

I fear by not finding the Cards of your friends or your own that I
have caused the delay in not writing which I hope you will excuse
and place to my ill health.

¹ J. J. Ruskin's account book (Bembridge, Ruskin MSS.) lists a payment to Turner
of £210 in August 1848 for *Brunig* and *St. Gothard*, which John Ruskin remembered
as the drawings referred to in Letter 308. *Brunig* is untraced, but the other drawing
may be *The Descent of the St. Gothard* (Agnew, 1967, No. 96), which was later in the
collection of Munro of Novar (q.v.), and described by Ruskin in 1857 as Turner's
last drawing (pl. V).

Have the goodness to give my respects to Mr and Mrs Ruskin and accept the same yourself and Mrs Ruskin.[1]

Yours truly
J. M. W. Turner

312. Turner to John Ruskin

MS. British Library Add. MS. 50119, fo. 73
Publ. Finberg 1939, p. 423

My dear Ruskin
!!! Do let *us* be happy[2]

Yours most truly and sincerely
J. M. W. Turner

Athenaeum Pall Mall
Novr. 1848

313. Turner to John Ruskin

MS. British Library Add. MS. 50119, fo. 74

Dec.r 22 1848

My dear Ruskin
"With very great pleasure—to begin the New Year I say yes at Denmark Hill.

The Comp.ts of the Season to you and Mrs R
Belive me truly
J. M. W. Turner

J. Ruskin Esq.re

[1] Ruskin had married Effie Gray on 10 Apr. 1848.

[2] Finberg conjectures that Turner is alluding to signs of estrangement between Ruskin and his wife, but they do not appear to have developed as early as this. However, in a letter of 21 Nov. 1848, Effie Ruskin wrote: 'John is much taken up about the state of the world at present . . .' (Admiral Sir William James, *The Order of Release* (1947), p. 134).

314. Turner to Ignaz Moscheles

MS. Untraced (Sotheby, 31 July 1955 (293))

[1848]

'When Jubal¹ strung the corded shell' [*with a sketch of a shell.*]

[*Addr.*] Ignaz Moscheles
Leipzig.

315. Turner to F. H. Fawkes

MS. Untraced
Publ. Thornbury 1862, ii. 90–1

[24 December 1849]

Dear Hawkesworth

Mother Goose came to a rehearsal before Christmas Day, having arrived on Saturday for the knife, and could not be resisted in my drinking your good health in a glass of wine to all friends at Farnley Hall, also wishing happiness and the *comp^ts of the season to all.* The pie is in most excellent taste, and shall drink the same *thanks* on Christmas Day. Many thanks for the brace of pheasants and hares—by the same train—indeed, I think it fortunate, for with all the strife and strike of pokers and stokers for the railroads—their commons every day growing worse—in shareholders and directors squabbling about the winding up of the last Bill,² to come to some end for those lines known or supposed to be in difficulty.

Ruskin has been in Switzerland with his whiffe this summer, and now said to be in Venice. Since the revolution shows not any damage to the works of high Art it contains, in Rome not so much as might have been expected. Had the 'Transfiguration' occupied its old situation, the St. Pietro Montoreo, it most possibly must have suffered, for

¹ 'The father of all such as handle the harp and organ' (Genesis 4:21). Turner's quotation is from Dryden's *Song for St. Cecilia's Day*, Nov. 22 1687: '... What passion cannot Music raise and quell?/When Jubal struck the corded shell,/His listening brethren stood around/And, wondering, on their faces fell/To worship that celestial sound ...'

² Probably the Railway Abandonment Bill (1849) (see H. Lewin, *The Railway Mania and its Aftermath*, 2nd edn. (1968), pp. 372 ff.). Fawkes had had an interest in the Skipton Railway Company, whose line through Wharfdale was sanctioned by Parliament in 1846, but was never carried out (F. H. Fawkes, *North-Eastern Railway. An Address to the Landowners of Wharfdale* (1861), p. 4).

the church is completely riddled with shot and balls.[1] The convent on Mount Aventine much battered with cannon balls, and Casino Magdalene, near the Porto Angelino, nearly destroyed; occurred by taking and storming the Bastion No. 8.

This is from an eye-witness who has returned to London since the siege by Gen. Oudinot.

I am sorry to say my health is much on the wain. I cannot bear the same fatigue, or have the same bearing against it I formerly had—but time and tide stop not—but I must stop writing for to-day, and so I again beg to thank you for the Christmas present.

<div style="text-align: right;">

Believe me most truly
Your oblidged Servant
J. M. W. Turner

</div>

W. H. Fawkes Esq., Farnley Hall.

316. George Jones to Turner

MS. Cincinnati Memorial Public Library; Hirsch Collection

<div style="text-align: right;">

Sunday 14th April 1850
Royal Academy

</div>

My Dear Turner—

I saw your pictures this morning for the first time, and more glorious effusions of mind have never appeared—*your* intellect defies time to injure it, and I really believe that you never conceived more beautiful, more graceful, or more enchanting compositions, than these you have sent for exhibition[2] —God bless you & preserve you as you are for your affectionate and admiring Friends—

<div style="text-align: right;">

Geo Jones—

</div>

Gertrude's[3] kindest wishes

[1] Raphael's *Transfiguration*, installed in S. Pietro in Montorio in 1523, was taken to Paris in 1797 and returned to Rome in 1815. On returning to Rome, it was installed in the Vatican (H. Sass, *A Journey to Rome and Naples* (1818), pp. 121 f.). Turner made a perspective diagram based on the composition (T.B. CXCV, 163).

[2] *Mercury sent to admonish Aeneas* (B.–J. No. 429); *Aeneas relating his story to Dido* (B.–J. No. 430); *The visit to the tomb* (B.–J. No. 431); *The departure of the fleet* (B.–J. No. 432), were Turner's last exhibits at the Royal Academy of 1850. For other views by Jones of Turner's late style see p. 4.

[3] Jones's wife.

317. Turner to Charles Stokes

MS. Miss Hazel Carey

[? May 1850]

Dear Stokes
 I have the impression *wholly wrong* about the River Drawings[1]—
they are Fifty Guineas

Yours truly
J. M. W. Turner

Saturday afternoon

318. Turner to F. H. Fawkes

MS. Untraced
Publ. Magazine of Art, 1887, pp. 295 f.

Dec[r] 27. 1850

Dear Hawkesworth
 Many thanks for the Pie it is excellent—it did only arrive in time
to drink the healths of all friends at Farnley and wishing the compli-
ments of the Season and to Lady Barnes and Family—Farnley like
former times.
 Old Time has made sad work with me since I saw you in Town.
 I always dreaded it with horror now I feel it acutely now what-
ever—Gout or nervousness—it having fallen into my Pedestals—and
bid adieu to the Marrow bone stage.
 Your catalogue[2] is capital yet I could wish to see the Total number
even in writing even at the end.
 Fairfax's Sword Black Jug and the Warrant[3] I do not find? perhaps
you are right upon second thought
 Mr Vernons[4] collection which he gave to the National Gallery are
now moved to Marlborough-House and the English Masters likewise.
 The Crystal Palace is proceeding slowly I think considering the

[1] Stokes acquired twenty-four drawings connected with *Turner's Annual Tour—The
Loire* through Griffith (q.v.) for 25 guineas each on 31 May 1850 (*Burlington
Magazine* cxii (1970), 696). This letter may refer to two of them (see also Letter 325).
[2] Possibly a manuscript Catalogue of the Turners at Farnley.
[3] The frontispiece to the Album of *Fairfaxiana* at Farnley, which became detached
and passed through the collections of Charles Stokes and Ruskin to the Ashmolean
Museum (T.B.E. No. 185).
[4] The large collection of British Art formed by Robert Vernon (q.v.) passed to the
National Gallery in 1847.

time, but suppose the Glass work is partially in store, for the vast Conservatory all looks confusion worse confounded.[1]

The Commissioners are now busy in minor details of stowage and hutting, all sent before the Glass Conservatory is ready—to be in bond under the duty to be lay'd on if sold.

Have the goodness to accept my thankfull remembrance and all at Farnley.

<div style="text-align:right">

And believe me
most truly yours,
J. M. W. Turner

</div>

F. H. Fawkes Esq^r
Farnley Hall.

319. Turner to David Roberts

MS. Victoria and Albert Museum, MSE Fri 86 CC. 33, No. 181

<div style="text-align:right">

Dec^r 30th 1850

</div>

Dear Roberts

I am sorry to say that I feel too unwell to be with you on the New-years-day.

Wishing you and your party all happiness then and many years to come

<div style="text-align:right">

Believe me to be
Yours truly
J. M. W. Turner

</div>

David Roberts Esq^{re} R.A.
No 8 Fitzroy Street

320. Turner to Lady Eastlake

MS. Columbia University, Spec. MS. Collection

Dear Lady Eastlake

Allow me on the arrival of the New year to congratulate you and Sir Charles Eastlake with with many returns of happy returns of this day.

My illness prevents me from any hope on the 8th inst. of having

[1] Work on the Crystal Palace had begun in September 1850 and was not completed until early in 1851 (Y. ffrench, *The Great Exhibition, 1851*, 1950). See also Letters 323, 325.

that pleasure; night air and continued want of health intensifying
[? interfering].

Wishing you and Sir Charles all happiness—This day and many of
them to come.

Believe me
most truly
J. M. W. Turner

321. Turner to George Jones

MS. Bembridge School

[*Postmark* Jan 2 1851]
1851

Dear Jones

Many happy returns of this day New-Year and many of theme to
come to you and Mrs Jones

My want of health continues on me hevilly

But Believe
Yours most truly
J. M. W. Turner

G. Jones Esq^r
7 Park Terrace East

[*Envelope*] G. Jones Esq^re R.A.
No 7 Park Terrace East//New Road

[Altered to *Crescent* and endorsed *Not known in Park Terrace Regent's
Park near the New Mall J. Scott*]

322. Turner to John James Ruskin

MS. British Library Add. MS. 50119, fo. 75
Publ. J. S. Dearden, *Connoisseur*, 172 (1969), 40

J.M.W.T. begs to present his respects to Mr & Mrs Ruskin and sorry
his indifferent health will prevent him the pleasure of being present
at Denmark Hill on the Birth-day of the talented Mr J. Ruskin—but
wishing him many happy returns of the day.

May Mr T request to be remembered to him and Mrs R. and hope
the like to Mrs & Mr J. J. Ruskin.

January 30 1851

323. Turner to F. H. Fawkes

MS. Untraced
Publ. Magazine of Art, 1887, p. 296

Dear Hawkesworth

Many thanks for the Brace of Longtails and Brace of Hares.

In regard to the drawings—you say 19.[1] I do not recollect how they were seen but you must [be] the best Judge in what way you wish them to be rendered convenient to yourself, for you seem to wish to bring them with you to Town.

The Birds I think were pasted or fixed in Major Fawkes Book of Ornithology rather of a large size to illustrate his wishes.[2]

A Cuckoo was my first achievement in killing on Farnley Moor in ernest request of Major Fawkes to be painted for the Book.

The Crystal Palace has assumed its wonted shape and size. It is situated close to the Barracks at Knights Bridge, between the two roads at Kensington and not far from the Serpentine: it looks very well in front because the transept takes a centre like a dome, but sideways ribs of Glass frame work only Towering over the Galleries like a Giant.

respects to all at Farnley
Believe me
Dear Hawkesworth
J. M. W. Turner

F. H. Fawkes Esq[r]
Farnley Hall
Yorkshire
January 31, 1851

[1] This is probably a reference to the *Farnley* series of watercolours, which numbered twenty in the 1819 Fawkes catalogue. C. F. Bell noted that in the 1890s these drawings were in their original deep gilt frames as Turner had advised (Manuscript note, pp. 168–9 in Bell, *Exhibited Works of J. M. W. Turner* (1901), Victoria and Albert Museum, RC.N.28).

[2] The Farnley Book of Birds is now simply an album of Turner's seventeen bird studies (T.B.E. No. B127).

324. Turner to Thomas Griffith

MS. E. C. and T. Griffith
Publ. Finberg 1939, p. 433

<div align="right">

[*Athenaeum Stamp*]
Wednesday 7th of May 51
</div>

My dear Griffiths
Sorry to find you far away from Pall Mall[1] when I called to day.
How shall we meet. I am yet very unwell and unable to walk much.
Do let me know by a note at the Athenaeum what you wish.

<div align="right">

Yours truly
J. M. W. Turner
</div>

325. Turner to Thomas Griffith

MS. E. C. and T. Griffith
Publ. Finberg 1939, p. 433

<div align="right">

[*Postmark* King's Road Chelsea
May 20th 1851]
Atheneum 19th May
</div>

Dear Griffiths
Enclosed is an order to let you have them
In regard to the original sketches of the Swiss[2]' do let me know your
notion
 respecting the Loire[3] if it is inconvenient for you to come to Town
I will bring them to Norwood' perhaps a trip to do so may do me good
 'Do pray let me know your plans (the worlds fair taking *all* to
think of now[4] the prints I am not very *sanguine* about large or small
Mr Grundy has taken *no more* whatever.[5]

<div align="right">

Yours truly,
J. M. W. Turner
</div>

[*Sealed with a Mallard seal[6]*]

 [1] Griffith had opened a gallery in Pall Mall in 1845.
 [2] Probably the sample drawings for the large Swiss watercolours of 1842–4, which,
however, remained in Turner's hands (see T.B.E. Section 17).
 [3] The watercolours engraved in *Wanderings by the Loire* (1833). They were bought by
Charles Stokes (q.v.) and are now in the Ashmolean Museum, Oxford. (See Letter 317.)
 [4] i.e. The Great Exhibition (see Letters 318, 323).
 [5] Probably the dealer of Regent Street. The large prints are presumably the series
issued by Griffith in 1842; it is not clear what is meant by small.
 [6] See also Letter 329.

326. Turner to Thomas Griffith

MS. British Library Add. MS. 50119, fo. 82

29 of May 51

Dear Griffith

Thus far lucky I went to Queen Ann first but only to find myself behind the time you calld.

Do pray tell me your coming again to Town

Hannah has the sketches yet[1]

Dear Griffith
Yours truly
J. M. W. Turner

T. Griffith Esq^r
Norwood

327. Turner to Charles Stokes

MS. Miss Hazel Carey

August 1 1851

Dear Stokes

I am and have been so bad and fear the worst my limbs are so weak

May I ask you to call and Hannah[2] to take what may be wanted of the Excheqer Bill

J. M. W. Turner

C. Stokes Esq^r
City

[1] Presumably the Swiss or Loire sketches referred to in Letter 325.
[2] Hannah Danby, Turner's housekeeper at Queen Anne St.

328. Turner to Charles Stokes

MS. Miss Hazel Carey

[*Endorsed* Rec^d 20 Dec. 1851][1]

Dear Stokes

Enclosed is a wish for Mr F. Marsh[2] to advance on my account £100 I do not like the debts of Mr Wood^s—not paid. Have the goodness to do it

yours truly
J. M. W. Turner

[1] Turner died on 19 Dec. Stokes received a letter from one of Turner's executors, Phillip Hardwick, dated 20 Dec., and stating: 'Knowing the interest you have taken in all matters connected with Mr Turner, I thought you should be informed that we have lost him.'

[2] Possibly William Marsh, Turner's stockbroker (see Letter 125 and Finberg 1961, pp. 170, 439).

APPENDIX I
UNDATED LETTERS

329. Turner to A. W. Callcott

MS. British Library Add. MS. 50118, fo. 59

Dear Callcott

I am sorry to inform you of my unsuccessful voyage to the North this morning. first Holworthy had left home[1] secondly by inquiry found the Party fixd five precious Souls (not Fish) prepared, so have the goodness to receive the lamentation of Jeremiah

Will^m Turner

330. Turner to Edward Goodall

MS. Columbia University Spec. MS. Collection, W. E. Benjamin

47 Queen Ann St

Dear Sir

I am sorry to take you from home but I could wish you to call at your earliest convenience *about* [*deleted*]

Yours truly
J. M. W. Turner

[*Addr.*] E. Goodall Esq^re
Mornington Cottage
Mornington Crescent
Hampstead Road.

331. Turner to Thomas Griffith

MS. E. C. and T. Griffith

47 Queen Ann S^t West
Thursday Evening

My Dear Sir

There is something so candid and ingenuous in your Gift of the

[1] For Holworthy's home in London, see Letter 65.

10 L Cheque received this morning that I cannot but acknowledge my Thanks and beg to consider it as such—all my concern rests on it being one of the England (tho not made for the work)[1] and should Mr W[2] feel inclined ever to part with it I hope it will not be wrong in me to ask that Mr Stewart[3] may have the offer—with my respects to Mrs Griffith

> Believe me, Dear Sir
> Yours truly
> J. M. W. Turner

332. Turner to Thomas Griffith

MS. E. C. and T. Griffith

[*Athenaeum Stamp*]

Dear Mr Griffith

A great deal of pro and con took place I find—Yr [The *deleted*] at present *new flat*[4] if instead of being washed off—for a new colour will be if White and a little Black is mixed in warm water, and covering the present or rather mixing with the Brown it will all unite and reduce the yellow to a shade of its present glare keeping clear of the Picture, it avoid[s] any of the size creeping into the space of the Picture and its new Frame, for whatever gets hold will take away the Paint per force.

> Yours truly
> J. M. W. Turner

[1] Probably *Tynemouth*, destroyed by fire in 1962. It was engraved in *England and Wales* in 1831 (R. 251).

[2] B. G. Windus (q.v.). Windus lent *Tynemouth* to the Moon, Boys & Graves Exhibition in 1833, and in a letter from him to Griffith, endorsed '1844' (E. C. and T. Griffith), he thanked him for 'the very kind and handsome manner [in which] you presented me your Turner'—apparently the *Tynemouth*—and closing 'I have written to Turner to ask him to meet you on Thursday, I should like to see him again in Tottenham . . .' As *Tynemouth* was already in the Windus collection by 1833, the date of this letter (and Turner's) is problematical. Griffith was certainly in touch with Windus as early as August 1832, when E. W. Cooke met him looking at the Turners at Tottenham (Cooke Diary, Cooke Family Papers). This might suggest a date of late 1832 for Turner's letter. Finberg (British Museum Print Room, MS. *Life of Turner*, ii. 423 f.) proposes a date of about October 1840. See note 3.

[3] A partner in the publishing house of Smith, Elder & Co., which published Ruskin's *Modern Painters* when Murray had rejected it, and an 'old friend' of J. J. Ruskin (q.v., J. Ruskin, *Works*, iii, p. xxxii). J. J. Ruskin seems to have been in touch with Turner only from the late 1830s, and this argues for a later date for Turner's letter.

[4] i.e. the flat between frame and picture (see Letter 84).

T. Griffith Esq
+ This is to be done longdituinally not cross-way [*diagram*]¹

<div align="right">

T. Griffith Esq^re
1 2 1 Pall Mall²

</div>

333. Turner to Henry Josi

MS. British Library Add. MS. 50119, fo. 22

<div align="right">

Queen Ann St West

</div>

Dear Sir
 Have the goodness to permit the bearer J^s Brennan—to study in the British Museum.

<div align="right">

Yours most truly
J. M. W. Turner

</div>

Josce Esq^re

[*Addr.*]—Jossce Esq^re
 British Museum
 J.M.W.T.

[*Endorsed* Brannan³

334. Turner to Thomas Lupton

MS. Columbia University, Spec. MS. Collection, W. E. Benjamin

[*Addr.*] T. Lupton Esq^r

I find that [it] is likely that I shall be out on Thursday therefore make your call on Wednesday

<div align="right">

Yours &c
J. M. W. Turner

</div>

P.S. the Print is ready if you wish to have it on Monday be so good as to send the enclosed note to Mr Millington [?]

 ¹ The sizing was to be done lengthways to avoid the risk of touching the picture as much as possible.
 ² This address dates the letter after 1845.
 ³ Possibly J. Brannan, who exhibited *The Organ Boy* at the Royal Academy in 1859.

335. Turner to Harriet Moore

MS. Maggs Bros., 1931 (715)
Publ. Thornbury 1862, ii. 230

J. M. W. Turner begs to present his respects to Miss Moore, and begs
to say he is sorry an engagement for Christmas Day will prevent him
offering his apology and contrition for his misdeeds and errors,
regretted the more by him because he cannot but defer expressing his
disappointment in person.
 Respects
To Miss H. Moore.

336. Turner to H. W. Pickersgill

MS. Untraced
Publ. (Facsimile) C. Holmes (ed.) *The Royal Academy from Reynolds to Millais*,
Studio Special Number, 1904, p. P. vi

Friday

My Dear Pickersgill
 I beg to apologize in not sending an immediate answer, but by
some chance your letter was not deliv[er]ed until late last night. but
I will with great pleasure wait upon you on Thursday $\frac{1}{4}$ past 6 the 18th
 I pray what is to [be] done about Brand's[1] dinner at the Atheneum
—mentioned at Mr Hardwick's[2] for Wednesday the 17th

Yours most truly
J. M. W. Turner

337. Turner to H. W. Pickersgill

MS. Kenneth Hobson Esq.

Dear Pickersgill
 How unlucky I am for I must Dine at Miss Jones's[3] to day but have
made it conditional to be with you at 8 o clock precisely for the

[1] Probably the scientist, W. P. Brande, elected to the Athenaeum in 1836.
[2] Possibly the architect Philip Hardwick, R.A. one of Turner's executors from 1848.
[3] Probably Eliza, the sister of George Jones (q.v.).

meeting so that I am truly sorry that I am again prevented of your Sherry-Brown.

<div align="right">yours truly
J.M.W.T.</div>

W. Pickersgill Esq^r

338. Turner to H. W. Pickersgill

MS. Untraced (**Maggs Bros.**, 1909, No. 638)

<div align="right">Friday Morning</div>

... Sorry to say I am engaged out of town to-day, so I must be put down on the Black List, instead of the Brown Sherry...

339. Turner to Sarah Rogers

MS. Maggs Bros., 1923 (1147)
Publ. Catalogue of the Collection of Autograph Letters and Historical Documents formed by Alfred Morrison, vi (1892), 276

I am very sorry to say that I have an engagement today which will prevent me the pleasure of being with you in Hanover Terrace to-day, Good Friday.

<div align="right">Yours very sincerely
J. M. W. Turner</div>

P.S. Mr Osgood's picture is received.[1]

340. Turner to Clarkson Stanfield

MS. Untraced (**Maggs Bros.**, 1920, No. 2650)

<div align="right">16 July</div>

Pray make it any day most convenient to you and your friends to see the Gallery.

[1] Possibly a work by one of the American painters, S. S. Osgood (1808–85) who exhibited at the Royal Academy between 1836 and 1839, or Charles Osgood (1809–?), who showed there in 1842.

341. Turner to Robert Vernon [?]

MS. Untraced (Christie, 31 July 1974, lot 281)

Saturday Evening

[Accepting an invitation to dinner with him and a Mr. Jones.[1]]

342. Turner to Benjamin Godfrey Windus

MS. Untraced
Publ. Literary Gazette, 1851, p. 924

My dear Sir,
 Yes, with very great pleasure. I will be with you on the B.D.[2] Many of them to yourself and Mrs Windus; and with the compliments of the season, believe me,

yours faithfully
J. M. W. Turner

[1] Probably George Jones (q.v.), whom Vernon described in 1834 as an 'old friend' (T. S. Cooper, *My Life*, i (1890), 249).
[2] Presumably Windus's birthday.

APPENDIX II

CHARLES HEATH'S EGYPTIAN HALL EXHIBITION
June/July 1829

(The manuscript handlist of the exhibition, at Bembridge (Ruskin MS. 54/F), with notes of the ownership of the drawings during Turner's lifetime and at the time of compilation)

1. Salisbury from Old Sarum Intrenchment (Windus, cf. *Burlington Magazine* cxvi (1974), 272)
2. Eton College (Griffith; Agnew 1967, No. 64)
3. Knaresborough, Yorkshire (Agnew, *Turner* (1951), No. 75)
4. *Florence (Windus; Coventry, Herbert Art Gallery)
5. Orford (Christie 24 June 1960, lot 72)
6. Malmsbury Abbey (Tomkison; Windus; Agnew 1953, No. 83)
7. Fowey Harbour (Windus; Christie 22 July 1955, lot 83)
8. Lancaster Sands (Tomkison; Windus; T.B.E. 419)
9. Virginia Water (Windus; ?T.B.E. 258 and see No. 40 below)
10. Okehampton Castle (Griffith; Windus; National Gallery of Victoria, Melbourne, Australia)
11. Buckfastleigh Abbey (Windus; Exeter, Albert Memorial Museum)
12. Kilgarren Castle (Griffith, Windus; Agnew 1967, No. 61)
13. Hampton Court Palace (Griffith; Windus)
14. Coast from Folkstone Harbour to Dover (?Windus; Mellon Coll.)
15. Tamerton [i.e. Trematon] (Griffith; Windus)
16. Louth, Lincolnshire (Griffith; T.B.E. 422)
17. Saltash (Windus; Maw; B.M.T. 90)
18. Straits of Dover (Windus; ?E. Nettlefold)
19. Stoneyhurst College, Lancashire (Windus)
20. Launceston (Maw; Private Collection, Iran)
21. River Tavey, Devonshire (?Ruskin; Oxford, Ashmolean Museum)
22. Walton Bridge (Griffith; Agnew 1967, No. 63)
23. Plymouth Cove (Griffith; Victoria and Albert Museum)
24. Dartmouth Cove, with Sailor's Wedding (Windus; Gaskell Coll.)
25. Dunstanborough Castle, Northumberland (Griffith; Windus; T.B.E. 423)
26. Windsor Castle (Tomkison; Windus; T.B.M. No. 148)
27. Richmond Hill and Bridge with a Pic Nic party (Griffith; Ruskin; T.B.M. No. 174)

28. Stonehenge (Rogers; Louis Hawes *Constable's Stonehenge*, Victoria and Albert Museum, 1975, Pl. 18)
29. Richmond Yorkshire (Windus; ?T.B.E. 421)
30. Richmond Yorkshire (Windus; ?Cambridge, Fitzwilliam Museum)
31. Alnwick Castle, Northumberland (Griffith; Windus; ?National Gallery of S. Australia, Adelaide)
32. *Lake Albano (Windus; Edward Pugliese)
33. Exeter (Windus; Manchester City Art Gallery)
34. Colchester (Maw; Courtauld Institute of Art)
35. Yarmouth (Windus; Agnew 1967, No. 62)
36. *Lago Maggiore (Windus; ?T.B.E. 466)
37. Stamford (Griffith; Lincoln, Usher Art Gallery)
38. Valle Crucis Abbey, Wales (Griffith; Manchester City Art Gallery)
39. Holy Island Cathedral (Windus; Victoria and Albert Museum)
40. Virginia Water (?T.B.E. 258; see also No. 9 above)
41. Dock Yard, Devonport, Ships being paid off (Windus; Cambridge, Mass., Fogg Art Museum)

Those marked with a * are for a work on Italy, which will appear in the course of next Spring[1].

[1] This publication does not seem to have appeared.

BIOGRAPHICAL INDEX OF
CORRESPONDENTS

(Figures in bold refer to letters, others are page-references)

ALENSON, J., **231**.

ARCH, John and Arthur (fl. 1810–30), **108**, 55, 105, 116, 144, 273.
Quaker booksellers and publishers of Cornhill, London. Shareholders
in Cooke's *Southern Coast*, Allason's *Antiquties of Pola*, and other
publications employing Turner, as well as Britton's *Beauties of England
and Wales*. In 1827 planned, but did not execute, a sequel to Cooke's
Southern Coast, to be called *The English Channel, or La Manche*, from
drawings based on Turner's sketches made in the summer of 1826
between Dunkirk and Ushant (cf. T.B. CCXVI, CCXLVII, CCL,
CCLI, CCLV; Prospectus in British Library, Dawson Turner Collec-
tion, 1879 b. 1, Vol. iv). Had a reputation for close dealing with
their engravers (J. Britton, *Auto-Biography*, i (1849), 226).

AUCKLAND, William Eden, first Baron (1744–1814), **4**.
Statesman and Diplomatist. LL.D., M.P., F.R.S. Auckland was a
guest at R.A. Dinners from 1801 to 1803, and in 1805 and 1813. In
1814 he attended the opening of the British Institution. He is not
known to have patronized Turner.
 Literature: The Journal and Correspondence of William, Lord Auckland,
ed. The Bishop of Bath and Wells (1861–2).

BALMANNO, Robert (–c. 1851), **115**.
Art Critic and Secretary of the Artists' Joint Stock Fund. In the 1820s,
Balmanno was a notable collector of Blake and Thomas Stothard
(A. E. Bray, *Life of Thomas Stothard, R.A.*, 1851, p. 126; G. E. Bentley,
Jr., *Blake Records*, 1969). At the end of his life he seems to have gone
to America (Bray, p. 237).

BELL, Jacob (1810–59), **305**, 269.
Pharmaceutical chemist and art collector. Studied art under H. P.
Briggs, R.A. Started collecting at the age of twenty-five. An especial
friend of Edwin Landseer, with whom he travelled on the Continent
in 1840, and advised on his business affairs (F. Goodall, *Reminiscences*

(1902), p. 312). Fellow of the Society of Arts, and on the Council in 1848, the year in which Turner was approached to provide a retrospective exhibition, but declined (D. Hudson and K. W. Luckhurst, *The Royal Society of Arts* (1954), p. 52). Was collecting Collins (q.v.) in the 1830s (W. W. Collins, *Memoirs*, ii. 47, 63). Lent nine works to the Manchester Exhibition of 1857, including a Wilkie and a watercolour by W. Hunt; and left a small collection of modern pictures, including seven Landseers and a Leslie (q.v.), to the National Gallery in 1859.

Literature: D.N.B.

BICKNELL, Elhanan (1788–1861), **258, 279, 309,** 157 n. 1, 195 n. 6, 196 nn 4 and 6, 277.

Whaling entrepreneur and collector. Brother-in-law of H. K. Browne (*Phiz*) and father-in-law of David Roberts (q.v.). Visited W. B. Cooke (q.v.) to look at the Turners 16 Jan. 1835 (E. W. Cooke *Diary*: Cooke Family). Began collecting modern British art from 1838, including works by Roberts, Stanfield, Leslie, Callcott, Eastlake, and Collins (qq.v.). E. W. Cooke met Turner, together with Stanfield, Roberts, Collins, Phillips (q.v.), and other painters at Bicknell's dinner on 24 Apr. 1841, and Ruskin (q.v.) dined with him there on 16 Dec. 1843 and 13 Mar. 1844 (Ruskin, *Diaries*). Most of Bicknell's Turners of all periods seem to have been purchased in the early 1840s; only one of them, *Campo Santo* (1842, B.-J. No. 397), is described as having been painted expressly for him (*The Times*, 27 Apr. 1863). Bicknell's humour is clear from a letter of 23 June 1845 to John Pye:

My getting the painting [*Ehrenbreitstein*: B.-J. No. 361] *appears* as distant now as it was in March 1844. I thought I had only to send to Queen Ann St. to have it—but the grim master of the Castle Giant Grimbo shakes his head and says he & you must first agree that all is done to the plate [see Letter 194] that is necessary, & the picture will be wanted to refer to. Now as I know he goes out a good deal fishing at this season—& then leaves town for some months tour in the Autumn, I hope you will do what is required while he is in town. He is at home today & tomorrow, for he is to dine with me tomorrow —he said he should then get off after the fish.

 Pray fasten your strongest hook into him before he fairly takes water again or he may get so far and so deep that even a harpoon will not reach him...
(Victoria and Albert Museum, 86 FF. 73, fo. 8)

 Bicknell had also financed Hogarth's print of *The Fighting Téméraire* (see Letter 291) and was quarrelling with Turner in this same year about his fee (H. I. Shapiro, *Ruskin in Italy* (1972) p. 248), and about the execution of *Whalers* (B.-J. No. 415). But Turner was still visiting Bicknell in 1847 (Falk, p. 207).

Literature: D.N.B.

BRITTON, John (1771–1857), **42, 43, 61,** 37, 239, 247.

Antiquary, topographer, and miscellaneous writer. Britton and Turner shared several friends and associates at the end of the 1790s: Robert Ker Porter, the amateur painter; The Earl of Essex (q.v.); J. Walker, the publisher of *The Copper-Plate Magazine*, for which Turner had been working; and perhaps Charles O'Brian, whose *British Manufacturer's Companion* (1795) found its way into Turner's library. Their first professional connection was in the *Hampton Court* plate of Britton's *Beauties of England and Wales* (1801, R. 63). Britton made what was probably the first general critique of Turner's work in *The British Press*, 9 May 1803: '. . . We have long observed and admired the improving execution of Mr TURNER . . . [who] generally attempts at the sublime, and though he sometimes fails yet his failure is like the fabulous Phaeton's . . . the most prominent performances of the present exhibition . . .' But later Britton confessed, 'I could not reconcile myself to be commonly courteous to [Turner], from his chilling, forbidding tone and laconism of language and behaviour.'

Literature: The Auto-Biography of John Britton (1849–56).

BUCKLAND, William (1784–1856), **262.**

Geologist, Canon of Christ Church, Oxford, Dean of Westminster. Fellow of the Geological Society, 1813; President 1824 and 1840. F.R.S. 1818. Author of *Reliquiae Diluvianae, or Observations on the Organic remains attesting the action of a Universal Deluge* (1823) and *Geology and Mineralogy Considered with Reference to Natural Theology* (*The Bridgewater Treatise*), 1836. Chantrey (q.v.) was one of Buckland's 'oldest and most intimate friends' (*Bridgewater Treatise*, 2nd. edn. 1858, i, p. lxviii; 1836 edn., i. 305 n; Cambridge, Trinity College, Add. MS. a 66[31] and Buckland to Dawson Turner, 2 Dec. 1837), and he was also the intimate of Charles Stokes (q.v.; cf. *Bridgewater Treatise* (1836), i. 396 n; Oxford, Bodleian Library, MS. Eng. Lett. d. 5, fo. 239). In the late 1830s Buckland was close to John Ruskin (q.v.) at Oxford (see *Works*, xxxvi. 14), and among his closest associates in the following decade was the comparative anatomist and zoologist Richard Owen (cf. R. Gordon, *Life and Correspondence of W. Buckland* (1894), pp. 181 f.; British Library, Add. MS. 38091, fos. 189 ff), who became a friend of Turner's from about 1845 (R. S. Owen, *Life of Richard Owen* (1894), i. 262–4, 336). Buckland was chiefly noted for maintaining a catastrophist attitude to geological formation at a time when the climate of opinion, notably under the influence of Charles Lyell, was moving towards gradualism.

Literature: W. F. Cannon in *Dictionary of Scientific Biography* (1970).

BUCKLER, John (1770–1851), **63,** 288.

Antiquarian and topographical draughtsman. Architect until c. 1830. Exhibited at the Royal Academy 1796–1849. F.S.A. 1810. Worked much for Sir Richard Colt Hoare (q.v.).

Literature: H. Colvin, *A Biographical Dictionary of British Architects 1600–1840,* 2nd ed. 1978.

BULLOCK, Edwin (fl. 1830–70), **260,** 193.

Ironmaster and collector, of Hawthorn House, Handsworth, Birmingham. Christie's Sale Catalogue (21–3 May 1870) states that Bullock started his collection about 1830, and that most works were acquired direct from the artists. Bullock exhibited a painting of fruit by Campadolio (? Stefano Camogli, *c.* 1690) at the Birmingham Exhibition in 1833. His collection also included works by Hondecoeter and Ruysdael, Troyon, and Rosa Bonheur. But it was chiefly devoted to modern British art, including forty-five drawings by Cox and seven paintings by Constable, as well as works by Jones, Eastlake, Cooper, Wilkie, Leslie, Pickersgill, Mulready, Roberts, Callcott, Stanfield, and Collins (qq.v.), and Etty, Cotman, Maclise, and Bonington.

Literature: G. Waagen, *Treasures of Art in Great Britain,* iv (1857), 403 ff.

CADELL, Robert (1788–1849), **173, 174, 175,** 143, 144, 156, 283.

Publisher. Partner in Edinburgh with Scott's publisher Archibald Constable, until 1825, and thereafter the sole publisher of Scott (q.v.), whose close friend he was. Scott called him the clock (ingenuity) and Constable the pendulum (the cautious regulator). It was Cadell who persuaded Scott to employ Turner on the illustrations to a new edition of his *Poetical Works* early in 1831, but he does not seem to have met Turner until a visit to London in June of that year, when he found the painter 'a little dissenting clergyman like person—no more appearances of art about him than a ganger'. Turner, however, proved amenable and their relations became friendly; they were together on part of Turner's Scottish Tour in the late summer of the same year.

Literature: G. E. Finley, *Landscapes of Memory: Turner as illustrator to Scott,* 1979.

CALLCOTT, Augustus Wall (1779–1844), **329,** 88, 89, 95 n. 2, 99, 103, 116 n. 2, 139 n. 3, 157 n. 2, 201, 240, 242, 244, 252, 256, 267, 268.

Landscape and genre painter. Student at R.A. Schools. Recognized as a rival to Turner by 1805 (Finberg 1961, p. 116) and as his leading rival from the following year. Turner supported his election as A.R.A. in 1806 and R.A. in 1810. Callcott served with Turner as Visitor to the Life School in 1811 and to the new Painting School in 1815. As arranger of the Royal Academy Summer Exhibition in 1818, gave preference to Turner's *Dort* over his own work (Finberg 1961, p. 251). Married Maria Graham in 1827 (see Letter 119) and made first trip to Italy. Knighted 1837. Conservator of the Royal Pictures, 1844. Turner was greatly moved by the news of his death (Finberg 1961, p. 405, and Letter 272).

Literature: D.N.B., D. Brown, 'Turner, Callcott and Thomas Lister Parker', *Burlington Magazine* cxvii, 1975; D. Cordingly, *Connoisseur*, October 1973.

CANOVA, Antonio (1757–1822), **86,** 120 n. 6.

Venetian sculptor and painter. The most prominent artistic personality of his day. Especially close to English patrons and artists in Rome, where he settled after 1780. Entrusted with the repatriation of the Italian works of art looted by Napoleon, for which Pope Pius created him Marchese d'Ischia in 1816 (see the portrait of the Pope by Lawrence at Windsor Castle). Visited London in 1815 and fêted by the Royal Academy. B. R. Haydon took him to see Turner's Gallery where 'He Exclaimed "grand Genie" as he looked at his pictures' (Haydon, *Diary*, 28 Nov. 1815, ed. Pope, i (1960), 484). On 15 Nov. 1819 Turner went with Lawrence, Chantrey, Jackson, Thomas Moore, and Canova to the Venetian Academy in Rome, where Canova had first studied:

and saw the naked model—a very noble figure of a man, who threw himself into the attitudes of the various ancient statues with striking effect. From thence we all went to the Academy of St Luke's, where there were near a hundred students, drawing and modelling from another naked figure, not quite so good as the former. (T. Moore, *Memoirs, Journal and Correspondence*, ed. Russell, iii (1853), 74)

Canova himself practised the comparison of the living model with the Antique, and Turner adopted it as Visitor to the Life School at the Royal Academy (cf. T.B.E. No. B 51). Canova left a complete collection of his casts and models to his native Possagno, and perhaps gave the stimulus to Soane and Turner to do likewise.

Literature: F. J. B. Watson, 'Canova and the English', *Architectural Review*, 122 (1957), 403–6.

CHANTREY, Francis Legatt (1781–1841), **77, 142, 151, 156,** 1, 3, 7, 9, 119, 125, 129, 130 n. 1, 131, 136, 138, 139 n. 2, 160, 171 n. 1, 184 n. 2, 186, 241, 243, 246, 247, 248, 270, 275, 288, 289.

Sculptor and illustrator. Taught drawing in Sheffield by John Raphael Smith. Working in R.A. Schools 1802, although not formally enrolled. R.A. exhibitor from 1805. 1811, introduced by Thomas Stothard to his patron Johnes of Hafod, for whom he produced an important monument. In 1815 Chantrey accompanied Stothard to Paris (Mrs. Bray, *Life of Thomas Stothard* (1851), p. 70). A.R.A. 1815; R.A. 1818. Knighted 1835. Chantrey was much interested in the natural sciences: Leslie often heard him quote Davy and Wollaston (Leslie 1860, i. 77); Cockerell noted that he 'smattered on geology' (*Diary*, 13 Dec. 1825; Mrs. Crichton coll.) and Jones records that Charles Stokes (q.v.) 'was a constant guest, and it was a common occurrence to meet men distinguished by science or literature [at Chantrey's Sundays] ... In the evening, the specimens of his minerals and fossils were examined and the instructive allurements of the microscope filled every moment with gratification' (pp. 98 f.). Chantrey's collection of paintings was chiefly modern: among the landscapes were works by Prout, James Stark, William Daniell, Stothard, Callcott, and Creswick, and he had genre paintings by Stothard, Bird, and Wilkie (cf. Christie, 30 Apr. 1853; 15 June 1861). He practised landscape himself, and his admiration for Turner was 'unbounded':

He could well comprehend the mental scope of [Turner], and although he disapproved of his later style as compared with that displayed in his pictures of 'Carthage', 'The Tenth Plague' and 'Crossing the Brook', yet he stood forward at all times in defence of Turner's efforts of imagination: (Jones, pp. 104 f.)

and he acquired *What you Will* (1822; B.–J. No. 229) into which Turner had introduced some of the classical statuary he had studied in Rome in 1819, and *Ducal Palace, Dogano, with part of San Giorgio, Venice* (R.A. 1841; B.–J. No. 390). Turner is reported to have corrected Chantrey's maquette for his statue of Canning at Westminster (*Once a Week*, 1 Feb. 1862, p. 163; Chantrey worked on this statue between September 1829 and July 1834 (Royal Academy, *Chantrey Ledger*, p. 213)). Cockerell (loc. cit.) attacked Chantrey's ignorant talk of ancient art and his ridicule of the ideal: 'says he will do anything but an allegory'. But Coleridge in 1819 wrote 'I am more and more delighted with Chantrey—the little of his conversation which I enjoyed, was ex pede Herculem, left me in no doubt of the power of his insight. Light, Manlihood, Simplicity, wholeness—these are the *entelechie* of Phidian Genius—and who but must see these in Chantrey's solar face, and in all his manners?' (*Letters*, ed. Griggs, iv. 911); and

Scott noted a few years later that Chantrey was 'a right good John Bull, blunt & honest & open without any of the nonsensical affectation so common among artists (*Letters*, ed. Grierson, ix. 115). Turner and Chantrey had a common interest in promoting British art: Chantrey left the income from his residuary personal estate for 'the purchase of WORKS OF FINE ART OF THE HIGHEST MERIT IN PAINTING AND SCULPTURE that can be obtained, either already executed or which may hereafter be executed by artists of any nation, provided such artists shall have actually resided in Great Britain during the executing and completing such works [which were to be] collected for the purpose of establishing A PUBLIC NATIONAL COLLECTION OF BRITISH FINE ART PAINT-ING AND SCULPTURE executed within the shores of Great Britain ...' (*Chantrey and his Bequest* (1904), pp. 15 ff.). Chantrey was appointed an Executor of Turner's first will (30 Sept. 1829), but not subsequently.

Literature: G. Jones, *Sir Francis Chantrey, R.A. Recollections of his Life, Practice and Opinions* (1849).

COBB, George (fl. 1820–40), **126, 127, 132, 171, 179, 183, 212, 213, 238, 240.**

Solicitor. First recorded in connection with Turner in a lease of 20 Aug. 1823 for premises at 65 Harley St. to Edward Brafield, Cabinet Maker (Boston Public Library MS. 1290). Cobb drew up Turner's will in 1831. He seems to have retired from Clement's Inn first to Wilton (Letter 212) and subsequently to Brighton (Letter 236).

COLLARD, W. F. [?] (fl. 1806–79), **245.**

Turner's correspondent may be the W. E. Collard who was a founder-member and Director of the Artists' General Benevolent Institution in 1814. He is probably the musician, partner in the piano firm of Clementi, who was a friend of William Collins (q.v.) and Washington Allston (W. W. Collins, *Memoirs of the Life of W. Collins* (1848), i. 94, 143), and whom C. R. Leslie (q.v.) described in 1812 as 'a man of excellent sense, though generally so facetious that one feels inclined to laugh at everything he says' (*Autobiographical Recollections* (1860), ii. 11). Moscheles (q.v.), who met him in the 1820s, called Collard 'one of the most intelligent men he ever came across' (I. Moscheles, *Recent Music and Musicians* (1873), p. 72).

Literature: E. Lamburn, *A Short History of a Great House: Collard & Collard* (1938).

COLLINS, William (1788–1847), **88,** 88, 240, 242, 245, 252, 267, 268f., 274, 288, 297.

Landscape and genre painter. R.A. Schools 1807. A.R.A. 1814. R.A. 1820. His *Scene on the Coast of Norfolk* bought by the Prince Regent in 1815. 1817 visited Paris with C. R. Leslie (q.v.) and Washington Allston. 1818 with Chantrey (q.v.) in Edinburgh. 1822 saw Turner in Edinburgh (Finberg 1961, p. 277) and married the daughter of Andrew Geddes, A.R.A. Close friend of Wilkie (q.v.). 1823 collaborating with Turner on Cooke's *Rivers of England*; Constable noted that he was a supporter of Turner in some 'civil war' at the Academy (*John Constable's Correspondence*, ed. Beckett, vi. 125). Collins in the 1820s was linked with Constable as a naturalist, and said to be more popular than the fantastic Turner (Finberg 1961, p. 289). In 1818 Colt Hoare (q.v.) suggested to Leicester (q.v.) that he should exchange one of his Turners for a Collins, 'who is more the painter of nature' (Hall, p. 67).

 Literature: W. W. Collins, *Memoirs of the Life of William Collins* (1848).

COOKE, George (1781–1834), **54, 80,** 55, 91, 105, 269, 276.

Engraver. Brother of W. B. Cooke (q.v.). A founder-member of the Artists' Joint Stock Fund, 1810. Apprenticed in 1795 to James Basire, whose work after Turner on an *Oxford Almanac* subject (?R. 38, 1799) fired his enthusiasm for Turner. An obituarist wrote:

Early impressed with an unbounded admiration of the works of Turner, and sharing in a deep and well-founded conviction of the advantages likely to accrue from any plan which should place those wonders of the pencil more within the scope of public attention, the brothers seldom met without discussing their favourite topic, and many a sheme was formed and abandoned,) before their wishes could be achieved ... (*Gentleman's Magazine*, 1834, pp. 658 f.)

Cooke engraved some twenty plates after Turner between 1813 (R. 89) and 1826 (R. 189), the probable year of his quarrel with Turner over some proofs by Edward Goodall (? R. 125, cf. F. Goodall, *Reminiscences* (1902), pp. 161 f.). In January 1825 both brothers were members of the Artists' Conversazione, together with several other of Turner's engravers, notably Lupton and Wallis (qq.v.), and Le Keux, W. Finden, Goodall, and Pye (qq.v.), with whom George Cooke signed a pledge on 10 July 1826 never to apply for associate membership of the Royal Academy, 'until it shall render to the Art of Engraving that degree of importance which is attached to it in the other countrys of Europe' (MS. in Philadelphia Free Library. The attendance book of the Artists' Conversazione is in the Leeds City Art

Gallery). Cooke owned two Turner drawings: *Landscape, view on a river* (Christie, 12 July 1833 (78)) and *Malmesbury Abbey* (Christie, 2 May 1834 (471)), as well as watercolours and drawings by Chantrey, Roberts (qq.v.), Wilson, Girtin, Dayes, Hearne, De Wint, Clennell, Cox, Crome, Francia, and Landseer. He owned paintings by Arnald, Barker and J. B. Crome, Heemskerk, Breughel, 'An Illuminated Capital Letter, with figures in adoration', 'A highly-finished Persian drawing' and 'A Saint—a curious picture, on a gold ground, with Russian inscriptions'.

Literature: Arnold's Magazine of the Fine Arts, iii (1833–4), 553–4.

COOKE, William Bernard (1778–1855), **47, 48, 49, 51, 53, 60, 66, 74, 75, 81, 82, 92, 95, 100, 102, 120, 121,** 59, 76, 79, 113 n. 1, 239, 240, 246, 269, 273, 299, 300.

Engraver and publisher. Pupil of William Angus, whose *Seats of the Nobility and Gentry* included a view of Fonthill Splendens after Turner (R. 62, 1800). Worked with his brother George (q.v.) on Britton and Brayley's *Beauties of England and Wales* (1801–16), which also included a plate after Turner (R. 63). His first commission for Turner was the *Southern Coast* series by May 1811 (Finberg 1961, p. 182). Engraved some thirty plates after Turner between 1813 (R. 88) and 1834 (R. 559). His account books of 1817–25 (Thornbury 1877, pp. 633–6) show that he employed Turner to work on many other plates than those after his own drawings. From 1822 to 1824 Cooke held large annual loan exhibitions of watercolours and drawings, chiefly Turner's, and mainly those used for his own publications, but also including specially commissioned works (cf. Finberg 1961, pp. 273 ff.). A large sale of his print stock, including many proofs after Turner, was held in 1828 (Southgate, 5–6 December), and another in 1830 (Southgate, 7 July and following days), which also included a number of drawings by Wilson, Francia, Copley Fielding, De Wint, and two landscape studies in oil by Lawrence (cf. Royal Academy, *Sir Thomas Lawrence* (1961), No. 32). Cooke's 'retiring sale' (Southgate, 16 July 1830 and following days) was entirely of prints, including many by Old Masters, and proofs after Turner.

Literature: D.N.B., Rawlinson.

COOPER, Abraham (1787–1868), **96,** 216 n. 3.

Battle and animal painter. A.R.A. 1817; R.A. 1820. 1812 member of the Artists' Fund, and later Chairman. 1816, two premiums at the British Institution for the *Battle of Waterloo* and *Blücher at Ligny*, which was acquired by Egremont (q.v.). His *Military Trumpeter* was bought

by Walter Fawkes (q.v.) Sidney Cooper remembered him as kind and genial, and recalled: 'He told me to study Nature, and then to carefully paint everything I saw at first' (T. S. Cooper, *My Life* (1890), i. 116–18).

Literature: D.N.B.

DARLINGTON, William Harry Vane, Earl of (1766–1842), **72.**

Matriculated at Christ Church, Oxford, 1783. Whig M.P. for Totnes, 1788–90, and for Winchelsea 1790–2. Created Baron Raby of Raby Castle and Duke of Cleveland, 1833.

DELAMOTTE, William (1775–1863), **2, 301.**

Watercolourist, painter, etcher and Drawing Master. Student at the R.A. from 1794, exhibitor 1796–1848. Working in Oxford 1797–1803. Showed South Wales sketches to Farington there on 19 Oct. 1800 (Farington, *Diary*). His early watercolour style was close to Girtin; from about 1803, when he became Drawing Master at the Royal Military College at Great Marlow, he was working in oils from nature in the Thames Valley (*Tate Gallery Report 1968–70*, p. 64; Tate Gallery, *Landscape in Britain* 1973/4 No. 250). Delamotte was probably the Oxford Drawing Master cited as the earliest owner of Turner's oil, *Kilgarren Castle* (R.A. 1799, B.–J. No. 11); certainly he was a subscriber to Turner's print *A Shipwreck* in 1806 (T.B. LXXXVII, p. 2: a 'fine proof', sold Sotheby, 23 May 1863, lot 378); and he bought many later prints after Turner (T.B. CXI, p. 97a, Sotheby, lots 369–76). Like Turner he visited Paris in 1802 and copied a Ruysdael in the Louvre (Sotheby, 22 May 1863, lot 127).

Literature: D.N.B.; J. C. Wood in *Apollo*, lxxxiii (1966).

DOBREE, Samuel (1759–1827), **5, 6.**

City Merchant and Banker. As well as the works referred to in the correspondence, Dobree owned Turner's *Fishermen upon a Lee-Shore* (B.–J. No. 16), *Sheerness as seen from the Nore* (Turner's Gallery 1808, B.–J. No. 76), *A Coast Scene with Fishermen* (B.–J. No. 144), and an impression of the print *A Shipwreck* (T.B. LXXXVII, p. 2). Dobree also commissioned works from George Morland and Wilkie, with whom he was on friendly terms from 1808. He owned a set of Goya's *Caprichos* and made an English version of the commentary on them (see *Burlington Magazine*, cvi (1964), 8–9). T. F. Dibdin, who met Dobree about 1820, wrote:

> His cellar was curious and his table was large. He loved art in all its varieties, and had been a sort of Maecenas in former days, to Chantrey, to

Turner and to Wilkie; having some five sea-pieces of the second (when his style was grand from the breadth of his shadows and the sobriety of his colouring), and of the latter, the original picture of 'Hiring the Servant' ... Mr Dobree had, of all men whom I knew, one of the most pleasant and unaffected modes of address, and reception of his friends. His heartiness of speech did not exuberate with noisy exclamation or generalising remark. It was quiet, warm and winning. A few words, in his *sotto voce* manner of uttering them, found their way directly to your heart. His hand was always fully grasped within yours ... not a sort of cold, stiff, protruding, pick-locking forefinger—but the whole four fingers and thumb went instantly within all the wards of friendship's lock. (*Reminiscences of a Literary Life*, ii (1836), 686–9.)

Literature: A. Cunningham, *Life of Sir David Wilkie* (1843), i, ii; Finberg 1953.

EASTLAKE, Sir Charles Lock (1793–1865), **140, 147, 149, 154, 160, 216,** 62, 63 n. 3, 120 n. 5, 218 n. 2, 225, 240, 242, 256, 262, 267, 269, 270, 274, 275, 279, 299, 301.

Painter, scholar, and art-administrator. A.R.A. 1827; R.A. 1830; P.R.A. 1850. Secretary of Royal Commission on the Fine Arts, 1841; Director of the National Gallery, 1855. Born in Devonshire; student at the Academy Schools in 1809 and friendly with Turner by 1811. Travelled in Greece and Italy. Probably with Turner in Rome in 1819, and shared a house with him there in 1828. Discussed Turner's work in *Materials for a History of Oil Painting* (1847) and *Contributions to the Literature of the Fine Arts* (2nd series, 1870). Turner owned and annotated his translation of Goethe's *Theory of Colours* (1840; cf. Gage 1969, ch. 11). His sale (Christie, 14 Dec. 1868) included proofs of two Turner prints: *Ancient Italy* (R. 657) and *Wreck of the Minotaur* (R. 811).

Literature: Gage 1968; D. Robertson, *Sir Charles Eastlake and the Victorian Art World*, 1978.

EASTLAKE, Elizabeth Rigby, Lady (1809–92) **320,** 256, 274, 277.

Writer on art, translator, amateur artist. Born in Norwich but brought up in Edinburgh. Moved to London and attended Sass's drawing school in 1832. Moved in the circles of John Murray, Samuel Rogers, Richard Ford, and H. A. J. Munro of Novar (qq.v.) and met Turner at Murray's in March 1844: 'a queer little being, very knowing about all the castles he has drawn—a cynical kind of body, who seems to love his art for no reason than because it is his *own*.' She visited Turner's Gallery with Munro in 1846. Elizabeth Rigby was one of Turner's most perceptive admirers, especially of his late work, and much affected by Ruskin's writings, which she none the less criticized severely in the *Quarterly Review* for March 1856. She married

Charles Lock Eastlake (q.v.) in 1849. Just after Turner's death she recorded: 'It is odd that, two days before he died, he suddenly looked steadily and said he saw "Lady Eastlake". This the woman who lived with him [Sophia Booth], and whose name he passed under in a quarter where nobody knew him...'

Literature: Lady Eastlake, *Journals and Correspondence*, ed. Smith (1895).

EGREMONT, George O'Brien Wyndham, Third Earl of (1751–1837), **146,** 2, 3, 28 n. 2, 56 n. 2, 118, 127, 132, 133, 159, 168 n. 1, 169, 195 n. 5, 247, 261, 275, 280.

Farmer, racehorse breeder and art patron. F.R.S., F.S.A. Travelled as a young man in Germany and Austria. Began collecting British art from 1775. Assembled thirty-four works by Thomas Phillips (q.v.), twenty-two by Reynolds, and twenty by Turner, starting with *Ships bearing up for Anchorage* (B.–J. No. 18) in 1802. From 1802 until about 1813 Egremont bought Turner's work regularly, and owned fifteen oils by the latter date. But between 1813 and about 1827 he acquired no more Turners, perhaps because of the scandal arising from *Apullus* (see Letter 50): in 1825 he showed none of his Turners at the British Institution exhibition, *Pictures by Living Artists of the English School*, although he lent six other pictures from Petworth. Turner did, however, transmit Egremont's 20-guinea subscription to the Artists' General Benevolent Institution in July 1816 (Minute Books at the Artists' General Benevolent Institution). By August 1828 two of Turner's long landscapes, *The Lake, Petworth: Sunset, a Stag Drinking* and *The Lake, Petworth: Sunset, Fighting Bucks* were installed in the dining room at Petworth in the Grinling Gibbons carved compartments (J. Gore (ed.), *T. Creevey's Life and Times* (1934), p. 277). The subjects were a celebration of Egremont's policy of improvement at Petworth (cf. the Revd. Arthur Young, *General View of the Agriculture of the County of Sussex* (1813), pp. 188–9), and the other two panels of the series also reflect his business interests: *Chichester Canal*, in which he had been a principal shareholder, although he surrendered his holding in 1826 (P. A. L. Vine, *London's Lost Route to the Sea* (1965), pp. 78, 89); and *Brighton from the Sea*, showing the Brighton Chain Pier, opened in 1823, and in which Egremont held three £100 shares (Shareholders' Book in Brighton Public Library). Three other of Egremont's Turners bear directly on his estates: *Petworth: Dewy Morning* (1810), *Cockermouth Castle* (1810), and *The Forest of Bere* (B.–J. No. 77; cf. Young, op. cit., pp. 175–7). The series of 116 gouaches of Petworth also seems to date from about 1827–8 (cf. T.B.E. Nos. 341 ff.), and Turner's second visit to Rome in 1828 also had Egremont's interests in mind (see Letters 140, 146, 147). But although

Turner visited Petworth in 1827, 1829, 1832, 1834, 1836, and 1837, and possibly in 1830 and 1831; and although he probably executed many works there (e.g. B.–J. Nos. 338, 340, 445, 447, 449), Egremont acquired only one further work of Turner's: *Jessica* (B.–J. No. 333), which may be related to the *Woman with a Rosebud* at Petworth, then regarded as a Rembrandt, but now given to Koninck. Egremont told C. R. Leslie: 'I look upon Raphael and Hogarth as the two greatest painters that ever lived' (Leslie, *Autobiographical Recollections*, i. 105), although he owned no works by either; and in 1824 he had given Constable the impression that 'landscape affords him no interest whatever' (*John Constable's Correspondence*, ed. Beckett, vi. 171). By the late 1820s he may well have felt he had quite enough of Turner's work. In 1834 Egremont hoped to get Turner and Constable together at Petworth, but Turner had another engagement (*Correspondence*, cit. iv. 419). Turner led the procession of artists at Egremont's funeral. Three letters from him to Egremont (Sotheby, 24 July 1891 (111), bt. Murray) remain untraced.

Literature: R. Walker, 'The Third Earl of Egremont, Patron of the Arts', *Apollo* (1953), pp. 11–13. E. Joll, 'Painter and Patron: Turner and the Third Earl of Egremont', *Apollo*, cv (1977).

E.H. 236
ELGIN, Thomas Bruce, 7th Earl of (1766–1841), **17**, 131.

Diplomat and archaeologist. In 1799 he led an expedition to Constantinople and Greece, which brought back the Parthenon marbles, now in the British Museum. Among the artists approached to join the expedition as draughtsmen were Thomas Girtin, who declined the offer of £30 per annum, and Turner, who apparently asked for £400 per annum (Elgin later claimed that it had been £700–800, plus expenses), and also wanted to keep some of the fruits of his labours. Turner also declined. But their relations remained cordial: in 1822 in Edinburgh it was Elgin who secured for Turner permission to attend the Provost's Dinner (C. R. Cockerell's Diary, 23 Aug. 1822, in the possession of Mrs. Crichton).

Literature: William St. Clair, *Lord Elgin and the Marbles* (1967).

ELLIOTT, H. (recorded 1811–62), **266**, 294.

A life-long friend of W. F. Wells and his family (qq.v.). Private Secretary in the War Office from 1811, under the patronage of Palmerston, some of whose Gainsborough drawings were engraved by Wells in his *Collection of Prints* ... (1802–5) (Oxford, Bodleian Library MS. Finch c. 2 d. 5, fo. 318). Worked in the Office of Military Boards from 1822. Elliott was presented with Wells's *Fortress of Frederickshall*

after his death in 1836 (Roget 1891, i. 206 n). Elliott was an admirer of Byron's *Childe Harold* as 'full of fire and spirit, sublime, familiar, melancholy or jocular, as the author's fancy or subject prompt him ... [the poem] has more *extractible* passages than most poems of the same length: but many of the sentiments & opinions in it are of the very worst description' (MS. Finch, ibid., fo. 240). He may be the 'Elliott' listed as a subscriber to Turner's *Shipwreck* print in 1805 (T.B. LXXXVII, p. 2).

ELLIS, Charles (fl. 1845–61), **278.**
Poet.

ESSEX, George Capel-Coningsby, 5th Earl of (1757–1839), **22,** 241, 256.

As Viscount Malden, Capel-Coningsby succeeded to Hampton Court, Herefordshire, in 1781. Tory M.P. for Westminster 1779–80; created 5th Earl of Essex 1799; F.S.A. 1801. Hampton Court was sold in 1808, and Essex moved to the other family seat of Cassiobury Park near Watford, Hertfordshire. Essex collected chiefly British art: he owned Girtin's *Paris Views*, and patronized Edridge and Varley; he collected works by Hogarth, Gainsborough, Zoffany, Reynolds, Benjamin Barker, Callcott, Collins, Leslie, Wilkie, Landseer, Clint, Morland, Cooper, and George Jones. C. R. Cockerell, visiting Cassiobury, wrote:

he has works of all the best modern artists, Turner, Calcot, Wilkie, Landseer, Jones &c—however the faults of all modern houses in here in excess, too much stoved heat—too many doors receptive of too many tastes—too much refinement of nicknacks conundrums & contrivances—too much of minuteness & sacrificing to these the greater considerations of Taste, a magnificent ceiling above (a real work of art) neglected & overlooked & minutiae attainable by mechanics & ordinary fellows preferred before them & recommended (*Diary*, 28 Oct. 1825; D. Watkin, *The Life and Work of C. R. Cockerell* (1974), p. 80).

Essex's hospitality and his 'friendly familiarity' was proverbial (Farington, 7 July 1809; 6 Sept. 1813); among the frequenters of Cassiobury was Dr. Thomas Monro, who lived at nearby Bushey (J. L. Roget, *History of the Old Watercolour Society* (1891), i. 392).

Turner's first work for Essex was a series of five watercolours of Hampton Court based on sketches done in 1795 (T.B. XXVI, pp. 49–53 and flyleaf), for which Essex seems to have paid 2 guineas each about 1799 (cf. T.B. XXV, p. 1). Four of them are now in the Whitworth Art Gallery, Manchester, and one is in the Victoria and Albert Museum. Essex also ordered two more views of Hampton Court and

two of Ludlow Castle in 1798 (T.B. XXXVIII, pp. 11a, 63, 66, 67), but it is not known if they were executed. Eleven drawings of Cassiobury Park are in a sketchbook in use from about 1799 (T.B. XLVII) and another is on paper watermarked 1804 (T.B. CXXa): Farington records on 15 Nov. 1807 that Turner had been 'lately' making drawings of Cassiobury, and a note: *Ld Essex Casiobury 40* in a sketchbook of *c*. 1808 (T.B. CII, p. 1) may refer to a payment of 10 guineas each for the four views, two of them related to these sketches (T.B. XLVII, pp. 41, 43), which were engraved in aquatint for the *History and Description of Cassiobury Park* (1816, R. 818–21). Besides the oils referred to in the letter, Essex acquired *Trout Fishing on the Dee, Corwen Bridge and Cottage* (B.–J. No. 92) at Turner's Gallery in 1809 for £200 or guineas (Farington, 7 July 1809; cf. T.B. CXXII, p. 7a). The unfinished genre painting, *Harvest Home* (B.–J. No. 209) seems to have been intended for him (cf. T.B. LXXXVI, CXX C), and he was a subscriber to *The Shipwreck* print of 1805 (T.B. LXXXVII, p. 2).

Literature: J. Britton, *The History and Description of Cassiobury Park* (1837).

FAWKES, Francis Hawkesworth (1797–1871), **275, 302, 307, 315, 318, 323,** 98, 113, 206.

Son of Walter Fawkes (q.v.). Witnessed the inception of several of Turner's works at Farnley Hall, notably *Snowstorm: Hannibal and his Army crossing the Alps* (1812, B.–J. No. 126), and the watercolour *A First-Rater Taking in Stores* (1818, T.B.E. No. 194). Hawkesworth Fawkes is said to have persuaded his father to buy *The Dort* in 1818 (Finberg, *Turner Watercolours at Farnley Hall*, p. 17); and he himself purchased Turner's first Rembrandtesque subject-picture, *Rembrandt's Daughter* in 1827 (B.–J. No. 238). He exhibited twenty-seven of the Farnley Turner's at the Northern Society's Exhibition in 1826 (*Literary Gazette* 26 August, p. 540) and forty-two in 1839 (Finberg 1961, pp. 502–5). In 1828 Fawkes was patronizing Turner's friend in Rome, Joseph Severn (Finberg 1961, p. 292). Ruskin dedicated his *Pre-Raphaelitism* (1851) to him. Fawkes sent Turner a goose-pie regularly for Christmas between 1827 and 1851, and this seems to have been the chief occasion for their correspondence.

Literature: Thornbury 1877, pp. 234, 237–42.

FAWKES, Walter Ramsden Hawkesworth (1769–1825), **79, 83,** xxvi, 61, 66, 69, 81, 91, 98, 113, 206, 247.

Brevet-Col. in 4th W. Riding Militia, 1798–9. Farmer, sportsman, and collector. Amateur painter (cf. the Revd. H. F. Mills, *Elegaic Stanzas on the death of Walter Fawkes*, 1825). Whig M.P. for Yorkshire,

1802–7 (On his politics: Lindsay 1966, pp. 138, 239). High Sheriff of Yorkshire, 1823. Founder of Otley Agricultural Society. Author of *The Chronology of the History of Modern Europe*, 1810. In 1794 Fawkes commissioned four oils from William Hodges, with which he was so dissatisfied he vowed to buy only watercolours henceforth (Farington, 6 December). Paid 300 guineas for a Ruisdael in 1796 (Farington, 4 March) and acquired many Dutch and Flemish pictures from the Orleans Sale in 1798 (see Christie, 28 June 1890). Turner is said to have borrowed a Guercino *Pallas and Arachne* from him to make use of the figures (Armstrong, p. 88). In 1798 Fawkes commissioned work from the marine painter William Anderson (*Burlington Magazine*, cvii (1965), 24) and by about this time he owned a substantial collection of Swiss views by John 'Warwick' Smith. In 1819 he exhibited a large collection of drawings by Fielding, Varley, Hills, De Wint, Glover, Prout, Sawrey Gilpin, Heaphy and others, as well as Turner (see T.B.E. No. B136). Turner may have met Fawkes in 1798 or 1799, when he was working near Farnley at Harewood, and under the patronage of a close friend of Fawkes, Thomas Edwards of Halifax (H. E. Wroot, *Thoresby Soc. Miscellanea*, xxvi (1924), 230–3). They seem to have been close by soon after 1802, since Fawkes, who had long had a special liking for Switzerland, ordered some thirty watercolours from Turner's sketchbooks of that year, of which twenty were executed until about 1815. Fawkes subscribed to *A Shipwreck* print in 1805, and acquired some half-dozen oils from Turner between about this time (*Bonneville*, B.–J. No. 148) and 1818 (*The Dort*, B.–J. No. 137). But the weight of the collection was in watercolours: in addition to the Swiss series and those referred to in the letters, Turner made fifty-one drawings of the Rhineland at £10 each in 1817, and many occasional watercolours like the two figure subjects, emulating Heaphy: *Cottage Steps*, *Children Feeding Chickens* and *November, Flounder Fishing* of 1809 and 1811 (with Leger, 1968) and *Snowstorm: Mont Cenis* of 1820 (T.B.E. No. B90). More than sixty of these watercolours were exhibited publically at Fawkes's London home in 1819, to which exhibition Turner 'generally came alone, and while he leaned on the centre table in the great room, or slowly worked his rough way through the mass, he attracted every eye in the brilliant crowd, and seemed to me like a victorious Roman General, the principal figure in his own triumph' (W. Carey, *Some Memoirs of the Patronage and Progress of the Fine Arts* (1826), p. 147). Turner probably visited Farnley first in 1809 (see Letter 23): he was there most years until 1824, but never afterwards. Fawkes was a guest at the Academy Dinner in 1811, 1813–16, 1818, and 1821, several times sitting next to Turner, who also transmitted Fawkes's contributions to the Artists' General Benevolent Institution. After his death, Thomas Uwins wrote 'Fawkes buys from his own

feelings. He is a man of sound good sense, with a long purse and a noble soul' (Finberg 1961, p. 292).

Literature: Athenaum, 1879, ii; *Magazine of Art*, 1887, pp. 295 f.; A. J. Finberg, *Turner Watercolours at Farnley Hall* [1912]; id., *The Studio*, lv (1912), 89–96; Gage 1969, p. 32.

FINCH, Robert (1783–1830) **135,** 120 n. 8, 129 n. 4, 132 n. 9, 133, 135 n. 2, 136, 294.

Antiquary and traveller. B.A. (Oxon.) 1806. Ordained 1807. M.A. 1809. F.S.A. From 1814 travelling in Portugal, France, Switzerland, Italy, Greece, and the Holy Land. Married 1820. Collected an important body of Old Master and modern paintings and drawings, sculpture and coins (his inventory is Oxford, Bodleian Library MS. Finch c. 3). Among the modern artists with whom Turner had associations Finch owned works by Teerlink, Bassi, W. Ewing, Girtin, Hearne, W. F. Wells (15), Clara and Harriet Wells, Gainsborough, Wilson, and F. C. Lewis. Finch was an intimate friend of Wells and his family (qq.v.), and he owned a drawing of a *Farm-Yard* by Turner (No. 18 in his inventory) and a watercolour *View near Rhaidder* (1792) (No. 37 in his Inventory, now Oxford, Ashmolean Museum, Herrmann No. 88).

Literature: D.N.B.

FINDEN, Edward Francis (1791–1857) and William (1787–1852), **176, 184, 237,** 130 nn. 2 and 3, 172, 187, 246, 276.

Engravers and publishers. Both pupils of Turner's engraver James Mitan (William Finden's Indenture of 9 Apr. 1802 is in the Philadelphia Free Library). William Finden was secretary of the Artists' Conversazione in the late 1820s (Attendance Book in Leeds Art Gallery); he signed the undertaking of July 1826 not to apply for membership of the Academy until engravers were more fully recognized by that body (see under George COOKE), and one of his last acts was to petition Queen Victoria in the same cause. Edward Finden's first work after Turner was in 1826 (R. 315); William's in 1833 (R. 410, 411), but their most important enterprises with Turner were *Byron's Life and Works* (1832–4), which they financed and published in partnership with Murray, and *Landscape Illustrations of the Bible* (1833–6). In 1842 they were engaged on three large plates after Turner: *Nemi, Oberwesel*, and *The Fighting Téméraire* (R. 659–61), when they were declared bankrupt (see Letter 249). In the 1820s they also worked on engravings after the Elgin Marbles and on William Brockendon's *Passes of the Alps* (1829).

Literature: D.N.B.

FORD, Richard (1796–1858), **287,** 198 n. 3, 249, 274.

Traveller, writer, collector, and amateur artist. Married a natural daughter of the Earl of Essex (q.v.) in 1824. In Spain 1830–4; supplied Spanish sketches to David Roberts (q.v.) in late 1830s. In 1840–5 working on *A Handbook for Travellers in Spain* for John Murray (q.v.). Among Spanish painters, Velasquez was especially admired by Ford, and of the moderns Goya, whose series of small paintings in the Academy of San Fernando in Madrid he called 'among the best productions of modern Spanish art' (*Handbook*, ii. 736). Ford was a friend of Charles Lock Eastlake (q.v.), and Lady Eastlake recalled a lunch with him in June 1850: 'The house is full of exquisite works of art and Mr Ford was all wit and brilliancy' (*Journals and Correspondence*, i. 250). After 1843 Ford worked up his early Spanish sketches into gouache drawings in a style closely based on Turner's *Rivers of France* (Brinsley Ford Coll.); in the *Handbook* Turner is occasionally recalled, as in the account of Granada from the Alhambra (i. 371): 'Then in the short twilight how large the city below looms, always a grand sight from an elevation, but now growing in mystery and interest in the blue vapours. How Turner would paint it!' Ford's three large watercolours by Turner were probably Views of Cassiobury, inherited from Essex (G. Waagen, *Treasures of Art in Great Britain*, ii (1854), 223 ff.). He visited Turner's Gallery again in 1850 (Ford Family Papers).

 Literature: Wildenstein (London), *Richard Ford in Spain* (1974) (Catalogue by Denys Sutton and Brinsley Ford).

FOWLER, Charles, **221.**

Secretary to the Artists' General Benevolent Institution.

GEDDES, Adela (fl. 1828–46), **294.**

Wife and biographer of the painter Andrew Geddes (1783–1844), who was a close friend of Turner's in the 1820s (see Letters 112, 116, 154, and Thornbury 1877, p. 464). Adela Geddes may be the 'Mrs G' described as an 'old friend' of Turner's in a note from A. W. Callcott to Mulready (qq.v.; Victoria and Albert Museum MS. 86 NN1). Certainly she met Turner in Rome when visiting the city with her husband in 1828 (Adela Geddes, *Memoir of the Late Andrew Geddes Esq. R.A.* (1844), p. 16). She wrote of his art (ibid., p. 24):

His colouring, to which he had given the greatest attention, was that in which he most excelled. His landscapes, to the lovers of truth and effect, are charming, and his *Mercury and Argus* evinces excellence of the highest kind; but his

landscapes generally are painted in that broad style which gives pleasure more to the artist and connoisseur than to the public.

GILLY, Mr **10.**

GIRTIN, James (or Jack) (1773–*c.* 1820), **13,** 266.

Engraver, printer, and publisher, brother of Thomas Girtin, whose *Views in Paris* he published in August 1802. James Girtin purchased several works, including the only known oil, at his brother's sale in June 1803 and continued to run his panorama, the *Eidometropolis* after his death. His last dated publication was a mezzotint by S. W. Reynolds after Opie's portrait of Thomas Girtin, dated 1817, the year in which a fire destroyed his premises.

Literature: Pye–Roget; T. Girtin and D. Loshak, *The Art of Thomas Girtin* (1954).

GOODALL, Edward (1795–1870), **162, 330,** 3 n. 5, 94, 246, 268.

Self-taught engraver. Goodall's son (*Reminiscences*, p. 2) states that Turner was impressed by his father's painting *North-End, Hampstead—Sunset* at the 1823 R.A. Exhibition (160) and entrusted him with much work as a result; but Goodall had already engraved *Tantallon Castle* for Scott's *Provincial Antiquities* in 1822 (R. 198), and as early as July 1820 he contracted to engrave fifteen plates after Turner, Callcott, Westall, Nash, and McKenzie for an untraced publication on London (Document in Philadelphia Free Library). Goodall worked on a wide range of plates for Turner, from small vignettes to Rogers, Campbell, Moore, and Milton, to large plates like *Cologne,* 1824 (R. 203), *Tivoli,* 1827 (R. 207), and Goodall's last work for Turner during the painter's lifetime, *Caligula's Palace* of 1842 (R. 653). He signed the undertaking of 10 July 1826 not to apply for membership of the Academy (see under George COOKE).

Literature: F. Goodall, *Reminiscences* (1902).

GRIFFIN, Richard & Co., **206.**

Glasgow bookselling and publishing firm of Richard Griffin (1790–1832) and John T. Griffin (1802–?). Established by 1820, transferred to London 1848.

Literature: The Centenary Volume of Charles Griffin and Company, Ltd. (1920).

GRIFFITH, Thomas (1795–?), **234, 235, 264, 324, 325, 326, 331, 332,** 87 n. 3, 111, 218, 224 n. 1, 237f., 265, 269, 273, 281, 282, 297. Art-dealer. Pensioner at Trinity College, Cambridge, 1813; B.A. 1817; M.A. 1824. Admitted to the Inner Temple 1827 but not called to the Bar. He is perhaps the T. Griffiths who lent twelve drawings to the Retrospective Exhibition of the Old Water Colour Society in 1823 (Roget, i. 436). Griffith lent twenty-seven of Turner's *England and Wales* drawings to the Moon, Boys & Graves Exhibition in 1833, many of which he had probably acquired at the 1829 Egyptian Hall Exhibition (see Letter 128). In January 1834 John Sell Cotman wrote to Dawson Turner (q.v.) that Griffith 'behaved to me like a prince— A name known to you as a large collector, and a wholesale purchaser of the *best works* of modern art' (Cotman to Turner, 8 Jan. 1834, Mrs. G. Palgrave Coll.) Griffith in the 1830s was a frequenter of the *City of London Artists' and Amateurs' Conversazione*; and on 2 Nov. 1840 a group of about twenty artists, including Turner, Stanfield, Roberts (qq.v.), Uwins, Copley Fielding, and Harding presented him with a suitably inscribed piece of plate in recognition of his services to art. Ruskin's mother in 1838 described Griffith as 'dishonest in the common acceptation of the word' (*Ruskin Family Letters*, ed. Van Akin Burd (1973), ii. 527), but the *Athenaeum* wrote on the occasion of the presentation:

It is pleasant to find an amateur of pictures, whose fortune places him above the necessity of dealing, engaged in the delicate task of smoothing the difficulties which occasionally arise between painters and their patrons, and to see the artists manifesting their grateful sense of such liberal aid... To those purchasers of drawings who prefer negotiating with a third person, who is by circumstances independent of both parties, it may be satisfactory to know that the artist fixes and receives the whole price paid for his productions. (*Athenaeum*, 1840, p. 893)

Certainly Griffith opened a regular Gallery in Pall Mall in 1845, and was Turner's major dealer and print-publisher in this decade. Turner was frequently a dinner-guest at Griffith's; Ruskin (q.v.) first met the painter there in June 1840. Griffith attempted to negotiate the purchase of *Dido Building Carthage* (B.–J. No. 131), by a syndicate, for £2,500 or £3,000, to present it to the National Gallery (J. D. Coleridge to C. R. Cockerell, 17 Feb. 1857; Royal Academy Scrapbook, printed *The Times* 27 Dec. 1951). He took James Lenox (q.v.) to see Turner in 1848, when the American collector offered £5,000, and then a blank cheque, for the *Fighting Téméraire* (B.–J. No. 377; see W. J. Stillman, *Autobiography of a Journalist*, i (1901), 106). Both attempts were fruitless. Griffith also made an exceptionally fine collection of about sixty *Liber* proofs (Pye–Roget, pp. 80–3). Turner made him an executor of his will in 1848.

HAMMERSLEY, James Astbury (1815–69), **219.**

Landscape painter. Son of John Hammersley, who presumably sent him to train with Turner's closest follower, James Baker Pyne, after Turner had declined to teach him. Teaching at the Government School of Design, Nottingham, from about 1846. Head of Manchester School of Design, 1849–62.

Literature: D.N.B.; Thornbury 1877, pp. 275–80.

HAMMERSLEY, John, **271.**

See HAMMERSLEY, James Astbury.

HEATH, Charles (1785–1848), **128, 145,** 37 n. 4, 49 n. 1, 120, 291, 293, 299.

Engraver and print publisher. Son and pupil of James Heath (1757–1834), one of Turner's early engravers (R. 73–5). A Director of the Artists' General Benevolent Institution, 1814. Heath first worked after Turner on the figures of John Pye's *Pope's Villa* in 1811 (R. 76) and on four other plates before 1822. But his reputation derived chiefly from the *Annuals* he promoted in the 1820s and 1830s, to which Turner contributed several plates, and from the *England and Wales* series of 1826–38, which Heath brought out in partnership with Robert Jennings, and for which Turner received 60–70 guineas per drawing (Rawlinson, i, pp. xlvii–xlviii). Heath's finances were precarious; his ten public sales between 1826 and 1848 included only one Turner drawing, *Havre*, published in the *Keepsake* in 1834 (R. 330; Christie, 2–3 Mar. 1837, lot 68), but he sold most of the stock of *England and Wales* in 1840 (Sotheby, 23–8 April, lots 1131–1205), when it was bought up by Turner for £3,000 (Rawlinson, ibid.), and of the *Annuals* and *Turner's Annual Tours* in 1842 (Sotheby, 23–6 July). Other items in his sales included paintings and drawings by Bonington, Cox, Stothard, Martin, Linnell, Fielding, Leslie, Prout, Boxhall, De Wint, Uwins, Maclise, and Creswick, and lithographs by Géricault (Southgate, 9–13 May 1826, lot 8) and Delacroix (Sotheby, 23–8 Apr. 1840, lot 1394). Heath seems to have been most interested in *England and Wales*; he exhibited drawings not only at the Egyptian Hall in 1829 (see Appendix II), but also at the *Artists' and Amateurs' Conversazione* in January 1831 (*Athenaeum*, 1831, p. 75), and he presented a set of the prints to King Louis Phillipe in 1838 or 1839 (*Gentleman's Magazine*, xxxi (1849), 100).

Literature: E. Shanes, *Turner's Picturesque Views in England and Wales*, 1979.

HENSHALL, J., **190, 195.**

Possibly the engraver of *Winchelsea* in *England and Wales* (R. 245), and *Forum Romanum* in *The Remembrance* (R. 340), both of 1830.

HOARE, Sir Richard Colt (1758–1838), **8, 11, 12, 14, 16,** 242, 246, 264.

Banker and antiquarian. Studied watercolour with John 'Warwick' Smith. Inherited Stourhead in Wiltshire in 1785. Grand Tour 1786–7, where he became friendly with Sir John Fleming Leicester (q.v.) and the Swiss watercolourist Louis Ducros, several of whose works he acquired. His *Hints to Travellers in Italy* (1815) was in Turner's library. Turner may have met him by 1795; certainly Colt Hoare had become a major patron by 1799; and the association continued into the 1820s.
Literature: Woodbridge 1970; Gage 1974.

HODGSON, BOYS & GRAVES, **191, 192.**

See MOON, Sir Francis Graham.

HOGARTH, J., **291,** 240.

Printseller and publisher. Issued Willmore's *Old Téméraire* (R. 661) and Pye's *Ehrenbreitstein* (R. 662) after Turner.

HOLLOND, Robert (?–1877), **205.**

M.P. for Hastings, 1837–52.

HOLWORTHY, James (1781–1841), **55, 65, 67, 68, 70, 90, 94, 104, 112, 116, 119, 122, 133, 164,** 141, 231, 275.

Watercolour painter and teacher. Pupil of John Glover (1767–1849). Original member of the Old Water-Colour Society, 1804. Exhibitor at R.A. 1803–4 (Welsh views) and at the O.W.C.S. until 1824. Left London in 1822, although he seems to have kept a house there, and settle on an estate in Derbyshire. Married a niece of Joseph Wright of Derby in 1821 (Roget) or 1824 (Monkhouse). Holworthy was living with Glover at 4 Mount Street, London, in 1804 (Farington, 30 May), and is probably the *Holworthy Junr* subscribing to Turner's *Shipwreck* the following year (T.B. LXXXVII, p. 2; another Holworthy, of 19 Charlotte Place, also a subscriber, may be his father). He was possibly the Holworthy buying prints from Turner in 1811 (T.B. CXI, p. 97a). A receipt for his payment for the first number of *Liber Studiorum*, dated 19 Mar. 1814, is in the collection of Mr. Kurt Pantzer. About 1814 he was living near Turner's close friend, W. F.

Wells (q.v.) at York Buildings, and was a visitor to Turner's Gallery (Finberg 1961, p. 212). Holworthy seems to have been the owner of Watteau's *L'Isle enchantée*, which had been in the collection of Sir Joshua Reynolds, and from which Turner borrowed a number of figures for his *England: Richmond Hill on the Prince Regent's Birthday* of 1819 (H. Adhémar, *Watteau* (1950), p. 226, No. 188, repr. Pl. 115; and B.–J. No. 140).

Literature. Roget; Monkhouse.

HOWARD, Henry (1769–1847), **113,** 136, 139 n. 3, 274, 290.

Portrait and historical painter. Student at the Royal Academy 1788. First silver medallist for Life Drawing 1790. Visited Italy 1791. A.R.A. 1800; R.A. 1808. Secretary 1811; Professor of Painting 1833. Much patronized by Egremont (q.v.) from 1818 and Soane (q.v.) from 1819. A close friend of H. S. Trimmer (q.v.).

Literature: F. Howard, *Memoir* in H. Howard, *Lectures* (1848); Thornbury 1877, pp. 258–60.

HUMPHRY, Ozias (1742–1810), **3.**

Miniature painter. Travelled in Italy and India. R.A. in 1791. Failure of eyesight led him to abandon painting by 1797. An early supporter of Blake. Humphry's notebook (British Museum Add. MS. 22949) shows him to have been an enthusiast for landscape in nature and art, and notably for Richard Wilson. His views on landscape painting are sometimes very close to Turner's (e.g. 1803 in *Walpole Society* xiii (1925), 83–4). He had been closely associated with Turner in the Academy Council in 1803, and from about the same time was the intimate of Turner's patron Lord Egremont (q.v.).

Literature: G. C. Williamson, *Life and Work of Ozias Humphry R.A.* (1918).

JOHNS, Ambrose Bowden (1776–1858), **52, 58, 59,** 61, 130, 301.

Landscape painter. Apprenticed to Benjamin Robert Haydon's father, a Plymouth bookseller, and self-taught as a painter. Haydon relates that about 1802–3 Johns 'had brought down from town some plastercasts of the Discobolos and Apollo' which he sold to Haydon; and that he also had a library of art books, from which Haydon took Reynolds's *Discourses* (Haydon, *Life*, ed. Taylor (1853), i. 14; cf. also Letter 52). Johns owned a version of Thomas Girtin's *White House at Chelsea* (now Bacon collection), one of the works of Girtin which Turner most admired. He was also a friend of Blake's wife and an

admirer in the 1820s of the work of John Linnell (G. E. Bentley Jnr., *Blake Records* (1969), p. 366). In 1813 Turner went on a tour of South Devon with Eastlake (q.v.) and Johns, who supplied him with a portable painting box and materials to make a series of oil sketches (B.–J. Nos. 213–25), and accompanied him everywhere (Thornbury 1877, pp. 152–3). The Leeds sketch may be the one which, according to Samuel Prout, Turner sent back to Johns as a memento of the visit (*Plymouth, Devonport and Stonehouse Herald*, 18 Dec. 1858). One of Johns's drawings was engraved as a Turner in 1838 (Rawlinson, ii. 331), and other works by him have passed as Turner's in the sale room.

Literature: G. Pycroft in *Report and Transactions of the Devonian Association*, xiii (1881).

JONES, George (1786–1869), **136, 141, 161, 316, 321,** xxvii, 1, 2, 3, 5, 6, 9, 121, 131, 136, 139 n. 3, 143 n. 1, 160, 177, 178, 204, 211, 217, 236, 242, 252, 270, 275.

Historical painter, student at the Academy from 1801, exhibitor 1803 to 1811, when he joined the Peninsular Army. Winner of a second British Institution premium for a *Battle of Waterloo* in 1816, first premium for another in 1820 (Chelsea Royal Hospital), and another in 1822, when he became an A.R.A. He was elected R.A. in 1824, the year of his first known contact with Turner. He was Academy Librarian from 1834 to 1840, Keeper from 1840 to 1850 and Acting P.R.A. from 1845 to 1850. An obituarist adjudged him 'eminently conservative in all that tended to maintain the constitution and laws of the R.A.' (*Athenaeum*, 25 Sept. 1869, p. 409). Even Haydon thought him 'amiable in private life' (*Diary*, v. 80) : he married in 1844. Jones was an enthusiastic angling companion of Turner's (Thornbury 1877, p. 281). For their rivalry as painters, above pp. 5f. and Thornbury 1877, p. 323, and as illustrators of Thomas Moore, Moore, *Memoirs, Journal and Correspondence*, vii. 182–3; *Letters* ii. 849 f. In 1831 Turner appointed Jones a Trustee of his proposed Charitable Institution, and an executor of his will; and he helped to arrange and catalogue the Turner Bequest after the painter's death.

Literature: D.N.B.

JOSI, Henry (1802–45), **333.**
Printseller, son of the engraver Christian Josi. Keeper of Prints and Drawings in the British Museum from 1836 until his death.

Literature: D.N.B. (s.v. Christian Josi).

KNIGHT, John Prescott (1803–81), **300,** 267.

Portrait and subject painter. Student at the Academy Schools, 1823; A.R.A. 1836; R.A. 1844. With Turner on the Academy Council 1845–6 and with Turner and Pickersgill (q.v.) on the Hanging Committee 1845. Knight succeeded Turner as Professor of Perspective in 1837 (on his teaching, see G. D. Leslie, *The Inner Life of the Royal Academy* (1914), pp. 17–19).

　Literature: H. Dyson, *John Prescott Knight, R.A. A Catalogue* (Stafford, 1971).

LAHEE, James (fl. 1810–52), **39.**

Copper-plate printer. 'He is among the most punctual men of business with whom I am acquainted; and in the mezzotint department of art the acknowledged *"facile princeps"*' (T. F. Dibdin, *Reminiscences of a Literary Life* (1836), ii. 619 n). Lahee formed a celebrated collection of proofs of the *Liber*, which were sold to Thomas Lupton (q.v.) in 1852 for £200 or guineas (Pye–Roget, pp. 76 f., 88). He held that not more than thirty fine proofs could be taken from each plate (ibid., pp. 71 f.).

LAWRENCE, Sir Thomas (1769–1830), **110, 111, 144,** xxv, 120 nn. 5 and 6, 121, 136, 137, 159, 243, 247, 279, 289.

Portrait painter. Supplemental A.R.A. 1791. R.A. 1794. P.R.A. 1820. Knighted 1815. Lawrence spoke warmly in favour of Turner in 1798 and seems to have commissioned the large watercolour *Abergavenny Bridge* in the Victoria and Albert Museum (Finberg 1961, pp. 52, 56). In 1809 he described Turner as 'indisputably the first landscape painter in Europe' (ibid., p. 156), and in 1819 claimed of himself that he 'has never been insensible of the superiority of his talents, or cold or insincere in his admiration of them' (Williams, ii. 161). The earliest evidence of their close contact is in Rome that year, when Lawrence wrote to Farington on 6 Oct.:

Mr Turner is come—I had the sincerest pleasure in seeing him for he is worthy of this fine City, of all the Elegancy and Grandeur that it exhibits. He is going immediately to Naples, but his longest stay, doubtless, will be here. He feels the beauty of the Atmosphere and Scenery as I knew he would—even you would be satisfied with his genius & high Respect for Wilson, and the pleasure he feels at so often seeing him, in and round the Campagna of Rome ... Mr Turner s[t]ays tolerably well ... (Royal Academy, Lawrence Corresponence, iii. 27)

Lawrence lent a Turner watercolour of *St. Agatha's Abbey* (B.M. 1915–3–13–48) to the Cooke exhibition in 1823, and he owned *The*

Quarter Deck of the Victory (T.B.E. No. 96) and a proof set of one number of *Ports of England* (Christie, 17 June 1830 (185)). He acquired the oil, *Newark Abbey on the Wey* (B.–J. No. 65) at the Leicester Sale in 1827. As well as his well-known collection of Old Master drawings (see Letter 168), Lawrence owned drawings by Wheatley, Zuccarelli, Gainsborough, Guardi, Cades, P. Sandby, Penry Williams, John Brown, Jacob More, M. Ricci, Pannini, A. J. Carstens, Stothard, Bonington, Danby, J. Vernet, Greuze, F. C. Lewis (q.v.), J. F. Lewis, and two sketchbooks by Géricault. His sale also included eighty-two 'Patna drawings' and 'Nine curious Chinese Drawings'.

Lawrence's painting by Rembrandt of *Joseph and Potiphar's Wife*, purchased in 1820 (Williams, ii. 280), served as a model for Turner's *Rembrandt's Daughter* of 1827 (cf. Gage, *Turner: Rain, Steam and Speed* (1972), pp. 50–1).

Literature: D. E. Williams, *Life and Correspondence of Sir Thomas Lawrence* (1831).

LEICESTER, Sir John Fleming (1762–1827), **9, 20, 36, 78,** 103, 246, 260, 302.

Patron of British art and amateur watercolourist, painter, and lithographer. Taught by Thomas Vivares and Paul Sandby. M. A. Trinity College, Cambridge, 1784; working in Rome with Richard Colt Hoare (q.v.) 1786. In Parliament as a moderate Whig 1791–1807. Founder-member of the British Institution 1805–6; member of the Calcographic Society 1810; Patron of the Royal Hibernian Academy 1813. Had begun collecting English art in the 1790s (Gainsborough and Turner), built a gallery at his London home in Hill St. in 1806, and had commissioned some thirty works by British artists by 1810. The gallery opened to the public in 1818. In 1823 he offered his collection to the Government as the nucleus of a National Gallery of British Art, but it was declined; much of it was dispersed at Christie's in July 1827. He was created Baron de Tabley in 1826.

Leicester's first purchase from Turner seems to have been a watercolour of a *Storm* in 1792 for 25 guineas (Hussey, p. 113); by 1804 he had probably acquired *Kilgarren Castle* (B.–J. No. 11; see p. 248); and, apart from works mentioned in the letters, he owned *The Blacksmith's Forge* (B.–J. No. 68), *Pope's Villa at Twickenham* (B.–J. No. 72), two pictures of the lake at Tabley (B.–J. Nos. 98–9), *Newark Abbey on the Wey* (Mellon Coll.; B.–J. Nos. 98–9), *Newark* painted between 1807 and 1810. Turner visited Tabley and seems at least once to have worked on Leicster's own paintings, and charged for his services (W. Jerdan, *Autobiography*, ii (1852), 260). Among Leicester's lithographic works were studies of birds and fishes from nature: he planned an illustrated treatise on British fishes. Turner

certainly fished a good deal during his stay at Tabley in 1808 (Farington, 11 Feb. 1809).

Literature: W. Carey, *Some Memoirs of the Patronage and Progress of the Fine Arts* (1826); C. Hussey, 'Tabley House II', *Country Life*, liv (1923), 113–19; D. Hall, 'The Tabley House Papers', *Walpole Society* xxxviii (1960–2), 93, 120–1.

LENOX, James (1800–80), **288,** 173 n. 4, 219f., 258.

New York book-collector, historian, and philanthropist. A.B. (Columbia) 1818. Called to New York Bar 1822. Founder of the Lenox Library, 1870. In 1845 Lenox acquired Turner's *Staffa, Fingal's Cave* (R.A. 1832, B.–J. No. 347) for £500 through C. R. Leslie (q.v.), but found it 'indistinct', and was only reassured when Leslie, after having consulted Turner, suggested that this was due simply to the bloom on the varnish incurred during the voyage to America. Lenox apparently removed it, and was satisfied. In 1848 he attempted to buy Turner's *Fighting Téméraire* through Griffith (q.v., but see also Letter 226), but had to be content with a print. In 1850 he bought *Fort Vimieux* (B.–J. No. 341). Lenox also collected works by Constable and other British artists.

Literature: A. Holcomb, '"Indistinctness is my fault". A Letter about Turner from C. R. Leslie to James Lenox', *Burlington Magazine*, cxiv (1972), 557–8.

LESLIE, Charles Robert (1794–1859), **226,** 240, 242, 245, 246, 251, 252, 259, 265, 267, 279, 283.

Genre and portrait painter, biographer of Reynolds and Constable. Born of American parents in England, but spent his childhood in the United States, returning there in 1799. Returned to London 1811. A.R.A. 1821; R.A. 1826. Professor of Painting 1847–51. Leslie was an enthusiastic admirer of Turner's work—'my great favourite of all the painters here'—from at least 1816 (*Autobiographical Recollections*, ii. 56), and they met several times at Petworth in the 1830s. Leslie was often entertained at Turner's Gallery, but Turner seems to have visited him only twice: in 1840 (see J. Ruskin, *Dilecta*, ch. I, §§1, 4, 11), and in 1850, when he was invited round to discuss the vacant presidency of the Royal Academy (G. D. Leslie, *Inner Life of the Royal Academy* (1914), pp. 143–4). Leslie's admiration for Turner's art was unbounded: in 1845 he described him to James Lenox (q.v.) as 'the greatest living genius, not only in England, but in the world, and whose genius is such that it may not be equalled in a century' (*Burlington Magazine*, cxiv (1972), 557–8). But he had reservations about Turner's manner: 'he was a confused speaker, and wayward

and peculiar in many of his opinions, and expected a degree of deference on account of his age and high standing as a painter, which the members [of the R.A.] could not invariably pay him' (Leslie, i. 200).

Leslie devoted a good deal of his chapter on Landscape in his *Handbook for Young Painters* (1855), based on his Academy lectures, to toning down the exaggerated praise by Ruskin (q.v.) of a painter of whom Leslie wrote: 'there never lived one in whose works greater absurdities or a larger number of impossible effects might be pointed out' (pp. 266–73).

Literature: Leslie.

LEWIS, Frederick Christian (1779–1856), **18, 19, 21, 158,** 255, 264.

Aquatint engraver and landscape painter, pupil of J. C. Stadler, studied at the Royal Academy Schools, where he became the friend of Charles Turner (q.v.) and Edwin Landseer. Collaborated with James Girtin (q.v.) on Thomas Girtin's *Picturesque Views in Paris* (1803); made his first engraving for Turner in 1804 (see Letter 7) and worked about 1807–8 on John Chamberlaine's *Original Designs* (1812) and William Young Ottley's *Italian School of Design* (1823). In 1837/40 Lewis published *Imitations of Drawings by Claude Lorrain in the British Museum*.

Literature: Pye–Roget; *D.N.B.*

LOVEGROVE, S. **130.**

LUPTON, Thomas Goff (1791–1873), **334,** 33 n. 1, 246, 263.

Mezzotint engraver, noted chiefly for his introduction of steel into this form of engraving, for which he won the Isis Medal of the Society of Arts in 1822 (cf. *Athenaeum*, 1873, i. 702). President of the Artists' Annuity Fund in 1836. Lupton was a pupil of George Clint, who had engraved two *Liber* plates for Turner in 1812. The *D.N.B.* states that he was assistant to S. W. Reynolds by 1814, but Lupton himself stated in 1848 (Pye–Roget, pp. 64 f.) that he was still with Clint when he begged Turner to allow him a *Liber* plate and engraved *Solway Moss* (R. 52, 1816). Lupton engraved two further *Liber* subjects in 1819 and five *Rivers of England* in 1823, and he proposed to engrave and publish *Ports of England* (R. 779–790) in 1826, but was hit by the slump and these were not published until after Turner's death. His large plate of *Calais Pier* (R. 791, *c.* 1827) and *Folkestone* (R. 798, *c.* 1830), his last work for Turner, remained unfinished, and his attempt to re-engrave and issue fifteen *Liber* plates between 1856 and 1864

was a failure. Lupton was especially friendly with Turner, of whom he said:

Of reserved manners generally, but never coarse (as has been said), though blunt and straightforward, he had a great respect for his profession, and always felt and expressed regret if any member of it appeared to waste or neglect his profession ... Turner among his social friends was always entertaining, quick in reply, and very animated and witty in conversation. (Thornbury 1877, p. 223)

In 1858 Lupton sent Ruskin a letter from Turner (untraced) which, he said: 'forcibly exhibits his moral rectitude (as I believe was the case in all his transactions of life). In reading it you will perceive how anxious he was that no delay in the business should be or appear to be with him' (Bembridge, Ruskin MSS. 54/C: Lupton to Ruskin). Lupton's son, N. O. Lupton, was the first winner of the Turner Medal at the Royal Academy (cf. T.B.E. Nos. B59–60).
 Literature: D.N.B.

McConnel, Henry (fl. 1831–*c.* 1874), **187, 193, 198.**
Manchester textile manufacturer. Governor of the Royal Manchester Institution from 1831, when he seems to have begun his own collection with the purchase of a William Collins (q.v.). Presented the Institution with a Salvator Rosa (Records in Manchester Central Reference Library). Lent many modern British pictures to the Manchester Art Treasures Exhibition of 1857 and the International Exhibition of 1862. Commissioned work from Callcott (q.v.), Landseer, and the flower painters M. O. and A. F. Mutrie, as well as Turner, and left a large collection of British pictures, including works by J. P. Knight, John Thompson of Duddingston, Mulready (5), Leslie, Eastlake (qq.v.), Constable, Wright of Derby, Morland, and Millais (Christie, 27 Mar. 1886). His first Turners were sold in 1849 (see Letter 193), but he later bought *The Campo Santo* (1842, B.–J. No. 397), *Rockets and Blue Lights* (B.–J. No. 387), *Neapolitan Fisher Girls* (1840; B.–J. No. 389), and an untraced *Wreck Ashore* (Christie, lot 74), possibly not by Turner.

McCracken, Francis (fl. 1840–*c.* 1857), **273, 284, 296.**
Belfast shipowner, packing-agent and art-dealer. Packing agent to the Royal Academy in the 1840s. After having been interested in Turner and Francis Danby and his son, McCracken turned in the 1850s to the Pre-Raphaelites, whom he sometimes embarrassed by

wanting to pay for their work in kind. In 1853 D. G. Rossetti satirized him as *Maccracken*, in imitation of Tennyson's *The Kraken*:

Getting his pictures, like his supper, cheap,
Far far away in Belfast by the sea ...
By many an open do and secret sell,
Fresh daubers he makes shift to scarify,
And fleece with pliant shears the slumbering 'green'
These he has had, though aged, and will lie
Fattening on ill-got pictures in his sleep.

Yet even Rossetti described McCracken as a 'frenzied enthusiast' (Letter 125), Ford Madox Brown spoke of 'frequent and enthusiastic' letters from him (F. M. Hueffer, *Ford Madox Brown* (1896), p. 86), and Holman Hunt recalled that he was an 'incessant correspondent' (*Pre-Raphaelitism and the Pre-Raphaelite Brotherhood* (1905), i. 282).

MACRONE, John (1809–37), **196.**

Publisher. A Scot, but in London from the early 1830s, and in partnership with James Cochrane by 1833. Macrone had set up by himself in St. James's Square by September 1834. He published *Monthly Magazine, London and Westminster Review*, and assisted Dickens to bring out *Sketches by Boz*. In July 1836 Macrone proposed to Thomas Moore that Turner should illustrate his new edition of Moore's *Works*, 'with his best style of illustrations, going, if necessary, to Ireland for the purpose' (T. Moore, *Journal, Memoirs and Correspondence*, ed. Russell, vii. 163–4), but the only part of this plan to be executed was the edition of Moore's *Epicurean* with four vignettes after Turner, which appeared after Macrone's death, in 1839 (cf. M. Omer, *Turner and the Poets* (1975), Nos. xxix–xxxii, 176–9). He was a close friend of Edward Goodall (q.v.), the engraver of the *Milton* and the *Epicurean* (F. Goodall, *Reminiscences* (1902), p. 219). He died in poverty and his widow was assisted by Dickens. Moore found him in 1836 'a very agreeable, clever, dashing young fellow, knowing a great deal of the general literature of the day, and having seen and known something of most of the eminent men of the time, particularly his own countrymen, viz. Sir Walter Scott, Jeffrey, Hogg &c' (Moore, op. cit., p. 171).

Literature: The Letters of Charles Dickens, ed. House and Story, i (1965).

MARSHALL, Mr., **225.**

If the Mr. Marshall of Letter 225 is William Marshall of Eaton Place, whose collection in 1857 included works by Turner, Callcott, Collins,

Wilkie, and Eastlake (qq.v.), as well as Dutch, Italian, and Spanish Old Masters (G. Waagen, *Treasures of Art in Great Britain*, iii (1857), 183 ff.), he may also be the William Marshall of Patterdale Hall, Penrith, and Upper Grosvenor Street, who patronized Collins from 1821 (W. W. Collins, *Memoirs of the Life of William Collins* (1848), i. 170; ii. 14, 103 f., 345) and Wilkie from 1834 (A. Cunningham, *Life of Wilkie* (1843), iii. 77, 221; Collins, *Memoir*, ii. 103 f.). However, a John Marshall of Coniston and a James Marshall also appear as buyers of Turner and Collins.

MAW, John Hornby (fl. 1825–48), **178, 188, 189, 214, 228,** 237f.

Surgical instrument manufacturer and amateur artist, exhibiting at the Royal Academy 1840–8. Author of a treatise on landscape painting in watercolour and correspondent of the *Art Union*. Maw was a member of the *Artists' Conversazione* from about 1825 and a founder-member of the *City of London Artists' and Amateurs' Conversazione* in 1831, and these activities brought him into touch with Thomas Griffith and Jacob Bell (qq.v. and see British Library Add. MS. 45883, fos. 7v–8, 28v–9). Maw had acquired four of Turner's *England and Wales* drawings by 1833 (see pp. 237–8), and built up a large collection of watercolours by Bonington, John Sell Cotman, Cox, De Wint, J. F. Lewis, Prout, Cristall, Hunt, and Girtin (see Christie, 24 May 1842). Like Turner, he subscribed to George Field's *Chromatography* (1835) and *Outlines of Analogical Philosophy* (1839). He moved from Guildford to Hastings about 1838, and was well known for his hospitality to artists there. Samuel Prout wrote to him in 1838: 'You have a rich store of art, & you can talk with drawgs as with the artist, disentangling all the science & process, making the whole your own ...' (British Library Add. MS. 45883, fo. 33v).

Literature: S. D. Kitson, *Life of John Sell Cotman* (1937).

MILLER, William (1796–1882), **203, 223, 246, 250, 251, 256,** 94, 150 n. 5, 287.

Engraver and watercolourist. Honorary Member of the Royal Scottish Academy. A pupil of George Cooke (q.v.) in 1819, but returned to Edinburgh in 1821. Miller's first work after Turner was a trial replica of W. B. Cooke's *Plymouth Dock* in 1820 (R. 99A). He engraved some seventy plates and vignettes after Turner up to 1847 (R. 664).

Literature: D.N.B.

MONRO, Hector A., **197.**

A son of Turner's early patron Dr. Thomas Monro, and an amateur artist (Finberg 1961, p. 37).

MOON, Sir Francis Graham (1796–1871), **177,** 162 n. 4, 184, 188, 189.

Printseller and publisher. Bought up most of the stock of Hurst and Robinson (see under J. O. ROBINSON) after their bankruptcy in 1825. Joined with the printsellers Robert Graves and Thomas Boys to form Moon, Boys & Graves of 6 Pall Mall, although continuing to function independently. Left the partnership in favour of Hodgson in 1835. Moon was noted for his hospitality to artists (W. H. Harrison, *University Magazine* (Dublin), ii (1878), 705), and Graves was also especially hospitable to Turner (F. Goodall, *Reminiscences* (1902), pp. 56–7). Moon, Boys & Graves published many of Turner's works in the late 1820s and 1830s, but their most important act was to exhibit some eighty drawings, for *England and Wales* and Scott's *Poetical Works* in June and July 1833. At their *Conversazione*, held on 3 July,

Turner himself was there, his coarse, stout person, heavy look, and homely manners contrasting strangely with the marvellous beauty and grace of the surrounding creations of his pencil. Stothard was in a slipshod pair of shoes, down at heel, and with a pair of trousers splashed with the previous week's mud. He appeared to be absorbed in the contemplation of the works around him, and scarcely exchanged a word with anyone. Etty was there; also Stanfield, Brockendon, and other distinguished painters. I also observed Lord Northwick, one of the then great patrons of art. There was also Sams, the traveller in Egypt and the Holy Land, habited like a pilgrim, in a long great-coat reaching to his toes. He showed us a painted portrait, doubtless of the deceased, found with a mummy, and supposed to have been executed B.C. circa 300. The colours were remarkably vivid, especially the blue, which Etty said we could not equal. (Harrison, loc. cit. i. 701)

Literature: D.N.B.

MOON, BOYS & GRAVES **134,** 100 n. 2, 258.

MOORE, Mrs Carrick (fl. 1830–57), **241, 248, 269, 292,** 218 n. 2.

Wife of James Carrick Moore (1762–1860), a close friend of Henry Fuseli, whom he accompanied to Paris in 1802. Their circle included Chantrey, Jones, Wilkie, Eastlake, Samuel and Sarah Rogers (qq.v.), Charles Babbage and Michael Faraday. Mary Lloyd recalled that Turner

was seen to best advantage with the Poet Rogers, and his sister, also with Mr Carrick Moore and his family, and at Sir Charles Eastlake's ... who always

treated him with the greatest attention and respect ... When I was staying at Mr Carrick Moore's ... at their summer quarters at Thames Ditton, Turner was also their guest, and when the ladies proposed to go over the river to Hampton Court Gardens, Turner said 'and I will row you'. This was an offer difficult to refuse, so we got into the boat and started. Turner was then about eighty. There was some difficulty in landing by the sedgy bank, but we said it would do very well; however, Turner insisted on taking us further on to a more convenient place, because he said with his shrug 'None but the brave deserve the fair'. (M.L., *Sunny Memories* (1880), pp. 31 f., 36)

Literature: Christie, 6 Mar. 1973, lot 29.

MOORE, Harriet Jane (fl. 1822–76), **230, 242, 277, 303, 306, 335.**
Eldest daughter of Mrs. Carrick Moore (q.v.).

MOSCHELES, Ignaz (1794–1870), **314,** 245.
Pianist, composer, and conductor, one of the leading promoters of Beethoven in England, where he settled from about 1821 to 1847. Moscheles may have met Turner at Hullmandel's *Conversaziones* (for Turner's connection with Hullmandel, T.B.E. No. B105), or in the circle of Thomas Moore (see Moore, *Memoirs, Journal and Correspondence*, ed. Russell, vii. 8 (November 1833)), or through Edwin Landseer, J. C. Horsley or Richard Westmacott, with whom Moscheles was preparing *Tableaux-Vivants* in 1843. Moscheles was popular virtuoso performer, and was close to Paganini in London in 1831.
Literature: I. Moscheles, *Recent Music and Musicians*, ed. C. Moscheles (1873).

MULREADY, William (1786–1863), **105,** 202, 204, 214f., 242, 267.
Landscape and genre painter. R.A. Schools 1800. Married sister of John Varley 1803. Specializing in genre subjects from 1808. A founder of the Artists' Annuity Fund 1810. A.R.A. 1815. R.A. 1816. Member of the Academy Club on the celebrated excursion of July 1819 (Finberg 1961, p. 259). Turner and Mulready seem to have been on friendly terms (cf. Thornbury 1877, pp. 292 f.). Mulready was a highly inventive technician, and the high key and luminosity developed in his work from the 1830s led a critic to link him with Turner as suffering from a developing cataract (W. Liebreich, 'Turner and Mulready. On the Effect of certain faults of Vision on Painting', *Proceedings of the Royal Institution*, vi (1872), 450–63).
Literature: A. Rorimer, *Drawings by William Mulready* (1972).

MUNRO, Hugh Andrew Johnstone, of Novar (?–1865), **166,** 103, 107, 145, 158 n. 2, 161 n. 2, 184 n. 4, 198, 249, 277, 300.

Amateur artist and collector. Inherited a Murillo from his father and built up a large collection of Old Masters and modern British paintings and drawings, including three Titians, four Vandevelde's, and a dozen Watteau's, twenty-two Stothards, nineteen Wilsons, thirteen Reynolds, twelve Boningtons, twelve Wards, nine Blakes, six Constables, six Beaumonts (one presented to him by Constable in 1831), and two oils and eight watercolours attributed to Girtin. Turner and Munro were certainly close by 1826 (see Letter 119), and the early sea-piece, repainted in 1849 as *The Wreck Buoy* (B.–J. No. 428), of which Frost and Reeve state that 'it was [Turner's] own desire that this picture should belong to the Munro Collection', may have been acquired before the first of the other fourteen or so Turner oils to enter the collection: *Venus and Adonis* (B.–J. No. 150), bought in the saleroom in 1830 Munro gave an account of this sale.

When Mr Green's sale was going to take place, Turner gave me a call. He then knew I had bought any thing of which had come to the hammer. He asked me, if I meant to id for these pictures, for, said he, it would be most inconvenient & impossible for me to go there during the varnishing days. I said I should—he asked me how far I should go; as far as I recollect I said £200 for each, probably more for the large one 'Adonis leaving the couch of Venus'. He seemed much pleased: 'then I shall leave it entirely to you. I am willing to let the Beauville [sc. Bonneville take itws chance, but I am anxious about the other'. I was at the ale but did not bid in person & the agent who bid for me said his only opponent was a boy & he could not find out who he was. A long time after Peacock, a dealer, of much taste, in Marylebone St. said to me 'had I been able to be at Blackheath you would have had to pay more for those Turners but I could not go myself & *sent my boy*'. I got the pictures for £75 each (Turner's prices were then as you know £250 for 3 f by 4 f.) On my return to town I called at Somerset House to tell Turner what I had done. He shook his head & said I had got them too cheap—but thanked me for what I had done. (Manuscript note in Thornbury 1862, ii. 149, in the collection of Professor Francis Haskell)

Munro purchased Turner's work regularly in the early 1830s, and he told Thornbury (1877, p. 105) that he was responsible for sending Turner to Venice in 1833, although he was disappointed when the painter returned not with the expected watercolour, but with an oil, *Venice from the Porch of the Madonna della Salute* (R.A. 1835, B.–J. No. 362). Turner was responsible for persuading Munro to devote himself to painting (Finberg 1961, p. 360), and in 1836 they visited the Italian Alps, where Turner presented him with a sketchbook of his own drawings (Finberg, *Connoisseur*, xlvi (1935), 185–7). Munro in fact paid 83 guineas for *Venus and Adonis*.

It has been suggested that Turner gave Munro a lesson in water-colour on this occasion, but Munro recalled:

It is true that Turner came up to me when I was sketching near Salenche and asked me for a block that was lying near me. He reappeared in about two hours and throwing it down, where he had taken it up, said he could make nothing of my paper. I expressed my regret that he had thrown away his time. But it was some days before I had occasion to open the book again (so little did I expect to find what I did, viz. the 4 sketches in it). He *never asked me for them or never said a word about them.* (Manuscript note in Thornbury 1862, i. 230)

And in a letter to Ruskin he further recollected:

I generally made sketches at the same time, which I ferreted out and left for a long time in a parcel for Mr Griffith, in case he should ever fall in with Turner, in order that he might verify them. For I was much dis-appointed in looking over the large mass of the sketches he left in his own keeping to find none of them but the slightest needings, and as I had offered at the end of our journey to take the whole of them, it was unlike all I had ever observed of him to part with them to anyone else ... I found one he did on a back of mine (Dewint paper) among his remains—another of Geneva, also on a back of mine, was gone ... (14 Oct. 1857, Bembridge, Ruskin MS. 54/C).

Two or three of the Turner drawings in Munro's collection seem to have been made on this trip. Of the 130 or so Turner drawings Munro acquired, many were illustrations to the poets, and two views on the Suffolk Coast, *Orford Haven* and *Lowestoft Lighthouse*, were identified by Frost and Reeve, rather improbably, as illustrations to Crabbe (see also R. 305–12). Munro was the most important buyer of Turner's series of Swiss watercolours of the early 1840s (see T.B.E. Section 17), and by 1857 he owned the 'last drawing', probably the *St. Gothard* commissioned by Ruskin and completed in 1848 (see Letter 310). Turner made Munro a Trustee of his Charitable Institution in 1844 and an Executor of his will in 1849.

Literature: W. E. Frost & H. Reeve, *A Complete Catalogue of Paintings, Water-Colour Drawings and Prints in the Collection of the Late H. A. J. Munro Esq. of Novar* (1865).

MURRAY, John III (1808–92), **281,** 249, 256, 277.

Publisher and traveller. Author of the first Murray *Handbooks* (Holland, Belgium, North Germany, 1836). Turner was introduced to him through his father, John Murray II (1778–1843), who had shared the publication of the *Southern Coast* with Cooke and Arch (qq.v.), and who had published Hakewill's *Tour in Italy*, with Turner's

plates, in 1818 (cf. Finberg 1961, p. 253) and his illustrations to Byron in 1832–4 (R. 406–31). John Murray III was interested in geology and mineralogy, and was an early member of the Alpine Club; he is almost certainly the Murray Turner met in Dijon and the Tyrol, possibly in 1843 (Thornbury 1877, p. 103 and Letter 261). His intimate circle included William Brockendon (see pp. 125 n. 4, 131, 255, 270, 299), Charles Lock Eastlake, Elizabeth Rigby (later Lady Eastlake), Richard Ford, and Lord Robertson (qq.v.). A Turner watercolour of *An English Bridge, Shrewsbury* (*c.* 1796, Shrewsbury, Clive House Museum) has a note from Turner (probably of 11 July 1845) accepting an invitation from John Murray III, attached to the back, but it is not known if it belonged to the family.

 Literature: G. Paston, *At John Murray's. Records of a Literary Circle, 1843–1892* (1932).

ORD, James Pickering, **131**.

Collector of Edge Hill, Duffield, Derby. Chiefly interested in historical portraits (cf. Sotheby, 12–15 Dec. 1827; Christie, 21 Feb. 1845). Also owned many prints by Hogarth (Evans, 29 June 1835, lots 188–204) and paintings by Ruisdael, Wouwermans, Ostade, Janssen, Vandevelde, and modern works by F. R. Lee (9), Westall, Havell, Lance, Hart, Howard, Collins, Stanfield, T. S. Cooper, and Roberts (House sale, B. Payne 27–8 June 1843: copy of Catalogue in National Gallery Library).

PETTIGREW, Thomas J. (1791–1865), **107**.

Surgeon, antiquary, founder of the Philosophical Society of London (1810). Pettigrew's circle included, notably, S. T. Coleridge (cf. Coleridge, *Letters*, ed. Griggs, vols. iii, iv, v), Thomas Campbell, Samuel Rogers (q.v.), William Etty, Michael Faraday, and C. L. Eastlake (q.v.) (cf. Sotheby, 26 Feb. 1906, lots 215 ff. Letter 107 is lot 260). Pettigrew's *Conversaziones* were famous: John Taylor (q.v.) wrote:

At Pettigrew's no need of dice or cards
Or any acts that human kind debase.
There men of science, artists, wits and bards
In social union dignify the place . . .

('On the Evening Parties in Saville Street', *Poems on Various Subjects* (1827), ii. 75)

 Literature: D.N.B.

PHILLIPS, Thomas (1770–1845), **71, 180,** 92, 97, 100, 103, 107, 134, 136 n. 2, 139 n. 3, 143 n. 1, 169, 171 n. 1, 201, 240, 250, 288, 289, 291.

Portrait painter. Pupil of the Birmingham glass-painter Francis Eginton. Moved to London, 1790, and worked for West (q.v.) on the windows of St. George's Chapel, Windsor. 1791, student at R.A. Schools and soon exhibiting subject pictures. 1804 A.R.A., 1808 R.A. 1825–32 Professor of Painting. F.R.S. Founder-member of Artists' General Benevolent Institution. Phillips was a supporter of Turner's work by 1803 (Finberg 1961, p. 100) and they served together as Visitors to the Life School in 1811, and among the first Visitors to the new Painting School in 1815. In 1819 Phillips was recommending Constable to study composition from the *Liber Studiorum* (Finberg 1961, p. 263). He was a close friend of Egremont, Holworthy, and Dawson Turner (qq.v.). Turner and Phillips had similar views on Titian and Tintoretto in Venice (cf. Gage 1969, p. 91, and M. Pointon, *J.W.C.I.* xxxv (1972), 349); and they seem to have helped each other with their Academy Lectures (cf. Phillips, *Lectures on the History and Principles of Painting* (1833), espec. pp. 335–6, 340–3, 354; and Gage 1969, p. 251).
Literature: D.N.B.

PICKERSGILL, Henry William (1782–1875), **227, 257, 336, 337, 338,** 242, 263.

Portrait painter. Pupil of George Arnald, A.R.A., 1802–5. Exhibiting at R.A. from 1806. A.R.A. 1822, R.A. 1826. Director of A.G.B.I. 1825. With Turner, Visitor to the Life Academy 1830–1, and to the Painting School 1842. With Turner on the Academy Council and Hanging Committee in 1845 and the Customs and Excise Committee in 1846. A soirée at Pickersgill's about 1837, attended by Turner, Chantrey, Jones, Wyatville, Hilton, Shee, and Leitch, at which some of Leitch's drawings were discussed, is described by A. MacGeorge, *W. L. Leitch* (1884), pp. 79–81. Pickersgill's sale in 1875 (Christie, 16–17 July) included a large number of autographs, among them eleven letters from Turner, two from Delacroix, thirty-seven from David Roberts, and thirty-two from Eastlake (qq.v.).
Literature: D.N.B.

PYE, John (1782–1874), **138, 139, 194,** 37 n. 4, 42, 49, 51f., 54, 76, 78 n. 1, 88, 240, 246, 259.

Engraver. Founder-member of the Artists' Joint Stock Fund, 1810. Related to the Birmingham engraver William Radclyffe, with whom he moved to London in 1801. Assistant to James Heath, for whom he engraved Turner's *Inverary Castle* (R. 73) in 1805. Married

daughter of Samuel Middiman in 1808 (see Letter 26). His first independent work after Turner was *Pope's Villa*, 1809–10 (R. 76), and he engraved thirteen plates after Turner during the painter's lifetime, the last, *Ehrenbreitstein* in 1845 (see Letter 194). His own favourite was *Redcliffe Church, Bristol* (R. 81 ; cf. his *Memoir*: Victoria and Albert Museum, Pye MS. 86 FF. 73, fo. 89). Pye wrote of Turner's approach to engraving (ibid.):

He would turn his proofs, after touching them, from side to side and upside down that the key of colour might be maintained and carried into effect. He was wont to say that engravers have only white paper to express what the painter does with vermillion. He was never tired of going to Hampstead and would spend hours lying on the Heath studying the effects of the atmosphere, and the changes of light and shade, and the gradations required to express them. The great principle he was always endeavouring to advance was that of the art of translation of landscape, whether in colour or black and white, [and] was to enable the spectator to see through the picture into space.

Pye collected a large number of modern pictures and drawings, including Turner's *Newark Abbey* (*c.* 1807, B.–J. No. 201) and pencil sketches of shipping (Christie, 20–1 May 1874 (429)). He also owned a death mask of Turner (ibid., lot 431A), and was an assiduous collector of biographical data (cf. Armstrong, pp. 179–84), much of which he supplied to Thornbury (cf. *Atheneum*, 1862, pp. 19, 260, 296–7, 332). Turner refused to sell Pye a *Liber Studiorum* at trade price (R. Redgrave, *Memoir* (1891), pp. 287 f.), but Pye none the less assembled one of the finest collections of *Liber* proofs (Pye–Roget). He was a lifelong opponent of the Royal Academy because of its treatment of engravers, and in July 1826 he, together with six other engravers, including George Cooke, Edward Goodall, and William Finden (qq.v.), signed an undertaking never to seek or accept candidacy as Associate Engravers of that institution (MS. in Free Library of Philadelphia; cf. also Pye's *Patronage of British Art*, 1845).
 Literature: D.N.B.

ROBERTS, David (1796–1864), **319,** 240, 247, 256, 258, 274, 275, 186, 300.

Landscape painter. A.R.A. 1838; R.A. 1841. Trained in Edinburgh but working at the Drury Lane Theatre as a scene-painter by 1822. Visited Spain 1832 and Egypt and Syria, 1838. Roberts had met Turner in connection with the Artists' General Benevolent Institution in 1823 or 1824, and Turner supported him for his first exhibition at the Royal Academy in 1826 (Thornbury 1877, pp. 353, 299 f.). They subsequently met often at the houses of General Phipps, E. T.

Daniell (see Letter 241) and Munro of Novar (q.v.), and Roberts also invited Turner frequently to his own table, for Turner

loved the society of his brother painters, and was in reality 'a jolly toper', never missing a night at the meetings of the Royal Academy Club ... and as a proof that he loved them and these jolly parties, he *willed* that £50 annually should be spent expressly for that purpose on his birthday. (ibid., pp. 230, 625)

Roberts was the son-in-law of Elhanan Bicknell (q.v.) and negotiated the loan of two of Bicknell's Turners to the Royal Scottish Academy in 1845 and 1846. At a Roberts dinner in 1850, when Bicknell was a guest, Stanfield (q.v.) suggested that Turner should propose a toast while his host was out of the room. Turner 'hurried on as quickly as possible, speaking in a highly complementary manner of Roberts' worth and talents, but soon ran short of words or breath, and dropped down to his chair with a hearty laugh, starting up again, and finishing with a hip, hip, hurrah!'
 Literature: J. Ballantine, *Life of David Roberts, R.A.* (1866). H. Guiterman, *David Roberts, R.A. 1796–1864* (Privately printed, 1978).

ROBERTSON, Patrick, Lord (1794–1855), **295,**274.

Barrister and wit. Called to the Scottish Bench of Judges with the title of 'Lord Robertson' in 1843. In the Edinburgh circle of Scott (q.v.) and Lockhart, of John Murray III and Elizabeth Rigby, later Lady Eastlake (qq.v). Author of *Leaves from a Journal* (1844) and *Sonnets Reflective and Descriptive* (1849, 1854). At a dinner in 1844 Elizabeth Rigby found him

in his most brilliant mood, his humour with the truest point, his satire without the slightest sting. Sense, drollery, mimicry, wit, with lightening touches and unpremeditated combinations; all that you most looked for, and all that you least expected. The table roaring and the sideboard shaking. (*Journals and Correspondence of Lady Eastlake*, i. 153 f.)

 Literature: D.N.B.

ROBINSON, J. O. (fl. 1818–25), **97,** 93 n. 1, 100 n. 2.

Brother of a Leeds bookseller. Partner with Hurst, of Longman & Co. in a printselling and publishing business. Bought up the stock and Cheapside premises of the eighteenth-century printseller and publisher Boydell in 1818 (Farington, 30 Dec.). Among Boydell's publications, Hurst & Robinson retouched and reissued Earlom's engravings after Claude's *Liber Veritatis*.

ROGERS, Henry (?–1832), **150, 165.**

Banker. Younger brother of Samuel Rogers (q.v.). 'A man of taste and culture, but he has chosen a quieter and more domestic sphere than his older brother' (Clayden, ii. 82). Henry Rogers's collection of pictures passed to his sister Sarah (q.v.).

Literature: P. W. Clayden, *Rogers and his Contemporaries* (1889).

RODGERS, Samuel (1763–1855), **220, 254,** 3, 153, 190, 201, 218 n. 2, 238, 249, 270, 274, 281, 283f., 292.

Banker and poet. Rogers had met Turner by 1826, the earliest date connected with his illustrations to *Italy* (T.B.E. No. 272). Rogers described to Ruskin the genesis of the last vignette to that book (R. 372), probably in 1827:

I was stopping once at Petworth ... At breakfast I said to Turner: 'Make me a drawing of a Terrace with steps overlooking a lake with Cypress trees'. At luncheon he showed me that one that is engraved in the 'Farewell to Italy'.
[*Ruskin*] 'You mean a mere pencil sketch?'
[*Rogers*] 'No! I think coloured'. [T.B.E. No. 275]
When quitting Petworth with my sister, I said farewell to my hosts and friends at night, as I intended leaving very early in the morning for Bowood, wishing to call at Longleat on my way to see the old gallery. To my surprise I found Turner at the door, ready to see me off. 'How kind of you', I said. 'I could not think of letting two such old friends go away without saying "Good bye", he replied.' (Bembridge, Ruskin MS. 54/C)

Rogers originally offered Turner £50 for each vignette drawing (Rawlinson, ii, p. li), but in the end gave £5 for the loan of each, paid in 1831 (Clayden, ii. 6). The second book Turner illustrated for Rogers was *Poems* (1834). Rogers thought Turner 'a man of first-rate genius in his line. There is in some of his pictures a grandeur which neither Claude nor Poussin could give to theirs' (*Table Talk*, ed. Bishop (1952), pp. 111–12); but he also remarked that 'Turner, with all his talent, carried no weight' (British Library Add. MS. 32571, fo. 409). He seems to have acquired only three Turners: *Sea Piece, with fishing boats off a wooden pier, a gale coming on* (B.–J. No. 540), and two watercolours, *The Quarter-Deck of the Victory* (T.B.E. No. 96), bought from the Lawrence collection in 1830, and *Stonehenge*, probably bought from the Egyptian Hall exhibition in 1829 (see p. 238) and lent by Rogers to Moon, Boys & Graves in 1833. Rogers similarly admitted Constable's genius, but did not admire his works (Leslie, i. 240) and owned only a watercolour of *Stoke Church*. His large collection (Christie, 28 Apr. 1856 and following days) included antique marbles, gold, glass, bronzes, vases, and terracotta, Dutch,

Flemish and Italian pictures, including primitives and works by Rosa and Rubens, several paintings by Watteau, Wilson, Westall, Eastlake (q.v.), Stothard, Reynolds, Beaumont, Leslie (q.v.), Haydon (*Napoleon on St. Helena*, 1839–40), Bird, Fuseli, Bonington, sculpture by Flaxman, drawings by German and Italian, Dutch and Flemish masters and by Hogarth, Wilkie (q.v.), Uwins, Lawrence (q.v.), and Prout. Rogers also had a number of medieval illuminated manuscripts and a set of Goya's *Caprichos* (V. von Loga, *Goya* (1921), pp. 73, 222–3). His rooms at St. James's Place were 'hung with many beautiful pictures, so closely that the massive gold frames formed a good contrast to the dark crimson furniture and carpet. Many choice Etruscan vases on brackets, beautiful bronzes on stands, handsomely bound books of engravings, all formed a whole ...' (M.L., *Sunny Memories* (1880), pp. 8 f.) Rogers also collected photographs, and Ruskin reported:

Soon after the discovery of the Daguerrotype Mr Rogers brought some from Paris and at a dinner at St James' Place he was showing them to several artists who had never seen them before, and they considered the discovery would injure Turner particularly. When he came they said, 'Our profession is gone'. On looking at them he answered 'We shall only go about the country with a box like a tinker, instead of a portfolio under our arm'. (Ruskin MS. cit.)

Turner made Rogers an executor of his will in 1831, and, according to Ruskin, they last met late in 1851.

Literature: A. M. Holcomb, 'A Neglected Classical Phase of Turner's Art', *J.W.C.I.* xxxii (1969), 405–10.

ROGERS, Sarah (1772–?), **185, 285, 339,** 211, 270, 278.
Eldest sister of Henry and Samuel Rogers (qq.v.). Amateur artist. Companion to Samuel Rogers in Switzerland, Italy, Germany, and Holland in 1814, and in Switzerland in 1821. Supervised the publication of the 1822 edition of *Italy*. Noted for her kindness and amiability. Lived with Henry Rogers until his death, when she moved to 5 Hanover Terrace, Regent's Park, which was described in 1838 as 'a sort of imitation—and not a bad one either—of her brother's [Samuel] in St James's. She keeps autographs, curiosities and objects of *virtu* just like her brother' (Clayden, ii. 165). The collection, partly formed by Henry Rogers, included works attributed to Gozzoli, Verrocchio, Mantegna, Giorgione, Bronzino, Memlinc, Jan and Hubert van Eyck, Rubens, Teniers, Mabuse, Reynolds, Wilson, Gainsborough, Stothard, Leslie (q.v.), Bonington, Turner (B.–J. No. 539: according to Waagen, *Treasures of Art in Great Britain*, ii. 268, it was '*A Storm, treated almost entirely in brown*. A spirited but very mannered sketch'.)

and Wilkie (q.v.) (A. Jameson, *Private Picture Galleries* (1844), pp. 412 ff.). Samuel Rogers told Ruskin:

When Turner dined with Miss Rogers at Hanover Terrace, on leaving, his umbrella was missing. He was very anxious about it as it was one he used when out sketching. Mr Babbage [i.e. Charles Babbage] returned it, who had taken it in mistake for his own. It was a very shabby one, and in the handle (like a bayonet) there was a dagger quite two feet long. (Bembridge, Ruskin MS. 54/C.)

Literature: M.L. [Mary Lloyd], *Sunny Memories* (1880); P. W. Clayden, *Rogers and His Contemporaries* (1889).

ROPER, W. L., **153, 157, 167.**

Assistant Secretary to the Artists' General Benevolent Institution from 1817. A further fragment of a letter from Turner referring to him is in the Pierpont Morgan Library.

Literature: John Constable: *Further Documents and Correspondence*, ed. Parris, Shields, and Fleming-Williams (1975), pp. 321 ff.

ROSSI, John Charles Felix (1762–1839), **163.**

Sculptor. Student at the Royal Academy from 1781. In Rome 1785–8. A.R.A. 1798; R.A. 1802. Sculptor to the Prince of Wales (later George IV) 1797–1830. Sculptor in Ordinary to William IV from 1830. In 1835 Rossi was given 100 guineas a year by the Academy to relieve the embarrassment of his sixteen children. He was on the Committee of Enquiry into the Elgin Marbles in 1816, and pronounced them 'the finest I have ever seen' (J. T. Smith, *Nollekens and his Times*, ed. Whitten (1920), i. 250). In the 1820s he executed *Celadon and Amelia* and *The British Pugilist* for Lord Egremont (q.v. and see B. R. Haydon, *Diary*, ed. Pope, iii (1963), 115 (1826)). Rossi served with Turner and Soane (q.v.) on the Academy Council in 1803–4, when they were of the 'Academical' as opposed to the 'Court' party (Finberg 1961, pp. 95 ff.), and again in 1819–20 and 1828–9, when they were both on the Hanging Committee. In 1822 C. R. Cockerell found the sculptor 'sleepy and ignorant ... he knows nothing but Thompson and Milton' (D. Watkin, *The Life and Work of C. R. Cockerell* (1974), p. 101).

Literature: R. Gunnis, *Dictionary of British Sculptors 1660–1851* (1968).

RUSKIN, John (1819–1900), **202, 301, 308, 311, 312, 313,** xxvi n. 2, 205 n. 3, 206, 210, 212, 217 n. 1, 218, 222, 226, 237, 240, 241, 249, 253, 258, 266, 267, 278, 297.

Critic and amateur artist. First interested in Turner in 1833 through

the gift of Rogers's *Italy*. First met the painter on 22 June 1840, at dinner with Thomas Griffith (q.v.), who had just sold J. J. Ruskin (q.v.) Turner's *England and Wales* drawing of *Nottingham* (Nottingham Museum and Art Gallery) for 70 guineas (see J. Ruskin, *Diaries*, ed. Evans and Whitehouse, i (1956), 82–3). Turner visited the Ruskins for the first time to celebrate John's birthday (8 February) in 1843; in May of this year the first volume of Ruskin's first large-scale critique of Turner, *Modern Painters*, appeared, and on 15 May Ruskin found Turner 'particularly gracious. I think he must have read my book, and have been pleased with it, by his tone' (ibid., p. 247). But it was not until 20 Oct. 1844 that Turner thanked him for it:

I ought to note my being at Wyndus's on Thursday to dine with Turner and Griffiths alone and Turner's thanking me for my book for the first time. We drove home together, reached his house about one in the morning. Boylike, he said he would give sixpence to find the Harley St gates shut, but on our reaching his door, vowed he'd be damned if we shouldn't come in and have some sherry. We were compelled to obey, and so drank healths again, exactly as the clock struck one, by the light of a single tallow candle in the under room—the wine, by the by, first 'rate (ibid., p. 318).

Turner was always distrustful of Ruskin's criticism (see Letter 202), but Mary Lloyd recorded: 'One day Turner took me down to dinner at Mr Rogers, and he said "Have you read *Ruskin on Me*?" I said "No." He replied "but you will some day", and then he added with his own peculiar shrug "He sees *more* in my pictures than I ever painted!" but he seemed very much pleased' (*Sunny Memories*, 1880, p. 34).

There seems to have been something of an estrangement between Turner and Ruskin in 1846. Ruskin wrote to William Boxall 'I think there is nothing satisfactory but Turner after all and poor Turner is failing me'; and later, 'Turner's powers of thought and combination are so strange and vast that I feel a great gulph fixed between him and me' (M. Liversidge, 'John Ruskin and William Boxall: Unpublished Correspondence', *Apollo*, 85 (1967), 41–2). In 1854 Ruskin heard from Griffith that 'poor Turner brought my last letter, closing our intercourse, to Griffiths, and was very sorry about it, but could not make up his mind about answering or putting the thing to rights' (*Diaries*, ii. 489). And yet in 1847 Ruskin's name was sufficient to gain access to Turner's Gallery (W. H. Harrison in *University Magazine* (Dublin), i (1878), 546; the reference is probably to 8 Feb. 1847, when Turner and Harrison met at Ruskin's birthday dinner), and the correspondence of 1848 is very cordial. Turner made Ruskin an executor of his will this year.

Ruskin was given his first Turner drawing, *Richmond Bridge* (see p. 237), probably in February 1839 by his father, who had paid 55 guineas for it in January. He owned at some time over 300 drawings by Turner, as well as *The Slave Ship* (B.–J. No. 385), acquired in 1844, and *Grand Canal, Venice* (B.–J. No. 368), acquired in 1847. His own drawing style was much affected by Turner's, and the only drawing of his which Turner liked was a pastiche, *The Falls at Schaffhausen* (Fogg Art Museum: P. Walton, *The Drawings of John Ruskin* (1972), p. 52 and fig. 32). Ruskin made the first arrangement of the Turner Bequest in 1856–8 and proposed to write Turner's biography. He supplied Thornbury and later Ernest Chesneau with much material gathered between 1855 and 1860, some of which is now lost (*Works*, xiii, pp. xxviii, lvi).

Literature: L. Herrmann, *Ruskin and Turner* (1968) (also review by J. S. Dearden, *Connoisseur*, 172 (1969), 40). H. I. Shapiro, *Ruskin in Italy* (1972).

RUSKIN, John James (1785–1864), 215, **280, 282, 289, 293, 304, 310,** 322.

Merchant. Moved from Edinburgh to London 1801. 1814, formed wine-shipping firm of Ruskin, Telford & Domecq. Granted arms in 1835. Owned some £1,200 worth of pictures by 1840; moved to Denmark Hill in 1842 and began to develop his collection of paintings and drawings. Purchased first Turner watercolour for his son John (q.v.) in January 1839, and two others, *Gosport* (P. A. M. Murray Coll.) and *Winchelsea* (Untraced)) within the next year. In August 1841 he wrote to John 'I saw Turner at Griffiths but greatly prefer his pictures'; and the following year (11 Apr.): 'I find I see every day less of the Red & Yellow of Turner & More of his Beauty. I never find my Eye remains on any picture if I am leaving it to take its own way except Turner & Lewis. Ergo other pictures are rubbish nearly to me.'

All John Ruskin's purchases during his father's lifetime were sanctioned and paid for by him. Turner is recorded as dining with the Ruskins on 1 Jan. and 19 Mar. 1846, 8 Feb. and 3 June 1847, 4 Jan. and 8 Feb. 1848 and 1 Jan. 1849. He was invited on 9 Jan. and 8 Feb. 1851 but did not attend (J. J. Ruskin, *Diary*, Bembridge, Ruskin MS. 33).

In April 1860 Ruskin offered (unsuccessfully) to head a subscription list with £500, towards the purchase of Turner's *Venice, from the Porch of Madonna della Salute* (1835; B.–J. No. 362), for presentation to the Louvre, 'as Turner is so little known and so little esteemed on

the Continent' (J. Maas, *Gambart: Prince of the Victorian Art World* (1975), p. 114).

Literature: The Ruskin Family Letters, ed. Van Akin Burd (1973).

SCHETKY, John Christian (1778–1874), **101, 106,** 116 n. 2.

Marine Painter in Ordinary to George IV. Studied in Edinburgh under Alexander Naysmyth. Visited Paris and Rome 1801 and Portugal 1811. Settled in Oxford 1802–8. Exhibited at the Academy 1805–72 and at the Associated Artists in Watercolour 1802–12. 1808–11, Junior Professor of Civil Drawing at the Royal Military College, Great Marlow; 1811–36, Professor of Drawing at the Royal Naval College, Portsmouth. 1836, succeeded W. F. Wells (q.v.) at Addiscombe. A lifelong friend of Scott (q.v.), whose *Lay of the Last Minstrel* he illustrated in 1808. In touch with Turner by 1818, when Turner visited his brother and sister in Edinburgh. Schetky 'sang Scottish ballads and Dibdin's songs with much pathos' (*D.N.B.*). He had hoped to join the navy and, according to a pupil, had 'all the manners and appearance of a sailor—always dressed in navy-blue, and carried his *call*, and used to pipe us to weigh anchor, and so on, like any boatswain in the service.'

Literature: Miss Schetky, *Ninety Years of Work and Play. Sketches from the Public and Private Career of John Christian Schetky* (1877).

SCOTT, Sir Walter (1771–1832), **169,** 46 n. 2, 146, 148, 242, 244, 268, 277, 287, 289.

Author. Turner seems to have read Scott's poetry as it came out (see Letter 38). He probably met Scott in connection with the illustrations to the *Provincial Antiquities of Scotland* in 1818 (Finley 1972, p. 360): certainly as share-holders in the project they were expected to meet from time to time (Finley 1973, p. 387). Scott at first took a dislike to Turner, whose palm he thought as 'itchy as his fingers are ingenious' (Finberg 1961, p. 257), but early in 1831 he wrote to Rogers (q.v.) congratulating him on the *Italy* as 'a rare specimen of the manner in which the art of poetry can awake the Muse of Painting'; and he allowed himself to be persuaded by Cadell (q.v.) that Turner should illustrate a new edition of his own works. The details were left largely to Cadell to arrange, for Scott was little interested in the visual arts. C. R. Leslie (q.v.), who had visited him in 1824, noted:

He talked of scenery as he wrote of it—like a painter; and yet for pictures, as works of art, he had little or no taste, nor did he pretend to any. To him thay were interesting merely as representing some particular scene, person, or event; and very moderate merit in their execution contented him. There were things hanging on the walls of his dining-room, which no eye possessing

sensibility to what is excellent in art could have endured. In this respect his house presented a striking contrast to that of Mr Rogers in which there was nothing that was not of high excellence. (*Autobiographical Recollections*, i (1860), 93–4)

Scott especially distrusted Turner's colour (Finley 1972, p. 361 n). But the painter's visit to Abbotsford in August 1831 seems to have been a happy one, and he continued to take a lively interest in the poet after the latter's death. He was a subscriber to the Scott Memorial fund.

 Literature: G. E. Finley, *Landscapes of Memory: Turner as Illustrator to Scott* (1979); Mordechai Omer, *Turner and the Poets* (Exhibition at Marble Hill House, Twickenham/Norwich/Wolverhampton) 1975.

SHEEPSHANKS, John (1787–1863), **229, 231.**

Leeds clothier, settled in Hastings about 1833, later moved to Bond Street in London, then out to Blackheath, and finally returned to London at Rutland Gate. Fellow of the Royal Horticultural Society. Early in his life, Sheepshanks collected copies of Italian masters; he then built up a collection of Dutch and Flemish etchings, which he sold to the British Museum in 1836 and, with the proceeds, began at Blackheath to collect contemporary British art (G. Waagen, *Treasures of Art in Great Britain*, ii (1854), 299). His lavish and frequent entertainment of painters and engravers was celebrated. As early as 1847 he proposed to Robert Vernon (q.v.) that they should make a joint gift of their British collections to the nation (*Journal of the Royal Society of Arts*, cxxiv (1976), 558), but Vernon declined, and it was not until 1856 that Sheepshanks presented 233 oils and 298 drawings and sketches, separately, to the government as a possible 'supplement to the Vernon Gallery, or Mr Turner's bequest, if it should be desirable in either case' (F. M. Redgrave, *Richard Redgrave: A Memoir compiled from his Diary* (1891), pp. 164–5). The collection is now housed in the Victoria and Albert Museum. The earliest Turner owned by Sheepshanks was the watercolour, *Hornby Castle*, for *England and Wales* (R. 185, 1822), acquired from the publishers for 20 guineas. The oil, *St. Michael's Mount, Cornwall* (B.–J. No. 358), may have been bought direct from the Royal Academy Exhibition in 1834, but *East Cowes Castle* (R.A. 1828, B.–J. No. 243) and *Life-Boat and Manby apparatus* (R.A. 1831, B.–J. No. 336) were purchased from a dealer in or after 1835. *Line Fishing off Hastings* (B.–J. No. 363) may have been bought from the Academy that year. The condition of these pictures was deplored by Constable as early as 1836: 'some of Turner's best work is swept up off the carpet every morning by the maid and put into the dust hole' (cf. B.–J. No. 243). Sheepshanks prided himself on the lack

of ostentation in his gallery, and although his collection embraced all the leading British artists of his day, he showed a preference for small anecdotal pictures and 'hasty sketches and first ideas' (*Art Journal,* 1857, pp. 239 f.).

Literature: D.N.B.; F. Davis, *Victorian Patrons of the Arts* (1963), pp. 74–9. John Constable, *Correspondence,* ed. Beckett, iii (1965), iv (1966).

SOANE, Sir John (1753–1837), **7, 15, 103, 114, 117, 118, 168, 170,** 127, 130, 139, 243, 261, 280, 289.

Architect. Associate of the Royal Academy 1795, R.A. 1802. Professor of Architecture 1806. Turner owned his *Sketches in Architecture* (1793), and a note of 'Turner' in Soane's diary of the previous year perhaps refers to him (Gage 1969, p. 23). They were both on the Academy Council in 1803, and there are many references to Turner's visits in Mr. and Mrs. Soane's diaries between 1803 and 1818 (Sir John Soane's Museum). Turner was at the presentation of the Belzoni Sarcophagus at Soane's house in March 1825 (B. R. Haydon, *Correspondence,* ii (1876), 93). He assisted Soane with his inaugural lecture in 1809 (Finberg 1961, p. 154) and Soane alluded to 'the beauties and almost magical effects' of Turner's architectural drawings in another lecture in 1812 (*Lectures,* ed. Bolton (1929), p. 88). Both speakers had a taste for quoting doggerel, sometimes using the same verses (Turner: British Museum Add. MS. 46151 K, fo. 13 (1811); Soane: *Lectures* p. 98 (1812)). When Soane was suspended for an indiscretion in February 1810, Turner seems to have warned him of the danger (cf. Bolton 1927, pp. 148–50); but he none the less incurred a bitter attack in Soane's pamphlet, *An Appeal to the Public Occasioned by the Suspension of the Architectural Lectures at the Royal Academy* (1812); and there is no record of Turner's visits between February 1810 and December 1812. Activities in the Artists' General Benevolent Institution brought Turner and Soane closer again from 1816: both were Directors in 1818 and Trustees the following year. A.G.B.I. annuities were held jointly in their names in the Bank of England (cf. T.B. CCLXXXVI, pp. 9–11). Turner's second Gallery, completed in 1822, owes something to Soane's idea (Gage 1969, pp. 161 f.); and from the title of his *Forum Romanum* (see Letters 114, 117) Turner must have known of Soane's plans for a Museum by 1826. Certainly their respective plans, about 1830, for permanent collections of their works, and for artistic charities and prize medals, suggest an identity of outlook, if not positive collaboration. Soane was knighted in 1831.

Literature: Bolton 1927.

SOLLY, R. H., **69.**

Chairman of the Artists' Joint Stock Fund from 1811 (J. Pye, *Patronage of British Art* (1845), p. 326). F.R.S. Fellow of the Royal Society of Arts. Possibly the Horseman Solly who in 1836 gave Frederick Goodall a commission for two watercolours, one of which won the Isis medal at the Society of Arts: 'always the kindest of friends, though never a great buyer' (F. Goodall, *Reminiscences* (1902), p. 173).

STANFIELD, Clarkson (1793–1867), **340,** 99 n. 6, 240, 258, 270, 274, 277, 288, 299.

Marine and landscape painter. In the merchant service from 1808 and the Royal Navy from 1812 to *c.* 1818. Worked as a scene-painter with his close friend, Roberts (q.v.), in Edinburgh until 1822, when they went to London. A.R.A. 1832; R.A. 1834. Stanfield's *Throwing the Painter* (1826) was the start of a joke which led to Turner's *Now for the Painter* (R.A. 1827, B.–J. No. 236; see Thornbury 1877, p. 293). In the late 1820s Stanfield had become the leading follower of Bonington, and after Bonington's death he was given two Royal commissions, which angered the Academy (*The Times*, 2 Jan. 1832). He had shown a *Venice* at the Academy in 1831, and Lord Lansdowne (an admirer of Bonington) commissioned from him a series of Venetian views for the dining-room at Bowood, the first of which, *Venice from the Dogana* was sent to the Exhibition in 1833. Turner saw it on varnishing day and painted *Bridge of Sighs, Ducal Palace and Custom-House, Venice: Canaletti Painting* (B.–J. No. 349) 'in two days' to teach Stanfield a lesson (*Arnold's Magazine of the Fine Arts*, iii (1834), 408–9), for 'Turner could not brook that a noble Lord should have passed over him to give such a commission to Mr Stanfield' (*Morning Chronicle*, 6 Jan. 1834). The gesture was generally regarded as spiteful, but the two artists were soon on good terms: they shared a boat with some students to watch the burning of the Houses of Parliament, on 16 Oct. 1834 (John Green Waller, *Diary*, London University Library, Carlton Coll. MS. 317, fos. 54 f.). They were often together in the late 1830s (Thornbury 1877, p. 459; F. R. Beecheno, *E. T. Daniell* (1889), p. 13), and Charles Landseer told a story of their antics on varnishing day at the Academy (R. Redgrave, *Memoir*, 1891, p. 343). Stanfield, who was a close friend of Dickens, took Turner to the Dickens farewell supper in 1844 (Finberg 1961, p. 401). Stanfield, in contrast to Constable, De Wint, and Copley Fielding, was described as 'enthusiastic and generous in spirit' towards Turner (note by H. A. J. Munro of Novar in a copy of Thornbury 1862, ii. 34, in the collection of Professor Francis Haskell). He owned two drawings by Turner: *Southampton* and *The Old Light, North Foreland* (Christie, 13 May 1868, (698–9)),

as well as many prints after his work, including *Liber Studiorum* and *England and Wales* (ibid., 14 May, 958, 992, 1037, 1078 ff.).
 Literature: D.N.B.

STEVENSON, Robert (1772–1850), **84, 85.**
Engineer to the Northern Lighthouse Board or Commission and the Cumbrae Lighthouse Trust. Designer of bridges and railways, geologist. Supervised the building of the first of his twenty or so lighthouses in 1791. Visited lighthouses throughout Great Britain 1801, 1813, 1818, when he published the first general account of lighthouses. The Bell Rock lighthouse, his most important work, 1807–11 (Stevenson's diary of its construction edited by his grandson, R. L. Stevenson, *Works*, xv (1907), 80–167). Toured the Scottish lighthouses in 1814 with Walter Scott (q.v.), who described him as 'a most gentleman-like and modest man'. In April 1819 he approached Scott for an introduction to Turner as a possible illustrator of his *Account of the Bell Rock Light House*. Scott recommended Stevenson to approach John Thomson of Duddingston (q.v.), although 'a sketch of the Bell Rock from so masterly a pencil [as Turner's] would be indeed a treasure' (Finberg 1961, p. 257). Stevenson was not deterred, and Scott's friend Skene claimed that he supplied Turner with a sketch of the subject (J. Skene, *Memoirs of Sir Walter Scott* (1909) p. 109). He confused Turner with Stevenson's daughter, who provided a vignette for the second title-page of the *Account* based on a sketch by Skene, for Stevenson himself said Turner worked from several sketches made by Andrew Masson in 1816, and by Macdonald in 1820 (*Account*, p. 529). The plate (R. 201) is credited to J. Horsburgh, but in a letter of 1824 to the printer, McQueen, Stevenson states that William Miller (q.v.) also worked on it (I. Bain, 'Thomas Ross & Son', *Journal of the Printing Historical Society*, 1966, p. 14). Miller had been working on *Views in Greece* (1822) for H. W. Williams, whose 'friendly advice and assistance' was also acknowledged by Stevenson in his book. Stevenson told McQueen that Turner had asked for 350 impressions of each plate.
 After working on the *Bell Rock*, Turner became increasingly interested in lighthouses (cf. T.B. CXCVIII (1821)), and from 1824 he produced drawings for engravings including them at *Ramsgate* (R. 117, 782), *The Eddystone* (R. 771, 773 drawn by 1817 (Thornbury 1877, p. 633)), *Lands End* (R. 288, drawing T.B.E. No. 431), *Lowestoft* (R. 293, drawing B.M. 1958-7-12-441), and *Orfordness* (R. 310). The late watercolour *Yarmouth Roads* (T.B.E. No. 626) seems to show the Cromer light.

Literature: D. Stevenson, *Life of Robert Stevenson* (1878); R. Stevenson, *English Lighthouse Tours 1801, 1813, 1818,* ed. D. A. Stevenson (1946).

STOKES, Charles (1785–1853), **109, 129, 317, 327, 328,** 121, 160, 228 n. 3, 241, 244.

Stockbroker, 1813–45. Antiquary, geologist, lithographer. F.S.A. 1811 (see his articles in *Archaeologia,* 1816, 1845). Fellow, secretary and Vice-President of the Geological Society. F.R.S. 1821. Director of the A.G.B.I. in 1823 and Auditor in 1824. An obituarist wrote:

there was scarcely any department of the natural history of sciences with which his acquaintance was not considerable. Careless of fame and brimful of benevolence, he laboured incessantly, whenever a moment of leisure permitted, to advance science by every means that lay within his power. He collected rare and interesting specimens at any cost, not for their own sakes, but to place at the disposal of any competent person who had the requisite knowledge and determination to investigate the subjects they could serve to elucidate. Before microscopic science was in fashion, he was at work encouraging the makers of microscopes, suggesting improvements, purchasing beautiful instruments and testing their application. When lithography was in its infancy in England, he foresaw what could be done with the rising art; and, sparing no expense, found a zealous and talented ally in the late Mr Hullmandel for experimenting on his suggestions [see Stokes's article in *Encyclopaedia Britannica, Suppl.,* V, 1824] ... he was as remarkable for literary, antiquarian and artistic knowledge ... (Herrmann, p. 699)

Crabb Robinson, who met Stokes in 1825 in the company of Phillips, Collins (qq.v.), and Ward, noted that he was 'a disputer, and so far an unpleasant companion, but said to be able and scientific' (*Diary,* ed. Sadler (1869), ii. 295). Stokes may have met Turner through Chantrey (q.v.), whose drawing of him, dated 1821, was etched by Mrs. Dawson Turner. To Cooke's 1822 exhibition he lent the *Southern Coast* drawings *Dartmouth, Minehead,* and *Poole,* and in 1824 *The Mew Stone* (National Gallery of Ireland), *Bridport* (Bury Art Gallery), and *Fowey.* He owned six *Liber* drawings, acquired from Henry Dawe, and twenty-four *Loire* drawings (Cooper Notebooks, ii. 6, 10 (Kurt Pantzer Coll.) and Letter 317), as well as some fifty other drawings and watercolours, chiefly of the 1790s (Sotheby, 28 Nov. 1922). Of Turner's prints he formed a celebrated collection of *Liber* proofs, and of touched proofs of the *Richmondshire* and *England and Wales* series (Sotheby, 28–9 Apr. 1854). Stokes also owned a large collection of Old Master prints and watercolours by Cozens, Malton, Hearne, Dayes, Girtin, Buckler (q.v.), Copley Fielding, and Stanfield (q.v.).

Literature: L. Herrmann, *Burlington Magazine,* cxii (1970), 696–9.

TAYLOR, John (1757–1832), **37, 38, 40,** 38, 274.

Newspaper proprietor and editor. A major shareholder in *The True Briton* from about 1803 (Farington, 26 Mar.), and the following year in *The Sun*, of which he became editor-in-chief in 1817 (Farington, 2 May). An extreme Tory (see *Notes & Queries*, 3rd ser. XI, 96), and an outspoken critic of Walter Scott (see *The Caledonian Comet* (1810), and Farington, 21 May 1815). Taylor was unofficial press officer for the Royal Academy from 1795 (Farington, 29 Apr.); and a close friend of many artists, notably Soane, Chantrey, Lawrence, Phillips, and Constable, who subscribed to his *Poems on Various Subjects* (1827) and some of whom were commemorated in them. He had a reputation for flattery (Farington, 18 Apr. 1814) and was nicknamed 'everybody's Taylor'. But Crabb Robinson, who records this, also found 'he had lively parts, puns, jokes and is very good natured' (*Diary*, ed. Sadler (1869), i. 485). *The Sun* attacked Turner's *Boats Carrying out Anchors* (B.–J. No. 52), in 1804, and Taylor himself described Turner as 'a madman' two years later (Finberg 1961, pp. 109, 126).

Literature: John Taylor, *Records of my Life* (1832).

THOMSON OF DUDDINGSTON, John (1778–1840), **137,** 267, 287.

Presbyterian Minister and landscape painter. In the circle of Sir Walter Scott (q.v.). Turner and Thomson presumably met in 1818; probably again in 1822, and certainly at a dinner given by Thomson in Edinburgh in 1831 which was the occasion of an anecdote by William Bell Scott (*Autobiographical Notes*, ed. Minto (1892), i. 84; see also G. E. Finley, *J.W.C.I.* xxxv (1972), 373, xxxvi (1973), 387). A community of interests and a mutual warmth of feeling between Turner and Thomson is recorded by several writers (e.g. Miller 1854, p. xxxviii), but anecdotes published by Thornbury (1877, pp. 138–40) suggest that Turner was no great admirer of Thomson's work, which is occasionally very close in style to his, and has given rise to a belief in their collaboration on particular pictures.

Literature: W. Baird, *John Thomson of Duddingston* (1895); R. W. Napier, *John Thomson of Duddingston* (1919).

TRIMMER, Henry Scott (*c.* 1780–1859), **56,** xxvi, 6, 39, 261.

Grandson of Gainsborough's friend, Joshua Kirby. B.A. (Oxon.) 1802. Vicar of Heston, 1804–59. Amateur painter. Turner and Trimmer met about 1806, when Turner moved to Hammersmith, near Heston. Trimmer gave Turner instruction in Latin and Greek in return for painting lessons (cf. T.B. CLXIII, pp. 3a, 13; CXX,

V); and he seems to have given Turner a copy of his grandfather's treatise on Perspective (1765). Trimmer took out an insurance on Turner's life, and in 1831 Turner made him a Trustee of his Charitable Institution and an Executor of his will. Both were interested in the chemistry of colours and both subscribed to Field's *Chromatography* (1835). Turner thought of giving Trimmer his *Frosty Morning* (B.–J. No. 127), and at his death Trimmer's collection included the following works by Turner: a pencil *Landscape with Figures* (15) and *A Landscape, with Cattle, in the manner of Gainsborough* (16; cf. B.–J. No. 45), both said to have been presented by Turner; an early *Sea-piece, with fishing boats in a stiff breeze* (42) and a *View of a town on a river, with boats and figures* (47); and an impression of *A Shipwreck* (17). Trimmer's collection also contained many sketches and drawings by Gainsborough, and paintings by Gainsborough, Wilson, Hogarth, Barrett, Romney, Northcote, Copley, Reynolds, Wright of Derby, Fuseli, and a range of Dutch, Flemish, and Italian Old Masters, including paintings attributed to Rembrandt, Velasquez, Titian, Canaletto, and Vernet. (Christie, 17 Mar. 1860). Turner also painted a cat into Howard's portrait of the Trimmer children (Sotheby, 12 Mar. 1969 (28)).

Literature: Thornbury 1877, pp. 121–8, 223–5.

TURNER, Charles (1774–1857), **23, 35, 143, 199,** pl. I, 3, 7, 25 n. 3, 26, 27, 32 nn. 2 and 4, 122, 266.

Aquatint and mezzotint engraver. In London from 1795, working for Boydell and studying at the Academy Schools. Engraver in Ordinary to his Majesty, 1812. Engraver of many of Lawrence's portraits, and of paintings by Eastlake and Jones. Associate Engraver at the Royal Academy, 1828. Met J. M. W. Turner in December 1795; his mezzotint, *Jack's Return* of 1798 (Whitman 893) is said to have a background after him. His first major work for J. M. W. Turner was *A Shipwreck* (1805, see Letters 10, 35). Of *Liber Studiorum* Charles Turner claimed to have agreed to engrave fifty drawings and to have completed twenty-five (Rawlinson 1878, p. 188), although only twenty-four have been attributed to him. The first signs of a quarrel show themselves by about June 1808 (Finberg 1924, p. 60); the rift had occurred by early 1810. Charles Turner claimed in 1852 that it lasted nineteen years (Pye–Roget, pp. 59 ff., Whitman, p. 12), but J. M. W. Turner seems to have favoured his election as Associate Engraver as early as 1814 (Farington, 24 Oct. 1814), and his engraving of *The Burning Mountain* after J. M. W. Turner is dated November 1815 (R. 792; Whitman 863). Charles Turner's last *Liber* plate, *Windsor Castle from Salt Hill* (R. 74) is based on sketches of 1818, and a 'last proof' is dated February 1823, the

year in which Charles Turner was already working on plates for *The Rivers of England* (R. 752, 754, 756, 758, 767). In 1831 J. M. W. Turner appointed Charles a Trustee of his proposed Charitable Institution and an Executor of his Will. Charles Turner was close to the painter until his death, and after it acquired several drawings from the painter's former mistress, Sarah Danby (Whitman, pp. 20–1; diaries now in the Osborn Collection, Yale University Library MS. d. 62). Two pencil portraits of J. M. W. Turner by Charles, of about 1798 and 1807 (Pl. I), are in the British Museum, and he later made two inferior mezzotint portraits, based on his own paintings (Whitman 573, 574), which were published after the painter's death. Some written notes by him on the painter's life and appearance (Sotheby, 20 Mar. 1940, lot 692, bt Stevens) have not been traced.

Literature: A. Whitman, *Charles Turner* (1907).

TURNER, Dawson (1775–1858), **73, 210, 211, 215, 243, 255, 267, 268, 272, 283, 290,** 97, 169, 275.

Banker, antiquary, botanist, bibliomaniac, cataloguer, collector. Fellow of the Linnaean Society, 1797, Fellow of the Imperial Academy, 1800. F.R.S. 1802. F.S.A. 1803. Dawson Turner was a notable patron of John Crome and John Sell Cotman; he had a sizeable collection of Dutch and Italian pictures at Yarmouth, including a Giovanni Bellini and a number of late medieval manuscripts; and he showed some interest in French Neo-Classical painting. Among J. M. W. Turner's friends he was closest to Thomas Phillips (q.v.), through whom he seems to have first approached Turner, with a view to acquiring a copy of *Liber Studiorum*. Phillips wrote that J. M. W. Turner had increased his *Liber* prices (Cambridge, Trinity College, Phillips to Dawson Turner, 12 Mar. 1817; cf. Letter 73), but Dawson Turner did acquire a *Liber*, apparently direct from the artist (Sotheby, 17 Mar. 1853, lot 3197; cf. Letter 268). The stimulus to buy a Turner painting probably came from John Crome, who returned to Norfolk from the 1818[?] Exhibition 'with his whole soul full of admiration at the effects of light and shade, and brilliant colour, and poetical feeling, and grandeur of conception, displayed in Turner's landscapes' (D. Turner, *Outlines in Lithography*, 1840, p. 25). But he never acquired a Turner oil or watercolour. Dawson Turner was also a friend of Charles Heath (q.v.; cf. his portrait in *One Hundred Etchings by Mrs. Dawson Turner*, 1837), whose *England and Wales*, and several copies of whose *Turner's Annual Tours* of the early 1830s were in his sale (lots 1534, 2882–3, 3134, 3199). He also owned a subscription copy of the *Southern Coast*, possibly through William Alexander (see Letter

66), an autograph note from whom was sold with Dawson Turner's copy (lot 3198).

Literature: T. Fawcett, *The Rise of English Provincial Art 1800–1830* (1974), pp. 104–9.

TURNER, William (1745–1829), **10, 123, 124, 125,** 34 n. 1, 60, 61, 89, 94, 96, 102, 107, 113, 135 n. 2, 137.

Turner's father. Barber, born at South Molton, Devon. He had moved to London by 1773, when he married Mary Marshall. He lived over his shop in Maiden Lane, Covent Garden, where Turner was born. Mary Turner was committed to Bedlam in 1801; and William Turner seems to have retired by the following year, when he was living with his son in Norton Street (Finberg 1961, p. 12). He moved with J. M. W. Turner successively to Hammersmith and Twickenham, from where he was in the habit of walking the 11 miles into London, sometimes, it seems, two or three times a week (Farington, 24 May 1813). He was drawn by John Linnell at one of Turner's Academy Lectures in 1812 (Pl. II). William Turner acted as gallery assistant and sometimes secretary to Turner (see Letter 21). Turner claimed to have felt his death 'like that of an only child', but he delayed erecting a memorial until 1832, and then could not remember the date (T.B.E. No. B 4).

Literature: Finberg 1961; J. Lindsay, *J. M. W. Turner. A Critical Biography* (1966).

VALPY, Abraham John (1787–1854), **181.**

Classical printer and editor. Fellow of Pembroke College, Oxford, from 1811. Printer of Red Lion Court, Fleet Street, from 1822, retired 1837. Founder of the *Classical Journal*, 1810–29; publisher of *The Pamphleteer* 1813–28 and of *The Museum*, 1822–5. He brought out a fifteen-volume Shakespeare in 1832–4 and his last, unfinished, work seems to have been *National Gallery of Painting and Sculpture*, four parts of which appeared between 1833 and 1834. Uvedale Price complained to Samuel Rogers in 1824 of Valpy's 'mixture of presumption and affectation': 'I did not much like the manner and style of the letters I received from him' (P. W. Clayden, *Rogers and his Contemporaries*, i (1889), 393 f.).

Literature: D.N.B.

VERNON, Robert (1774–1849), **341,** 5, 121 n. 1, 198, 224, 284.

Horse-dealer, collector and F.S.A. Assembled some 200 British pictures between 1820 and 1847, when the majority were presented to the

National Gallery. Vernon stressed that he purchased direct from the artists (T. S. Cooper, *My Life*, i (1890), 225). His collection was described in 1839:

> Mr Vernon has not gathered his stores into 'A Gallery'. Every room of his mansion is filled with them—from the parlour to the attic; they are evidently brought together far less for display than to render HIS HOME intellectually delightful; to receive enjoyment from every chamber to which he has constant and hourly access. His good taste is displayed also in the other arrangements of his appartments; there is no gaudy drapery or gilded furniture to attack the eye and distract the attention; the chairs, tables and sideboards, are perfectly plain; the pillars simple and quiet; and the looking-glasses framed in weak and narrow strips of moulding. Even the brass rods that hang the pictures are painted over. (*Art Union*, i (1839), 19)

Of the five Turners which Vernon acquired between 1832 and 1842 only one, *Neapolitan Fisher Girls* (1840, B.–J. No. 388) was not in the Vernon Bequest. Vernon also seems to have been introduced to Wilkie by Turner in 1834 (A. Cunningham, *Life of Wilkie* (1843), iii. 91).
 Literature: Vernon Heath, *Recollections* (1892).

WALLIS, Robert (1794–1878), **182, 186,** 246.

Engraver. Son and pupil of Thomas Wallis, an assistant to Charles Heath (q.v.). Working in London from *c.* 1818, and engraved some thirty-seven plates after Turner between 1822 (R. 199) and 1851 (R. 665), including many *England and Wales* subjects. His most celebrated work was the large *Nemi* (R. 659, 1840–2), a proof of which fetched 90 guineas about 1875.
 Literature: D.N.B.

WELLINGTON, Arthur Wellesley, First Duke of (1769–1852), **247,** 140 n. 2.

General and Constable of the Tower of London. At the John Jackson Sale, Christie, 15 July 1831, Turner bought a whole-length unfinished portrait of the Duke by Jackson (lot 153; lot 29 of Turner's own sale, Christie, 25 July 1874).
 Literature: [D. Sutton], 'The Great Duke and the Arts', *Apollo*, xcviii (1973), 160–9.

WELLS, Clarissa Anne (Clara) (*c.* 1790–c. 1871), **87, 148, 155, 204, 207, 218, 239, 249, 263, 265,** 61 n. 2, 255, 294.

Daughter of W. F. Wells (q.v.). Intimate friend and sketching-companion of Turner's from about 1800 (cf. Thornbury 1877, pp. 235–6). Probably the *Miss Wells* listed separately from Wells and his family as a subscriber to *A Shipwreck* in 1805 (T.B. LXXXVII, p. 4).

The closeness of their relationship was recalled in a letter to H. Elliott (q.v.) of 1853, referring to about 1806:

Turner passed so much of his time with us, and was so completely one of our own family, that all my early recollections are so bound up with him that when my mind travels back to those early days, such a flood of thought and reminiscences of him pour in upon me, that it seems but as yesterday, tho fifty years are passed and gone since then. In after life of course our paths diverged and we saw less of each other, yet I feel sure that with both of us, there was not the smallest diminution of real affection and true esteem—we each respected the other—and I am sure no two persons (man and wife excepted) ever knew each other to the heart's core better than we did—but enough, it is dangerous to open memory's floodgates. (Rawlinson 1906, pp. xii–xiii)

Certainly Clara's liveliness and freedom with all her men-friends by 1814 was enough to arouse the jealousy of a would-be suitor, Robert Finch (q.v.), to whom Elliott wrote consolingly:

I take her to possess more constitutional liveliness & elasticity of mind than most people, & having long been accustomed to the unreserved society of pleasing & estimable men, of whose principles & good intentions she felt secure, she has been accustomed to treat her male friends like brothers; and such a young man as Charles Wheeler for intance, whose mind & manners have never had the formation to be derived from good female society, would gladly see in her an elder sister, & the air of confidence & good understanding we observe between them would naturally enough be acquired. But I have never seen her pay exclusive attention to him, to the neglect of others; it is true that some of the 'common crew' who are not capable of understanding and appreciating her, would say on seeing them together that there was a flirtation between them. But so might they say of you the next half hour, of me the next, of Turner the next, of Wilson the next ... (Oxford, Bodleian Library MS. Finch c. 2. d. 5, fo. 284)

Turner's relaxation in this circle is illustrated in another letter of Elliott to Finch, of 27 July 1813, about a trip to Richmond:

The expedition ... took place and afforded one of the most delightful days I have ever spent—everything went off well, & there was no drawback to our enjoyment. Our four-oared boat just held our party of 17, consisting of the Wells's, Herbsts, Miss Perks, Turner, Wilson, Thos, Chas & Jas Wheeler, Edward & I. The six last only rowed, Wilson all the way there & back, Edw & I provided one oar between us, & the Wheelers for the other two. We dined in a beautiful part of Ham Meadows upon half-made hay, under the shade of a groupe of elms near the river, & had coffee and tea at Turner's new house. Miss Perks took a guitar and Edward a flute & we had a great deal of music & singing ... we had good veal & fruit pies, beef, salad &c—but our table cloth being spread on the short grass in a lately mown field we reposed after the Roman fashion on triclinia composed of the aforesaid hay ... (ibid., fo. 270)

It is possible that Clara was the Miss —— of Letter 56, and that Turner hoped to settle with her at Sandycombe Lodge. In the event she had married Thomas Wheeler, the surgeon, by 1820. In 1829 she wrote rhapsodically to Finch of Turner's *Loretto Necklace* (B.–J. No. 331) at the Exhibition:

it is the most perfect work of art that ever has been produced ... such a classical picture never was seen; it is the true epic, it is the Iliad and the Odyssey all in one—there never has been such a picture and I believe there never will be one painted to equal it—not even by Turner himself—I assure you as I looked at it, the tears sprang to my eyes in pure delight and admiration ... (ibid., d. 17, fos. 203 f.)

Turner left Clara £100 by a codicil to his will dated 1849.

WELLS, Emma, **93, 208, 209, 252,** 129 n. 4, 132, 187 n. 3.

Daughter of W. F. Wells (q.v.). Unmarried during Turner's lifetime. In 1823 Emma thought of nursing her sick sister Clara Wheeler and her husband (Elliott to Finch, Oxford, Bodleian Library MS. Finch c. 2, d. 5, fo. 323). Another sister, Harriet (see Letter 159) suggested to Finch in 1813 that Emma was the most teachable of the three sisters (ibid., d. 16, fo. 323). She was probably one of the children who helped Turner to improvise a watercolour landscape at Knockholt about 1807 (P. G. Hamerton, *Life of J. M. W. Turner* (1895), pp. 190–1). Turner left her £100 in a codicil of his will dated 1849.

WELLS, William Frederick (*c.* 1762–1836), **89, 99, 152,** 81, 163 n. 1, 197, 251, 255, 261, 283, 294.

Watercolour painter, etcher, and drawing-master. Exhibited at the R.A. from 1795. Author of *A Treatise on Anatomy*, 1796. Founder of the Old Watercolour Society, 1804; President 1806–7; withdrew 1813 because of John Glover's success in introducing oils into the exhibitions. Wells's daughter Clara (q.v.) recorded that the Society was founded under the mottor 'We oftimes lose the good we else might gain by fearing to attempt' (Shakespeare) and added: 'My father's aim was to prove that it was not *rivalry* nor any antagonistic feeling against the Royal Academy, which promoted the wish for a separate Exhibition, but simply to display to advantage what was strictly and purely a British Art in Water-Color Painting' (C. Wheeler, *Sketch of the original Formation of the Old Water Color Society*, 1871, pp. 3–4). Collaborated with J. Laporte on *A Collection of Prints Illustrative of English Scenery, from the Drawings and Sketches of Gainsborough* (1802–5; publ. 1819). Master of Civil Drawing at Addiscombe Military College, 1813.

Wells was introduced to Turner by Robert Ker Porter about 1792 (Pye–Roget, pp. 20–1); he was a subscriber to *A Shipwreck* in 1805, as well as distributing prints for Turner to other members of the Watercolour Society and other patrons (T.B. LXXXVII, pp. 2, 4). *Liber Studiorum* was conceived in his cottage at Knockholt, Kent, in October 1806 (*Athenaeum*, 1854, p. 720). After his retirement to Mitcham about 1820 'his habits have become less social & attractive & his Family somewhat less refined and intellectual' (H. Elliott to R. Finch, 6 Dec. 1822: Oxford, Bodleian Library MS. Finch d. 5, fo. 319). Wells's work is generally classicizing; his attitude to landscape is also expressed in a letter to Finch of September 1812:

I should certainly be delighted in taking a grave sentimental sort of ramble with you on the bold romantic beach you have so well described. I should like to watch the gradation of the rosy tints of evening, passing from the cool grey surface of the Scarborough crags till they rested on the more glowing & animated countenances of the Naiades, & Dryades, whom I presume occasionally cheer your evenings walk, & for *a moment* call your attention from the towering rocks, the raging sea or the castled cliff—indeed my Dear Sir after all, though I certainly view the romantic features of nature with all the enthusiasm that can attatch to my profession, yet I feel a charm arising from the intercourse & contemplation of animated nature, particularly when presented in her loveliest form, for which the Alps, the Appenines, & even the frigid regions of the Fellifield [? Norway] are but a poor substitute ... (ibid., d. 16, fo. 303)

He may be the 'Wells' who attended the Thomas Monro sale with Turner (Christie, 26 June 1833) and bought eight lots of Turner drawings (84–5, 88, 93, 101–2, 108, 114). Turner made Wells a Trustee of his Charitable Institution and an Executor of his Will in 1831; and was deeply affected by his death, telling Clara 'I have lost the best friend I ever had in my life' (Thornbury 1877, p. 236).

Literature: J. M. Wheeler, 'W. F. Wells', *The Old Water Colour Society's Club*, 46 (1971).

WEST, Benjamin (1738–1820), **64,** 74, 95 n. 2, 130.

Historical painter. Born in Pennsylvania, but settled in Europe in 1760. Member of the Academies of Florence, Bologna, Parma. Arrived in England 1763. Close to George III from 1766; History painter to the King 1772. An original member of the Royal Academy; P.R.A. 1792–1805 and 1807–20. West was a rather uncouth and semi-literate figure; Leigh Hunt said of him that he would 'talk of his art all day long, painting all the while' (*Autobiography*, ch. IV). He painted a number of subjects which were later taken up by Turner: *Agrippina* (1768); the *Departure of Regulus* (1769), *The Deluge* (1805),

and *Death on a Pale Horse* (1817). He occasionally turned to landscape and was a notable supporter of the young Constable. He became critical of Turner's work, and Turner for his part voted against him and in favour of Wyatt for President in 1805 (Finberg 1961, p. 121). But he hoped to acquire a subject-picture by West in 1829 (see Letter 154).

Literature: J. Galt, *The Life, Studies and Works of Benjamin West, P.R.A.* (1820).

WESTMACOTT, Richard, the younger (1799–1872), **259,** 130, 139 n. 3, 271.

Sculptor, son, and pupil of Sir Richard Westmacott, R.A. R.A. Schools, 1818. Italy, 1820–6. A.R.A., 1838. R.A., 1849. Professor of Sculpture from 1857. Turner moved in the circle of Westmacott's father at the Academy, and was certainly in touch with him by 1829 (see Letter 154).

Literature: R. Gunnis, *Dictionary of British Sculptors, 1660–1851* (1968).

WETHERED, William (fl. 1840–63), **270, 274, 276, 286, 297, 298, 299,** 207

Tailor and woollen draper, collector and art-dealer. At 60 High St., King's Lynn, in 1845; had moved to 2 Conduit St., Bond St., London, by 1849 (*Art Journal*, 1849, p. 99), with a residence at 22 Regent's Park Terrace, Camden Town, until 1856. His collection included oriental china, bronzes, and virtu, and many modern British paintings, notably works by Etty and Linnell. Wethered was in close contact with Etty by 1843 (A. Gilchrist, *Life of Etty* (1855), ii. 153), and was commissioning work from Collins (q.v.) in 1845 (W. W. Collins, *Memoirs of the Life of W. Collins* (1848), ii. 269 ff.), and from Linnell from 1847 (A. Story, *Life of Linnell* (1892), ii. 21, 137 ff., 267 ff.). Wethered has been identified (Finberg 1961, p. 408) with the 'Wetherall Esq.' who was the first recorded owner of Turner's *Pluto and Prosperine* of 1839 (B.–J. No. 380), but from a letter of Ruskin to him, dated 12 Dec. 1843 (Copy: Victoria and Albert Museum, 86 FF. 73, fo. 10) it appears that Wethered had only just thought of collecting Turner, and was seeking advice. Ruskin suggested that he might care to acquire *Slavers* (B.–J. No. 385) or *Rockets and Blue Lights* (B.–J. No. 387), both with Griffith (q.v.) at this date. The only work of Turner's in Wethered's recorded sales (Christie, 7–8 Mar. 1856; 27 Feb. 1858), was a proof set of *Tour in France* (i.e. *Turner's Annual Tours*) (8 Mar. 1856 (84)). Wethered told Linnell in 1862:

When I had transactions with the late Turner his prices to me were 200 guineas each for the Venetian subjects and a like sum for English landscapes

[but cf. Letter 296]. The size of the former works was 2 feet by 3 feet and the latter 3 feet by 4 feet so that when I am asked 200 gs. for yours 14 inches by ten I naturally take alarm at the price. (E. R. Firestone, 'John Linnell and the Picture Merchants', *Connoisseur*, clxxxii (1973), 129)

Literature: J. Maas, *Gambart: Prince of the Victorian Art World* (1975), p. 44.

WHEELER, J. J. **224,** 66, 194, 294.

WHITBREAD, William Henry (1795–1867), **200, 217,** 128, 133.
Son of the founder of the brewing dynasty, Samuel Whitbread (1758–1815). M.P. for Bedford 1818, 1820, 1826, 1830, 1831–2. High Sheriff of Bedford, 1837. In a sketchbook of about 1810–12 (T.B. CXXIX p. 2), Turner characterized Whitbread's beer as 'frothy tho poor'.

WILKIE, Sir David (1785–1841), **233,** 7, 31 n. 4, 97, 138 n. 2, 160, 183, 242, 244, 246, 248, 252, 269, 270, 279, 280, 293, 300, 301.
Genre and portrait painter. A.R.A. 1809; R.A. 1811; King's Limner for Scotland 1819; knighted 1836. Trained in Edinburgh but moved to London in 1805. His immediate success inspired Turner to paint *A Country Blacksmith* in 1807 (B.–J. No. 68) and a series of genre pictures in the following years. In a poem of about 1811 (T.B. CXI, p. 65a) Turner attacked Wilkie and his chief rival, Edward Bird, for having 'stopt contented/At the alluring half-way house/Where each a room hath rented'. Wilkie was puzzled by the roughness of Turner's work in 1805, but had come to admire it by 1808 and was on friendly terms with Turner by 1810 (Cunningham, i. 79, 173, 293 ff.). But Turner did not visit Wilkie until the end of 1821: Wilkie wrote to Geddes, 'Turner had never been to see me before, but we found him a good-humoured fellow, neither slack in wit himself nor loth to be the cause of wit in others' (D. Laing, *Etchings by Sir David Wilkie* (1875), p. 140). Wilkie visited France and Holland in 1814, Italy and Spain from 1825, and in 1840 he set out for the Holy Land. In April 1841 he wrote to Thomas Phillips (q.v.) from Jerusalem:
It has been with me an often repeated joke with our highly talented friend Mr Turner, that he ought to have mounted the staff and scallop-shell for such a peregrination; and he will recollect well where he said I wished to send him, when I tell him I thought of him, and wished for him when I passed the ancient city of Jericho, though then, from the ravages of the retreating army, a smoking ruin ... (Cunningham, iii. 443–4)

Turner was deeply moved by Wilkie's death (cf. *Letters of Dr. John Brown*, ed. Brown and Forrest (1909), p. 334), and painted a

memorial picture, *Peace, Burial at Sea* in 1842 (B.–J. No. 399). The black sails, he told Stanfield (q.v.), he could not make black enough to express his sorrow (P. G. Hamerton, *Life of Turner* (1879), p. 292).
Literature: A. Cunningham, *The Life of Wilkie* (1843).

WILLMORE, James Tibbitts (1800–63), **201,** 162 n. 4, 211 n. 1.
Engraver, apprenticed to William Radclyffe in Birmingham. Moved to London in 1822. Assistant to Charles Heath (q.v.), he was elected an Associate Engraver at the Royal Academy on the strength of a proof of *Ancient Italy* (R. 657) shown there in 1843. He worked on W. Brockendon's *Passes of the Alps* (1828–9), and his first large plate was after Eastlake's *Byron's Dream* (1834). It was perhaps this which led Turner to invite Willmore to work on a large plate for himself, although Willmore himself attributes this offer to the success of *Alnwick Castle*, for *England and Wales* (R. 242) in 1830. According to the engraver they met, and Turner, 'with many most cordial grunts … gave him an hour's lecture, difficult to understand, on the art of engraving', advising him 'by all means to sacrifice everything to his art', and commissioning the large plate. It was delayed, and Turner visited Willmore at home with his family. Turner remarked: 'I hate married men, they never make any sacrifice to the Arts, but are always thinking of their duty to their wives and families, or some rubbish of that sort', but the interview led to a concrete proposal for Willmore to engrave *Mercury and Argus* (R. 650) sharing the costs, and Turner taking 250 of the 850 impressions.

Turner regarded Willmore as one of his six best engravers (Rawlinson i, p. lxvi), but according to another engraver of *Turner's Annual Tours*, he found his plates for that publication 'too soft, spongy and black', so that 'on more than one occasion … he introduced a moon, and thus changed a daylight into a night effect' (M. B. Huish, *The Seine and the Loire* (1890), pp. x–xi; the reference is probably to *Montjen* (R. 445)). He engraved some thirty-seven plates after Turner between 1828 (R. 226) and 1851 (R. 667). In September 1833 Willmore wrote to W. B. Cooke (q.v.) that he would engrave subjects for him at the *Annuals* price of 40 guineas, but 'very full subjects and Turner's are excepted' (Letter in Philadelphia Free Library). There is a large collection of Willmore's proofs in the Birmingham City Art Gallery.
Literature: Art Journal, 1863, pp. 87 f.

WINDUS, Benjamin Godfrey (1790–1867), **342,** 150 n. 4, 214 n. 3, 232, 237f., 281.
Coachmaker and collector, with an office in Bishopsgate, London,

and a house at Tottenham. Formed a collection of watercolours from about 1820, some of which he lent to the Old Watercolour Society in 1823 (Roget i. 436). He lent a Turner watercolour of *Margate* to Cooke's 1823 Exhibition, and also owned Girtin's *White House* (Tate Gallery) by this date. By 1834 Windus owned some fifty Turners (Finberg 1961, p. 353), probably including the twenty *Southern Coast* drawings in his collection in 1840, and the *Hastings, A Storm* (T.B.M. No. 87) and *A Calm, Twilight-Folkstone*, and *Cologne*, which had been commissioned by W. B. Cooke in the 1820s. Windus lent sixteen *England and Wales* drawings to the Moon, Boys & Graves exhibition in 1833; in 1840 he owned thirty-six of the series, at least twenty-eight of which had been in the 1829 Egyptian Hall exhibition (see pp. 237f). Several of these were probably painted for Windus at Tottenham (Gage 1969, p. 32). By 1840 Windus also owned eighteen of the twenty-six vignettes for Byron's *Life and Works* (1832–4), the four vignettes for Moore's *Epicurean* (1839; R. 634–7), twenty of the twenty-six drawings for Finden's *Landscape Illustrations to the Bible* (1835–6), and all sixty-seven vignettes for Scott's Poetical and Prose Works, and Lockhart's *Life of Scott* (R. 517–56, 566–8), for which Windus paid 12 guineas apiece (J. Burnet, *Turner and his Works* (1852), p. 43). Robinson described the collection in 1840:

This collection principally consists of drawings by *Turner*, which alone amount to upwards of two hundred; these have been collected at various periods, regardless of expense, and they may be very justly considered the most choice and interesting specimens of the pencil of that great artist.

The cottage, though not large, contains several well-proportioned apartments, fitted up in an extraordinary style of neatness and with much taste. The library and drawing rooms are hung with the choicest of *Turner's* drawings, framed and glazed, to the number of seventy; the remainder of the collection are preserved in portfolios ...

The dining room is hung with a miscellaneous collection of drawings by *Harding, R. Westall, Cattermole, J. Lewis, D. Roberts, J. Christall, Chalon, Liverseege, F. Taylor, J. Edridge*, &c., forming a pleasing variety.

Mr Windus also possesses a matchless collection of drawings and sketches by Sir David Wilkie, upwards of six hundred and fifty in number, with a complete collection of the engravings from his works, in the choicest states; and also a small but very select collection of drawings by *Stothard* ...

Windus turned to buying Turner oils in 1841, but he was still commissioning drawings as late as 1845 (cf. T. B. CCCLXIV, pp. 289, 381). Many of his drawings were later acquired by Munro of Novar (q.v.). Windus may have been active as a dealer; his Wilkie collection was sold in 1842 (Christie, 1–2 June), just after the painter's death; and he put five of his Turner oils on the market in 1853 (Christie,

20 June). But Thornbury's story that Turner broke with Windus because he found him reselling watercolours at higher prices seems unlikely in the light of Letter 3̄3̄1̄. Windus made his collection readily accessible to visitors, and in the 1850s was a leading supporter of the Pre-Raphaelites.

Literature: W. Robinson, *The History and Antiquities of Tottenham* (1840), i. 83–90.

WOOLLCOMBE, Henry (1777–1847), **57, 62.**

Solicitor and historian. Founder of the Plymouth Institution in October 1812; frequently President, and sole President 1827–46. Mayor of Plymouth 1813–14. On friendly terms with many artists, including Wilkie and Johns (qq.v.), who was curator of the Institution. He had met Turner with Eastlake (q.v.) in 1813, and noted that he was 'an artist whose works I have so much admired; he is brought hither by the beautiful scenery of our neighbourhood, there is a chance of his occasionally residing amongst us. I certainly wish this may take place, as it is always desirable to attract talent around, where it is accompanied by respectability' (*Diary*, 24 Aug. 1813; Mrs. Woollcombe). On 1 Sept. Woollcombe noted that he was 'well pleased' with Turner's sketches of the neighbourhood. The early emphasis of the Institution was on natural history; the first exhibition of Fine Arts was in 1815.

Literature: T. Fawcett, *The Rise of English Provincial Art* (1974), p. 188.

WYATT, James (1774–1853), **24, 25, 26, 27, 28, 29, 30, 31, 32, 33, 34, 41, 44, 45, 46.**

Carver and gilder, printseller, art dealer. Mayor of Oxford 1842–3. 'A remarkable man in many ways, and one of nature's gentlemen' (J. D. Millais, *Life and Letters of Sir J. E. Millais* (1899), i. 34 ff.). Perhaps introduced to Turner by William Delamotte (q.v.), many of whose drawings Wyatt owned. His sale (Christie, 4–6 July 1853) included, among the engravings, a *View of Twickenham, after Turner— small* (266, not in Rawlinson), and an early watercolour of St. Mary Magdalen, Oxford (420), as well as a full-size copy of the *High Street* (546) and many etchings and proofs of both engravings referred to in the letters. Wyatt's collection also included several Dutch and Flemish paintings, an Italian landscape by Fransisque Millet (463), two Wilson landscapes, oils by Uwins, Mengs, W. Westall, Nasmyth, Angelica Kauffmann, Monamy, Sir William Allen, Zuccarelli, Copley, Sidney Cooper, Barker, Solomon Hart, and J. E. Millais. Among the watercolours were works by Copley Fielding, Callow, Delamotte, and William Turner of Oxford; and prints by and after Mortimer,

Hogarth, Rembrandt, and Dürer. Wyatt's successor, Ryman, told Rawlinson (i. 37) that he had been told Turner especially admired Raphael Morghen's engraving after Guido Reni's *Aurora*, while he was staying with Wyatt at Oxford.

YARBOROUGH, Charles Anderson-Pelham, Baron (1749–1823), **1,** 24.

Whig M.P. for Beverley 1768–74 and for Lincolnshire 1774–94, when he was raised to the peerage as Baron Yarborough of Yarborough. Sheriff of Lincolnshire 1771; F.R.S. 1777; D.C.L.(Oxon) 1793; F.S.A. 1796. Most of Yarborough's Old Master collection, including two Claudes and a Joseph Vernet, and works by Cuyp, Gaspar Poussin and Rosa, were inherited from his father-in-law in 1801: they were described as 'very indifferent' (Farington, 7 May 1805). He had however bought Bernini's *Neptune and Glaucus* from the Reynolds Sale in 1794 (W. T. Whitley, *Artists and their Friends in England* ii. 181 f.). Turner visited Brocklesby to make sketches and three draw-ings of James Wyatt's Mausoleum to Yarborough's wife at the end of 1798 (Finberg 1961, p. 52; T.B. LXXXIII, CXXI U); one at least of them was engraved (see Letter 7). In 1804 Yarborough bought Turner's *Festival of the Vintage at Macon* (B.–J. No. 47) for 400 guineas; inscriptions on sketches in the *Calais Pier* sketchbook linking them with *Ld. Yarborough's Picture* (T.B. LXXXI, pp. 54, 116–17) are prob-ably retrospective. Yarborough and his son the Hon. Charles Pelham, were both subscribers to the *Shipwreck* print of 1805 (T.B. LXXXVII, pp. 2, 4) and Pelham bought Turner's *Wreck of a Transport Ship* (B.–J. No. 210) in 1810.

Yarborough was said 'with two other noblemen' to have financed Turner's Continental visit of 1802 (*Manchester Art Treasures Exhibition*, 1857, Provisional Catalogue, p. 111).

Literature: G. Waagen, *Treasures of Art in Great Britain*, Supplement (1857), pp. 64 ff., 501 ff.

YOUNG, John (1755–1825), **50.**

Engraver, cataloguer, and art-administrator. Assistant Keeper of the British Institution 1810, Keeper 1813. Pupil of John Raphael Smith; Court Engraver to the Prince of Wales 1789. Ran a drawing school in 1811 (Farington, 21 May). Secretary of the Artists' Joint Stock Fund 1810; Honorary Secretary of the Artists' General Benevolent Institution, 1813. Young catalogued the collection of Sir John Leicester (q.v.) in 1819, and engraved Turner's *Bridgewater Sea Piece* (B.–J. No. 14) in mezzotint in 1824 (R. 777).

General Index

The places Turner visited or with which he is associated are also listed under 'Tours'.